A Theory of Art

A THEORY OF ART

Karol Berger

NEW YORK OXFORD
OXFORD UNIVERSITY PRESS
2000

Oxford University Press

Oxford New York
Athens Auckland Bangkok Bogotá Buenos Aires Calcutta
Cape Town Chennai Dar es Salaam Delhi Florence Hong Kong Istanbul
Karachi Kaula Lumpur Madrid Melborne Mexico City Mumbai
Nairobi Paris São Paulo Singapore Taipei Tokyo Toronto Warsaw

and associated companies in
Berlin Ibadan

Parts a and b of chapter 4 originally appeared in *The Journal of Musicology* 12(4)
Fall 1994, pp. 407–33. © 1994 by the Regents of the University of California.
Reprinted with permission.

Library of Congress Cataloging-in-Publication Data
Berger, Karol, 1947-
A theory of art / Karol Berger
p. cm.
Includes bibliographical references and index.
ISBN 0-19-512860-5
1. Arts—Philosophy. 2. Aesthetics. 3. Poetics. I. Title.
BH39.B393 1999
700'.1—dc21 98-47060

1 3 5 7 9 8 6 4 2

Printed in the United States of America
on acid-free paper

For my three ladies, Anna, Trine, and Zuzia

. . . sonst bin ich verloren!

"This poet came from a country where the universal ugliness and vulgarity bothered him even more than the criminal tyranny," writes Czesław Miłosz about a fellow exile from utopia, Joseph Brodsky.[1] Anyone who experienced the long, gray, Brezhnevite winter of the 1960s and 1970s in Moscow, Warsaw, or East Berlin will immediately see how exactly right this observation is. But how is this possible? How could ugliness bother one to such an extent that it would influence one's moral and political decisions? How could it push one onto the road which ends with exile? Have we not learned that the aesthetic and the ethical are two separate realms?

And if there is no exit? Primo Levi describes how in Auschwitz a recollection of a few lines from Dante, the words of Ulysses to his crew ("Consider your origin: you were not made to live as brutes, but to pursue virtue and knowledge") afforded him a rare moment of exaltation: "As if I also was hearing it for the first time: like the blast of a trumpet, like the voice of God. For a moment I forget who I am and where I am."[2] Levi was too sober a participant not to observe that much of the time a cultivated man was at a disadvantage in the Hobbesian world of forced labor and barrack life. And yet, the recollected verses "made it possible for me to re-establish a link with the past, saving it from oblivion and reinforcing my identity."[3] Can poetry save lives, then?

The questions of the kind that Miłosz's and Levi's observations raise lie at the origins of this book. What, if anything, has art to do with the rest of our lives, and in particular with those ethical and political issues that matter to us most? And will at least some of the art created today, under the more clement skies, meet this most exacting criterion of value and offer any help when recollected by those drowning in some future deluge?

Philosophical theorizing about the arts is almost as old as philosophy itself.

Its most distinguished examples, respectively ancient and modern, are Aristotle's *Poetics* and Hegel's *Aesthetics*. Some of the best philosophers have contributed to the discipline of aesthetics since it was established in the middle of the eighteenth century (Kant, Schopenhauer, Nietzsche, Dewey, Heidegger come readily to mind) and the discipline continues to flourish today (with such practitioners on both sides of the Atlantic as Danto, Gadamer, Goodman, Ricoeur, Scruton, and Wollheim, among others). While my book belongs to the broad family of philosophical art theories, a combination of three factors distinguishes it from the other books in the field known to me.

First, ever since Plato philosophers have been much exercised by the question of what art is, have felt impelled to take on the problem of getting art's ontological status right, of finding a way to distinguish art from other entities. One way or another, this is still the guiding task of most philosophical work on art done today. (Arthur C. Danto, for instance, writes: "In my view, the question of what art really and essentially is . . . was the wrong form for the philosophical question to take. . . . [T]he real form of the question should be . . . : what makes the difference between a work of art and something not a work of art when there is no interesting perceptual difference between them?"[4]) I do not think that the task is unimportant (and, in fact, devote chapter 1 to it), I just think that one should not stop with it, that there are more interesting tasks ahead of us. We might want to say, in effect, Let's not worry too much about the ontological status of this object, let's even concede in advance that it *is* art. What really matters is what happens next (the question I pick up in chapter 2): even if we grant to this object the status of art, we still do not know whether and why we should bother ourselves with it. And to know this should be much more useful to us than to know how to distinguish art from other entities. In short, I am trying to shift the focus of aesthetics to the question, What should the function of art be, if art is to have a value for us?

Second, unlike most philosophers today, who define art primarily in terms of either poetry or painting, I tend to privilege music (without, I hope, doing grave injustice to either literature or visual arts). My musical focus is particularly clear in chapter 3, where the questioning acquires a more explicitly historical character than elsewhere in the book. The reason for this focus is my conviction that music represents the central features and dilemmas of the social and historical situation of art today in a particularly radical, acute, and clear fashion. Thus the diagnosis of chapter 3 might be profitably read against the background of the current Parisian debate concerning the crisis of contemporary art, a debate conducted almost exclusively with reference to the visual arts.[5]

Third, the range of the questions I ask is not limited to those traditionally asked by writers on aesthetics, but also includes issues in poetics and hermeneutics. The two areas of inquiry that all too often ignore one another, the aesthetics of philosophers and what literary scholars now grandly call Theory, are here brought together. The question asked in the chapters devoted to poetics (chapters 4 and 5) is, Given the functions of art identified above, how does art fulfill them? In

other words, while aesthetics is about the aims of art, poetics is about its means: it attempts to show what the world represented in an artwork should consist of if it is to fulfill its functions. In chapter 4 I identify the elements that constitute an artworld, then in chapter 5 I show how these elements may be formally arranged. Finally, the chapter devoted to hermeneutics (chapter 6) asks, Given the aims and means of art identified above, how should art be interpreted?

In short, my book differs from other books in the field in that it shifts the focus of attention from the question of what art is to the question of what art is for, it argues that music offers the best insight into the contemporary situation of the arts, and it combines aesthetics with poetics and hermeneutics. The book addresses a heterogeneous audience, not only philosophers, but also literary scholars, art historians, and musicologists, and not only academics, but also professional artists as well as art lovers—in sum, anyone with a serious interest in the arts. This varied potential audience accounts for several stylistic, generic, and disciplinary features of my text. Stylistically, I have attempted to keep the text free of technicalities and write in relatively plain English, without dumbing it down in any way. Generically, the text falls somewhere between a scholarly treatise and an essay: while I do not ignore other writers in the field and quote from them all too copiously, my main concern is to develop my own position rather than to demolish the arguments of my predecessors. And the disciplinary identity of the book is deliberately vague: it inhabits the no-man's-land between the philosophy of art, literary theory, art theory, and musicology.

I have been fortunate to be able initially to test various ideas developed in this book in conversations and seminars conducted with a number of friends and colleagues over the last decade or so and I mention some of these occasions here with gratitude. Andrzej Rapaczynski and Wojciech Karpiński will find in these pages echoes of the discussion conducted intermittently in the museums and galleries of Italy, Paris, and New York. I have learned more about the nature of poetry from Stanisław Barańczak and Adam Zagajewski than from many a learned tome. The late Carl Dahlhaus was most generous with his time during my year in Berlin and was as dazzling and inspiring as a conversation partner as he was as a writer. Like so many others, I have derived great benefit from the Faculty Seminar on Interpretation which John Bender and David Wellbery so ably directed at Stanford. Similarly useful were several faculty seminars for literary scholars, art historians, and musicologists organized at the Stanford Humanities Center by Hans Ulrich Gumbrecht. I have benefited also from the discussions that accompanied the conference on music reception which I co-directed with Michał Bristiger at the Institut für die Wissenschaften vom Menschen in Vienna and the colloquium on music and narrative which I co-directed with Anthony Newcomb at the Doreen B. Townsend Center for the Humanities of the University of California at Berkeley and the Humanities Center of Stanford University. The generous sponsorship of these events by the institutions just mentioned

is gratefully acknowledged. The ideas developed in chapter 3 were first presented as a Hanes-Willis Lecture at the University of North Carolina at Chapel Hill and as an Astor Lecture at the University of Oxford. I am indebted to the music faculties of both institutions for many hours of profitable discussions and for their warm hospitality. The last section of chapter 4 was originally presented at the opening session of the 1993 International Congress of the Gesellschaft für Musikforschung at Freiburg and has benefited from the reactions of the session's organizer, Hermann Danuser, as well as those of other participants. My Stanford students deserve particular gratitude for the patience and tenacity with which they have forced me to clarify my ideas.

Several sections of this book have already appeared, or will shortly appear, in print elsewhere. Sections 3.b–c make use of the material presented in my "Concepts and Developments in Music Theory, 1520–1640," forthcoming in *The New Oxford History of Music,* vol. 4, ed. J. Haar (Oxford: Oxford University Press). Sections 4.a–b appeared in *The Journal of Musicology,* 12 (1994), 407–33, and section 4.c in H. Danuser, ed., *Musik als Text. Bericht über den Internationalen Kongreß der Gesellschaft für Musikforschung, Freiburg, 27.9.-1.10.1993* (Kassel, Germany: Bärenreiter, 1998). Sections 5.a–b appeared in N. K. Baker and B. R. Hanning, eds., *Musical Humanism and Its Legacy: Essays in Honor of Claude V. Palisca* (Stuyvesant, N. Y.: Pendragon Press, 1992), pp. 451–70. I am grateful to the editors and publishers for allowing me to use this material here.

Two year-long research fellowships, one from the Alexander von Humboldt Foundation and another from the American Council of Learned Societies, have allowed me to devote long periods to the uninterrupted reading, thinking, and writing that a project of this sort requires. I acknowledge their generous sponsorship with gratitude. I am similarly grateful to Stanford University for providing me with research support and, above all, for its incomparable intellectual environment.

I could not possibly express the full extent of my gratitude and appreciation to a number of my friends and colleagues who took the trouble to read some or all of my manuscript and to share their reactions with me. James McKinnon and Reinhard Strohm commented on chapter 3, Kendall Walton subjected chapters 1 and 4 to a detailed critique, Thomas Grey, Stephen Hinton, Wojciech Karpiński, and Anthony Newcomb gave me their views of the complete manuscript, and I received long letters evaluating the whole project from John Daverio and from Lydia Goehr. I am grateful to all of them for making me see where and how the text should be improved. I am similarly grateful to my wife, Anna Maria Busse Berger, for her passionate involvement in this project through all the stages of its development. To Laurence Dreyfus and Richard Taruskin I owe most particular thanks for having annotated virtually every page of their respective copies of the entire manuscript with invaluable comments. I consider myself privileged and blessed in the generous intellectual companionship of so many fine minds.

CONTENTS

"Somehow it seems to fill my head with ideas—only I don't know exactly what they are!"

Alice on "Jabberwocky," in
Lewis Carroll, *Through the Looking-Glass*

A THEORY OF ART

Prologue

The Function and Value of Art

> Consider a discipline such as aesthetics. The fact that there are works of art is given for aesthetics. It seeks to find out under what conditions this fact exists, but it does not raise the question whether or not the realm of art is perhaps a realm of diabolical grandeur, a realm of this world, and therefore, in its core, hostile to God and, in its innermost and aristocratic spirit, hostile to the brotherhood of man. Hence, aesthetics does not ask whether there *should* be works of art.
>
> Max Weber, "Science as a Vocation"

What is art? One is tempted to paraphrase St. Augustine's answer to another inquiry: "What is time then? If nobody asks me, I know: but if I were desirous to explain it to one that should ask me, plainly I know not."[1] Having said this, Augustine went on to look for an answer anyway, and so should we. But first I should clarify the question, make it more precise, show that it is worth asking, and think what a satisfactory answer would have to look like.

In a pragmatic spirit, I take the question, What is *x*? to be equivalent to, What is the function of *x*? or, What is *x* for? We know what something is when we know what can be, should be, or is being done with it. When someone asks, What is a hammer?, there is nothing better you can do than to take a hammer and drive a nail into a board with it. Our pretheoretical understanding recognizes in art a family of social practices, sustained by appropriate institutions, and evolving within the historical context of continuous traditions. Art is what those who write poetry do, as well as those who write novels, and those who compose string quartets (or perform them), and those who paint landscapes, and many others. Central to any understanding of a practice must be to grasp its point. We do not know what someone is doing unless we know what his purpose or intention is.

3

A painter's identical actions would be interpreted in one way by an observer who thought that the point of the activity in front of him was to put a protective coat of paint over the wall and in another by someone who interpreted it as an effort to provide the heavenly backdrop to the Assumption scene. If we are to understand what art is, we have to grasp the points of the many practices we commonly subsume under this term and see what these points have in common, or at least in what way they constitute a "family" in Wittgenstein's sense of the term.[2]

What is, then, the function of art? What are all these sculptures and paintings, operas and symphonies, poems and novels, dramas and films actually for? Why would healthy, enterprising, and intelligent men and women want to devote their life efforts to making objects of this sort, when they could easily follow so many other obviously valuable and satisfying professional paths in politics, business, or the army; law, medicine, or education; engineering, science, or scholarship? Why should those of us who did choose these other paths want to spend any of our leisure time in the company of artworks? Why should private patrons, civic organizations, and governments divert any part of their financial resources toward the support of artists and artistic institutions and away from economic growth, infrastructure, health care, education, scientific and technological research, or security? Clearly, the question that will drive our inquiry is not a matter of idle curiosity. The possibility of a rational debate on the proper allocation of resources, whether public or private, to the arts rests on our having an answer to the question of the function of art.

The need to answer the question of art's function becomes more acute as the autonomy of the artist grows. Autonomy is widely seen today, especially among theorists and historians of a sociological bent, as the single most important feature distinguishing modern from premodern art. The commonly heard claim is that until quite recently, as recently perhaps as the mid-eighteenth century, art in the strong, specifically modern, sense of this term—that is, art as an autonomous practice pursuing goods of its own—did not exist, or existed only on the margins of a large family of heteronomous artistic practices. Much of what today would be classified as art was produced to accompany, embellish, and enhance the public and private rituals and ceremonies of religious, political, and social life. Premodern art was embedded within a wider sphere of social practices and derived its significance from them. It was predominantly heteronomous, since the goods it pursued were not internal to the artistic practices themselves. Instead, art served the goals of the principal social institutions: the church and the state, the guilds and corporations of the civil society, the family. Thus, the question of art's function, or rather functions, was not at issue. A statue of Judith slaying Holofernes placed on the central square of a medieval city-state would serve to remind the citizens of the proud republic of the fate awaiting usurping tyrants. An opera extolling the clemency of a Roman emperor performed during the coronation festivities of an absolute monarch would serve as a lesson of royal virtue for both the ruler and his subjects. A chorale prelude for the organ would remind a Lutheran congregation of both the melody and the significance of the

text they were about to sing. A small crucifix would serve as the focus of private domestic devotion. A representation of a dog on a double portrait of newlyweds would remind them and other onlookers of the central role played by the virtue of fidelity in a well-ordered marriage. In all such cases the artwork had a clearly defined function: it served the goals of the principal social institutions, goals external to the practice of art itself.

But it is a defining feature of modern art that it is autonomous, that the goals of its producers are internal to the practices of the various arts themselves, and not imposed on them from without. It is precisely the autonomy of modern art that gives rise to the question of the function of art and makes the question so difficult to answer. Once art has been emancipated from the context of social practices that gave it its significance, what is its point? What is the function of functionless art? What are these goods internal to artistic practices, and are they good enough to replace the older, external ones, to make the arts worth bothering with?

A good example of how a historical sociologist develops the contrast between the premodern and modern art is provided by Norbert Elias's reflections on Mozart.[3] Elias understands the contrast between the premodern and modern art (or rather, as he calls them, "craftsmen's art" and "artists' art") in the manner of the Weberian ideal types. The most distinctive feature of the premodern, or craftsmen's, art was its heteronomy, the fact that the goods one pursued in working at it were primarily not internal to the practice of art itself, but rather internal to other, nonartistic social activities of art consumers. Art was produced for a personally known patron of a far higher social status than that of the art producer. Art was not as yet a specialized domain, moreover, but a function of other social activities of the consumers. In particular, it was an aspect of the competitive spending on status. Since art was created for specific social functions, not the least of which was the society's self-display, the patrons were not individualized, but rather represented social groups. In other words, premodern art was addressed to groups of people assembled for purposes other than aesthetic ones. These facts had important consequences. The individual artist's imagination was subordinated to the canon of taste of the social group to which the patrons belonged. This resulted in a weak individual and the strong social character (style) of the artwork.

Modern art, by contrast, is produced for a market of anonymous buyers, with a social parity existing between the artist and the buyer (democratization). It addresses not groups, but a public of isolated individuals, and its function is specifically aesthetic. This changes the balance of power between the artist and patron in favor of the former. The result is the artist's greater independence from the society's taste (the artist now molds the taste of the public, instead of serving it) and the greater individualization of the artwork's character.

The problem for a historical sociologist is to find the reasons for the change from the premodern to modern form of art—that is, the reasons for the change in the social situation of artists. Not surprisingly, Elias looks for explanations in the

social ascent of a wealthy middle class, in the displacement of the court aristocracy by the professional bourgeois public as the upper class. One example of this is Elias's awareness that the transition from the craftsmen's to artists' art did not happen simultaneously in all artistic fields, that in German-speaking lands, for instance, it occurred much earlier in literature (and philosophy) than in music or architecture. The development of the market for books that allowed a writer a freelance existence, however precarious, preceded by decades the development of comparable market institutions—such as music publishing, copyright, or public concerts—for music.

Later, in chapter 3, I shall explain why it is plausible that various arts achieved a significant degree of autonomy long before the eighteenth century. Instead of the growing autonomization of art, one should rather stress the growing autonomization of the artist as a feature of the modernization process. Once an artist stops working for a specific patron (a church, a court) and offers his products for sale to patrons whose identities cannot be fully specified in advance, that is, once he begins to function within the market, he may be better able to produce works that embody his, rather than his patrons', values, thereby increasing his autonomy (even if in practice this autonomy is frequently undermined by the increased economic insecurity). In fact, in Europe and its cultural extensions it has been positively expected of the artist for more than two centuries now, that he will be autonomous and original in this sense. It is undeniable that the modernization of art involves the autonomization of the artist, although the full complexity and the uneven character of this development as it pertains to individual arts should not be underestimated: unlike painters, who, with their artisanal traditions, found successful ways to exploit market mechanisms early on (think of Titian's, or Rembrandt's, studios), composers began to devise strategies for functioning within the market only in the late eighteenth century, and their success even today is not unqualified. (Mozart's is a paradigmatic early case, and the extremely small number of art music composers, as compared to painters or novelists, who between his time and ours actually managed to make a living as composers is striking.) All the same, the autonomization of the artist and its corollary requirement of originality surely contributed to the growing urgency of the question concerning art's function. Not surprisingly, the process of autonomization was accompanied by the birth of a general art theory, the philosophical subfield of aesthetics.

When it comes to the social situation of art, and probably to much else as well, we are still living in the era that took shape decisively in the decades around 1800, the era of inexorably increasing social equality and democratization, the early outlines of which were grasped with particular clarity by Tocqueville. Today more than ever, the principal sources of support for those painters, composers, and writers who actually manage to make a living from their art take the form not of the personal patronage of the rich and powerful, but of the impersonal market or the state (acting either directly or through the mediation of the tax code). No less today than in 1800, artists expect to be autonomous and are

expected to be original. And today, more than ever before, we find it hard to agree on what it is exactly that we expect from them. We are still very much the moderns.

To be sure, we are the postmodern sort of moderns.[4] Jean-François Lyotard may well be onto something when he claims that we have lost faith in any of the grand overarching "meta-narratives" that gave earlier moderns their sense of identity and direction, narratives that purported to make sense of the totality of human history.[5] The slow intellectual drying-out and the subsequent rapid po-litical demise of Marxism, the most influential of all modern meta-narratives, in particular, makes us wary of any kind of secular prophecy and ready to embrace a vision of a plurality of coexisting life forms and partial, local stories that make sense of these life forms. But two cautionary remarks are in order. First, our world remains as modern as it was for the last few centuries. What is postmod-ern is not the world, but the pluralist acceptance that there is more than one true story to be told about it. Second, and more important, the distinction Ly-otard draws between modernism and postmodernism is far too stark.

It is not true that the only choice we have is between a belief in universal history grasped by an all-explaining meta-narrative and a belief in a plurality of equally valid life forms and local stories that make sense of them. A large and fruitful territory lies between these two extremes, a vision of a plurality of life forms and stories, indeed, but not ones that coexist by politely ignoring one an-other, but rather ones that are engaged in a never-ending competition. Lyotard has got it right in so far as the demise of meta-narratives is concerned. But the vision of a plurality of equally valid coexisting life forms may be compelling only to those whose outlook is underpinned by one more meta-narrative, that of a continuous and rapid global growth of prosperity. The rest of us postmoderns will have to recognize that various life forms will continue to compete for re-sources with one another in any foreseeable future. The postmodern vision re-mains plausible only so long as we imagine that the only dilemmas we shall ever face are of the order of choosing between a cappuccino or a caffè latte, or de-ciding to buy a Volvo or a BMW. Once we recognize that we may also face other sorts of questions, such as, Shall we tax the rich, or shall we treat them as a sep-arate culture pursuing its own legitimate life form? or, Shall we intervene in a distant country, or shall we allow one tribe to practice its life form by engaging in ethnic cleansing?, postmodernism loses some of its plausibility.

If the competition for resources among various life forms is not to take a vi-olent turn, if choices between conflicting claims are to be based upon the force of arguments rather than arms, we have no alternative but to engage the com-peting life forms in a rational dialogue. A genuine dialogue requires not only that the two sides listen to one another, but that each puts its views in jeopardy by comparing them with the views of the dialogue partner, and that each is prepared to change its views as a result. Without accepting any all-embracing universal meta-narratives, one must be prepared to exchange one's own story, as well as the story told by one's interlocutor, for a slightly less local and parochial, but still

far from universal, story one will be able to tell together with one's interlocutor as a result of the dialogue. ("The superiority of one position over another," writes Charles Taylor, "will consist in this, that from the more adequate position one can understand one's own stand and that of one's opponent, but not the other way around."[6])

This sort of piecemeal local pragmatic negotiating, together with huge doses of plain violence, has characterized the practice of the modern age from its beginnings a few centuries ago. It may well turn out that the recourse to universal meta-narratives, far from being the most central feature of modernity, has been an important, but ultimately atavistic, sideshow, a nostalgic search for a suitable secular replacement for the grand religious meta-narrative of the premodern era. On this account, the label of "postmodernism" would be no more than an attempt by lapsed Marxists to give their disenchantment the dignity of an epochal change. What I am suggesting, in short, is that perhaps postmodernity is not a new era at all, but rather a state of mind of the post-Marxist intelligentsia, unprecedentedly affluent (and hence ready to approach the world in the spirit of cheerful playfulness) and wary of any new commitments.

Be that as it may, whether we are postmoderns or simply more than usually confused moderns, our daily disputes about such issues as public funding for the arts, or censorship, or university curriculum make it abundantly clear that we need a theory of art, an answer to the question concerning the function of art, no less than our ancestors living around 1800 did.

It should now also be clear that the question we started with, What is art?, consists really of two questions rather than one: What is the function of art? and What is the value of this function? One might look for answers to the first question in two ways. One might investigate it empirically-historically and find out what the function or functions of various arts have actually been once these arts achieved autonomy from their traditional contexts. Or, one might explore the problem in a more speculative-philosophical fashion and ask not so much what the function of the autonomous art *was* and *is,* but rather what it *should,* or *might, be.* If we decided to stop at our first question, if all we wanted to know was what the function of art actually is, the first line of investigation would be quite sufficient. The kinds of answers that this line leads to are well illustrated by Martha Woodmansee's well-supported historical claim that the idea of autonomous art was introduced in late-eighteenth-century Germany to stem the commercialization of literature promoted by the new social and economic situation of the arts in the marketplace,[7] or by Pierre Bourdieu's sociological claim that art today serves the function of perpetuating class distinctions.[8] (Pascal had already noticed that beauty might be used to demonstrate power: "It is not mere vanity to be elegant, because it shows that a lot of people are working for you. . . . It means more than superficial show or mere accoutrement to have many hands in one's service. The more hands one employs the more powerful one is. Elegance is a means of showing one's power."[9]) Such claims may be illuminating in their own way, particularly, if one does not assume that they tell one all one needs to know

about the function of art, but they do not fully answer our concerns. We need and want to know more, we want to know not only what the function of art is, but also whether this function justifies our efforts, whether art is worth the bother. To answer this further question a more philosophical line of inquiry will be necessary. A historical inquiry would leave us with lots of interesting facts, but by itself it would not allow us to evaluate them. Various actually proposed and practiced understandings of art would compete with one another blindly, but their respective claims could not be compared and rational choices among them could not be made. Asking not what the function of art is, but rather what it should or might be, has the advantage of allowing us to evaluate what actually is and not only what might or should be. It makes public deliberation possible. It opens room for debate, for the confrontation of competing views and proposals that might result in choices and preferences supported by rational arguments. Thus, the question I want to pursue is, What should the function of art be, if art is to have a value for us?

But this does not mean that a philosopher can or should ignore history altogether. Speculation does not happen in a vacuum. While a historical or sociological inquiry can perhaps ignore philosophical questions and simply investigate what was, or is, the case, the reverse is not possible. Whoever wants to speculate on what should be cannot ignore what is. The reason is that the pretheoretical notion of art which must provide the point of departure for any speculation is historically given. It makes sense to speculate about possible functions of art only if the art in question is recognizably similar to one that actually exists. What we want is not a completely new practice, but rather an understanding, and at best an improvement, of what is already current.

I know of no better description of the appropriate relationship between a social practice and its theory than the one Charles Taylor provides in his essay, "Social Theory as Practice." Taylor captures the kind of relationship between art and its theory I would like to maintain in my inquiry:

> There is always a pre-theoretical understanding of what is going on among the members of a society. . . . Social theory arises when we try to formulate explicitly what we are doing, describe the activity which is central to a practice, and articulate the norms which are essential to it. . . . The stronger motive for making and adopting theories is the sense that our implicit understanding is in some way crucially inadequate or even wrong. . . . [Moreover,] if theory can transform practice, then it can be tested in the quality of the practice it informs. . . . A theory which badly misidentifies the goods we can seek in a certain domain will ground a practice which will fail to realize these goods. . . . Good theory enables practice to become less stumbling and more clairvoyant.[10]

The knowledge of the kind St. Augustine talks about, the knowledge I have when nobody asks me questions but which disappears when an explanation is in order, is of the practical rather than theoretical kind. I may not be able to explain very clearly what art is yet still know, roughly, what to do with the word and recognize appropriate occasions for its use. It is only when this practical knowledge

begins to fail me in some ways, or, more crucially, when the practice itself runs into difficulties, that a need for a more explicit theory articulating the point and the norms of the practice arises. Once born, a theory may acquire an internal dynamic of its own and develop more or less independently of any promptings from a stalled practice. But it may also begin to influence the practice, to help it run more smoothly by making its norms more transparent and by correctly identifying its point.

This sort of two-way traffic between practice and theory is to be expected in any area of social action that has achieved a certain degree of maturity. The aesthetic domain is no exception. Alasdair MacIntyre points out that a practice evolves within the historical context of the relevant tradition.

> [W]hen a tradition is in good order it is always partially constituted by an argument about the goods the pursuit of which gives to that tradition its particular point and purpose. . . . A living tradition then is an historically extended, socially embodied argument, and an argument precisely in part about the goods which constitute this tradition.[11]

This book is a contribution to the ongoing argument about the point of art, a contribution in which I pay close attention to what earlier participants in this particular debate had to say and try to keep in mind the relevant features of the social practice of art itself, features of the practice as it is pursued today and as it has evolved over the past few centuries.

The argument about the point of art is particularly timely today, when public attitudes toward art are ambiguous at best. General appetite for certain, even fairly elite, art forms seems to be broader and sharper than ever: try to get a good seat at any major opera house (if you can afford one) or to look at paintings at an overcrowded Matisse retrospective. But at the same time, in the United States at least, art is not enjoying good press, its function is much contested, and a consensus as to its ultimate value can no longer be taken for granted. An unexpected and involuntary alliance of right-wing populist politicians and left-wing populist academics, unwitting Platonists all, suspects art of corrupting the young, whether by seductive images of morally unconventional behavior, or by the insidious perpetuation of socially and politically undesirable distinctions and attitudes. Art-bashing has again become *salonfähig*.

This rise of old political and new academic philistinism is surely an indirect proof that art still retains its power to disturb and unsettle comfortable bureaucracies. But it would be unwise and complacent to dismiss current trends in this way and not to notice that they are based on some compelling, even if confused, intuitions. In particular, the suspicion that art may be much more relevant to our moral, social, and political concerns than the ideology of artistic autonomy seems to allow needs to be taken seriously and carefully examined. The new antiaesthetic attitude deserves attention, and not simply because it may endanger the survival of some artistic traditions and practices; after all, we do not even know yet whether these traditions and practices should be continued and why. It de-

serves attention in the first place because it is so widespread, not just among opportunistic politicians, but also among the very intellectual class which has a professional stake in art's survival and which has traditionally provided arguments for its defense. The doubts of this class force us to do precisely what I intend to do in this book: to consider whether art still has a worthwhile role to play in our private and public lives.

The doubts I have in mind are perhaps nowhere more apparent than in the current battles over the curriculum and appointments at American universities. The battles have a background which is partly ideological and partly economic. We want, with good reason, to introduce into the curriculum of literature, art, and music departments as many of the previously excluded voices as possible, voices of women, minorities, cultures deemed peripheral, and so on. University resources being finite, we cannot introduce them all; we are forced to make choices whereby a stronger department of x studies implies a weaker or absent department of y studies. But this is precisely a distinction we do not like to make, because of a confused egalitarianism which assumes that all discrimination is inherently unjust.

What is unjust, however, is only discrimination based on force or inherited privilege, rather than on reasoned argument. Whether we like it or not, we are economically compelled to make choices, and it is better that we make them as a result of public deliberation based on rational argument than as a result of random lottery or application of force and political pressure. We should make as many voices as possible heard. But once they are heard, we should not assume that they are all equally valuable and we should not be afraid to discriminate among them. A reasonable and just discrimination among the voices, however, will be possible only when we know what the purpose of speaking is. It is only then that we shall be able to compare the voices with one another and decide which ones are doing their appointed job best.

It would be premature at this stage in the discussion to offer any answers, however preliminary, to the questions concerning the function and value of art. But certain features of a solution to the problem can be imagined in advance. If we are to be satisfied that art is a worthwhile pursuit, we would have to find for it a function that fulfills the following conditions. First, the function would have to be culturally indispensable, or at least important, in the sense that we could not conceive of a civilization worth having without this function being taken care of. Art would have to be able to make an indispensable, or at least important, contribution to the proper working of a human society worth striving for. Second, the function would have to be of such character that it could be fulfilled only by art and nothing else. Art would have to be shown to be irreplaceable. Third, it would also have to be demonstrated that the function in question may be fulfilled by much of the existing art. (The "existing art" would clearly have to encompass not only the art produced today, but everything that most people concerned with art at all would consider art today, whether produced recently or in a distant past. This is a domain with admittedly blurry edges, but so vast

that it provides us with more than enough unambiguous material.) As already stated, our task is not to invent a new social practice, but rather to improve or simply clarify the ongoing one. If most of the art as we know it cannot do the job we think art should be doing, our theory would turn out to be not a theory of art at all, but a theory of something else, something for which we had illegitimately appropriated the name of art.

In short, we want to find out what the function of art should be if art is to be considered a worthwhile occupation, and we know that this function would have to be culturally important, or better yet, indispensable, one that can be fulfilled only by art, and, moreover, by much of the art that already exists.

PART I

AESTHETICS:
THE ENDS OF ARTWORKS

AESTHETICS I.
THE NATURE OF ART

a. The Media of Culture

According to Giovanni Pico della Mirandola, God greeted Adam thus:

> Neither a fixed abode nor a form that is thine alone nor any function peculiar to thyself have we given thee, Adam, to the end that according to thy longing and according to thy judgment thou mayest have and possess what abode, what form, and what functions thou thyself shalt desire. The nature of all other beings is limited and constrained within the bounds of laws prescribed by Us. Thou, constrained by no limits, in accordance with thine own free will, in whose hand We have placed thee, shalt ordain for thyself the limits of thy nature.[1]

Pico was on to something. The essence of humans consists in their not having any essence, or rather not knowing what this essence might be in advance. To be sure, we appear on earth in circumstances not of our own making, circumstances we do not control, and we come with significant genetic baggage; we may rightly feel that God exaggerated with this "constrained by no limits." Still, it is the case that we come here without any inborn, immediate knowledge of ourselves, without knowing who we are, or, more precisely, without knowing what we should be doing. This knowledge is never simply given us; we have to find out for ourselves. The question, How shall I live? has guided philosophical reflection on humanity from its beginning in ancient Greece. For Plato, this seems to have been *the* philosophical question, since he has Socrates say in the *Republic:* "our inquiry concerns the greatest of all things, the good life or the bad life."[2] That the question needed to be asked and has been asked testifies itself to the fact that answers to it were not felt to be self-evident and given, at least not to those to whom faith in a religious revelation has not been granted.

An unavoidable part of the answer to the question, How shall I live? is that I shall have to seek an answer to this very question myself.

"Immediacy" is the key word here. As natural organisms, we have immediate awareness of pleasure and pain resulting from the fulfillment, or lack thereof, of our desires and from other forms of interaction with the environment. But even a very rudimentary knowledge of the objects that satisfy our desires and those that do not, of what to seek out and what to avoid, requires something more than immediate awareness. It requires the ability to compare what is before us, the content of our immediate experience, with our previous experiences, that is, it requires the ability to objectify these previous experiences in some way and to store them in memory, so that we may recall them in imagination when necessary. To be able to objectify our experience, to stop its flow so as to consider its contents at leisure, we need a medium of some sort, that is, a material (one that can actually be perceived and hence also imagined) in which an imprint of an experience can be preserved, and a representational code which allows us to translate an immediate experience into this mediated imprint and the reverse, retranslate the imprint into an experience.

(Incidentally, we should not confuse the distinction between the immediate and the mediated with the distinction between the real and the imagined. As our cultural competence, our ability to use media, grows, much of our actual experience, beyond the most rudimentary sensations of pleasure and pain, is heavily mediated, that is, involves making comparisons between what is really there and what we recall in imagination. But this in no way obliterates the distinction between a real object of experience, an object that does exist in the same space and time as our bodies, and an imaginary object that does not. In a sense which is relatively trivial today but was a revelation two centuries ago when Herder put forward his conception of language as not a simple representation of an independent experience but rather a medium partly constitutive of this experience,[3] it may be true that "nothing is extra-textual," that all experience worth talking about is mediated, that is, a "text." But this does not have to prevent us from making a distinction between those "texts" that are about real objects and those about imaginary ones.)

As humans, we have developed a number of such media in the processes of biological and cultural evolution, the most sophisticated, powerful, and versatile of these being, of course, language. Thanks to the media and our ability to use them, the ability to code and decode, we are not imprisoned in the immediacy of current experience as Nietzsche imagined most animals to be most of the time:

> Consider the herd grazing before you. These animals do not know what yesterday and today are but leap about, eat, rest, digest and leap again; and so from morning to night and from day to day, . . . enthralled by the moment and for that reason neither melancholy nor bored. . . . man says 'I remember' and envies the animal which immediately forgets and sees each moment really die, sink back into deep night extinguished for ever.[4]

We also have at our disposal a repertory of mediated experience, our own as well as that of other humans. This repertory allows us to begin to find out what we should seek and what we should avoid. It allows us also to begin to make choices between various objects of our desire (we cannot have them all). At a later stage, it will allow us even to make choices between competing or conflicting desires (we cannot have these all, either). As we learn to make choices between various objects of our desire and even between the various desires themselves, we may also learn to use our chief medium, language (*logos*), to offer reasons for our choices, that is, to justify our desires and our ensuing actions. Gradually, we may thus raise ourselves above the natural order of causes (without, of course, ever leaving it entirely) into the "logical" order of reasons. Once we get that far, we have also learned to offer reasons for our emotions, that is, to justify our feelings.

A fully developed and mature ethical life will be constituted by deliberation on the question, How shall I live? and will aim precisely at justified action (at telling me what I should do) and justified passion (what I should feel). But regardless of whether we get that far or not, the cultural media are indispensable, if we are to begin to look for answers to the question of how to live. They are the media of self-representation, self-discovery, even self-invention, and ultimately, of self-understanding.

Cultural media have three important features that have already been implied by the description above, but should be brought out more explicitly. First, I suggested a moment ago that the media can serve not only the aim of self-representation, but also of self-invention. How is that possible? It has been said that a medium allows us to translate an immediate experience into a mediated imprint and the reverse, retranslate the imprint into an experience. Thus the imprint, properly decoded, becomes the source of an imaginary experience, that is, of an experience the object of which is not real (existing in the same space and time as our bodies do), but imagined. But if we can have imaginary experiences of this sort, we can also encode them in our media. That is, the imprint does not have to be a record of actual experience, it can also capture an imaginary one. Media users can be true creators, not just recreators of experience. I can use the media not only to record what has actually happened, but also to envisage new possibilities, what has not yet happened. Thus I can not only represent, but also, to a certain extent at least, invent myself and my world.

Second, we do not invent the media, but inherit them. This is particularly clear in the case of language. We do not make up our first language from scratch. We may and often do extend the range of the language we use. We introduce new terms, propose new metaphors, learn foreign languages, and even invent new artificial ones (like Esperanto). But all of these extensions and inventions build on the language we have inherited. In a sense, this is true also of our visual media. This is not to deny that someone did in fact invent photography or moving pictures, but rather to point out that these inventions were based upon, and extended, the fundamental practice of making images of the visual world on flat

surfaces, a practice that we inherit just as we inherit language. No matter how inventive, creative, and revolutionary we are, most of the fundamental features of the media we use are not of our own making. In other words, our media of self-representation and self-understanding are fundamentally and inescapably shared, and, consequently, we are social beings through and through. In order to find out who I am and what I want, in order even to ask these questions, I have to use tools that are not my own, tools that I get from my ancestors and contemporaries. This is not to say that I may never aspire to genuine individuality, to being my own self, distinct from other selves. This is to say, however, that even individuality is social. I cannot invent myself *ex nihilo,* in total disregard of, and independent of, others, since my only available means of formulating the aspiration to individuality and of realizing it, of asking and answering the question, How shall I live?, are socially shared. Herder was right: language does not simply represent my individual experience, it also partly constitutes it.

Third, the media of self-representation are at the same time the media of world-representation. If it is the function of the media to objectify experience, they must encode not only the experiencing subject, but also and in the first place the experienced object. Just as I cannot represent individuals in total isolation from other individuals, from their human environment, past and present, I also cannot represent them in total isolation from their environment in general, natural and human-made. I cannot talk about the self without also bringing in in some way its world. The media allow us to consider and explore ourselves and our world at the same time. More precisely, we explore ourselves only in exploring our world.

Let us call the physical objects produced in the process of encoding an experience in a medium "works." In this broadly inclusive sense, a work does not have to be linguistic, of course. Poems and philosophical dialogues have or are works, but so do sculptures, paintings, photographs, pieces of music. Now what is essential about works is that they are physical, real objects (that is, objects existing in the same space and time as we do), the purpose of which is to be "read" or decoded, that is, to allow us to experience an imaginary object different from the real one. Let us call this further, imaginary, object a "world." Works (real objects) are there to be read (decoded) and thus transformed into worlds (imaginary objects). The work which is really out there in front of us demands that we imaginatively see or hear in it the world which in reality is not out there. ("To be a work means to set up a world," says Heidegger.[5]) Thus, the structure of a medium (in the sense in which we use this term here) involves two objects of vastly different ontological status, a real work and an imaginary world.

Works can be either visual or aural. We are not normally expected to imagine in the objects of smell, taste, or touch something else that is really not there, although this does happen occasionally—Proust's madeleine comes to mind—and although, when forced by necessity, we may substitute these senses for sight or

hearing, as when we use the Braille alphabet. But it would be naive to think that all that is expected in the appreciation of food and wine or in erotic pleasure is a fine-tuned discrimination of the properties of the object actually out there. Once they transcend mere natural hunger and sexual appetite, once they begin to aim at the pleasures of the table and bedchamber rather than self-preservation and procreation, the gourmet and the libertine (to say nothing of the lover) know full well that the objects they desire are shot through and through with concepts and images, are cultural as much as natural. (If you have any doubts on this score, think how quickly your pleasure would be extinguished if you realized that the delightful dish, or erotic partner, you were enjoying contained some taboo ingredients, that Milady was branded.) We are beings capable of transforming even the most rudimentary facts of physiology into poetry. In culinary and erotic arts, the imaginary suffuses and transforms the natural object of desire.[6] Chamfort's bitter maxim to the effect that "love as it exists in society is merely the mingling of two fantasies and the contact of two skins"[7] can be abundantly illustrated by novelistic descriptions from Stendhal through Flaubert to Proust.

b. Visual Media

The most fundamental classification of visual works seems to be to divide them into three- or two-dimensional objects. Other ways of classifying them are, of course, possible too. We might want to emphasize the distinction between works that are motionless and those that move, for example. But the division based on the number of dimensions seems to be both the most dependent on the basic properties of sight and the most deeply ingrained in our tradition of thinking about the media (where it appears as the distinction between sculpture and painting). No such classification seems to be possible in the case of aural works. In fact, no useful or traditional way of dividing aural objects is available to us.

The ontological issues involved in making the distinction between work and world seem to be simpler in the case of the visual, more complex in the case of the aural media. We can readily understand that there is a distinction to be made between the sculpture as a three-dimensional work consisting of a carved block of marble and the same sculpture as a world we are asked to recognize in the carved marble, a world consisting, say, of a human body. We imaginatively see human flesh in the carved marble, even though we know that what is really there is stone. Or rather, we see them both, the work and the world, the stone and the flesh, and we know which one is real and which imaginary.

The same distinction is maintained even when the three-dimensional work is moving and living flesh, rather than stone. What we are asked to recognize in the body of the actor is not the body of the actor, but the body of the character he represents, not Ferruccio Soleri, but Arlecchino. When at the end of the spectacle Soleri takes off his mask to thank the audience for the applause, the sudden transformation of the imaginary character into the real actor has a startling effect. It is the effect that an artist may and often does put to creative uses: think of the "unfinished" (*non finito*) quality of so much of Michelangelo's sculpture

that inevitably raises the neo-Platonic thoughts of the spirit attempting to liberate itself from the matter. Such thoughts are possible precisely because we are aware of both the marble and the body.

Sculpture presents theoretical difficulties for an ontologist only at its extremes, when it is completely realistic or completely abstract, and it is instructive to see that even though the two extremes could not be further apart (what else could one expect of the extremes), the difficulties they create are very similar indeed. It is obvious that the distinction between work and world remains valid no matter how realistic the sculpture and no matter whether it is made of bronze, marble, plaster, or colored wax. It ceases to be valid only when the sculpture replicates rather than represents a real object, that is, when it is in every respect identical to the object, or, what amounts to the same thing, when the object is offered as the sculpture in the manner of Duchamp's urinal (and, strictly speaking, even this is not a perfect replica, having been abstracted from the context, such as plumbing, that made its proper use possible). A replica of this sort makes a point about the ontological structure of sculpture, and the point it makes is, paradoxically, the very same one I have made here: by reaching the extreme where the distinction between work and world disappears, the urinal emphatically reaffirms the validity of the distinction for any sculpture in an even slightly less extreme position. It is worth noting that a point of this sort does not have to be made visually at all: nothing is lost when it is made conceptually, which is to say that, for the purpose of making a point about the ontology of sculpture, the urinal is equally effective as an object and as an idea (in this respect, too, it does differ from the real thing). More importantly, it makes a point that can be interestingly made this way only once. This is why the other extreme of sculpture, that of abstraction, is of much larger significance.

Abstraction is clearly a matter of degree. As long as it is not a replica, even the most realistic sculpture will omit or simplify certain features of the actual or possible real object it portrays. And as long as the abstraction remains partial, the distinction between work and world remains intact. The distinction collapses only when the abstraction is complete, when the three-dimensional object in front of us does not demand that we see in it anything other than itself. There is no reason to doubt that we are capable of making such objects, objects designed to be looked at, but not to represent any features of the visual world: in the late twentieth century, our public spaces are full of them. And not only an immobile, but also a moving three-dimensional work can remain abstract. When a ballet is not narrative or representational in any way, we are not asked to see in the body of the dancer anything other than itself.

Now it would appear that once sculpture reaches the stage of perfect abstraction, it ceases to be a medium of any kind. But our cultural habit of viewing sculpture as a visual medium is so strongly ingrained that we tend to see even abstract sculpture this way. There is no necessity in this: we can resolutely refuse to see in an abstract sculpture anything other than the real object in front of us. But as a matter of cultural fact well documented in critical writing, very often we actu-

ally treat abstract sculpture as if it were a medium of representation, an embodiment of values, worldviews, aspirations. When Christo wrapped the Reichstag in Berlin, most commentators refused to see in the result merely a huge building elegantly and neatly wrapped in white plastic. The talk was, rather, of the recent German reunification, of the two parts of Berlin finally coming together.

The most naive form this kind of viewing can take is to pretend, like Polonius, that the sculpture is not fully abstract and to see a visual representation in it. A seemingly more sophisticated form is to acknowledge visual abstraction, but to claim that the object in front of us represents something nevertheless, something invisible, typically a state of mind ("expression" is the name we commonly use for the representation of an internal state of mind rather than of an external world). This, however, is only seemingly a more sophisticated stance. We can recognize a person's state of mind visually only by observing the bodily behavior, posture, gestures, facial expression. Thus, if we are to see an expression of a state of mind in a piece of sculpture, we must see in the object in front of us either a representation, imperfectly abstract, of something analogous to a human body, or a trace of a moving human body that has formed the object which invites us to reconstruct imaginatively this moving body and to read the state of mind from it (a kind of "action sculpture" analogous to "action" painting).[8]

In the former case, we still behave like Polonius. There is nothing shameful about this sort of response. It is, to be sure, theoretically naive, but it testifies to a powerful need on the part of artists and audiences to find a suitable context of human interests for even a perfectly abstract sculpture, to reintegrate it into the web of our vital concerns. When Brancusi calls his most celebrated sculpture *Bird in Space,* he is encouraging us to take what might easily be considered as a perfectly abstract real object as a representation or at least a suggestion of soaring flight, he wants our imagination to take off. Reading an abstract three-dimensional work as an expression of a state of mind is something we often do not only when the work is immobile, but also when it moves. Note that in interpreting abstract dance this way, we transform the real body of the dancer into the imaginary body of the character whose state of mind is being expressed: after all, we do not need to suppose that it is the dancer himself who is exhilarated when we take his leap as expressive of exhilaration.

What may be at work in the case of a completely abstract sculpture or dance being interpreted as a vehicle of expression is a more or less explicitly articulated suspicion that a sculpture or dance that is purely abstract might be pointless and not worthy of our effort and time. The suspicion seems justified. The only plausible alternative I can envisage for those who would want to avoid this sort of theoretically shaky "expressionism" without giving up the conviction that completely abstract sculpture is a worthy pursuit is to see the sculpture as a real object and nothing but a real object decorating and articulating real spaces—squares, gardens, buildings, interiors. The price one pays in this case, however, is that sculpture loses its autonomy and becomes an element in the larger work by the designer of public and private spaces, whether architect, gardener, or interior decorator.

The other strategy mentioned above, that of interpreting an abstract sculpture as "action" sculpture, unlike the "expressionist" one, does allow us to escape the charge of naiveté. But in this case, sculpture is not a medium: we are not seeing in the object in front of us something that is not really out there. Rather, we see the real object and use it to reconstruct the behavior of its maker, which we then interpret as a direct expression of his state of mind.

Both strategies of interpreting perfectly abstract sculpture have in common that, while highly symptomatic of our cultural needs, they are optional: we may just as well be tough-minded and refuse to see in the sculpture anything beyond the work. In this respect abstract sculpture differs from representational sculpture where we do not have this choice (or, what amounts to the same thing, where the exercise of such a choice would be a misinterpretation). It is instructive to realize that we can also exercise the same choice with natural or manmade objects that were not meant as sculpture at all (say, with pieces of driftwood found stranded on a beach). The same cultural need to give an object a meaning by integrating it into a context of human interests and concerns is also at play here.

Many premodern Europeans tended to read the natural world in this way, that is, as a work, a book written by God. Michel Foucault proposed that sixteenth-century knowledge was governed by the assumption that the world is a pervasive web of correspondences or resemblances between things, with each thing being not only a thing, but also a sign pointing toward another, corresponding thing. When all things were also signs, the world was a book to be deciphered, and the task of knowledge was to trace the correspondences.[9] Modern science dissolved this worldview within its own domain, but modernist art gave it a curious afterlife: "the only really surprising thing would be that sound could not suggest colour, that colours could not give the idea of melody, and that both sound and colour together were unsuitable as media for ideas; since all things always have been expressed by reciprocal analogies" writes Baudelaire in his essay on Wagner.[10] He goes on to quote his sonnet "Correspondances" from Les fleurs du mal:

> La Nature est un temple où de vivants piliers
> Laissent parfois sortir de confuses paroles;
> L'homme y passe à travers des forêts de symboles
> Qui l'observent avec des regards familiers.
>
> Comme de longs échos qui de loin se confondent
> Dans une ténébreuse et profonde unité,
> Vaste comme la nuit et comme la clarté,
> Les parfums, les couleurs et les sons se répondent.

It may be that modernism is tempted by such a revival of the premodern worldview because it needs to reintegrate abstract art into the web of human concerns without denying its abstraction. Note that it is precisely in his essay on music, on Wagner, that Baudelaire invokes analogies and correspondences.

Clearly, the difference between works and other real objects, whether natural

or manmade, cannot always be recognized by examining the object alone, in isolation from the cultural practices in which it is used. Arthur C. Danto made this point with reference to works of art, rather than works in general, when he formulated his institutional theory of art, which he recently summarized, with avowedly "mixed feelings," as follows: "you cannot *tell* when something is a work of art just by looking at it, for there is no particular way that art has to look." How, then, do you tell whether something is a work of art or a mere artifact? "[I]n order to do so one had to participate in a conceptual atmosphere, a 'discourse of reasons,' which one shared with the artists and with others who made up the art world."[11] And further: "something being a work of art is dependent upon some set of reasons. . . . The discourse of reasons is what confers the status of art on what would otherwise be mere things, and . . . the discourse of reasons is the art world construed institutionally."[12] The same, it seems to me, might be said of works in general, except that the difference between a work and a real object can be recognized by just looking at the object in question when the work is clearly representational. But when it is either a replica or a perfectly abstract work, we have the choice of treating it either as a work or as a simple artifact (or natural object). It is a matter of cultural habits and practices which of these two possibilites will be entertained.

The fact that the same choice can be exercised with any real object, whether natural or manmade, explains why the boundary between works and other objects is historically changeable and culturally contingent. It explains, in particular, why the same object can be seen from these two distinct perspectives. The status of some artifacts in our culture, most notably buildings, is practically defined by this double perspective. Buildings, like other artifacts we make, serve particular functions and may be seen and evaluated from a strictly utilitarian point of view in which what matters is how well given functions are served. But, at the same time, buildings may be seen, and in many cultures often are seen, as vehicles of significance that transcend purely utilitarian considerations, as embodiments of their owners' self-images, that is, as works. A palace or a villa is never just a machine to be inhabited (though it is also this). It is, above all, a symbolic embodiment of its owner's aspirations. Villa Barbaro incorporates an aspiration of its owners to a form of life idealized by Pliny the Younger, that of a part-time gentleman-farmer. The neoclassical facades of public buildings in Washington convey the modern republic's awareness of its ancient Roman ancestry. In other words, a building may be seen simply as an artifact designed, like any other artifact, to perform a given set of functions. But it may also be seen in addition as a work, an object in which we may see embodied its builders' and owners' aspirations, values, preferences as to the forms of life worth cultivating. This is why Gadamer is right to claim that

> the concept of decoration must be freed from this antithetical relationship
> to the concept of the art of experience and be grounded in the ontological
> structure of representation, which we have seen as the mode of being of the
> work of art. . . . Ornament or decoration is determined by its relation to what

it decorates. . . . Ornament . . . belongs to the self-presentation of its wearer. . . . But presentation is an ontological event; it is representation. An ornament, a decoration, a piece of sculpture set up in a chosen place are representative in the same sense that, say, the church in which they are to be found is itself representative.[13]

It might be objected that the embodying of aspirations is a function like any other, that it does not suffice to mark the difference between an artifact and a work, that there is, for instance, no essential difference between the function of providing a suitable space for habitation and that of projecting the owner's power. Even in a simple well-designed hammer I may see more than an object, I may see an endorsement of the form of life of a competent and efficient carpenter. The objection is, indeed, valid. But the conclusion that it supports is simply that there is no essential boundary between works and other things, that any thing can become a work, that is, a real embodiment of an imagined world, once it is seen within the context of human interests. Once we place it within such a context, we may see in any object something else in addition to the object itself, namely, an imaginary world of human practices and aspirations that the object implies, since it might function in such a world. (To avoid a possible misunderstanding, let me add that "imaginary" does not necessarily mean "fictional": we can imagine both actual and fictional objects, both Dreyfus and Charlus.)

In short, an artifact behaves like a replica or perfectly abstract work. It allows us to interpret it either as a work, that is, an embodiment of a world, or as a simple artifact. I may see a world in it, but I may also simply use it. The difference between most works (those that involve neither replication nor perfect abstraction) and artifacts is that a work requires being interpreted as a world, while an artifact leaves it optional whether we shall so interpret it. Works must be seen or heard as embodying worlds; artifacts may be so seen or heard, but they may also simply be used.

The ontological issues involved in making the distinction between work and world are largely similar, though not identical, when the work is two- rather than three-dimensional. In painting as well there is clearly a distinction to be made between a stretched canvas with paint applied to its surface (the painterly work) and the human face emerging against a background (the painterly world) we are expected to see in the painted surface and in addition to it. The same distinction can be made not only when the two-dimensional work is immobile (as in painting, drawing, various printing techniques, or photography), but also when it moves, when it consists of light moving on a screen (as film and video technologies made possible): here it is hardly the screen and moving light we are expected to see, but the man on horseback riding off into the sunset.

In painting, just as in sculpture, the distinction and tension between the work and the world may be put to a creative use by the artist. The texture of the work, which depends on the way the paint has been applied to the surface, on the brush strokes—rapid and light, or heavily labored, polished and smooth, or deliberately undisguised—contributes to the expressive character of the world.

There is an unmistakable relationship between Van Gogh's brush work and the world of field labor concentrated in the peasant shoes Heidegger saw.[14] Moreover, the tension between work and world can contribute to the expressive character of the painting even when the artist's intention is not at all clear, or when the effect is unintended. Francesco Guardi's masterpiece, *The Gondola in the Lagoon* (in Milan's Poldi Pezzoli Museum), presents a world consisting essentially of light disappearing behind a growing curtain of mist, a Whistlerian study in grays, a world so insubstantial as to threaten to dissolve at any moment, just as mist, or Venice, eventually will. (Guardi is the poet and prophet of Venice's end, of the dissolution of its solid forms into air, water, and light, into a literary and pictorial myth.) It is impossible today to overlook the precarious state of the work: the support of the stretched canvas, with all its imperfections, is clearly visible through the very thin layer of oil paint, at places (the sky, in particular) extremely thin and badly cracked. And it is hard not to notice how the fragile artifact resonates in consonance with the ephemerality of the represented world.

In the case of the two-dimensional work, just as in the case of sculpture, theoretical difficulties emerge for an ontologist only at the extremes of complete realism or complete abstraction. When painting replicates rather than represents a real flat surface, or, what amounts to the same thing, when a real flat surface is offered as a painting, its ontological structure differs in no way from that of completely realistic sculpture. Whether cases of this sort can be of much interest is doubtful, but they certainly can arise: all that one needs to do is, precisely, to offer any real flat surface as a painting, or replicate one in every respect.

The pole of complete abstraction is much more interesting. Everything we have said above about abstraction in the case of the three-dimensional work pertains also to the two-dimensional one. We should not doubt that perfectly abstract painting is possible: think, for instance, of a canvas evenly covered with one color.[15] But it is striking that complete abstraction is much more difficult to achieve when the work is two-dimensional than when it is three-dimensional. The difficulty is wittily engaged in Frank Stella's *Tahkt-I-Sulayman, Variation II* of 1969 (at the Minneapolis Institute of Arts), a complex pattern of squares and circles with contradictory clues that make a consistent interpretation impossible: on the one hand, the squares are "in front of" the circles, and the circles overlap so that a part of one is "in front of" a part of another; on the other hand, the circles are not foreshortened, so that they can also be seen as a flat pattern. Stella himself makes his intentions seem straightforward and unambiguous: "My painting is based on the fact that only what can be seen there *is* there. It really is an object. . . . What you see is what you see."[16] What you see is what you see, no doubt about it. But what do you actually see, a flat pattern or figures in three-dimensional space? What you actually see is far from straightforward and unambiguous. Very often what passes for abstraction in painting is not complete abstraction at all. Imagine a painting showing two overlapping squares in two different colors against a white background. It would be very difficult not to see in this case that one of the squares was in front of the other and that both

were seen against, that is, were in front of, the background. In other words, it would be very difficult to see the real work only and not the two imaginary objects appearing in an imaginary space.

It is on the basis of Malevich-like examples of this sort that one gets persuaded by Richard Wollheim's argument that much (though not all) abstract painting should be considered a species of representational painting.[17] In both figurative and abstract painting, we see not only the real object, the differentiated flat surface, but also (I would prefer to say, primarily) the imaginary presented world, the space with objects in it, something in front of, or behind, something else. In this sense, figurative and abstract painting are both species of representational art. They differ only in the kind of concepts, figurative ("woman") or abstract ("rectangle"), under which we bring what we see in the painting. More precisely, I should prefer to say that they differ in the degree of abstraction of the concepts under which we bring what we see in the painting. Putting it thus allows us to see immediately that the line dividing the abstract from the figurative painting is necessarily blurred (something we might also have learned from some nineteenth-century painters, such as Turner), and to understand why this is so.

What this suggests is that, in painting, it is important to distinguish the case of the work as a real abstract two-dimensional object (our first example above, the one of a canvas evenly covered with one color) from the case of the work as representing an imaginary abstract object (the second, Malevich-like, example). Much of what is generally considered abstract painting belongs in fact to the latter rather than the former category. Why is genuine abstraction so much more difficult to achieve in painting than in sculpture? Why is it that so much of "abstract" painting is in fact representational (representing abstract objects) while no abstract sculpture could be representational in this sense? We touch here on the most fundamental difference between the sculptural and painterly worlds, between what can be represented by three-dimensional works and what by means of two-dimensional ones. (This was a subject of much interest to Leonardo and those sixteenth-century Italian art theorists who, like Benedetto Varchi, were much exercised by the question of the relative merits of sculpture and painting.[18])

A three-dimensional work can represent the surfaces of three-dimensional objects of the visual world. Less obviously, it can also represent the space in which these objects appear, provided the objects are imaginary. Imaginary objects carry their imaginary space with them, so to speak. Take the small bronze *Hercules and Antaeus* of Antonio Pollaiuolo (at the Uffizi). As a *Hercules,* a real object existing in real space it is, well, small. But the Hercules it represents is by no means small. He is, rather, a huge hunk. This shows that the space this imaginary Hercules appears in is different from the real space in which the *Hercules* bronze appears. A two-dimensional work can represent surfaces and spaces too, but in addition it can also represent the light in which these represented objects are seen. This representation of imaginary light lies beyond the realm of what is possible in freestanding sculpture. The impoverishment of the work, or, if you

will, its increased abstraction, from three to two dimensions entails the enrichment of the world, or, if you will, its increased realism. The imaginary visual world that can be represented by means of painting is much richer than the one representable by means of sculpture, since it includes not only the imaginary surfaces of objects and the imaginary space, but also the imaginary light in which the objects appear. Sculpture makes use, instead, of real light, that is, in a sculptural world the imaginary surfaces of represented objects (human flesh, say) appear in the same light in which the observer appears.

Note that the appearance of imaginary space in sculpture seems to be possible only when the sculpture is representational, that is, when its objects are also imaginary. This may explain why genuine abstraction is so much rarer in painting than in sculpture. What commonly happens in "abstract" painting is that its shapes and colors invite us to see an imaginary space with imaginary abstract objects in it, that is, to read the work as representing objects that are abstract. This does not seem possible in freestanding sculpture unless it is representational to begin with.

Note also that sculpture meets painting halfway when it ceases to be freestanding and takes the forms of high- or low-relief, since in these forms it increases its potential for representing imaginary space. Think, for instance, of the imaginary spaces in Giovanni Antonio Amadeo's virtuoso high-reliefs embellishing the pulpits of the Cathedral of Cremona, which are created by foreshortening in the architectural backgrounds and the use of different scales of figures in front. (The images are astonishingly visionary, by the way, prefiguring and predating by some half century the elongated limbs and contorted postures of the mannerists.) But note that, while in the relief form sculpture goes in the direction of painting, increasing its capability to represent space, it does not become painting, since it still cannot represent the light in which its represented objects are seen. For this, tonal contrasts would be necessary.

For its own part, painting can move in the opposite direction and approach the condition of sculpture. This happens when a flat surface is painted so as to create the illusion that it has been made of a different material, when, for instance, painted plaster is made to look like polished marble, as often happens in Renaissance interiors. Here we can distinguish the real work (the painted wall) from the imaginary world (the polished marble), but what gets represented is, as in the case of sculpture, no more than the surface, and this is seen in real space and light. It is precisely the absence of the represented space and light that makes this case different from that of a fullblown painting. It may be instructive to think of the *Last Supper* that Andrea del Castagno painted for the refectory of Sant'Apollonia in Florence, where Jesus and his disciples sit with their backs to a wall seen frontally and consisting of marble panels represented with great realism. If most of the fresco disappeared and only one panel or its fragment survived, it would be impossible to decide by visual inspection alone whether what we have in front of us is a fragment of a wall painted to look like it is made of marble, or the sole surviving fragment of a representational fresco by Castagno

in which the work in front of our eyes (the real wall covered with real pigments) has to be decoded as the imaginary world (the marble wall in the imaginary space behind the dining figures).

c. Music

The ontological issues involved in making the distinction between work and world are considerably more complex when the work is aural. We have already observed that, contrary to the case of visual works, which can be divided into three- and two-dimensional ones, there seems to be no useful or traditional way of dividing aural works into classes. We traditionally have several large classes of visual media, such as architecture, sculpture, and painting (with further subdivisions possible, of course, when additional classificatory criteria, such as the absence or presence of motion, are introduced), while there is strictly speaking only one purely aural medium, music.

Contrary to what some might at first expect, and what I may have hastily suggested earlier, the musical work is constituted not by the written "text," the score, but by the actual sounds produced by the singing or playing musicians (or by the sound-generating or -reproducing machines), sounds that, as physical objects, exist in the same space and time that we do. The written text, and notation in general, is merely a tool some musicians use when they want their music to be played by others, or when they want to play music composed by someone else, or when they want to prop their own memories while composing (which is not to deny that in certain circumstances, such as those that attended the development of the European art music tradition, this tool can acquire a life of its own and become indispensable to composers as they formulate ideas of unprecedented power, depth, and complexity). A musical work clearly can, and many musical works actually do, exist without any written text.

What is perhaps most striking about music when compared with the visual media is that it is much less interested in representing the outside world. In most highly developed cultures, and certainly in the West, a degree of representational realism has always been, and continues to be, central to the way one uses and understands visual media. Even today, when abstraction is so important to the practice of visual arts, we could give up on representational realism only at a tremendous loss to our visual culture. Photography, film, and television ensure that, more than ever, we are constantly surrounded by realistic portrayals of the outside world. This is not the case with music. A degree of representational realism is available also to the aural medium. We can use sounds to represent the sounds of our natural and manmade environment. Birds in particular have been a much-loved subject of musical representation in Europe from the fourteenth century through Messiaen. But our aural culture would not be significantly impoverished if we gave up on this sort of realistic representation altogether; certainly it would not be impoverished to anything approaching the degree to which our visual culture would. Over the centuries, our ability and wish to record specific features of the real world have been incomparably greater when these

features were visual than when they were aural. Today, we very much want to know what fifteenth-century Florence or nineteenth-century Paris looked like, and we do a lot to find out, helped in the process by the relevant ancestors. About how these places sounded, we know much less. To be sure, we do know more and more about how the music produced in those places sounded like. But what was the city soundscape, the noises made by human throats, traffic, church bells? It is not that we do not care to know. Recently, historians have been more and more imaginative about such things (recall Alain Corbin's histories of odor and sonorous landscape, or Reinhard Strohm's Huizinga-inspired evocation of the sounds of Bruges).[19] It is rather that music is of little help when we try to find out. The eye is by far our most sensitive and discriminating instrument of exploration of the outer world, the world beyond the confines of our skin. If we keep in mind that our visual media include photography and film, we realize that even today a degree of representational realism remains the norm for them. In music, by contrast, it is abstraction that has been the norm.

Another way of bringing out this contrast between the visual media and music would be to observe that, whereas painters can use as their material all colors visible to the human eye, until very recently musicians in the West and elsewhere could use only a very small selection of what is audible as their material. Even today, when we no longer believe that there must be limits on the material from which music may be made, most music continues to be made from an extremely narrow selection from the range of what is audible. A traditional way of making this point used to be to say that music is made not of sounds (that we find readily available in the outer aural world), but of tones of definite pitch (that actually can be *found* in nature, as opposed to *made*, only rarely, if at all). For most music this claim is valid even today. This in itself is indicative of how much less than painting is music drawn by representational realism. While a painterly work often wants to reflect the light that strikes our retina in a way that resembles how a real object, the model of the pictorial representation, would reflect the light, a musical work is not usually aiming at this sort of resemblance. Consequently, a musician can afford to be much more choosy about his material.

But if it is true that music tends toward abstraction rather than realism, what sort of abstraction is it? The kind we have found to be typical in sculpture, where the work itself may become an abstract real object, or the kind often encountered in painting, where what is abstract may be not the work but the represented imaginary world? Both kinds, I would like to claim, are possible in music, and most commonly they are present simultaneously. To put it briefly, most music is in part representational, but what gets represented in it are abstract objects. To be sure, as in sculpture and painting, in music, it is also possible to create works in which we are asked to hear nothing but what is in fact presented to our ears. The music of our own century, in particular, is full of relevant attempts. Indeed, the emergence of a significant repertory of artworks that want to be nothing but real objects is surely a central development in both visual arts and music of the past ninety years (and an aspect of the tendency toward extreme abstraction that

will be described and interpreted in chapter 3). Nevertheless, much more commonly, we are expected to hear in the aural work (whether vocally or instrumentally produced) not only the real sounding object, but also something that is really not out there, something imaginary. Just as we do not see the world of painting if all we perceive is a stretched canvas with paint applied to its surface, we do not hear the world of music if all we perceive are the sounds produced by the musicians or machines. For the world to be perceived, we have to hear in the real sounds also the imaginary (and most often abstract) content.

What is, precisely, this imaginary content? Most Western art music consists primarily of melodic lines; to follow this music is in the first place to follow its lines. At its most minimal, music can consist of nothing but a single melody (we call this monophony), as in medieval plainchant. More commonly and artfully, there will be several simultaneous melodies to follow (polyphony), and these may all be equally important, or they may come into various relations of domination and dependence, as in the classic vocal polyphony of the fifteenth and sixteenth centuries. If the dependent material does not form continuous lines, or forms them only intermittently, we have a melody with accompaniment (homophony), as in the early modern operatic monody. Much of the textural effort in the most artistically ambitious modern instrumental music from the late eighteenth to the early twentieth century went into preserving the distinction between melody and accompaniment, while devising various ways of making the accompaniment melodically distinctive, rather than perfunctory. Thus, in general, one might say that the object to attend to in Western art music will typically consist of melodies in various relations of equal or unequal importance, with an optional and more or less melodically distinctive accompaniment.

Now, with two exceptions, everything about this object is real. There is nothing imaginary about melodies: we hear a melody when we recognize that its successive pitches belong together in a single temporal shape, and what we perceive in such a case is a real object. Similarly, there is nothing imaginary about the rhythmic organization of a melody, nor about its tempo, nor about the timbre and the dynamic intensity of its pitches. The imaginary enters into the perception of music only when the music is in a very broad and inclusive sense tonal and metric; the imaginary content of real sounds depends on the closely interrelated phenomena of tonality and meter.

In the broadly inclusive sense in which I use the term here, music is tonal when its pitches are heard to be of unequal importance, when some of them are perceived to be relatively unstable, wanting to move, or being pulled, toward others, and when these others are perceived to be the relatively more stable goals of tonal motion, or centers of tonal gravity that pull the less stable pitches toward themselves. It was the eradication of this sort of inequality among pitches that was the goal of Arnold Schoenberg's two-stage revolution, first in the free atonality of the seven years that preceded the First World War, and then in the more systematic twelve-tone organization of the 1920s, a method one of the central aims and the main effect of which was to prevent tonality from reappearing.

Until this revolution, all Western music, as well as much of the music made outside of Europe, was in this broad sense tonal, though the specific shapes tonality took in various times and places differed widely.

(Note, by the way, that if my interpretation of the twelve-tone method of composition as designed to prevent tonality from reappearing is correct, the method closely parallels cubism as interpreted by Ernst Gombrich: "Cubism . . . is the most radical attempt to stamp out ambiguity and to enforce one reading of the picture—that of a man-made construction, a colored canvas. If illusion is due to the interaction of clues and the absence of contradictory evidence, the only way to fight its transforming influence is to make the clues contradict each other and to prevent a coherent image of reality from destroying the pattern in the plane."[20] Elsewhere, Gombrich expressed his doubts concerning the twelve-tone method itself: "It seems to me inescapable that neither the painter nor the musician can simply switch off the field of force [such as created by tonality] without having his resources severely curtailed. He can still create patterns, but he can no longer relate them to our expectations. Much ingenuity and imagination has certainly gone into alternative systems like the creation of serial orders composed of 12 neutral tones, but I remain unconvinced that these experiments have justified the dismantling of one of the greatest inventions of mankind, the tonal system."[21] Gombrich is surely right that the dismantling of tonality severely curtailed music's resources. What needs to be understood, however, is the depth of passion that motivated such voluntary self-limitation. In chapter 3, I shall offer an interpretation of the high modernist effort to eradicate illusion.)

Similarly, music is metric when its rhythms can be interpreted according to an underlying pulsation of beats of equal duration but heard to be of unequal importance, when some of the beats are perceived to be relatively unstable and to require a continuation of the pulsation, while others are perceived to be relatively stable and capable of bringing the pulsation to a satisfactory closure. A systematic step-by-step challenge to (though not yet complete eradication of) this sort of inequality among beats, a challenge accomplished through the creation of irregular and unpredictable beat patterns, is one of the reasons why Igor Stravinsky's *The Rite of Spring* (1911–13) is one of the key works in the canon of musical modernism.

It should be clear that the tonal and metric phenomena are closely interrelated: in each case, a similar set of imaginary meanings having to do with the opposition between stability and instability are attached to real objects, pitches in the case of tonality, and beats in that of meter. The two phenomena may be divorced from one another (music may be tonal without being metric, and the reverse), but more typically, in much of Western art music, they are correlated.

The tonal and metric hearing of pitches and beats, the fact that we hear some of them as wanting to move, or as being pulled, toward others, means that what we hear in real sounds is something imaginary.[22] Real sounds do not, and cannot, move anywhere. In a melody, one sound does not move from one position in the tonal space, one pitch, to another. Rather, it is succeeded by another sound.

The imaginary motion is something we hear in a melody when we hear it tonally. Similarly, real sounds cannot be endowed with a will to move, nor can they pull other sounds. Tonal motion, will (the *Tonwille* in Heinrich Schenker's terms), and gravity are not the attributes of real sounds, but rather metaphors that describe our experience of tonal music, what we imaginatively hear in it. To a certain extent, we may choose from among these metaphors. We may, for instance, think of a sound as either wanting to go somewhere, or as being pulled in some direction. But some use of metaphors of this sort, metaphors of motion, directed tension, relaxation, gravitation, goals strived for and achieved, and so forth, is inescapable, if we want to describe the experience of hearing music tonally. As Eduard Hanslick famously put it: "The content of music is tonally moving forms" ("Der Inhalt der Musik sind tönend bewegte Formen").[23]

We have established that the real musical work one attends to typically consists of a melody or melodies with an optional accompaniment. The imaginary world we hear in this work when we hear tonally (and metrically), then, consists of lines of directed motion, imaginary lines traced by sounds that seem to want to move in specific directions and either do so, straight on or with detours, or frustrate the expectations they themselves aroused and move in new directions. These imaginary lines are, clearly, not identical with the real melodies of the musical work. They are, rather, what we hear in these melodies.

The same point is expressed in more technical language (that of Hugo Riemann) when we say that what we hear in the real tones of tonal music are their imaginary harmonic "functions" or meanings: we hear not just a tone, but, say, that this tone is a fourth above the local prime, the local tonal center, and, consequently, we experience it as a dissonance that wants to descend a step to the nearest consonance. (The harmonic meaning of each tone in a piece of tonal music is defined by its relationship with the local tonic, the local center of tonal gravitation, and the local tonics themselves may create larger gravitational systems to which the more local ones will be hierarchically subordinated.) It is probably because the harmonic functions of tones are what truly matter in any understanding of tonal music that the tonal system we use is to a considerable extent independent of the actual sounds that embody it: a tonal work may be performed using various tuning systems and pitch standards (not to mention various instruments), without the identity of the work being at risk.

In short, a musical world is always at least in part real, that is, indistinguishable from the work. But, if the music is tonal (and metric), its world is also partly imaginary. Note by the way that, in so far as the musical world is imaginary, its imaginary objects exist in an imaginary, rather than real, time. Imaginary objects carry their own imaginary space or time with them. We have already seen this to be the case with sculpture. Similarly, the imaginary objects of music appear in an imaginary, rather than real, time. Susanne K. Langer has argued that "the semblance of this vital, experiential time is the primary illusion of music. All music creates an order of virtual time, in which its sonorous forms move in relation to each other—always and only to each other, for nothing else exists there."[24] For

Langer, the essence of all music is "the creation of virtual time, and its complete determination by the movement of audible forms."[25] For Roman Ingarden, the "quasi-time" is what music has in common with literature, theater, and film:

> each phase except the last of a musical work contains a 'future' with respect to further phases of the work that, by being anticipated, colors in a specific way the phase being actualized. Sometimes the work's finale is also anticipated in this way, without of course opening up perspectives onto any further phases. Only works characterized by quasi-temporal extension, that is, musical, liter-ary, theatrical, and film compositions, can have such endings. The continuum of experienced real time does not have this type of ending. Even when real objects . . . come to the end of their existence, . . . a perspective always opens further temporal phases . . . ; but no such 'afterward' is possible once the musical work has come to an end. . . . In the same manner its [the work's] con-tent does not designate any 'before.' . . . The organized quasi-time of the com-position is complete at both ends and does not enter into the time-continuum of the real world.[26]

It is crucially important to understand the mechanism whereby the musical world, the imaginary pattern of lines of directed motion, comes into being. The tendency, or harmonic function, of a tone is not something that we recognize thanks to a special training in music theory. Rather, it is a phenomenon that we experience directly, without any mediation of theoretical concepts. (To what extent this direct experience is universal and to what extent it is culturally ac-quired is still an open question. It is not at all unlikely, however, that we are all born wired to hear tonally.[27]) That the leading tone wants to move a half step up to, or is pulled up by, the tonic, is something I experience directly long before I learn to use such concepts as the leading tone, dominant, or tonic. My ability to use such concepts depends on my ability to experience tonal tendencies of sounds, and not the reverse. A theory of tonal harmony is successful to the ex-tent that it describes my experience of the tonal tendencies of sounds correctly, and this is all we should expect from it. We should certainly not expect it to tell us how to experience tonal music. This we can do competently without any the-oretical equipment.

Now, what I actually experience when I experience the tonal tendency of a sound is the dynamics of my own desire, its arousal, its satisfaction, its frustra-tion. It is my own desire for the leading tone to move up, the satisfaction of my own desire when it so moves, the frustration thereof when it refuses to budge or when it moves elsewhere, that I feel. (I might, at a different level so to speak, also desire that the resolution to the tonic be delayed so as to make the music more interesting. But before the question of such a second-level desire can even arise, I must first experience my craving for the tone to move up.) Thus, the precondition of my being able to hear an imaginary pattern of lines of directed motion in a tonal work is that I first experience the desires, satisfactions, and frustrations of this sort. In tonal music, the direct experience of the dynamics of my own desire precedes any recognition of the represented object, of lines of

directed motion, and is the necessary precondition of such a recognition. I must first experience the desire that the leading tone move up, before I can recognize the representation of an imaginary ascending line when it so moves. As Kierkegaard knew, "the sensuous-erotic in all its immediacy . . . can be expressed only in music."[28]

It follows that tonal music, like a visual medium, may represent an imaginary object different from myself, an imaginary world, albeit a highly abstract one, consisting of lines of directed motion. But, unlike a visual medium, tonal music also makes me experience directly the dynamics of my own desiring, my own inner world, and it is this latter experience that is the more primordial one, since any representation depends on it. While visual media allow us to grasp, represent, and explore an outer, visual world, music makes it possible for me to grasp, experience, and explore an inner world of desiring. While visual media show us objects we might want without making us aware of what it would feel like to want anything, music makes us aware of how it feels to want something without showing us the objects we want. In a brief formula, visual media are the instruments of knowing the object of desire but not the desire itself, tonal music is the instrument of knowing the desire but not its object. This, incidentally, is what makes Schopenhauer's understanding of music as the representation of will so compelling, provided one divorces it from his metaphysical assumptions—that is, provided one takes the "will" to stand simply for individual human will rather than for the ultimate noumenal ground of reality. (So long as his metaphysics is left in place, Schopenhauer himself has to admit that "the point of comparison between music and the world, the regard in which it stands to the world in the relation of a copy or a repetition, is very obscure."[29] If the world is will, "it is essentially impossible to demonstrate this explanation [of the inner essence of music], for it assumes and establishes a relation of music as a representation to that which of its essence can never be representation, and claims to regard music as the copy of an original that can itself never be directly represented."[30]) And even Schopenhauer did not exclude the more empirical understanding of the music-as-representation-of-will theory when he discussed the nature of melody:

> Now the nature of man consists in the fact that his will strives, is satisfied, strives anew, and so on and on. . . . Thus, corresponding to this, the nature of melody is a constant digression and deviation from the keynote in a thousand ways, . . . yet there always follows a final return to the keynote. In these ways, melody expresses the many different forms of the will's efforts, but also its satisfaction by ultimately finding again a harmonious interval, and still more the keynote.[31]

When music is neither tonal nor metric, the imaginary world does not arise and all we hear is the real sounding object. But even in this case, if we choose to make this abstract object the vehicle of further ideas about humans and their world (and we already know that we always have this option with any real object), the sphere in which we are likely to look for successful analog of what we

hear is that of inner feeling rather than of outer world. Visually presented worlds are spatial, they consist of spatially extended objects. An aurally presented world consists of objects extended in time. Thus, it is like the temporal inner world of our experiencing, not like the spatial outer world we experience.

As Hegel put it, music's "own proper element is the inner life as such. . . . music's *content* is constituted by spiritual subjectivity in its immediate subjective inherent unity, the human heart, feeling as such."[32] Hegel captured the nature of the medium very clearly:

> [S]ound in contrast to the material of the visual arts is wholly abstract [in the sense that it cannot portray the world of objects]. . . . On this account what alone is fitted for expression in music is the object-free inner life, abstract subjectivity as such. This is our entirely empty self, the self without any further content. Consequently, the chief task of music consists in making resound, not the objective world itself, but, on the contrary, the manner in which the inmost self is moved to the depths of its personality and conscious soul.[33]

We have just established that in the decoding of music the relationship between the cognitive component, that is, the recognition of the represented imaginary object, and the component of sensation, that is, the experience of the dynamics of desire, is the reverse of what it is in the decoding of a visual work. In music, I have argued, I must experience the desire that the leading tone resolves by moving up a half step as well as the satisfaction of the desire when it so moves, before I can recognize the imaginary ascending line. This is very different from what happens in visual media where, on the contrary, a recognition of the imaginary represented object must come before any experience of the object can take place. I must first see a human face in the painted surface before I can experience the expression of the face. This fundamental difference in the relationship between the cognitive component and the component of sensation in the reading of visual and aural works accounts, I believe, for the often-observed fact that music has a much more direct and powerful impact on us than either sculpture or painting. (As Hanslick put it, not without misgivings, "music works more rapidly and intensely upon the mind than any other art. . . . The other arts persuade, but music invades us."[34] Kant shared these misgivings: "[M]usic has a certain lack of urbanity about it. For . . . it scatters its influence abroad to an uncalled-for extent . . . and thus, as it were, becomes obtrusive and deprives others, outside the musical circle, of their freedom. This is a thing that the arts addressed to the eye do not do, for if one is not disposed to give admittance to their impressions, one has only to look the other way."[35]) Music I must experience before I can begin to think about it, and I can always leave the thinking altogether out. A painting can begin to exert its emotional impact only after the represented object has been recognized, and this even when the object is abstract, that is, when the painting approaches as closely as it can the ontological condition of music. It is a contrast of this sort that Aristotle may have had in mind when he observed that

the objects of no other sense, such as taste or touch, have any resemblance to moral qualities; in visible objects there is only a little, for there are figures which are of a moral character, but only to a slight extent, and all do not participate in the feeling about them. Again, figures and colors are not imitations but signs of moral habits, indications which the body gives of states of feeling. The connexion of them with morals is slight, but in so far as there is any, young men should be taught to look, not at the works of Pauson, but at those of Polygnotus, or any other painter or sculptor who expresses moral ideas. On the other hand, even in mere melodies there is an imitation of character. . . . Some . . . make men sad and grave . . . , others enfeeble the mind . . . , another, again, produces a moderate and settled temper. . . . The same principles apply to rhythms; some have a character of rest, others of motion, and of these latter again, some have a more vulgar, others a nobler movement. Enough has been said to show that music has the power of forming the character.[36]

Plato also noticed the particular power of music: "[E]ducation in music is most sovereign, because more than anything else rhythm and harmony find their way to the inmost soul and take strongest hold upon it."[37]

It should also be noted that music's ability to have a direct impact on our nerves and bodies is not limited to the effects of tonality, though these are undoubtedly the most subtle among the aural medium's expressive means. In addition, and equal in power (though not in subtlety, since no imaginary object emerges in this case), is the direct effect on our bodies of music's rhythmic organization and tempo. Our bodies react, our feet dance, our hands clap, our breathing adjusts itself to the rhythm and tempo of the music before our minds are able to tell us that they recognize in the music a ponderous march or a lilting waltz. As Hanslick observed, "it is not because it is dance music that it lifts the foot; rather, it is because it lifts the foot that it is dance music."[38] Here too the experience comes first, the concept later. Even when the outward bodily expression of the music's impact has been heavily suppressed and censored in what Norbert Elias calls "the civilizing process," the body's reactions to the music have been merely internalized, but not obliterated. An active listener, no matter how civilized, listens with his muscles as much as with his ears and brain. Even Hanslick, with his suspicion of the body, priggishly took notice: "It is not to be denied that dance music brings about a twitching of the body, especially in the feet, of young people whose natural disposition is not entirely inhibited by the constraints of civilization."[39] Nietzsche, by contrast, was more aware of the price of civilization: "To make music possible as a separate art, a number of senses, especially the muscle sense, have been immobilized (at least relatively, for to a certain degree all rhythm still appeals to our muscles); so that man no longer bodily imitates and represents everything he feels. Nevertheless, that is really the normal Dionysian state, at least the original state. Music is the specialization of this state attained slowly at the expense of those faculties which are most closely related to it."[40]

There is nothing quite like that direct engagement of the body in our reading

of visual works. We have already seen that in painting a recognition of the imaginary represented object must come before any experience of the object can take place. Note that this is the case not only with regard to the impact of the represented world, but also with regard to the impact of what sixteenth-century Italian theorists called the "design" (*disegno*), that is, the organization or composition of the work, in the case of painting, the arrangement of colors on two-dimensional surface by means of lines separating various color patches. A design might be expressive the way any abstract real object might. But a pictorial composition achieves its expressive effects in a manner that differs in at least two basic respects from that of music. First, while a pictorial composition can be expressive and thus have an emotional impact on us, it does not affect our bodies directly, does not make our muscles move, the way rhythm and tempo do. And second, in representational painting at least, the expression of a composition, and often even the composition itself, cannot be seen correctly if the represented world, the arrangement of the imaginary three-dimensional figures in the imaginary space, is not taken into consideration. Without doing that, we cannot know what comparative weight we should assign to individual patches of color, nor—more crucially—can we know the relative importance and especially the direction of the lines.

A partly triangular composition will be expressive of peaceful repose when the apex of the triangle is formed by the face of a calmly sitting Madonna (as in Giovanni Bellini's north-wall altar at S. Zaccaria), or of a sweeping upward surge when at the apex there is the face of the airborne Virgin in the process of the Assumption with her gaze fixed on her heavenly destination (as in Titian's main altar of S. Maria dei Frari). The expressive effect of the composition in those cases depends not only on the relative sharpness of the angle the two sides of the triangle make, but more crucially on the direction we attribute to lines, and this depends in turn on our recognition of the represented bodies, their postures, and their movements. Similarly, the expressive character of Caravaggio's favorite composition of a diagonally divided vertical rectangle is vastly different depending on whether the represented subject is the *Crucifixion of St. Peter* (in S. Maria del Popolo), where the raising of the heavy, diagonally placed cross with its victim is expressive of the laborious upward movement of the recalcitrant matter (perhaps to be spiritually completed by the reward awaiting the martyred apostle in heaven), or the *Deposition* (at the Vatican Pinacoteca), where the movement is downward, weighted by the dead body of the Crucified, or yet the *Madonna of the Pilgrims* (in S. Agostino), where the movement goes both ways, up and down, with the diagonal lines formed by the represented bodies, the exchanged glances, and especially the light falling from the upper-left corner weaving an umbilical cord that links the humble pilgrims with the object of their adoration, and, reciprocally, the loving Mother of God with humanity. Thus, in painting, we have to recognize the represented object (recognize it as a human body, say, though not necessarily as the body of a specific person or character, of course) before we can read the composition, and hence also be moved by it, correctly.

This, again, is the reverse of the relationship between the cognitive component (recognizing) and the component of sensation (experiencing) in hearing music.

That in representational painting not only the expressive character of a composition but on occasion even its very formal shape cannot be read fully and correctly unless the represented world has been recognized is suggested with great force by those cases where the design is particularly complex. Take that mannerist masterpiece, Pontormo's *Deposition* at the altar of the Capponi chapel in S. Felicita in Florence, a work that manages a feat of great difficulty and rarity in art, the combining of utmost refinement and artificiality of design, color, and light with a profound expression of the emotion appropriate to the subject— grief. The arrangement of the figures suspends terrestrial laws (as is proper in a depiction of a drama whose universal significance transcends its particular historical and geographical location), since most bodies seem to float in the air instead of resting firmly on the ground ("as if a bunch of figures hovering in the air more than resting on the ground," in the felicitous phrase of a popular guidebook).[41] Even the making of the simile of a bunch of grapes requires that the imaginary figures in the imaginary space be recognized. The need to concentrate on the represented world as well as on the abstract arrangement of lines and colors becomes considerably more pressing if we want to go beyond that simple simile and read the composition in more detail and with greater precision. The unusually complex design becomes legible when we recognize that the human figures are arranged to form two vertical bows that meet at both ends, creating together the shape of an almond, the right-hand bow centered on the body of Mary, the left-hand one on that of Jesus. We can then go on to notice the correspondence of the two central figures, the way their arms and hands, their necks and heads, and finally their bodies, one fainting, the other dead, echo one another—a juxtaposition around which everything else revolves. All of these complex and subtle correspondences, juxtapositions, and echoes are centrally important for the composition of the work, they *are* its composition: the lines of the pictorial work acquire their direction, and the colors their comparative weight, from the figures they happen to articulate. The composition is fully legible without our having to identify the figures as Mary, Jesus, Mary Magdalen, John, and the rest. All we need to do is to go beyond the real patches of color toward the imaginary represented world. But, of course, a further identification of the figures as the actors in the cosmic drama of the Deposition endows the composition with added significance, since without this knowledge the correspondence between the suffering of the Son and the grieving of the Mother is devoid of meaning, or at least puzzling.

In short, I explain the greater power of music's impact on us in part by the fact that the effects of the most important components of the aural medium, the effects of tonality and meter as well as of rhythm and tempo, are experienced directly, without the mediation of cognition (in part, since more will be said on the subject of music's power below). In representational painting (whether figurative or abstract), by contrast, recognition is the precondition of experience, with

regard to the impact of both the represented world and the composition. (It probably goes without saying that the comparison is offered in a purely descriptive, neutral spirit: those who exalt cognition over other mental activities will ascribe greater dignity to visual media, while those for whom sensation and other noncognitive mental activities define humanity more centrally will privilege music. There is not much point in such invidious comparisons and contests, unless we derive satisfaction from putting some mental activities—or some categories of people supposedly particularly generously endowed with them—down.) In only one area is the impact of both the visual and aural media similarly direct. The actual matter of a visual or aural work, the matter abstracted from the way it has been formed by specific spatial or temporal relations, that is, the color and texture of stone or paint (what sixteenth-century Italian theorists used to call the *colorito,* as opposed to the *disegno*), the timbre and dynamics of sounds, are the object of direct sensation, without any mediating cognitive activities.

d. Language

It might seem at first glance that language, like music, is an aural medium. This, however, is not quite the case. Unique among media, language may be embodied in either audible or visible material.

The temptation to compare music with language is very difficult to resist not only because among the arts literature has had, since ancient times, the most highly developed compositional and critical theory (paradigmatically so in Aristotle's *Poetics* and *Rhetoric*), and not only because until fairly recently music was symbiotically linked with language in practice (instrumental genres fully emerged as equal in aesthetic rank to those of vocal music only in the eighteenth century), but also—and perhaps primarily—because the two media seem at first glance to be similarly embodied in sound. It is, however, necessary to observe how different the significance of sound is in language and in music.

The difference comes out most clearly when we reflect on the role of written notation, of what we shall call the "text," in both media. In language and in music an inscription might be understood as a set of visually fixed instructions for producing specific sounds. But in language an understanding of a written notation can bypass the mediation of sound. In other words, language can be adequately embodied not only aurally, but also visually. If we know the language and can read it, we shall understand the meaning of a written sentence in it, whether or not we bother to voice it or to imagine how it sounds. We shall understand it even when the language is long dead and we have no idea whatsoever of how it was pronounced when it was spoken. Isaiah Berlin recalls how Anna Akhmatova recited for him two cantos from Byron's *Don Juan* during their meeting in 1945 in Leningrad:

> [A]lthough she read English, her pronounciation of it made it impossible to understand more than a word or two. . . . Perhaps, I thought afterwards, that is how we now read classical Greek and Latin; yet we, too, are moved by the

words, which, as we pronounce them, might be wholly unintelligible to their authors and audiences.[42]

Nothing of this sort would be possible in the case of tonal (as opposed to atonal and serial) music. In tonal music an understanding of a written notation cannot bypass the effort to produce the sounds it instructs us to make either in reality or in imagination. In other words, tonal music's only adequate embodiment is sound. The idea that we might resurrect a dead musical repertory without being able to know, at least approximately, how it sounded is absurd, as is the idea that we might develop a musical sign language for those deaf since birth (sign languages of the deaf are independent visually transmitted languages, of course, not visual representations of aural languages such as English or French, as some might imagine). Musical understanding, unlike linguistic understanding, is inescapably tied to the one material, sound, in which music is embodied. In this respect, again, music resembles painting (the understanding of which also cannot be divorced from real or imagined perception of the material in which it is embodied) more than language.

The relative indifference of language to the specific material in which it is embodied must surely be linked to its referentiality. Words, whether spoken or written, refer to concepts. If we understand the language, we get that to which a sentence refers regardless of whether the sentence is embodied in sound or in ink. Conversely, the lack of reference makes this independence from a specific material impossible in music (as well as in visual media). The aural materials of music, as well as the visual materials of painting, do not normally refer to concepts. To be sure, the imaginary objects they represent may be brought under concepts, just as any real object may, but this "being brought under a concept" is not the same as "referring to a concept." A general concept brings together ("grasps") a great number of particular objects, whether real or imagined (we shall call such imagined particular objects "images"). When a word refers to a general concept, these particular objects remain unspecified and all we get is the concept (which we may cash imaginatively in a number of ways by bringing a number of images under it). But when a particular object, real or imagined, is brought under a concept, we get both the concept and the object. If it is the case that a musical "voice" or a painted "personage" (the terms will be discussed at length in chapter 4) may be brought under concepts but do not refer to concepts, present nothing but themselves, the specific material in which they are embodied matters crucially, since they have no existence outside of their embodiment.

In Hegel's aesthetics, language's independence from a specific material is the reason why "poetry" (literature) is the "most spiritual" of the arts:

> Yet this sensuous element, which in music was still immediately one with inwardness, is here [in poetry] cut free from the content of consciousness, while spirit determines this content on its own account and in itself and makes it into ideas. To express these it uses sound indeed, but only as a sign in itself without value or content. The sound, therefore, may just as well be a mere

letter, since the audible, like the visible, has sunk into being a mere indication of spirit. . . . Poetry is the universal art of the spirit which has become free in itself and which is not tied down for its realization to external sensuous material.[43]

To be sure, Hegel's claim is somewhat different from mine. For him, the material of literature is neither sound nor ink, but the imagination itself. In literature the imagined takes the role of marble in sculpture, paint in painting, or sound in music:

> Granted the withdrawal of the spiritual content from sensuous material, the question arises at once: What, in default of musical notes, will now be the proper external object in the case of poetry? We can answer quite simply: It is the *inner* imagination and intuition itself. It is *spiritual* forms which take the place of perceptibility and provide the material to be given shape, just as marble, bronze, colour, and musical notes were the material earlier on.[44]

In short, poetry's "proper material is the imagination itself."[45] Hegel's conclusion is confusing and unfortunate. The imaginary plays no less central a role in the constitution of a musical or painterly world than it does in the constitution of the literary world. In literature, no less than in music and painting, the aesthetic object, the world, is constructed when the imaginative consciousness gets involved with the real, material object, the work.[46] To be sure, the linguistic work can be imagined rather than real: when we think rather than communicate with others, we do not need to use real aural or visual signs, we can imagine them instead. (In Plato's celebrated image, "what we call thinking is, precisely, the inward dialogue carried on by the mind with itself without spoken sound."[47]) But there is no essential difference here from music and visual media. In those, too, the work can be imagined and need not be turned into a real object if we are not interested in communicating. Unless we are prepared to believe that Hegel anticipated those contemporary linguists according to whom we think not in natural languages but in a silent language of thought, a "mentalese,"[48] the source of the philosopher's claim that language's "proper material is the imagination itself" is perhaps the fact that, while musical or painterly worlds consist of aural and visual images, imagined objects, a linguistic world consists of concepts which may be imaginatively cashed. But these concepts are components of the linguistic world, not work. Whereas painterly and musical worlds are sensuous, linguistic worlds are conceptual.

Whatever the source of the confusion, the material of language is not the imagination, but sound or ink. But this "or" focuses an important kernel of truth in Hegel's argument and allows us to refine further our thesis of language's independence from the specific material. What matters here is not simply that language maintains a certain degree of independence from the material in which it is embodied, since a certain degree of such independence can also be claimed for music and even for painting. Each time a piece of music is realized in an actual performance its material embodiment is new and different, to say nothing

of such common phenomena of musical practice as the use of differing pitch standards, the transposition of a piece to a different pitch altogether, or its transcription to a different vocal or instrumental medium. And even in the case of painting, where the actual embodiment of the work is truly unique, we have to reckon with such phenomena as copying, reproduction, and transposition to a different medium (from oil painting, say, to copper engraving). What is unique in the case of language, however, is its ability to get embodied in either aural or visual material, its independence from the specific sense modality its material addresses.

It must be noted though, that this apparent independence comes at a steep price. It is, namely, the more complete, the more we suppress the nonreferential aspect of language. In fact, however, there is more to language than its referring function. When I speak about anything, my speech presents (refers to) this something, but it does more than that: it also presents myself, reveals something (however little or much) about the speaker, my interests, priorities, prejudices, temperament, mood. Invariably, more is said in language than what it refers to. Any actual use of language involves not only *reference,* but also the *self-presentation* of the speaking subject. Now it is precisely this function of self-presentation that gets suppressed when we think of language as completely independent from the specific material, aural or visual, in which it is embodied. For the referential function, the actual embodiment of the sign(ifier) may not matter. For the self-presenting function, a translation from one embodiment into another always matters and sometimes it may be fatal (that is, impossible). The big difference between language, on the one hand, and painting and music, on the other, is that while the former can, in some (nonartistic) uses, be reduced almost completely to reference, the latter cannot, because they (unlike, say, the visual and aural traffic signs) do not have the referential function, they are nothing but self-presentation. Music *is* what would get reduced in such cases, what gets lost in translation. And while we can get away with disregarding the self-presenting function of language in some of its uses, in science, for instance, we certainly cannot afford it when language becomes an artistic medium. Here the difference between language in general and literature in particular (the difference Hegel ignored in the passage quoted above to the detriment of his argument) becomes relevant.

In *Of Grammatology,* Jacques Derrida argues against the assumption that there is such a thing as a signified that escapes "the play of signifying references that constitute language."[49] In the infinite chain of references, every signified turns out to be yet another signifier, with no final, "transcendental," signified at the end. The signified, Derrida stresses in his de Saussurean-cum-Heideggerian idiom, "is *always already in the position of the signifier.*"[50] The assumption that the transcendental signified is possible lies, for Derrida, at the root of what he calls the "Western logocentrism" (or "phonocentrism") which maintains that "the voice is closest to the signified, whether it is determined strictly as sense (thought or lived) or more loosely as thing" and that the written signifier is derivative.[51]

Logocentrism, in turn, supports "the historical determination of the meaning of being in general as *presence*,"[52] what Derrida calls the "metaphysics of presence." "The formal essence of the signified [in the Western tradition] is *presence*, and the privilege of its proximity to the logos as *phonè* [voice] is the privilege of presence."[53] In short, if there is no transcendental signified at the end of the chain of references, or—to put it into another idiom—if no meaning can appear unmediated and disembodied (and Derrida would surely be right, though hardly original, to stress this point), there is no reason to privilege one kind of signifier (medium, embodiment) over another, to believe that "living voice" is closer to the meaning of what is said than "dead writing" (because one assumes, say, that the former captures the "spirit" of what is said, while the latter only fixes its "letter").

The argument is persuasive, but one has to recognize that it crucially depends on the prior assumption that language is nothing but "the play of signifying references," on disregarding that side of language which involves the self-presentation of the speaking (or writing, or thinking) subject, the side that Derrida, far from "deconstructing," merely suppresses. One might also say that the argument depends on taking as one's model scientific rather than artistic uses of language (and, indeed, the written symbolism of mathematics plays the role of a privileged example in *Of Grammatology*). But once we give up this one-sided and reductive picture of language, once we recognize the side of self-presentation, we cannot keep disregarding—as we have seen—the specific medium in which an utterance is embodied, we cannot assume that it might be translated with complete impunity. This richer picture of language does not commit us to assuming in advance that sound is always and everywhere prior to ink, or handwriting prior to typewriting or -setting, although it is in general the case that the voice presents the language-using subject more richly than writing. (As Rousseau observed, by and large writing alters language, "substituting exactitude for expressiveness. Feelings are expressed in speaking, ideas in writing. In writing, one is forced to use the words according to their conventional meaning. But in speaking, one varies the meanings by varying one's tone of voice."[54]) It merely asks of us to take the original embodiment of the utterance seriously and to keep in mind that a translation to a different medium may make a difference. And neither does this richer picture of language commit us to any "metaphysics of presence," including the early modern Cartesian metaphysics of the unmediated self-transparency of the subject. It certainly can (and perhaps even must) coexist perfectly with the belief that there is no such thing as an unmediated, disembodied meaning. To pay attention to the self-presentation of the speaking (writing, thinking) subject involves no specific metaphysical commitments.

In short, my claim is that language, unique among the media, can be embodied in either visual or aural material, though, *pace* Hegel, and similarly to other media, it must be embodied somehow, and, *pace* Derrida, its specific embodiment matters if language's function of the self-presentation of the language user, the function language shares with other media, is not to be entirely suppressed

in favor of language's referential function, the function which is unique to it. It is a corollary of this claim that whereas in tonal music the aural work is necessary and primary while the written text is optional and derived, in language either the aural work or the written text can take the necessary-primary or optional-derived position. To put it more precisely, in language, the necessary and primary work as well as the optional and derived text that represents the work may be either aural or written. Thus, while Aristotle could plausibly argue that, of the six "parts" or components of tragedy, the "spectacle," or staging and enacting, is the least important one, an inessential "pleasurable accessory,"[55] no such claim could plausibly be made about tonal music, where performance (whether actual or imaginary) is of the essence.

Language differs from other media radically not only in the character of its embodiment, but also in the nature of its code. In language, unlike in other media, work and world can be in a different sense-modality, that is, an aural work, say, can refer to a world that is not aural. But, if the work is in a different sense-modality than the world, the former cannot resemble more or less closely the latter. It simply cannot resemble the latter at all. Thus, in spite of such marginal phenomena as onomatopoeia, linguistic codes by and large are uniformly abstract, or, to put it into de Saussure's terms, they are "arbitrary." The latter term is better chosen, because if a work cannot resemble a world more or less closely, it makes little sense to talk of "abstraction" (abstraction from what?). Consider the difference between a completely abstract visual work and a completely arbitrary linguistic one: the former is nothing but a real object, it does not represent anything else, but calls full attention to itself; the latter, however, is a real object that focuses full attention on something other than itself, namely, on the meaning to which it refers.

This brings us to the fundamental difference between the constitution of the visual and musical works, on the one hand, and the linguistic ones, on the other. German thinkers of the time of Goethe made current a useful distinction between sign and symbol. Hegel presents it as follows:

> The sign is some immediate intuition, representing a totally different import from what naturally belongs to it. . . . The *sign* is different from the *symbol:* for in the symbol the original characters (in essence and conception) of the visible object are more or less identical with the import which it bears as symbol; whereas in the sign, strictly so-called, the natural attributes of the intuition, and the connotation of which it is a sign, have nothing to do with each other.[56]

The distinction between sign and symbol turns on the relationship between the signifier and the signified, arbitrary in the former case, based on resemblance in the latter. I would like to adapt the distinction and claim that only the linguistic work consists of signs; other kinds of works consist of symbols. As long as we consider exclusively the referential function of language, the specific material used to make a linguistic work does not matter: we may agree to use any real object to refer to a mental content (the arbitrariness of sign). It is not so with

nonlinguistic media, in which a real object, in so far as it is to represent mental content, must resemble this content to a certain extent (the nonarbitrariness of symbol). Note, however, that the linguistic work can be said to consist of signs only if we exclusively consider the referential function of language. As soon as we recall that language also has its other, self-presenting, function, the linguistic work will have to be seen as consisting also of symbols, just as other kinds of works do. My tone of voice, or my handwriting, can suggest that I am angry only if they resemble the sounds and gestures an angry man usually makes.

One important way in which signs differ from symbols is that the former are infinitely translatable into—that is, replaceable by—other signs. A symbol's capacity to be translated into, replaced by, another symbol is severely limited. It is precisely because the sign is arbitrary that it is so flexible in this respect. Since the world of a visual (or aural) work is also visual (or aural), and since the work must resemble to a certain extent the world it represents, a symbol can be replaced by another only if the latter resembles the former and addresses the same sense as the former did. The English word "cross" can be replaced by a word having the same meaning in any language, spoken or written; a sculpted or painted cross on a church wall can be replaced only by another sculpted or painted cross.

Closely related to the fact that only linguistic work consists of signs, and that only signs are infinitely translatable, is another, namely, that, while there are many languages, all translatable into one another, it would be misleading to talk, even metaphorically, of different mutually translatable languages of painting or music. To be sure, we have already seen that it is possible to present the world of a painting by means of an engraving, or to play a musical work on a different instrument. But transcription is hardly translation. In all cases of transcription, visual or musical, the similarity between the original and the transcribed work remains very great and anyone who knows how to decode the original will also be able to decode the transcription. By contrast, when the same world is presented in different languages, the original and the translated work usually differ to such a great extent that only those who understand both languages can recognize that the two works are related. In other words, what is essential about language, and where it differs fundamentally from the visual media and music, is that there are many languages and that they are translatable into one another. This is another indication or consequence (together with the fact that the linguistic work can be either aural or visual) of the arbitrariness of the linguistic sign.

Note, moreover, that there is a difference between the correct claim that signs are infinitely translatable, and Derrida's exaggerated claim that "the play of signifying references that constitute language" must never end, that the chain of references must always go on forever. A (real) sign(ifier) refers to something mental, to a signified, and this *may* be another (imagined) sign(ifier), just may, but does not have to. The signified, instead of being another signifier, can also be an image (in any sense-modality), an imagined experience of sight, hearing,

smell, taste, or touch. Now, an image has the character of a symbol rather than that of a sign, that is, it is not infinitely translatable. Therefore, the chain of references does not have to be infinite: it can go on forever, but it may also be arrested at an image. Similarly, what stands at the beginning of a chain of reference may, but does not have to, be a sign. It may just as well be a real or imaginary experience, and this is surely *hors-texte.*

So much for the constitution of the linguistic work and the character of the linguistic code. What remains to be discussed is the content of the world that may be represented in language as compared to what may be represented by means of the visual media and music. It should be obvious by now that the world representable by linguistic means is infinitely richer. In visual media or music, not only the work, but also the world that this work to a certain extent resembles must be visual or aural. A painting or sculpture cannot represent invisible things, although it can represent visual objects that will suggest them, as Caravaggio does when he fills his *The Rest During the Flight into Egypt* (at the Doria Pamphili Gallery in Rome) with sound by having an angel play violin from the music held by St. Joseph while Mary and her child are sleeping, or as Bernini does when he fills the face of St. Theresa of Avila (Rome, Santa Maria della Victoria) with symptoms of pain and delight of ecstasy. Thanks to the arbitrariness of the linguistic sign, the linguistic world knows no such limitations: the experience in any sense modality can be represented in language. (We have observed this already when comparing the representational powers of sculpture and painting: the more abstract the work, the more richly realistic the world.) There is no sensuous experience, and no accompanying pleasure or pain, that could not be talked about.

But the ability to represent sensuous experience as well as pleasure and pain does not exhaust language's representational powers. We can use language also to represent our desire for, or revulsion from, the object of our sensuous experience. I have suggested that while visual media are the instruments of knowing the object of desire but not the desire itself, tonal music is the instrument of knowing the desire but not its object. Language transcends these limitations and allows us to represent both the external object of desire (and not only its visual aspect) and the internal desire itself.

But even this does not exhaust language's powers. In addition to being able to do singlehandedly what visual media and music do separately, language enables us to do also something that it is impossible to do in any other medium: it allows us to represent thinking, deliberating, arguing. It possesses not only representational, but also logical powers. Thanks to language we can not only represent the objects of our desire as well as the desire itself, but we can also represent thinking about our aims and means, deliberating on the questions of whether our desire is justified and how can it be realized. As Aristotle put it, "mere voice is but an indication of pleasure or pain, and is therefore found in other animals . . . , but speech is intended to set forth the expedient and inexpedient, and therefore likewise the just and the unjust."[57]

We are fundamentally creatures that know the external objects in our environment, desire these objects internally, and think about the justification and realization of the desires. Thus there seems to be nothing that is completely beyond the representational powers of language. The celebrated sentence that closes Wittgenstein's *Tractatus* ("What we cannot speak about we must pass over in silence"[58]) is puzzling. How would we ever know that there is something of which we cannot speak? (Which is not to deny that there are many things, the *qualia* of an experience, which language cannot capture with any precision, which can be only "pointed to" rather than fully "said.") Aristotle is more likely to be right on this point when he says that "everything is a possible object of thought."[59] Gadamer observes that "the possibilities of our knowledge seem to be far more individual than the possibilities of expression offered by language." But in fact "all such criticism which rises above the schematism of our statements in order to understand again finds its expression in language. Hence language always forestalls any objection to its jurisdiction. Its universality keeps pace with the universality of reason."[60]

I have just made the claim that language is a medium for representing images that address any sense modality, that is, one which, alone, allows us to do everything that, and more than, we do, separately, with visual and aural media: by means of language, we can represent any external object, the pleasure or pain it causes us, and our desire for, or revulsion from, it. I have also claimed that, in addition, language is the medium for representing concepts and logical relationships, that is, the medium for representing argumentative thinking that only language can represent: language allows us publicly to deliberate on such questions as which objects of desire we should pursue and by which means. But if language is so universally versatile that it can serve to represent anything that can be represented by means of visual media and music, do we need the more limited nonlinguistic media at all?

We do, because in a crucially important respect they perform their task better than language. Thanks to the arbitrariness of the linguistic sign, as opposed to the nonarbitrary character of the visual or musical symbol, the actual sensuous qualities of the sign play an incomparably lesser role in conveying its meaning than they do in the case of the symbol. The sign is expected to disappear almost without a trace into its meaning, into the concept. And the concept itself, even when it is the concept of a perceptible object, does not need to be translated further into any specific image: we can grasp the concept of "table" and learn to use the word that conveys it, without having to imagine any specific table, without having to imagine anything at all. Even when we decide to produce an image, to visualize the content conveyed by the sign, the image can vary greatly as to the amount and distinctness of its details, and usually falls in both these respects far short of the content conveyed by the visual or aural symbol. Three facts, then, have to be kept in mind here: that the sensuous qualities of the linguistic sign are relatively insignificant; that the movement from the sign to the concept does not need to proceed further to the image; and that even when it

does, the image will normally be relatively vague and indistinct. By contrast, in the interpretation of the symbol, its sensuous qualities remain of paramount importance (because of the necessary resemblance between the symbol and its meaning), the meaning cannot be purely conceptual, but rather must necessarily have the form of an image (whether visual or aural), and the image will normally be relatively much more precise, detailed, and distinct than in the case of the image produced by the linguistic sign.

As a result, even though it may be used to describe a visual world, language cannot match the directness and precision the visual media bring to this task. Similarly, even though it may be used to describe desire, it cannot make us experience desire as directly, powerfully, and purely (without any knowledge of the desired object) as music can. A described world must be imagined by the reader (this is what is meant by its relative lack of directness) and it can be imagined to look in a great variety of ways (this is what is meant by the relative lack of precision in any description). By contrast, a depicted world can be seen directly in the work and, consequently, cannot be made to look differently each time one views the work. Anna Karenina looks somewhat differently to each reader, but Raphael's *La Velata* (in Palazzo Pitti) looks the same to each viewer. Similarly, a described desire must be imagined by the reader, who might imagine feeling it in a great variety of ways. The dynamics of desire embodied in the tonal motion of music is felt directly when a musical work is heard and it cannot be felt differently each time one hears the work.

But we would not do full justice to language if we left our comparison between its representational powers and those of visual and aural media here. There is, namely, one area where the directness and precision of painting or music is fully matched by language. In developing the comparison thus far, I have considered only the referential side of language, disregarding its self-presentational side. So long as we focus on the referential function only, we may claim, as I did above, that the sensuous aspects of the linguistic sign are meant to disappear to give way to the concept referred to, and that the movement from the concept to image is optional. But once we recall the self-presentational function, the sensuous aspects of the sign, the actual sounds, rhythms, and tempo of the speech, the tone of the voice, the look of the handwriting, cannot be disregarded completely, since they convey a wealth of information about the speakers, about their social and educational background, their attitude to whatever it is they are saying, their state of mind, that supplements the content of their speech. It follows that language can match the directness and precision of nonlinguistic media when, and only when, it is used to represent someone's speech.

A novelist falls far behind a painter when he describes a landscape, but he is equally direct and precise when he represents the voice of the narrator or personage that describes the landscape. Moreover, he cannot describe the landscape otherwise than as mediated by the voice of the narrator or personage. (I will have more to say on this subject in chapter 4.) We will learn more about the represented landscape from the painter, but we will learn more about the represented

speaker who describes the landscape from the writer. A painter represents the landscape directly, something that a writer cannot do, since his description is always mediated by a voice. But a writer can represent the voice directly. Thus, a depiction of the external world is more objective, while a description is more subjective, always filtered through the lens of individual subjectivity.

In short, painting gives us the represented world directly, language can only give us the represented speakers directly; the rest of the world represented in language is given us indirectly, as perceived by the speakers. And music? Like language, music can represent directly only the self-presenting "voices." (Again, more will be said on this notion in chapter 4.) But, unlike language, this is all music can represent. Knowing no reference, it cannot tell us what these "voices" talk about. Even without tonality and its special powers to represent desire, music can present their (the voices') states of mind, but not their intentional objects. One might say that music takes the self-presentational side of language, divorces it from reference, and amplifies it, developing differentiation, subtlety, and control in its handling of sound, rhythm, and tempo of which poetry can only dream. (This seems to have been Kant's view of music's relationship with language, when he claimed that music's "charm, which admits of such universal communication, appears to rest on the following facts. Every expression in language has an associated tone suited to its sense. This tone indicates, more or less, a mode in which the speaker is affected, and in turn evokes it in the hearer. . . . The art of tone wields the full force of this language wholly on its own account, namely, as a language of the affections."[61]) While painting gives us the object without the subject, music gives us the subject without the object. Language gives us both, directly the speaking subject, and indirectly, through the subject's speech, also the object.

Depending on our purposes, the contrast in directness and precision between the description of an external or internal world in language and the embodiment of a world in a visual medium or in music may be taken to show language's weakness or strength. In particular, directness and precision do not always have to be desirable, and the relative representational indeterminacy of language may sometimes be an advantage. We have seen that a linguistic representation, unlike a pictorial one, say, invites the reader to imagine the represented world and leaves him considerable freedom as to the specific content of the images produced. It forces the reader to be imaginatively more active and creative than a viewer or listener. By making the reader into a co-creator of the represented world, it involves him imaginatively in this world much more deeply and personally.

The relative representational indeterminacy of language may have yet another important advantage. It may help to keep a linguistic work fresh, alive, and interesting for a very long time, both for an individual reader and for generations of readers. If each reading produces a world some features of which will be new each time, it is understandable why individual readers and generations of readers might be tempted to reread. A linguistic work may be better than a pictorial or musical one at keeping a tradition of interpretation and application

or actualization alive. Religious iconoclasm may appeal not only to an understandable reluctance to represent the unrepresentable, but also to a fear that too direct and precise a representation may be detrimental to the creative life of the imagination and may stunt the continuing growth of an interpretative tradition.

One more subject needs to be discussed here. Now that we understand that language, unlike other media, is not just an instrument of representation, but also of rational thought, we may return once more to the Derridean topic of the relative claims of spoken and written discourse. While the claim that sound and writing may provide equally original, underived, embodiment for a linguistic utterance is correct, we may nevertheless consider the question whether sound or writing makes a better material for language. Hegel preferred sound, arguing that, since it is the nature of the sign to disappear into its meaning, it is proper for it to exist as a temporal, that is, disappearing sound:

> The intuition—in its natural phase a something given and given in space—acquires, when employed as a sign, the peculiar characteristic of existing only as superseded and sublimated. Such is the negativity of intelligence; and thus the truer phase of the intuition used as a sign is existence in *time* (but its existence vanishes in the moment of being). . . . This institution of the natural is the vocal note, where the inward idea manifests itself in adequate utterance.[62]

Another argument in favor of sound can also be made. One might be tempted to give preference to sound on account of its more abstract character. Precisely because we are much less interested in representing the aural world than in representing the visual one, sound is a more suitable material for making abstract, arbitrary signs: there is less danger that our signs will bring to mind uncalled for associations, be taken to represent something by resembling it, when these signs are aural. To be sure, this argument holds only for picto- or ideograms or for logography, that is, for writing systems in which a sign refers directly to a meaning, the kind of writing Hegel called "hieroglyphic;" it does not apply to a phonetized system of writing in which a sign refers to a phonetic value and not to a meaning, the kind of writing most fully exemplified by the alphabetic system. Hegel's comparison of the two kinds of writing is illuminating: "In particular, hieroglyphics uses spatial figures to designate *ideas;* alphabetical writing, on the other hand, uses them to designate vocal notes which are already signs. Alphabetical writing thus consists of signs of signs."[63] Clearly, in a phonetized system of writing the danger mentioned a moment ago does not arise. But this in itself strengthens rather than weakens our argument. Besides, as linguists point out, even alphabetic writing is not purely phonemic, with each sign designating one actual phoneme (unit of sound). Rather, different spellings of two different but similarly pronounced words (such as "recede" and "re-seed") are used to underscore that the words employ different root morphemes (units of meaning). In other words, even alphabetic writing is not purely phonemic (referring to sound alone) but, rather, contains a morphemic component (referring to the meaning).[64] In

Steven Pinker's words, "the goal of reading, after all, is to understand the text, not to pronounce it."[65]

However, even if these arguments are convincing, the speculation thus far seems idle. There is little point in asking whether voice or writing is a better embodiment for language, until we ask which of the functions of language is better supported by which kind of embodiment. Above, I have distinguished two fundamental functions of a linguistic utterance, that of referring to a subject matter, and that of the speaker's self-presentation. Now, if what we want to emphasize is the latter function, there can be no better embodiment for the utterance than a living voice; nothing could reveal the speaker's state of mind, his attitude to the subject matter of his speech, better. The living voice, after all, has many of music's means at its disposal: differences of pitch, rhythm, tempo, timbre, and dynamics. In comparison, handwriting comes a distant second, although handwriting can also tell us a lot about the state of mind of the writer, in the same way that gestures do, since, like the voice, it is produced directly by the body. Print is, of course, the least informative in this respect, since the direct relation between the sign and the body that produced it is severed. If, however, the referential function is to be foregrounded and the self-presenting one de-emphasized, then the order of preference would be reversed—print, handwriting, voice.

Now, what is probably most striking about the situation of linguistic embodiment today is the fact that recent exponential growth of electronic means of audiovisual communication increasingly challenges the hegemony of print as the privileged means of public, as opposed to private, communication. This is the practical context in which speculative comparison of the respective suitability of voice and writing for linguistic embodiment need not be entirely pointless, but, on the contrary, may prove to have interesting practical implications. I have just established that writing privileges the referential function of language and de-emphasizes the self-presenting function, while the reverse is true of voice. If this is the case, the shift in public communication from print to electronically transmitted voice (and image) cannot but affect the character of our political debates.

Print concentrates the reader's attention on the matter under discussion, rather than on the person who discusses it, and it allows the reader to control the temporal dimension of the discourse, to read quickly or slowly, and to read again. It gives the reader time to think through the issues carefully, encouraging dispassionate rational analysis. When a living voice is used, it is the speaker who controls the time of discourse, and it is on the speaker as much as on the matter discussed that the reader's attention is focused. Thus, when what is at issue is the character of the speaker, as it often is, say, during election campaigns, electronic media are inestimably efficient in transmitting the relevant information. But the very same media may be distracting when what is needed is a calm and impersonal deliberation on matters of public policy. (It is surely no accident that the age of totalitarian dictators was also the age of radio broadcast and film newsreel. Not that the dictators neglected to control the printed media, of course, but

they made very conscious use of the media and found print a less effective instrument of mass propaganda than radio and film.) Democratic politics in modern mass societies is to a very large extent a spectators' sport or theater (and will remain so until direct democracy replaces or at least supplements the currently dominant representative one): the business of the government is conducted by elected politicians, while the electorate voices its approval or disapproval in periodic elections. The print and electronic media transmit the spectacle. The latter are invaluable in communicating the character of the players, but the former cannot be replaced when the voters need to learn about the issues about which these players deliberate and make decisions.

It is the fact that they take the control over the time of discourse away from the reader that, more than anything else, accounts for the powerful impact the electronic media can have, a power that, depending on the context, may be considered glorious or pernicious, enhancing or threatening our liberties. And this brings us back again to the comparison of music and other cultural media, since here we have one more, thus far unmentioned, source of music's uncanny power over us. A sculpture or painting (though not a dance or film) we can see "in our own time," so to speak, for as long as we wish, with interruptions or without. Similarly, a written discourse (but not a spoken one, or one enacted in theater or on film) we can read in full control over the time of our reading, over its tempo and continuity. Not so with performed music, which imposes its temporality on us. While sculpture, painting, and written discourse leave us in control over the temporal dimension of our experience, music and spoken discourse (as well as dance, enacted drama, and film) literally grab us by grabbing away the control we otherwise have over this dimension. With the performing arts, it is only the various technologies of writing and recording that give us the control over time. When music is notated or recorded, when dance, enacted drama, or film are captured on video, we can read them the way we read novels. Recordings, in particular, have transformed our modes of listening now in subtle and complex ways, allowing for distraction and loss of continuity, immediacy, and intensity, to be sure, but also for intimacy and depth of experience and knowledge heretofore reserved only for the musically literate communing with the scores at their pianos.

e. Works and Performances, Originals and Copies

In certain respects, works in the visual media of sculpture and painting differ from those in the media of music and language, whether spoken or written. Visual works have two interrelated features. First, they are enduring objects that can be made, mutilated, repaired, and destroyed, to be sure, but that need not be repeated once they have been made, or before they have been destroyed. They are simply there, waiting for the viewer to see them. Second, each individual work is a single object, the "original," that may, but does not have to, belong to a family of related objects that closely resemble one another, and each original can be reproduced to make one or more "copies." The two features are interre-

lated: since visual works are enduring objects, it is natural for them to exist normally as single objects and only exceptionally in families, and to be capable of being copied.

In sculpture, painting, and drawing, there is typically a single original, though in principle nothing prevents an artist from making multiple versions, multiple originals that closely resemble one another. For some artists (Brancusi comes to mind), making multiple versions is the normal practice. In this latter case, we often talk loosely of multiple versions of a single work, which unnecessarily suggests that there exists a thing of a mysterious ontological status called "work" which differs from all of the versions. In the terminology adopted here, each of the versions is a work and, instead of postulating some mysterious essence they all have in common, one simply describes in as much detail as is available and useful the resemblances and differences between the versions. Prints and photographs typically have multiple originals; here also there is no need to think in terms of an ideal "work" which these real objects somehow exemplify, since artists, dealers, collectors, and connoisseurs have developed practical and useful ways of describing the relationships among such multiple original works. Just as for sculpture and painting, also for prints and photographs: the distinction between originals and copies remains valid and is not ontological, but depends on conventions developed by the relevant community. Whether two objects that closely resemble one another will be considered two originals or an original and a copy cannot be decided on the basis of an examination of the objects alone, without reference to any cultural conventions and practices.

Neither of these two features of visual works (the work as an enduring object and the original-copy distinction) are characteristic of musical and linguistic works. A musical work, as the term is understood here, is a real (or imagined) sounding object, identical with what is usually called a "performance." In this sense, no kind of music, whether art or popular, Western or non-Western, fails to be embodied in works (performances). But musical works are not enduring objects that patiently wait for us to hear them at a time we choose. They are, rather, transitory and ephemeral events that have to be produced each time we want to hear them and that we can hear only while they last. They come into being, last for a limited time, and then they are irrevocably gone. This is the case even when we ourselves produce the performance, whether in actuality or in imagination. Musical works change in time the way sculptures and paintings do not and, consequently, they impose their temporality on us. In principle, however, events of this sort are repeatable, provided the memories of the musicians producing the sounds are good enough or propped by adequate notation. The repeatability of musical works compensates for their ephemerality. Both visual and musical works can exist singly or in families, but while it is normal for visual works to stay single, since they endure and can be revisited, it is understandable that musical works will usually form families to overcome their transitory nature.

What is "good enough" and "adequate" in cases of repetition depends on the conventions of a given culture. Similarly, whether or not repetitions of work-

events are considered desirable is culturally contingent. These repetitions will be highly valued in cultures, like that of European art music in recent centuries, that want musical works to be repeatedly experienced and scrutinized in the manner of classic works of visual art and literature. Furthermore, like different impressions of a print, the repetitions cannot, of course, ever be identical, not even when the sounds are generated not by living musicians, but by computers. At the very least, they happen in different times. But the resemblance among them can be lesser or greater, and it can be strong enough to satisfy the requirements of a given music community, to enable members of this community to say that what they hear is a repetition rather than a new work. Again, the difference between a repetition and a new work cannot be established on the basis of hearing alone, without any reference to the relevant cultural conventions.

The fact that we normally, and somewhat loosely, talk of multiple performances of a single "work" has given rise to a vast philosophical literature that attempts to describe the mysterious ontological status of this ideal "work" which actual performances somehow merely exemplify.[66] It has seemed plausible to many people that the concept of "work" understood in the ideal sense is useful and inevitable even, since it accounts for the fact that actual performances of a given "work" can be better or worse, or more or less accurate. The concept gained particular plausibility with reference to the post-Beethovenian music culture with its clear division of labor among composers and performers. It seems that in such a culture the composer creates the ideal "work" and fixes it notationally in the score (or text, in the sense of the term adopted here), while the performers give this "work" sounding realizations that may be evaluated by comparison with the ideal "work." But in fact, also in the post-Beethovenian music culture, all we have is the composer's text, consisting of instructions for the performers that tell them what they should be doing, and the works the performers produce following these instructions. The text may be more or less precise, it may leave greater or smaller questions to be resolved at the performers' discretion, it may rely on unwritten, but commonly understood conventions. The work produced by the performers may follow the explicit and implicit instructions of the text with greater or lesser accuracy, and the performers may be more or less inspired or ingenious in resolving questions that the text left indeterminate. In any case, we have no access to the ideal "work" in comparison with which the actual performances are supposed to be evaluated; all we have access to is the same text, and the same relevant contextual knowledge, that is available to the performers. And the performances can well be evaluated with reference to this text. "Every performance is an event, but not one that would in any way be separate from the work—the work itself is what 'takes place' in the performative event," says Gadamer.[67] In short, all we have and all we are ever likely to get are necessarily works-performances and, optionally, scores-texts. The ideal "work" is the result of a typical seduction by language, a concept with no useful job to do (apart from providing an entertaining metaphysical puzzle for professional philosophers and a shortcut for musicians). All the same, I have no illusions that

my claims will make the music world stop talking about "works" (rather than texts or scores) and the "performances" or "interpretations" thereof. There is no harm in such loose talk (I intend to engage in it myself) provided it does not put us on a hopeless chase after this nonexistent entity, the ideal "work" distinct from both performances and scores.

I have established above that, since visual works are enduring objects while musical works are transitory events, it is normal for the former to exist singly and for the latter to form families. It follows, furthermore, that in the realm of visual works, the distinction between the original and its copies will tend, in some cultures at least, to become firmly entrenched, while in the realm of musical works this distinction will tend to have a limited applicability: where the works normally remain single, there will be a strong temptation to produce copies; where they tend to form families, the need to make copies will be less obvious. One area of music where the original-copy distinction clearly and commonly does apply is that of recorded live performances. A recording of a live performance remains in the same relation to the original performance as a photograph of a painting does to the original painting. (To avoid possible misunderstandings, I should add that it is not my aim here to downplay the central role of recordings in the circulation of music today, nor to deny that most recordings are far from simple copies of live performances. Most recordings we listen to are originals, not copies. Similarly, one would not want to overlook the central role played by photography in the circulation of nonphotographic visual art, or the fact that most such photography does more than simply copy: compare your experience of seeing the Piero della Francesca frescoes in St. Francis' Church of Arezzo with seeing them in a well-produced album.) A musical copy can also be produced by less mechanical means, just as a painting can be copied by a painter. Thus, a band may be formed to copy original performances of the Duke Ellington band. But in comparison with the very prominent role copying by hand has long played in our visual culture, these nonmechanical reproductions have always been of marginal importance in our music culture. Only with the advent of mechanical reproduction has copying become equally prominent in visual and musical domains.

It is striking, by the way, how different the impact of mechanical reproduction is in the visual and musical fields. In both areas mechanical reproduction deprives the work of what Benjamin identified as its "aura," compounded in equal measure of its uniqueness and its embeddedness within the original context.[68] But while we commonly consider a recording of a performance as an adequate vehicle of a musical experience, a photographic reproduction of a painting is rarely more than an *aide-memoire*, useful as a reminder of what the original looks like, but not an adequate substitute for seeing the original. This difference is partly the result of the fact that, while a recording does not normally change the temporal dimension of the musical work, a photograph usually changes the spatial dimensions of the painting. In at least one respect, however, a photographic reproduction functions similarly to a recording. When it captures aspects of the original which are difficult to see under the usual viewing conditions

(for instance, details of a distant fresco), a photograph, no less than a recording, enhances the intimacy and depth of experience and knowledge available to us.

Which of the two models of work obtains in language? Are linguistic works enduring objects or transitory events? It was my claim, it will be recalled, that, unlike a visual work which may be embodied only in visually perceptible material, and unlike a musical work which may be embodied only in sound, a linguistic utterance may be embodied either aurally, in sound, or visually, in writing. Now when a linguistic work is embodied primarily in sound, it behaves generally like music, while when its primary embodiment is writing, it resembles a work in a visual medium. Whether what we deal with in any specific case is one or the other kind of primary embodiment is a culturally contingent fact, that is, the question cannot be answered by examining the specific utterance in complete isolation. In both cases, however, the arbitrariness of the linguistic sign enables us to tolerate much greater variety of embodiments within a family of multiple originals than we would allow in either painting or music: think how relatively little difference it makes whether a poem is printed in black or crimson ink and how much difference it would make if Velázquez decided to make another version of the portrait of Innocent X, this time in black robes.

When language is embodied primarily in sound, the linguistic work is a transitory, ephemeral event which does not patiently wait for our scrutiny, but must be produced, or performed, anew, either from memory or from a written text, each time we want to have it. Just like when we read a score, a performance of a linguistic work may also be actual (as when we read aloud) or imaginary (as when we read silently). And just as with music, an imaginary performance, silent reading, does not have to, and rarely does, realize equally vividly and precisely everything indicated in the notation. When we read scores silently, we rarely imagine everything we would hear if the score was actually performed. Similarly, when we read a linguistic text silently, we rarely imagine precisely how the text would sound if read aloud. This is especially the case since with language we always have the option of treating the written text as if it were the primary embodiment of the work. But as long as we do not do this, as long as we consider the primary embodiment to be aural, the relationship between the sounding work and written text in language will be similar to that obtaining in music. The main difference will be that in our post-Ambrosian culture it is much more common to read linguistic texts silently than to do the same with music scores: the sight of a commuter silently reading string quartets astonishes fellow passengers today no less than the sight of St. Ambrose silently reading astonished St. Augustine: "But when he was reading, he drew his eyes along over the leaves, and his heart searched into the sense, but his voice and tongue were silent. Ofttimes when we were present . . . we still saw him reading to himself, and never otherwise."[69]

When language is embodied primarily in writing, the linguistic work is an enduring object, similar to a sculpture or painting, an object we can scrutinize in our own time, when we want. We can also read it aloud, of course, but in that case its sounding embodiment would be secondary, derived, and inessential.

For obvious reasons, "hieroglyphic" writing (in Hegel's sense, that is, writing in which the signs refer directly to what is meant, rather than to sounds) tends to encourage the view of writing as the primary embodiment of language, but it does not make it necessary. By the same token, "alphabetic" writing (where the signs refer to sounds, rather than to what is meant) tends to privilege the view of language as embodied primarily in sound, but, again, does not make this view inevitable. What is considered literature in the West today usually behaves like music, that is, it tacitly assumes the primacy of sound. For the most part, our written literature is meant to be read, aloud or silently, so that the sounding embodiment of language is not entirely bypassed. But such phenomena as some poems in Apollinaire's *Calligrammes,* to say nothing of the use of calligraphy in—and as—painting in China, show clearly that this must not always and everywhere be the case.

The above discussion offers no more than a map of possibilities: a work can be an enduring object or an ephemeral event; in either case, the work may be repeated, creating a family of closely related objects, or it may stay single; any original work is capable of being copied (with the distinction between a repetition and a copy being governed by the relevant conventions and practices). It is a matter of empirical research to establish which of these divergent possibilities are foregrounded in any particular culture. In the last few centuries, the high culture in the West has tended to privilege works as enduring objects to such an extent that even the medium ontologically condemned to ephemerality, music, has evolved practices that allow repetition, thus countering the necessarily transitory character of the musical work. The reasons and causes that account for this state of affairs are highly diverse. They surely embrace the aspiration that post-Beethovenian music acquire structural and expressive complexity equal to that of the greatest literature and painting and hence be objectified in works allowing repeated scrutiny. And equally surely, they include the development of a market economy and hence the commodification of music in the form of marketable scores. But even in the West, jazz has challenged the idea that repeatability is a necessary attribute of all artistically significant music: improvisation, spontaneity, and vitality may be valued as highly as permanence and repeatability. And then, no sooner was the challenge issued but recordings transformed this form of ephemerality, too, into enduring (and marketable) objects. It is only to be expected that in a highly developed culture the possibilities concerning the status of the work which we have mapped will be engaged in a complex fashion.

f. Representations and Arguments

We know now what the cultural media are generally for, what basic kinds of media there are, and what their fundamental structure is. We have learned that media involve works (real objects) that have to be transformed into worlds (imaginary objects). But clearly, not all works and worlds are works and worlds of art. We need to examine media further to learn when they can and when they

cannot be put to artistic uses. And to learn this, we need to turn our attention from works to worlds.

My claim here will be that there are two fundamental world-types, namely, representations and arguments;[70] that representations subdivide further into those of actual and those of fictional objects; and that arguments subdivide further into those about the world as it is (or was) and those about the world as it should be. A place for art will be found to result from the superimposition of these classifications.

The distinction between representations and arguments has already been adumbrated in some of what has been said above. We have already learned that in at least three respects language differs fundamentally from visual and aural media. First, a linguistic work can refer to images in any sense modality. By contrast, the imaginary worlds invoked by visual media consist of particular visual images, while those invoked by music consist of particular aural images. Second, unlike a work in the visual and aural media, a linguistic work does not refer to images directly. Rather, it does so through the intermediary of concepts, that is, it refers to general concepts under which a variety of particular images may, but do not have to, be subsumed. Third, and most important, language possesses not only representational, but also logical powers, that is, it enables us to do something that is impossible to do in any other medium, namely, to represent thinking, deliberating, arguing. It is the only medium in which we can represent not only the objects of our desire as well as the desire itself, but also the thinking and arguing about our aims and means, the deliberating on the questions of whether our desire is justified and how can it be realized.

The distinction between representations and arguments depends on these points, the last one in particular. Works in all media, language included, can evoke worlds that are representations, that is, consist of particular images, imagined sensuous experiences. Only a linguistic work can also evoke a world that is an argument, that is, consists of general intellectual concepts and logical relations among them. (In a different idiom, Croce similarly claimed that the "forms of knowledge are two: the intuition and the concept."[71])

Since arguments are possible in language only, in thinking about the distinction between the representational and argumentative world-types we need not worry about the visual and aural media at all. However, language's two fundamental functions, that of self-presentation of the speaker, which it shares with other media, and that of reference, which is unique to it, are both relevant to my forthcoming claim that in art- and history-worlds representations and not arguments are of the essence. When the referential function is considered, the claim implies that in artistic and historical uses of language, that is, in literature and history as opposed to philosophy or science, the reader will be encouraged not just to go from words to concepts and stop there, but to realize the concepts imaginatively, to move from universal concepts to particular images. When the self-presentational function is considered, the claim implies that in literature and history, unlike in philosophy or science, what matters is not only the world

referred to, or spoken about, by the speaking voice, but also the speaking voice itself. The voice itself, and not only what it speaks about, is an essential component of the world represented in a literary and even in a historical work. (The notion of the voice will be discussed in more detail in chapter 4.) Recall that, as I have argued above, the actual sounds, rhythms, and tempo of the speech, the tone of voice, the look of the handwriting, convey a wealth of information about the speakers, about their social and educational backgrounds, their attitudes to whatever it is they are saying, their states of mind, that supplements the content of their speech. Moreover, as I have argued, language can give us directly only the represented speakers; the rest of the world represented in language is given us indirectly, as perceived by the speakers.

Linguistic worlds need not, and rarely do, present these two types, representation and argument, in their pure form. Rather, they are usually mixed in various proportions. When they are so mixed, it is often possible to decide which type predominates. A world may be fundamentally a representation with an admixture of argument, or the reverse. But a mixture can also be such that the work may be equally fruitfully read and interpreted from either perspective, as a representation, or as an argument. Works of history are often of this sort, when they represent the events, and at the same time offer explanations of these events in terms other than the simple probabilistic narrative logic of antecedent events implying consequent ones. But not only works commonly classified as history may be this way. While it would be something of an exaggeration to claim that in Hegel's *Phenomenology of Mind* representation and argument are equally balanced, the book surely asks to be read as a philosophical argument and simultaneously a historical narrative, a *Bildungsroman* of human mind and culture.[72] Who could decide whether representations or arguments predominate in Kierkegaard's *Either/Or,* or even what in this book is a representation and what an argument? ("[T]he writers usually identified as 'philosophers' include both argumentative problem-solvers like Aristotle and Russell and oracular world-disclosers like Plato and Hegel," says Rorty.[73]) Similarly, Proust's world interweaves representations and arguments so closely that it has been fruitfully read both as a novel and as a work of philosophy.

Most linguistic worlds, however, not only mix representations and arguments, but mix them in such a way that one type clearly predominates. But there is an imbalance between these two world-types: representations can and often do exist independently of arguments, but arguments rarely if ever appear in a pure state, without any representations. Purely visual or musical representations are, of course, free of any admixture of argument, since argument is impossible where there is no language. But even when the medium is language, pure representation is common. Argument, by contrast, seems to need representations to argue about. That, in any case, is what Aristotle thought: "To the thinking soul images serve as if they were contents of perception. . . . That is why the soul never thinks without an image."[74] And further: "The so-called abstract objects the mind thinks just as, if one had thought of the snub-nosed not as snub-nosed but

as hollow, one would have thought of an actuality without the flesh in which it is embodied: it is thus that the mind when it is thinking the objects of Mathematics thinks as separate, elements which do not exist separate."[75] Croce, similarly, thought that images could exist independently of concepts, but not the reverse: "If we have shown that the aesthetic form [of knowledge, that is, knowledge productive of images] is altogether independent of the intellectual [form of knowledge, the one productive of concepts] and suffices to itself without external support, we have not said that the intellectual can stand without the aesthetic. . . . Concepts are not possible without intuitions."[76] (I do not know enough about the philosophy of logic and mathematics to be able to say whether pure argument is ever possible.)

When what predominates in a linguistic world is representation, the work that embodies the world belongs to one of the two very broadly conceived kinds of linguistic works, art or history. When argument predominates, it belongs to philosophy or science. In a preliminary and schematic fashion, one might say that art and history represent worlds, while philosophy and science argue about such representations. (Note that my "art," "history," "philosophy," and "science" are idealizations in which not all working artists, historians, philosophers, and scientists will want to recognize themselves.)

It should be clear that the place of art and history, as opposed to philosophy and science, is on the side of representation. This does not mean, of course, that all art must be representational in some narrow sense, or that all history must be nothing but the description and narration of past events. It does mean, however, that the world that is evoked in a work of art or history cannot have a purely argumentative structure, cannot consist of concepts and their logical relationships only, while it may, though does not have to, have a purely representational structure (even if no historian would want to, or should, be deprived of the ability to argue). In other words, it must have, predominantly and essentially, the structure of representation, that is, it must consist primarily of images. (Proust captured the distinction I am making here most succinctly when he compared early, immature poems of Hugo with *La Légende des Siècles:* "In these first poems, Victor Hugo is still a thinker, instead of contenting himself, like Nature, with supplying food for thought."[77]) And the reverse: the world that is evoked in a work of philosophy or science cannot be purely representational, cannot consist of images only. In other words, it must have, predominantly and essentially, the structure of argument, that is, it must consist primarily of concepts and their logical relationships. Something is an essential component of an object when we cannot have the object without this component. We cannot have art and history without representations and we cannot have philosophy and science without arguments.

What is the force of all these "musts" and "cannots"? Clearly, we could not prevent an avant-garde artist from offering a purely conceptual world as a world of art. But we can do two things. We can, feebly, point out that for most art as we know it, the representational world-type is of the essence. And we can, more

forcefully, remind ourselves that our aim here is not to establish what art is or can be, but rather what its function should be if it were to be culturally important, one that could be fulfilled only by art, and, moreover, by much of the art that already exists. If these conditions are to be respected, art, indeed, must be looked for on the side of representations, since arguments are the backbone of the worlds evoked by philosophy and science.

The distinction between history and art, in turn, depends upon a further subdivision of representational worlds into those representing actual objects, that is, objects that actually exist or existed in the real world independently of any representations thereof, and those representing fictional objects, that is, objects that exist only as representations. Note that the distinction between what is actual and what is fictional is not identical with the distinction between what is real and what is imaginary. I have established early on that the function of media is to enable us to encode real or imaginary experiences in works (real objects) and to decode these experiences by transforming the works into worlds (imaginary objects). All objects that make up a representational world are imaginary. But some of these objects portray actual objects that exist or existed in the real world, while others do not. The latter objects are not only imaginary, but also fictional. Representational worlds that portray actual objects are embodied in kinds of works we call history. Representational worlds that are also fictional are embodied in kinds of works we call art. Both history and art belong to the (predominantly and essentially) representational world-type, but images of the former portray actual objects, while images of the latter are predominantly or exclusively fictions. We cannot have history which does not at all represent the actual, the world as it is or was. And we cannot have art which does not at all represent a fictional world. Clearly, both these sweeping pronouncements cannot be left without comment.

It should be noted that, while my use of the term "history" has ample classical precedent in Aristotle, the term covers much more than the academic discipline of history. Its scope includes any portrayal of the real world, present as well as past, journalistic as well as historical. It should be noted also that there will be borderline cases. History and art can be mixed, though usually one will predominate, as when a historian imaginatively reconstructs the thoughts of a historical protagonist that, strictly speaking, cannot be documented, or when a novelist combines actual and fictional personages and settings. There are also borderline cases that are more difficult to decide. Take Van Dyke's portrait of Charles I (in the Louvre). As a portrait of a man who actually existed, it is a historical record, a work of history. Yet it is clearly more than a family snapshot or a journalistic photograph. Like every great portraitist, Van Dyke wanted to achieve more than a faithful record of how his model actually looked. His aim was also to convey an ideal vision of what his model should have looked like, the way the model wanted to appear and to be, a man of simple but incomparable elegance and authority. Thus the image is of an actual object and at the same time is fictional: history and art remain intertwined. Visual worlds, in particular,

often exhibit a dual nature of this sort. Note, finally, that, even though all media can, and both language and visual media often do, serve the aims of history and art, in practice we have no significant aural works of history: it has already been pointed out that our interest in portraying the aural features of the outer world is minimal.

This qualifies the statement that "we cannot have history which does not at all represent the actual" sufficiently to make it plausible. But what about the statement which seems to cry even more loudly for qualification, the statement to the effect that "we cannot have art which does not at all represent a fictional world"? What seems problematic here is that so much art is not obviously representational. It is not just that the imaginary worlds evoked by art may consist of abstract objects, as we have seen to be the case with most abstract painting and with tonal music. It is, rather, that much art is not representational even in this broad sense in which abstract painting or tonal instrumental music can be said to be representational. Recall, however, what has been said earlier about replicas and abstract works. When discussing the structure of media, I have established that, at the extremes, the work whose function is to represent a world ceases to represent and becomes no more than a real object (one that replicates other actually existing real objects, or one that does not, that is abstract). Replicas and abstract works are pertinent here, since art as we know it is full of them. Abstraction in particular remains a central preoccupation of the visual arts and music throughout the twentieth century, and works of even earlier, tonal music combine representational and abstract features.

As I have argued above, when confronted with a perfectly abstract work (or a replica, for that matter), we have the choice of either treating it as nothing but a real object, or assimilating it to our cultural habits and interpreting it as an embodiment of an imaginary world, an expression of a state of mind, for instance. In the former case, it is difficult to see what the point of a perfectly abstract work, or of a replica, might be (unless it becomes an element of a larger design by an architect, gardener, or interior decorator). Therefore, the latter choice has to be made if the work is to be worthy of our effort, is to have any value for us. Moreover, we know that we have the same choice when confronted with any real object: we may treat it either as an artifact designed to fulfill a function, to be used, or as an artwork, an embodiment of an imagined world of human practices and aspirations that the object implies, since it might function in such a world. Buildings, in particular, are real objects designed to be used, and in considering them we may always remain hard-headed realists and see them from a strictly utilitarian point of view as instruments serving their designated functions more or less efficiently. But with buildings we also have the option of treating them as embodiments of their builders' or owners' self-images, aspirations, values, and preferences as to forms of life worth cultivating, that is, as intimating imaginary *Lebenswelten*.

It is this ability to evoke imaginary worlds, and not representation in the strict and narrow sense, which is the distinguishing feature of art. This is the sense in

which my claim that "we cannot have art which does not at all represent a fictional world" can be justified. Even a perfectly abstract work, a replica, or an artifact, in so far as they are treated as artworks, must be seen or heard to embody an imaginary world, if they are to have any value for us. But we may draw a distinction between objects which must be treated as representations if they are to be understood at all (we might call them "poetic" artworks, since their paradigmatic examples are works employing the medium of language) and objects which give us the option of treating them either as mere instruments of use, or as embodiments of life forms (we might call these "design" artworks, since their most typical examples are works of architecture).

Note, however, that the broad sense in which representation is conceived in my claim forces me to revise one of my earlier conclusions. When a visual (or aural) work is representational in the broader, rather than narrower, sense, it is no longer true that, as I have previously claimed, the world it evokes must be visual (or aural). The world in such cases is, like a literary world, conceptual, that is, it consists of concepts each of which may, but does not have to, be realized (cashed in) with a variety of images. A heavy peasant dance evoked in a movement of a Bruckner symphony brings to mind concepts ("a peasant dance" and further, more broadly, "a peasant way of life") that may be filled in with most varied images in all sense modalities. Nevertheless, such a world still has the structure of a representation, and not of an argument.

I have claimed that the distinction between the representational worlds of history and art depends on whether their representations portray actual objects or are fictional. Somewhat similarly, the distinction between the argumentative worlds of science and philosophy depends upon a further subdivision of arguments. Both science and philosophy argue, result in beliefs, about the world. But while science aims to produce beliefs about the world as it is, philosophy aims to produce beliefs about the world as it should be.

I realize, of course, that much would have to be said to make this last claim plausible, much more in fact than I could say here without getting hopelessly sidetracked. My conception of philosophy, in particular, is at least as debatable as any other: an ongoing debate about the nature of philosophy is so central to this discipline that one would probably have to include it in any comprehensive definition thereof. Whatever else they do, philosophers also worry about the nature and aims of philosophy. But my purposes will not be served by my entering this particular debate. It will be quite sufficient here to note that arguments about the world as it should be, rather than as it is, are possible and that "philosophy" is the name under which we shall subsume all such arguments here. Two points might be made to defend such usage. First, the question, How should we live? was crucially important to the discipline's founding fathers, much more so than the epistemological questions which took center stage with Descartes, and it was a question about what should be, rather than what is. (Recall Socrates' stating in the *Republic* that his inquiry concerns "the greatest of all things, the good life or the bad life.") Second, to the extent that philosophy has historically

occupied itself also with what is, its scope has been narrowed step-by-step as particular sciences took over its various specific questions. Had philosophy occupied itself only with what is, its eventual demise would have been easy to predict. But questions concerning what should be, rather than what is, will, one hopes, continue to be asked, and these questions cannot be given scientific treatment. "Philosophy" seems to remain the historically best justified name for arguments dealing with questions of this sort.

AESTHETICS II.
THE USES OF ART

Against the art of works of art. —Art is above and before all supposed to
beautify life, thus make *us* ourselves endurable, if possible pleasing to
others: with this task in view it restrains us and keeps us within bounds,
creates social forms, imposes on the unmannerly rules of decency, clean-
liness, politeness, of speaking and staying silent at the proper time. Then,
art is supposed to *conceal* or *reinterpret* everything ugly, those painful,
dreadful, disgusting things which, all efforts notwithstanding, in accord
with the origin of human nature again and again insist on breaking forth:
it is supposed to do so especially in regard to the passions and psychical
fears and torments, and in the case of what is ineluctably or invincibly ugly
to let the *meaning* of the thing shine through. After this great, indeed
immense task of art, what is usually termed art, *that of the work of art,* is
merely an *appendage.*

Friedrich Nietzsche, *Human, All Too Human*

a. The Ethical Life

What I have done thus far was to find places for the most basic kinds of works
(history, art, science, and philosophy) in the grid of world-types. We know now
that both history and art represent worlds, the former actual, the latter fictional
ones, and that both science and philosophy argue about the world, the former
as it is, the latter as it should be. Thus we know now what these various kinds of
works do. The question that still needs to be explored more fully is what their
(and in particular, art's) point is, what the value is of their doing what they do.

An initial answer pertaining to all cultural media was suggested at the outset
in the section "The Media of Culture." I have established there that at bottom
we need the media since, in order to know what to desire and what to avoid, we

need to go beyond immediate awareness, to be able to objectify and store earlier experiences in some way, so that we may recall them in imagination when necessary. The repertory of mediated experiences, those of our own and those of our fellows, allows us to begin to find out what we should want and what we should avoid, to make choices between various objects of our desire and between competing or conflicting desires, to justify our desires and ensuing actions to ourselves and to others, to justify our feelings. Ultimately, the media allow us to deliberate on the question, How should we live?, to choose to the extent that it is possible our actions and passions and to justify our choices.

The extent to which such choices are possible does not seem ever to be fully knowable. That our choices are always limited in some ways by the circumstances is clear. Whether we ever are free to make choices is the subject of an intense centuries-long debate over determinism and free will (or, if you prefer the theological version of the debate, the subject of an equally intense controversy over how to reconcile God's omnipotence with our human responsibility for our own salvation or damnation). Regardless of what the outcome of this debate will be (if it ever has an outcome), it is unlikely to have significant practical consequences: it does not seem to be at all possible to live and act consistently with the conviction that nothing we do is ever the result of our free choice. We seem to have no choice in this matter, but to live and act as if we believed that we can make choices which, although limited in various ways by circumstances, are free in the sense that in choosing to act thus, we believe we could also choose to act otherwise. In other words, regardless of whether the conviction that we are able to make genuine choices, to act thus or otherwise, is metaphysically or otherwise justified or not, it is a necessary conviction: we may deny that we have it, but we cannot live and act consistently with this denial. As Hegel put it, "freedom is just as much a basic determination of the will as weight is a basic determination of bodies."[1] Or again: "The nature of spirit can best be understood if we contrast it with its direct opposite, which is matter. Just as gravity is the substance of matter, so also can it be said that freedom is the substance of spirit."[2] Instead of worrying about the metaphysical underpinning of our freedom, then, we would do better to make practical decisions as to when it makes sense to treat ourselves and others as free and when as determined. We might want, for instance, to treat the grown-up members of a moral community as more responsible for their actions and the children (as we try to educate them into a membership in such a community) as more determined. Similarly, we might want to consider the threat of torture or death a better excuse for a grown-up's wrongdoing than his having been deprived of a proper education or genes as a child. Isaiah Berlin made this point most admirably in his 1954 essay on "Historical Inevitability":

> It may well be that the growth of science and historical knowledge does in fact tend to show—make probable—that much of what was hitherto attributed to the acts of the unfettered wills of individuals can be satisfactorily explained only by the working of other, 'natural', impersonal factors; that we have, in our ignorance or vanity, extended the realm of human freedom much too far. Yet,

the very meaning of such terms as 'cause' and 'inevitable' depends on the possibility of contrasting them with at least their imaginary opposites. . . . Unless we attach some meaning to the notion of free acts, i.e. acts not wholly determined by antecedent events or by the nature and 'dispositional characteristics' of either persons or things, it is difficult to see why we come to distinguish acts to which responsibility is attached from mere segments in a physical, or psychical, or psycho-physical causal chain of events. . . . Yet it is this distinction that underlies our normal attribution of values, in particular the notion that praise and blame can ever be justly (not merely usefully or effectively) given. . . . I do not here wish to say that determinism is necessarily false, only that we neither speak nor think as if it could be true, and that it is difficult, and perhaps beyond our normal powers, to conceive what our picture of the world would be if we seriously believed it.[3]

Rousseau's Savoyard vicar thought similarly:

You will ask me again how I know that there are spontaneous motions. I shall tell you that I know it because I sense it. I want to move my arm, and I move it without this movement's having another immediate cause than my will. It would be vain to try to use reason to destroy this sentiment in me. It is stronger than any evidence. One might just as well try to prove to me that I do not exist.[4]

In short, we have no choice but to make choices. But must we also justify them? Here we do have a choice. We know as a matter of simple empirical moral psychology that our actions are motivated by either passions, or reasons, or a mixture of the two. A life of random choices, each taken at the moment's whim, without any deliberation and justification, is conceivable. But it is useful to be aware of the ethical and political consequences of such a life. A society whose members did not develop the practice of justifying their actions to their fellows would have no mechanism of resolving internal conflicts other than by naked force. The name of the practice of justification is most felicitous, because the essential function of this practice is precisely to provide an alternative to force, a mechanism of resolving conflicts by deliberation conducted under the guidance of the idea of justice (fairness, impartiality). But there seems to be no way of justifying either choice we make between the two fundamental forms of social life, the life of random choices or the life of justified choices. Much as we habitual writers and readers might think that the latter form of life is obviously preferable, we could not convince someone like Nietzsche in his least attractive moments not to value unfettered expressions of instinctual vitality above all else. The choice we make between the two fundamental forms of social life is itself unjustified. The best we can do is to be aware of what each choice implies, that is, to spell out in as much detail as possible the actual and likely consequences of either form of life and to make invidious comparisons between them. But in any case, the fact that we cannot really justify the life of justified choices makes no practical difference whatsoever: once we feel the need to justify such a life, we have already implicitly made the choice in its favor.

Once we see the benefits that the practice of justification brings and acquire

a taste for it, we are likely to broaden its scope. We will deliberate not only on cases when wills clash, but on all our central aims and means, wanting to justify them, to offer reasons for them, to ourselves and our fellows. That is, we will want to convince ourselves and others not only that we want something and are going to get it in a particular way, but also that we have reasons that justify our wanting it and our method of getting it. Moreover, we will deliberate under the guidance of not only justice, but also many other relevant virtues. After all, in any particular case, our aims and means may satisfy the requirements of justice, but be otherwise worthless. Justice is the essential indispensable bedrock virtue (Plato made it appropriately the subject of his most sustained inquiry in the *Republic,* one of the truly foundational books of our culture), but it offers guidance only in cases of conflict. We need to act in accordance with a number of virtues if we are to fill our lives with an ethically justifiable content. Again, we know as a matter of simple empirical moral psychology that our actions are motivated either by passions, or reasons, or both, and that when we are motivated by reasons, we justify our actions, to ourselves and to others, not only with reference to common interest (justice, fairness, impartiality), but also with reference to self-interest. (We also know that, even when convinced that common interest should override self-interest, all too often we misrepresent our motives, to others or to ourselves, consciously or not, by claiming to be motivated by justice when in fact we serve either self-interest or passion. But this complication need not detain us here.)

Virtues by themselves will not provide us with worthy aims: our aims are born at the crossroads between our natural capacities and contingent circumstances. But virtues allow us to evaluate our aims and means. While, as we have seen a moment ago, we do not really need to justify the practice of justifying actions, we do need to have at least a general sense of how such a practice might actually work. (It will quickly become obvious that my, admittedly very simplified, account of the practice of justification is largely derived from Aristotle, whose *Nicomachean Ethics* seems to me, as to a number of other recent writers—Hans-Georg Gadamer, Alasdair MacIntyre, Martha C. Nussbaum, and Roger Scruton in particular come to mind—still the best guide to these matters.[5] It is not that Aristotle's system of virtues is necessarily anything more than a historically and culturally contingent code of behavior suitable for an Athenian citizen. It is rather that Aristotle provides us with an account of how to think about justifying actions which works regardless of any specific ethical code we might want to adopt and which is more plausible than other available accounts.)

An action can be praised or blamed only when it is voluntary, that is, freely chosen, not done under compulsion or in ignorance of the circumstances. According to Aristotle, "on voluntary passions and actions praise and blame are bestowed, on those that are involuntary pardon, and sometimes also pity. . . . Those things . . . are thought involuntary, which take place under compulsion or owing to ignorance."[6] This implies that the action is a result of a deliberation: "choice involves a rational principle and thought."[7] And further: "so that since

moral virtue is a state of character concerned with choice, and choice is deliberate desire, therefore both the reasoning must be true and the desire right, if the choice is to be good, and the latter must pursue just what the former asserts."[8] We justify a particular action by claiming that it exemplifies some general principle of action that, for some reason, we find binding, obligatory, proper for people like us to follow. The intellectual virtue of practical wisdom (*phronesis*) is what we need in order to apply general principles to particular situations.

But how can we ever subsume actions under principles? A bodily movement by itself is not an action. It constitutes an action only when it serves an agent's purpose. (Thus, I understand the peculiar movements of your hand as an action when I realize that you intend to scratch yourself.) It is precisely because an action serves the agent's purpose that it may be seen to embody a general principle (whether the principle is made explicit or not) the form of which might be something like this: "Given the circumstances *x,* it is good to (or: we should) do *y.*" (Say, "if it itches, scratch," or, more to the point, "if offended, avenge yourself," or "if offended, turn the other cheek.") When the principle of an action is made explicit, one can assess whether one has succeeded or failed to do not only what one intended to do, but also what one should have done.

Aristotle's way of making this point is to say that an action is justifiable when it can be shown that its principle is in accordance with an ethical virtue (such as justice, courage, temperance, liberality, and others). A virtue is a learned skill or excellence, an acquired and permanent good disposition of character (*ethos*), exhibited in the exercise of one of our capacities. (As Aristotle explains, "we are adapted by nature to receive them [virtues], and are made perfect by habit." And further: "the virtues we get by first exercising them, as also happens in the case of the arts as well. For the things we have to learn before we can do them, we learn by doing them."[9] Again, "states of character arise out of like activities. . . . It makes no small difference, then, whether we form habits of one kind or of another from our very youth; it makes a very great difference, or rather *all* the difference."[10] Again, "we must take as a sign of states of character the pleasure or pain that ensues on acts . . . Hence we ought to have been brought up in a particular way from our very youth, as Plato says, so as both to delight in and to be pained by the things that we ought."[11]) A justifiable course of action is one that a virtuous person, a person of good character, would take, given appropriate circumstances. ("Actions . . . are called just and temperate when they are such as the just or the temperate man would do; but it is not the man who does these that is just and temperate, but the man who also does them *as* just and temperate men do them."[12]) MacIntyre summarizes Aristotle's view of practical reasoning as follows:

> There are first of all the wants and goals of the agent, presupposed by but not expressed in, his reasoning. . . . The second element is the major premise, an assertion to the effect that doing or having or seeking such-and-such is the type of thing that is good for or needed by a so-and-so. . . . The third element is the minor premise wherein the agent, relying on a perceptual judgment, asserts

that this is an instance or occasion of the requisite kind. The conclusion . . . is the action.[13]

But whence do ethical principles (the "major premises" above) derive their authority, why do we find them compelling, binding, obligatory, proper for people like us to follow? Thinkers of the Enlightenment assumed that there were two competing sources of authority of universally binding ethical principles, religious tradition based on divine revelation, and philosophical speculation based on either conscience or reason. According to the Savoyard vicar, I find the principles of conduct

> written by nature with ineffaceable characters in the depth of my heart. I have only to consult myself about what I want to do. Everything I sense to be good is good; everything I sense to be bad is bad. The best of all casuists is the conscience.[14]

And further:

> There is in the depths of souls, then, an innate principle of justice and virtue according to which, in spite of our own maxims, we judge our actions and those of others as good or bad. It is to this principle that I give the name *conscience*.[15]

In the vicar's celebrated formula, God has given me conscience so that I may love the good, reason so that I may know it, and liberty so that I may choose it.[16]

The vicar's view continues to find its adherents today. Colin McGinn has recently argued, following Russell, that judgements of ethics, no less than those of logic or mathematics, are immediate and a priori, that our knowledge of ethical truth is natural, spontaneous, innate, just as, according to Chomsky, our knowledge of grammar is.[17] For McGinn,

> ethical knowledge does not rely upon induction or abduction. . . . We believe it to be a law that bodies accelerate uniformly as they fall to earth on the basis of induction from past confirming instances, but we do not believe the 'law' that stealing is wrong by observing past confirming instances and then projecting to the future. For we do not *need* to rely on any such induction in the ethical case; we know that stealing is wrong just by knowing what stealing is.[18]

Furthermore, "the plain fact is that there are many things that are obviously morally wrong—murder, torture, theft, betrayal—and anyone who disagrees about these is either dishonest or confused."[19] McGinn may err, however, in his claim that while the truth of a belief about nature is coercive ("we are not free to believe whatever we like about nature, not if we want to thrive"), the truth of an ethical belief is not, because "moral facts do not have causal powers."[20] I suspect, rather, that we are not free to believe whatever we like about ethics either if we want to thrive. Think how intolerable a world would be in which ethical truths (such as those proclaiming the value of truth-saying, promise-keeping, or benevolence, to say nothing of respect for the life and property of another) were

systematically violated and denied and you will readily see that such truths are no less pragmatically coercive than the scientific ones.

It is important to notice, however, that the voice of conscience is much better at telling me what not to do than at telling me what to do. More precisely, it can tell me only what to do, and especially what not to do, in a given situation in which I already find myself. Remember that, according to Rousseau's vicar, I first want to do something and only then consult my conscience to see whether or not what I want is good. Conscience is of much less help when I decide on the kind of life I want to live, the sort of general aims I wish to pursue.

From this standpoint, the Enlightenment's second alternative to religion, the voice of reason, is, if anything, even less helpful. Kant's philosophy, in particular, represented the most ambitious attempt to provide the moderns with universally binding moral principles rooted in reason alone and thus to make the modern moral agent autonomous, free, answerable to no external authority. Kant believed he had found the ultimate principle of morals, one that should be binding on every rational will and with which every other moral principle should accord, in the categorical imperative, which requires of us in one formulation that we treat each human being never only as a means but always also as an end, and in another that we act on principles we can will to be universal laws.

It would be difficult not to feel sympathy with the recommendation that we try to respect the freedom of others and not treat them as machines and that we try to apply to our own behavior the same standards we apply to the behavior of everyone else. But it is equally difficult to avoid the impression that in a sense these recommendations are quite empty of actual content. Kant's categorical imperative can provide us with no concrete aims to pursue and no concrete principles to follow. At most, it might seem to set limits to our actions by providing us with a way of testing our principles. In fact, however, it is not certain that it does even that much, especially in its second formulation (which says that one must be able to will without contradiction that the principle will be universally followed). As many commentators beginning with Hegel claimed, it is difficult to find an action the principle of which one could not will to be a universal law, since one can always describe one's action so that the proposed principle will allow the action while not allowing others to do anything that would make the principle self-contradictory if universalized.[21] A guard in a concentration camp could perform his duties with the comforting conviction that his actions, being legal, were consistent with the categorical imperative. And even the first formulation of the categorical imperative offers a far from foolproof test, since a slave-owner can easily persuade himself that slaves are not quite human. (As an ordinary member of the German *Ordnungspolizei* that helped the Nazi genocide in occupied Poland so disarmingly put it: "The Jew was not acknowledged by us to be a human being."[22]) In Hegel's words,

> however essential it may be to emphasize the pure and unconditional self-determination of the will as the root of duty—for knowledge of the will first

gained a firm foundation and point of departure in the philosophy of Kant, through the thought of its infinite autonomy—to cling on to a merely moral point of view without making the transition to the concept of ethics reduces this gain to an *empty formalism,* and moral science to an empty rhetoric of *duty for duty's sake.* From this point of view, no immanent theory of duties is possible. One may indeed bring in material *from outside* and thereby arrive at *particular* duties, but it is impossible to make the transition to the determination of particular duties from the above determination of duty as *absence of contradiction,* as *formal correspondence with itself,* which is no different from the specification of *abstract indeterminacy;* and even if such a particular content for action is taken into consideration, there is no criterion within that principle for deciding whether or not this content is a duty. On the contrary, it is possible to justify any wrong or immoral mode of action by this means. . . . The fact that *no property* is present is in itself no more contradictory than is the nonexistence of this or that individual people, family, etc., or the complete *absence of human life.* But if it is already established and presupposed that property and human life should exist and be respected, then it is a contradiction to commit theft or murder; a contradiction must be a contradiction with something, that is, with a content which is already fundamentally present as an established principle.[23]

Hegel's own (and, to my mind, persuasive) view was that only the actual practices and institutions of our own society can give concrete content to our duty, which is to say that our duty is to engage in the perfecting of some of the practices of our society and to take care of the institutions that make these practices possible. This does not mean that we can never criticize the existing practices and institutions. If it did, how could we ever improve them, and how could we demand social or political change when confronted with tyrannical and unjust practices and institutions? It is here that conscience and maybe even Kant's categorical imperative can perhaps be useful after all, providing us with criteria, however fallible, by which we might judge our practices and institutions, say, whether they are consistent with the requirements of reason that the freedoms and rights of each person must be respected, and that our practices and institutions must be subject to laws that treat every individual alike. But while we may and should criticize and change some of our society's practices and institutions, we should recognize that we do not create those *ex nihilo,* but, rather, inherit them, and that only such inherited, ongoing structures can give rise to any concrete ethical and political principles of action. A withdrawal from the practices and institutions of our society makes sense only in, one hopes, exceptional circumstances, such as those of totalitarian tyranny. To hear Hegel again,

in the shapes which it more commonly assumes in history (as in the case of Socrates, the Stoics, etc.), the tendency to look *inwards* into the self and to know and determine from within the self what is right and good appears in epochs when what is recognized as right and good in actuality and custom is unable to satisfy the better will. When the existing world of freedom has become unfaithful to the better will, this will no longer finds itself in the duties

recognized in this world and must seek to recover in ideal inwardness alone that harmony which it has lost in actuality. . . . Only in ages when the actual world is a hollow, spiritless, and unsettled existence may the individual be permitted to flee from actuality and retreat into his inner life.[24]

And if we agree with Rousseau's and Kant's critics and find the voice of conscience and the categorical imperative useless not only as generators of principles, but even as a test of principles generated by other means, what then? If we can neither accept the claims of revealed religion nor be guided by conscience or reason alone, if we reject the universalist pretensions of both Christianity and the Enlightenment, what else is left? Even before Hegel's critique, Kant's younger contemporary, Johann Gottfried Herder, in his *Ideen zur Philosophie der Geschichte der Menschheit* (1784–91) provided widely heard arguments in favor of the belief that each historical community develops principles of action that are uniquely its own, that in part at least define its individuality, and that should be respected and cherished for this very reason. For Herder, principles derive their authority from nothing more than the tradition of the community whose ethical life they govern. Significantly, his vision incorporates an awareness of a plurality of valid communal traditions coexisting and competing with one another.

Some form of Herderian Romanticism may be the only way available to us, secular children of post-Enlightenment Europe. If a plurality of intersecting, contingent, historically evolving communal traditions is all we have, and if no independent (God's or philosopher's) point of view from which these traditions might be evaluated is available to us, we have no choice but to be ethnocentric and little choice but to be open-minded. We have to be ethnocentric, because we cannot step outside all particular traditions; we can evaluate them, our own included, only from the standpoint where we already find ourselves. But the awareness that there are many traditions and that they are all equally contingent urges us to keep our minds open. We can then evaluate principles evolved by others and by our own ancestors from the standpoint of the best overall vision of desirable life we have been able to develop thus far and thus allow our tradition to evolve further. "Practical reasoning," writes Charles Taylor, ". . . aims to establish, not that some position is correct absolutely, but rather that some position is superior to some other. . . . The rational proof consists in showing that this transition [from one position to another] is an error-reducing one."[25] Traditions, as both Gadamer and MacIntyre stressed, are not something fixed and closed: "when a tradition is in good order it is always partially constituted by an argument about the goods the pursuit of which gives to that tradition its particular point and purpose. . . . A living tradition . . . is an historically extended, socially embodied argument, and an argument precisely in part about the goods which constitute that tradition."[26]

Thus we can criticize and refine our principles of action in a communal enterprise involving a dialogue with other communities as well as practical experiment, trial and error. As Nietzsche knew, "objectivity" should be

understood not as 'contemplation without interest' (which is a nonsensical absurdity), but as the ability *to control* one's Pro and Con and to dispose of them, so that one knows how to employ a *variety* of perspectives and affective interpretations in the service of knowledge. Henceforth, my dear philosophers, let us be on guard against the dangerous old conceptual fiction that posited a 'pure, will-less, painless, timeless knowing subject'; let us be on guard against the snares of such contradictory concepts as 'pure reason,' 'absolute spirituality,' 'knowledge in itself': these always demand that we should think of an eye that is completely unthinkable, an eye turned in no particular direction. . . . There is *only* a perspective seeing, *only* a perspective 'knowing'; and the *more* affects we allow to speak about one thing, the *more* eyes, different eyes, we can use to observe one thing, the more complete will our 'concept' of this thing, our 'objectivity' be.[27]

In learning how to justify our actions, we may simultaneously learn how to justify our passions. That passions can be justified, that reasons can be offered for having them, or for changing them, may come as a surprise to those who have been taught by Plato that passions are entirely irrational. But Aristotle is a much more profound teacher in this matter also. In his unsurpassed account of emotions (*Rhetoric,* book 2, chapters 1–11), Aristotle pointed out that each emotion can be analyzed into three components. There is, first, what might be called the component of sensation, the way it feels to be in a particular emotional state, the painful or pleasurable state of mind of the person affected by the emotion. There is, second, what might be anachronistically called the intentional object of the emotion or, as Aristotle puts it, the people toward whom the emotion is felt. And finally, there are also the grounds on which the emotion is felt, that is, precisely, the reasons that justify our feeling it. Take, for instance, Aristotle's first example, anger. First, the philosopher tells us, anger is accompanied by a painful sensation. Second, it is felt towards people who have conspicuously and without justification slighted us or our friends. Third, our feeling angry is justified when the people we feel angry with have indeed conspicuously and without justification slighted us or our friends. Now, slighting is a voluntary act. If, feeling angry with some people, we learn that we were mistaken about the matter, that their actions did not have the intention of slighting us, we lose the grounds for the emotion and we have every reason to change our feelings, to quiet the anger and grow calm. Thus, an emotion can be rationally justified, and it can be modified as a result of an argument. Needless to say, just as we do not really have to justify our actions, we are also not compelled to justify our passions. But once we choose a life of justified actions, we are likely to want to justify our passions too.

In sum, a fully developed ethical life involves not only choosing both the aims and the means of our actions, but also justifying the most important choices, as well as justifying and hence, to the limited extent that it is possible, choosing some of our passions. We justify particular actions (and passions) by showing that they exemplify general principles ("Given the circumstances *x,* it is good to do [or feel] *y*") which derive their authority from the relevant communal traditions

(themselves subject to continuous criticism and revision). The most basic kinds of works identified above—history, art, science, and philosophy—divide among themselves various tasks that together allow us to understand ourselves and our world, to know how we should live, that is, to make precisely the choices an ethical life requires.

b. Art and History

At the very least, we must have a repertory of mediated experiences, a memory of what actually happened, and it is the task of history (in the very broad sense in which this term is understood here) to provide it. (History in the usual, more narrow, sense is memory subjected to scholarly rigor and hence made simultaneously more systematic and more reliable.) By telling us what actually happened to ourselves and to others, history allows us to make the first step beyond our immediate awareness, to compare present and past experiences, and such comparisons are a prerequisite to our being able to make choices that are informed rather than random among the objects of desire and among desires themselves.

History represents men and women acting and suffering in particular circumstances which limit their choices. To be sure, this definition, acceptable though it probably would have been to Thucydides, Gibbon, and Michelet (but perhaps not to Burckhardt), sounds rather old-fashioned today when the most interesting work professional historians have been doing in recent decades has tended to concentrate on, and stress the determining role of, circumstances (natural as well as manmade, that is, circumstances such as geography, climate, demography, economy, social relations and institutions, culture, and others) and when the narration of individual human actions and sufferings has been considered less interesting. There is certainly nothing wrong with this particular emphasis. On the contrary, it accounts for much that is most vital in recent achievements of the discipline. But the more traditional narrative mode of history is unlikely to be eclipsed, or conceded to popular writers, permanently. We need to understand better and better both the circumstances that constrain and delimit our freedom of action, and the ways we actually act in such circumstances. It has been established above that we justify a particular action by claiming that it exemplifies some general principle of action that we have accepted and that may take the form: "Given the circumstances x, it is good to do y." If we are to learn from history, from the comparison of present and past experiences, we need the kind of history that probes both circumstances and actions. Besides, the history of our own century, so crucially shaped by particular decisions made by particular individuals (such as Hitler, Stalin, Churchill, Roosevelt, to stick to just one generation), suggests that we would be unwise to abandon the narrative mode, with its emphasis on acting and suffering individuals, altogether. Tocqueville, as so often, has something sensible to say on this subject:

> Historians who write in aristocratic ages generally attribute everything that happens to the will and character of particular men. . . . Historians who live in

democratic ages show contrary tendencies. Most of them attribute hardly any influence over the destinies of mankind to individuals, or over the fate of a people to the citizens. But they make great general causes responsible for the smallest particular events. . . . I am firmly convinced that even in democratic nations the genius, vices, or virtues of individuals delay or hasten the course of the natural destiny of a people. . . . In all ages some of the happenings in this world are due to very general causes and others depend on very particular influences. These two kinds of causes are always in operation; only their proportion varies. General causes explain more, and particular influences less, in democratic than in aristocratic ages.[28]

More to the point, history in the broadest sense invoked here, that is, history as a memory of what actually happened, includes much more than what professional historians write. It includes journalism and all sorts of informal remembering we all constantly engage in and transmit whether in writing or orally. People who think that history has nothing to teach them simply disregard how much history has already taught them. Our decisions regarding such matters as whether to put our hand into a fire, or to start a war, are potentially wiser when informed by a memory of what happened last time we chose to put our hand into a fire or to start a war.

The impression that history has nothing to teach us results from the fact that history's lessons are difficult to interpret. History teaches by example. Our ability to learn from examples requires being able to move from particular representations to general principles and back. This is clearly a matter of what Aristotle called practical wisdom, a skill more difficult than most to acquire. Like all skills, it requires at least some natural aptitude and plenty of practice. The material a practice of this sort needs consists of the particular examples of our own and our fellows' experiences. Thus, the use of the examples history provides is twofold. First, we may find a particular past experience to be comparable to, and hence to illuminate, our present experience. Second, the very process of understanding historical representations involves bringing particular actions under general principles and hence exercises the skill of practical wisdom. The obvious advantage of using the mediated experiences of others is that we can learn from such experiences without having to suffer their consequences. Thus we may learn from history without having to live thereafter with burned fingers or bombed-out cities.

But our repertory of mediated experiences does not have to be limited only to a record of what actually happened. We know already that we can encode in our media not only actual, but also fictional experiences. We know that media users can be true creators, not only recreators of experience, that they can use the media not only to record what actually happened, but also to envisage new possibilities, new, as yet not actualized, events. Thus I can not only represent, but also, to a certain extent at least, invent myself and the world. This is precisely what art does: "there is a profounder sense in which the historian's activity is an artistic one," writes Isaiah Berlin.[29] Croce, similarly, claimed that "historicity is not form but content: as form, it is nothing but intuition or aesthetic fact."[30]

As will become clear in chapters 4 and 5, the content of the worlds represented by history and art is similar, in that both represent men and women acting and suffering in particular circumstances which limit their choices. But by contrast with history, art represents not actual, but fictional worlds. Like history, art allows us to step beyond our immediate awareness, to compare the present experience with the experiences stored in it. And like history, art teaches by example. No matter how abstract or fantastic, fictions of art are sufficiently like the actual world to be usable in the same fashion historical representations are, provided we have the wish and sufficient skill so to use them. But instead of telling us what actually happened to ourselves and to others, art tells us what fictionally happened to people like us (and all people, actual and fictional, are, by definition, to some extent like us) and hence also what, given certain circumstances, might happen to us.

As was the case with history, there are people who assert that art, too, has nothing to teach us. It is difficult not to sympathize with their motives in a century loud with demands, not infrequently enforced by the full power of the state, that art serve political or moral aims, a century during which, repeatedly, a significant part of the intellectual opinion in the West has given and continues to give active support to politically driven philistinism. But, again, those who claim that art has nothing to teach them ignore how much they, together with all of us, have already learned from it.

Art, in the very broad sense in which the term has been used here, is after all much more than just Rembrandt and Beethoven and Dante. In all societies, premodern and modern, European and non-European, art has always been all-pervasive. From our early childhood on, we are constantly surrounded by visually, aurally, and verbally produced images of fictional experiences. What is perhaps even more significant, we not only passively receive such images, but actively and constantly produce them, drawing pictures, singing songs, telling stories and jokes, fantasizing. There is a continuum between these mundane everyday activities and those of Rembrandt and Beethoven and Dante, between the "naive" art of the amateurs and the "sentimental" art of the professionals, if I may be allowed this rather free adaptation from Schiller. It would be unrealistic to suppose that all these images of fictional experiences play no role whatsoever in the channeling of our desires and aversions, particularly in younger years. Just think how much we learn about who we are and what we want by imagining ourselves in various situations, especially once we learn to reflect on our imaginings and to interpret them in the light of our frequently hidden motives. Advertising agencies know better than our sceptics, and so did Plato when he claimed that old wives' tales should be taken seriously as a component of the education of the young and even subjected to censorship, advice we still take seriously in our individual and social practices and in discussions about what we should allow our children to see and hear.[31]

Aristotle provided us with an explanation of the educational power of representations:

Besides, when men hear imitations, even apart from the rhythms and tunes themselves, their feelings move in sympathy. Since . . . virtue consists in rejoicing and loving and hating aright, there is clearly nothing which we are so much concerned to acquire and to cultivate as the power of forming right judgments, and of taking delight in good dispositions and noble actions. . . . The habit of feeling pleasure or pain at mere representations is not far removed from the same feeling about realities.[32]

More recently, Roger Scruton has stressed the role of art in the education of feeling:

A man who declares that his tender feelings have been awoken by the child he sees in the picture is at odds with himself when he shows himself unable to feel tenderness towards a real child. Thus . . . we may . . . test the sincerity of his remark through his subsequent behavior. . . . What I feel in the presence of works of art may find its ultimate expression in my behaviour towards my fellows.[33]

Representations, whether of actual or fictional worlds, teach us to feel aright, to rejoice or grieve, to bestow praise or blame, when appropriate, so that we might feel aright also when confronted with the real world. "[O]ne of the oldest functions of art," writes Paul Ricoeur, is "that it constitutes an ethical laboratory where the artist pursues through the mode of fiction experimentation with values."[34] Art's great advantage over history in the economy of our ethical life is that it allows us to go beyond the actual, to make imaginative experiments, and thus to broaden immeasurably our repertory of mediated experience. It is in this sense that art allows us to create ourselves. Thanks to art, in learning from particular examples we are not limited to what actually happened, we may anticipate and invent. And we may do so at a relatively low cost, since, when something goes wrong, imaginative experiments involving fictional characters do much less damage than experiments with real people. We may learn from fictional experience the same way we may learn from actual experience, without having to suffer the consequences of actual experience.

Thus, to the extent, and the way, that we learn from history, we also learn from art, but where the examples of history have the weight and solidity of the actual world as it is, the examples of art allow us to imagine the world that never was, but that might and perhaps even should, or should not, be. Without history, our choices would be deprived of a hard reality test. Without art, they would be unimaginative and uninventive; they would reproduce traditional modes of acting, rather than opening up new ways. We clearly need both. Art has an essentially utopian dimension: it is about the world that is not. If we want to do more than simply perpetuate the world as it is (in itself, not a mean, and increasingly difficult, task), if we want to improve the world, to bring it more in line with what it should be, the examples produced by the imaginative experiments of art are indispensable. In short, both history and art provide us with representations of particular experiences which we may use to illuminate our own experiences and

to hone our skill of practical wisdom. But where the examples of history allow us to confront our experiences with the world as it is, those of art confront us with the world as it might be. Thus, the former encourage us to take or avoid roads taken in the past, the latter to try or not try something new.

Stendhal famously claimed that "beauty is only the promise of happiness," a phrase that for good reason captivated both Baudelaire and Nietzsche.[35] (In the bleak twentieth century, this became Péter Nádas's "beauty is the advance payment on desire."[36]) The reason Stendhal sounds exactly right is that we tend to call beautiful those artistic worlds in which we think we would feel at home. It is the world as it should be that is beautiful. But it is important to keep in mind that not all art is, or need be, beautiful, that beauty is only one of many goals an artist might want to pursue.

Thus far I have been stressing art's utopian dimension. But it should not be overlooked that fictions of art have another equally important and closely related dimension. They serve not only to invent alternatives to, but also to illuminate, the actual world. Just as we may apply art's examples to our own experiences, we may apply them to the larger historical experience of our world. In both cases, fictions may throw light on the actual. Art's advantage over history in this task is that, not bound by all the contingent features of what actually happened, it can represent only what is of the essence in particular actions and circumstances. It can thus make the essential meaning of the actual more clearly apparent in its representations than honest and detailed history might. One would not want to substitute Stendhal's account of the battle of Waterloo, or Proust's of the Drey-fus affair, for works of historical scholarship, but the novelists' accounts captured something essential about these events with particular clarity and force and are likely to continue to shape our imagining and understanding them as powerfully as any work of history.

The aim of an artist, argued Baudelaire, was to extract the poetry from mere fashion, the eternal from the transitory.[37] It is for similar reasons that Aristotle thought poetry was more philosophical than history, more philosophical precisely in the sense of being less bound to the contingent, of allowing the essential to shine forth more clearly:

> The distinction between historian and poet . . . consists really in this, that the one describes the thing that has been, and the other a kind of thing that might be. Hence poetry is something more philosophic and of graver import than history, since its statements are of the nature rather of universals, whereas those of history are singulars. By a universal statement I mean one as to what such or such a kind of man will probably do or necessarily say or do—which is the aim of poetry, though it affixes proper names to the characters; by a singular statement, one as to what, say, Alcibiades did or had done to him.[38]

Heidegger approved ("Aristotle's words in the *Poetics,* although they have scarcely been pondered, are still valid—that poetic composition is truer than exploration of beings"[39]) and so did Hegel:

> Neither can the representations of art be called a deceptive appearance in comparison with the truer representations of historiography. For the latter['s] ... content remains burdened with the entire contingency of ordinary life and its events, complications, and individualities, whereas the work of art brings before us the eternal powers that govern history without this appendage of the immediate sensuous present and its unstable appearance.[40]

To be sure, for Hegel, already the representations of historiography, when truly successful, are less burdened with the contingency of ordinary life, and hence are more philosophic in Aristotle's sense, than the actual experience itself:

> a truly artistic historian ... sketches for us a picture that is far higher and truer than any we could gain by ourselves as eye-witnesses. Reality is overburdened with appearance as such, with accidental and incidental things, so that often we cannot see the wood for the trees. ... It is their indwelling sense and spirit which alone makes events into great actions, and these are given to us by a genuinely historical portrayal which does not accept what is purely external and reveals only that in which the inner spirit is vividly unfolded.[41]

The last word here should perhaps be given to Hamlet, who said more or less all that needs to be said on the historical dimension of art when he instructed his players on "the purpose of playing, whose end, both at the first and now, was and is, to hold, as 'twere, the mirror up to nature; to show virtue her own feature, scorn her own image, and the very age and body of the time his form and pressure."[42] Or, in Richard Rorty's modern translation: "To every age, its own glory and its own stupidity. The job of the novelist is to keep us up to date on both."[43]

c. Art and Philosophy

But while the representations of history and art are indispensable tools of the ethical life of justified choices, they are not sufficient for such a life; equally necessary are the arguments of science and philosophy. We have seen that history and art allow us to make the first steps beyond immediate awareness, to compare real experiences with actual and fictional imaginary ones, and we have seen that such comparisons are a prerequisite to our being able to make choices among the objects of desire and among desires themselves. Comparisons of this sort help us to make choices, ultimately because we learn from them about the necessary or probable consequences of a particular course of action. Already in comparing real and imaginary experiences we move beyond pure representations and operate not only with images, but also with concepts: a concept enables us to bring together diverse images and hence also to compare them. But to be able to lead the life of justified choices we need more. As we have seen, we justify a particular action by claiming that it exemplifies some general principle, the form of which might be: "Given circumstances x, do (that is, a good man would do) y." This cannot be done so long as we operate with images alone, or even with images and concepts. What is needed, in addition, is argumentative logic

linking the concepts in a course of reasoning aimed at demonstrating the truth of a belief expressed in a given principle. Specifically, we need to derive general principles from particular instances (whether by inductive logic or, if Popper's view that "the logic of scientific discovery" does not rely on induction is correct, by the Popperian hypothetical-deductive method: the creative formation of imaginative hypotheses followed by the deductive derivation of falsifying instances and the empirical search for such instances), and we need deductive logic to derive conclusions concerning particular instances from general principles.

In short, it is the role of images (imaginary experiences) to provide us with material to compare with real experiences. It is the role of general concepts under which particular images are brought to provide us with a mechanism to make such comparisons of experiences with images possible. It is the role of arguments to produce true beliefs about general principles of action and about particular actions. And it is the role of practical wisdom to allow us to subsume particular actions under general principles.

The production of arguments resulting in true beliefs about what is and about what should be is, as we have seen, the job of science and philosophy, respectively. Of the two, science provides our thinking about action with a reality test, tells us what is and what is not possible for us to do. (Indirectly it, of course, also provides us with technological tools that enable us to do what is possible.) But what it cannot do is tell us which of the roads open to us we should actually take. This is the task of philosophy in the admittedly peculiar sense in which the term is understood here.

The respective roles of science and philosophy run parallel to those of history and art. One might say that history and science share their aim (to capture the world as it is), but differ in the means they employ (representations and arguments, respectively). Similarly, art and philosophy have a common aim (to tell us about the world as it should be, as well as is) but diverse means (again, representations and arguments, respectively). Thus, on our grid, art intersects with both history (with which it shares the means, but not the aim) and philosophy (with which it shares the aim, but not the means). A fully developed ethical life of justified actions and passions clearly requires all four kinds of works. Since we justify particular actions (and passions) by showing that they exemplify general principles, we need to represent and to argue about the world as it is and as it should be in order to develop a repertory of general principles and the ability to apply them to particular instances. Without representations, we would lack the material of particular instances from which to derive general principles. Without arguments, we would lack the ability to move back and forth between particular instances and general principles. Without specifically artistic representations, we would lack the ability to chart new roads ahead. Without specifically philosophical arguments, we would lack the ability to decide whether such roads should or should not be taken.

If it is the (or, at least, a) task of philosophy as this term is understood here to derive general principles of action (and passion) from particular instances

(actions, experiences), to formulate and support our ethical and political norms, how does it accomplish this task, what is the logic of its arguments? Whatever the specific logic of scientific inquiry is, it may well involve such steps as the inductive comparing of representations, the formation of hypotheses, the deductive derivation of falsifying instances, and the empirical search for such instances. Some such steps may also be involved in a philosophical argument, but they cannot suffice. Amassing similar instances and inductively deriving from them general principles can yield knowledge about what is likely to happen given such and such circumstances, but it can never produce beliefs about what should happen. Someone who does not know how to swim will quickly learn from experience that he is likely to drown in deep water, and hence that, to avoid drowning, he should either learn how to swim or avoid getting into deep water. But no amount of experience and inductive reasoning can produce the conviction that one should avoid drowning. Similarly, it is easy to see how one might go about trying to falsify a belief like, "If you do not want to drown and do not know how to swim, avoid getting into deep water." But it is not obvious how one might try to falsify a belief like, "Under no circumstances, should you want to drown."

But this is not to say, as philosophers at least since the eighteenth century often have, that we cannot derive "ought" from "is," quite the contrary. How, then, is "ought" derived? What is involved in producing beliefs like, "In the circumstances x, a good man should do y"? It is important to keep in mind that, in moral reasoning, we never begin with a blank page. We are always already moral agents, long before we begin to philosophize. We do not have the luxury of waiting to act until we have had a chance to develop a fully explicit and coherent system of moral and political norms. In ethical life, as elsewhere, practice precedes theory. By the time we begin to make our first attempts at explicitly formulating our ethical principles, we are already in some way in possession of a great many of them, as well as in possession of an overall vision, however inchoate and provisional, of a life worth living. MacIntyre, in his developing of an Aristotelian way of thinking about ethical life, is right to stress that moral virtues are embodied in social practices.[44] "A virtue is an acquired human quality the possession and exercise of which tends to enable us to achieve those goods which are internal to practices and the lack of which effectively prevents us from achieving any such goods," is MacIntyre's "partial and tentative definition."[45] As Aristotle stressed, we develop virtues not by hearing someone persuasively preach them to us, but rather by learning how to take part in the practices in which such virtues find their place.[46] It is only by engaging in practices that we acquire a fund of knowledge about what a "good man" (a good monk or soldier, pianist or scientist, father or citizen) does in given circumstances. Philosophy attempts to make this implicit knowledge explicit.

This does not mean, as some might suppose, that we are always condemned to adopt already existing practices and norms and can never criticize or extend them. It means only that we cannot criticize them from an impartial, neutral point of view, a standpoint that presupposes nothing, no social practices, institutions,

or traditions. Such a standpoint, God's standpoint, is not available to us humans. But practices do not exist in isolation. In a society of any complexity, there are always a great many of them already going on all at once. Sooner or later, we discover that we cannot take part in all of them, though we need not limit ourselves to just one. We also discover that, in Max Weber's words, "the various value spheres of the world stand in irreconcilable conflict with each other."[47] If we are to acquire any virtues at all, we need to make a long-range commitment to some practices, but by committing ourselves to one set of practices rather than another, we commit ourselves to an overall vision of life we want to have and we realize that our choice is irreconcilable with other such possible overall attitudes toward life. We can then subject all sort of practices to a critique from the standpoint of this ultimate attitude toward life that we have adopted. In this way we discover that the activities of a soldier, or a stockbroker, are inappropriate for most monks. Moreover, in addition to this external critique, we can also subject any practice to an internal critique by clarifying its aims, identifying more clearly the goods it seeks to produce, and thus improving it by making it more coherent and self-perspicacious.

But a commitment to this rather than that way of life can never be the result of a compelling argument. Alternatives are always possible. You may think that a diminution of human suffering and misery is a worthy aim of political action, but there is no way of convincing someone who does not see it (or of falsifying your belief). Argument can be usefully employed, however, to demonstrate that a particular practice or action is consistent or not with a particular vision of life. It also finds its use in our imagining the likely consequences of various visions and making invidious comparisons among weltanschauungen. In short, theories about how we should live cannot be proven or falsified. All we can really do in defending such theories once we have ascertained that they are internally coherent is to show in as much detail as we can their likely consequences and to make comparisons among competing visions.

All of this suggests that moral and political philosophy is a kind of a social theory.[48] It cannot be profitably conducted in a platonic vacuum of pure ideas. Rather, it presupposes a rich context of social practices, institutions, traditions. Its aim is to make explicit, criticize, and improve the norms that govern our already ongoing practices. What it cannot do effectively is to produce ethical and political principles in abstraction from any ethical and political practices and institutions. At least some, though not necessarily all, of these practices and institutions must be actual present and past practices and institutions of our own and of other societies. Some may also be fictional, envisioned, but not realized, utopian possibilities. (By the way, if on this account philosophy is a social theory, a theory of social practices, we may extend its realm to include not only moral and political, but also other kinds of practices, including those of historians, artists, scientists, and philosophers themselves. The scope of philosophy would include, then, in addition to theories of ethics and politics, theories of history, art, science, and philosophy itself.)

An important consequence is that, in our terms, the arguments of philosophy cannot exist in isolation from the representations of history and art. Without representations, arguments are empty; without arguments, representations are blind. We have to represent our practices if we want to have anything to argue about at all. And for reasons already brought forward, some of our representations may be of fictional rather than actual practices. This suggests that Hegel's thesis of the end of art cannot simply be sustained and needs to be reexamined.

Hegel's famous conclusion that "art, considered in its highest vocation, is and remains for us a thing of the past"[49] is so often misunderstood that we need to take a close look at the passage that precedes it:

> But while on the one hand we give this high position to art, it is on the other hand just as necessary to remember that neither in content nor in form is art the highest and absolute mode of bringing to our minds the true interests of the spirit. For precisely on account of its form, art is limited to a specific content. Only one sphere and stage of truth is capable of being represented in the element of art. In order to be a genuine content for art, such truth must in virtue of its own specific character be able to go forth into [the sphere of] sense and remain adequate to itself there. This is the case, for example, with the gods of Greece. On the other hand, there is a deeper comprehension of truth which is no longer so akin and friendly to sense as to be capable of appropriate adoption and expression in this medium. The Christian view of truth is of this kind, and, above all, the spirit of our world today, or, more particularly, of our religion and the development of our reason, appears as beyond the stage at which art is the supreme mode of our knowledge of the Absolute. The peculiar nature of artistic production and of works of art no longer fills our highest need.[50]

And further:

> [A]rt no longer affords that satisfaction of spiritual needs which earlier ages and nations sought in it, and found in it alone, a satisfaction that, at least on the part of religion, was most intimately linked with art. The beautiful days of Greek art, like the golden age of the later Middle Ages, are gone. The development of reflection in our life today has made it a need of ours, in relation both to our will and judgement, to cling to general considerations and to regulate the particular by them, with the result that universal forms, laws, duties, rights, maxims, prevail as determining reasons and are the chief regulator. But for artistic interest and production we demand in general rather a quality of life in which the universal is not present in the form of law and maxim, but which gives the impression of being one with the senses and the feelings, just as the universal and the rational is contained in the imagination by being brought into unity with a concrete sensuous appearance. Consequently the conditions of our present time are not favourable to art.[51]

For Hegel, the reason why "art, considered in its highest vocation" (that is, as a "mode of bringing to our minds the true interests of the spirit"), "is and remains for us a thing of the past" is that, in my terms, art makes use of representations rather than arguments. Sensuous images of myth and, above all, sculp-

ture, may have been sufficient adequately to embody the most fundamental beliefs that guided a citizen of the ancient Athenian *polis*. A citizen of a modern European state, however, judges and acts on the basis of beliefs that can no longer be embodied in images alone, but rather require concepts and arguments for their proper expression, that is, he judges and acts on general principles ("universal forms, laws, duties, rights, maxims") and not particular images. Hence, in the modern world the arguments of philosophy and not the representations of art bring to our minds "the true interests of the spirit" in their most developed and most perspicacious form.

Ours is a world, says Hegel, "where the essence of ethical life, i.e. justice and its rational freedom, has already been worked out and preserved in the form of a *legal* regime, so that now, alike in itself and in the external world, this regime exists as an inflexible necessity, independent of particular individuals and their personal mentality and character."[52] In such a world, "the scope for ideal configuration is only of a very limited kind. For the regions in which free scope is left for the independence of particular decisions are small in number and range."[53] The end of art is thus not the result of any purely internal development of art, but rather the outcome of the evolution of societies and their self-understandings under the conditions of modernity:

> [I]n the world of today the individual subject may of course act of himself in this or that matter, but still every individual, wherever he may twist or turn, belongs to an established social order and does not appear himself as the independent, total, and at the same time individual living embodiment of this society, but only as a restricted member of it. He acts, therefore, also as only involved in it, and interest in such a figure, like the content of its aims and activity, is unendingly particular. . . . He is not, as he was in the Heroic Age proper, the embodiment of the right, the moral, and the legal as such.[54]

I will have to leave it to classicists to decide whether Hegel's thesis does justice to the respective roles of art and philosophy in the spiritual life of a citizen of ancient Athens. As a description of their respective roles in our lives it is persuasive only if we supplement it with a reminder that, however important philosophy has become for us, it can never completely supplant art in our overall spiritual economy. There is a sense in which Hegel is right: the liberal state is with distance modernity's greatest artifact. Even so, representations can never be superseded by arguments, and art is not likely to be completely replaced by philosophy. Art (and history) cannot be truly left behind, since its representations are the indispensable material for philosophy and for developing practical wisdom. What might seem more plausible, and is subject to empirical verification, is a modification of the Hegelian thesis according to which earlier stages of individual life and collective culture would rely more on artistic representations, while later ones would make fuller use of philosophical arguments. Initially, representations can guide our actions without arguments (we can be inspired by individual examples). As we mature, we ask for reasoned principles. In this

sense, Hegel might be right that in the modern world art no longer expresses our highest ideals, that they can be found more adequately and fully expressed in philosophy.

But while a thesis postulating such a change of emphasis might be plausible, there can be no question of art being completely replaced by philosophy. Even for us moderns, both have indispensable roles to play in the overall economy of our ethical lives. Philosophy offers arguments for how we should act (in matters of private morality and public policy); art (and history) offer examples. Gadamer observes that "human passions cannot be governed by universal prescriptions of reason. In this sphere one needs, rather, convincing examples."[55] Common sense, he adds a little later, the sense of community, of moral and civic solidarity, "is in fact largely characterized by judgment. The difference between a fool and a sensible man is that the former lacks judgment, i.e. he is not able to subsume [a particular under a universal] correctly and hence cannot apply correctly what he has learned and knows. . . . It [judgment] cannot be taught in general, but only practiced from case to case."[56] And further:

> Both taste and judgment are evaluations of the object in relation to a whole in order to see if it fits in with everything else. . . . This kind of sense is obviously needed wherever a whole is intended, but not given as a whole. . . . Thus taste is in no way limited to what is beautiful in nature and art . . . but embraces the whole area of morality and manners. Even the ideas of morality are never given as a whole or determined in a normative, unambiguous way. . . . Judgment is necessary in order to make a correct evaluation of the concrete instance. . . . It is always a question of something more than the correct application of general principles. . . . The judge does not only apply law in concreto, but contributes through his very judgment to the development of the law. . . . Like law, morality is constantly developed through the fecundity of the individual case.[57]

Similarly, Martha Nussbaum has defended the moral and political indispensability of literature, and in particular of the novel, by claiming about the reader's experience "first, that it provides insights that would play a role (though not as uncriticized foundations) in the construction of an adequate moral and political theory; second, that it develops moral capacities without which citizens will not succeed in making reality out of the normative conclusions of any moral or political theory, however excellent."[58]

You will recall that art represents by using individual images, aims at producing experiences of actions and passions that might be subject to justification. Philosophy argues by using general concepts and logical connections, aims at producing thoughts, knowledge, beliefs about actions and passions that might be subject to justification. Both offer us self-images and self-understandings. Both explore not how things are, but how they should be (in this they differ from history and science). Both aim at education (*Bildung*) in the deepest sense of the term, the sense of character formation, at finding out who we are and how we should cope. The examples offered by art cannot be supplanted by philosophy's arguments, since these examples develop our ability to listen to others, hearing

strange, unfamiliar voices, and we acquire this indispensable ability like any other virtue or skill by imitating models. In short, philosophy provides reasons and aims at *episteme,* knowledge, art provides models and aims at *phronesis,* practical wisdom. At bottom, both art and philosophy are our means of reflecting on ethical and political practice.

It is not at random, by the way, that I have been invoking Gadamer here. Gadamer's was the earliest important voice in what has become a contemporary chorus regretting and criticizing the late eighteenth-century separation of aesthetics from ethics and politics. *Truth and Method* begins with a description of the process that led to Kant's limiting the operation of the judgment of taste to aesthetics and thus giving aesthetics its autonomy. But, unlike most of his successors, Gadamer notices that not only art, but also ethics paid a steep price for this separation and autonomization. The judgment of taste, Gadamer correctly argues, was the central component of the classical idea of practical knowledge. Once its operation was limited to aesthetics, the Aristotelian notion of practical knowledge was destroyed. Art gained autonomy, but, together with the rest of the humanistic disciplines, lost any practical justification as a component of a moral and political education. Taste has been disempowered.

There is one more closely related reason why art can never be fully supplanted by philosophy, why philosophy needs art. We have seen that the function of cultural media is to allow us continuously to reinvent ourselves, that is, our ends and means. Art and philosophy in particular are concerned with various ends we might pursue and, while art shows these ends, philosophy argues for or against them. But in representing ends, art also develops our capacity to imagine what it would feel like to achieve them. And this capacity is an indispensable component of any rational pursuit of an end. The "knowledge of what it will be like to fulfill one's aim," writes Roger Scruton,

> is essential to the reasoned pursuit of it, and it is a form of knowledge that is both intrinsically practical . . . and also incipiently aesthetic. To know what something is like in advance of the experience of it, is to have an imaginative apprehension of that experience. The ability to participate imaginatively in future experiences is one of the aims of aesthetic education, and it is only by the cultivation of present discrimination, and the present sense of what is appropriate, that it can be properly achieved.[59]

Finally, there is yet another reason why we need to revise the end-of-art thesis. As many thinkers have recently argued, our individual and collective identities necessarily take the form of narratives (I shall have more to say on the subject of this form in chapter 5).[60] The extent to which we care about our personal and collective identities differs vastly from case to case, as does the extent to which we are successful in constructing identities of sufficient complexity and coherence, but it is difficult to imagine how an individual or a community could flourish without some minimal sense of identity. Now, we identify ourselves as individuals and as communities by means of stories we tell about ourselves, about

where we come from and where we are going, and we have no other way of establishing and defining them than by narrative means. "In order to have a sense of who we are, we have to have a notion of how we have become, and of where we are going," writes Charles Taylor.[61] We are the stories of our projects, accomplishments, and failures, and stories are kinds of representations, not arguments.

Moreover, we can either follow stories scripted for us by someone else (our families or communities), or we can attempt to be to at least a certain extent the authors of our own life stories. One of the most fundamental ways in which we modern Westerners like to think of ourselves is as the kind of people who are able to be the authors of their own life stories to a much greater extent than our premodern ancestors were. To be sure, all of this makes only history, but not art (in the very broad sense in which these terms have been defined above), inescapable. But for reasons already invoked, given that we want to author and tell stories about ourselves, we might just as well compare them to the broadest possible repertoire of other such stories, including fictional ones. "[T]he moral justification of the institutions and practices of one's group," writes Richard Rorty,

> . . . is mostly a matter of historical narratives (including scenarios about what is likely to happen in certain future contingencies), rather than of philosophical metanarratives. The principal backup for historiography is not philosophy but the arts, which serve to develop and modify a group's self-image by, for example, apotheosizing its heroes, diabolizing its enemies, mounting dialogues among its members, and refocusing its attention.[62]

When taken in this sense, young Nietzsche's defense of myth (recall that a *muthos* is a plot, a story) and refusal to accept its replacement by the Socratic science as permanent becomes plausible:

> The images of the myth have to be the unnoticed omnipresent demonic guardians, under whose care the young soul grows to maturity and whose signs help the man to interpret his life and struggles. Even the state knows no more powerful unwritten laws than the mythical foundation that guarantees its connection with religion and its growth from mythical notions.[63]

It is for reasons of this sort that the importance of representations may have actually increased rather than decreased in modern times. Rorty finds it "tempting to think of our culture as an increasingly poeticized one."[64] Charles Taylor, too, notes the unprecedented social prestige of the modern artist, hardly a sign of the decline or end of art:

> There is a set of ideas and intuitions, still inadequately understood, which make us admire the artist and the creator more than any other civilization ever has. . . . The widespread belief today that the artist sees farther than the rest of us . . . depends on that modern sense . . . that what meaning there is for us depends in part on our powers of expression, that discovering a framework is interwoven with inventing.[65]

Let us note, moreover, that Hegel's thesis does not imply that all artistic production will stop. Art, Hegel thought, "ends with the artist's personal productive mastery over every content and form," a stage of its development reached in Hegel's own time.[66] The artist today "is no longer dominated by the given conditions of a range of content and form already inherently determined in advance, but retains entirely within his own power and choice both the subject-matter and the way of presenting it."[67] But even if the highest interests of mankind have found better modes of expression elsewhere, there still remains plenty for artists to do: "It is the appearance and activity of imperishable humanity in its many-sided significance and endless all-round development which in this reservoir of human situations and feelings can now constitute the absolute content of our art."[68] Tocqueville concurs:

> Among a democratic people poetry will not feed on legends or on traditions and memories of old days. The poet will not try to people the universe again with supernatural beings in whom neither his readers nor he himself any longer believes, nor will he coldly personify virtues and vices better seen in their natural state. All these resources fail him, but man remains, and the poet needs no more. Human destiny, man himself, not tied to time and place, but face to face with nature and with God, with his passions, his doubts, his unexpected good fortune, and his incomprehensible miseries, will for these peoples be the chief and almost the sole subject of poetry. . . . Equality, then, does not destroy all the subjects of poetry. It makes them fewer but more vast.[69]

As a postscript, let me add that in recent years, Hegel's end-of-art thesis has received an interesting, though intentionally one-sided, reinterpretation at the hands of Arthur C. Danto. Danto's version deemphasizes the motif that was central to Hegel, namely, art's replacement by religion and philosophy as the main modes of "bringing to our minds the true interests of the spirit," the modes in which we articulate our most important self-understandings and beliefs. Instead, Danto chooses to stress another motif. As he puts it, "the history of art has come, in a way, to an end . . . in the sense that it has passed over into a kind of consciousness of itself and become, again in a way, its own philosophy."[70] As originally formulated, the thesis seemed to suggest that art had reached its appointed destiny by making its own ontological status into its subject:

> [A]rt . . . evolved in such a way that the philosophical question of its status has almost become the very essence of art itself, so that the philosophy of art, instead of standing outside the subject and addressing it from an alien and external perspective, became instead the articulation of the internal energies of the subject. It would today require a special kind of effort at times to distinguish art from its own philosophy. . . . Art . . . has turned into self-consciousness, the consciousness of art *being* art in a reflexive way. . . . Artworks have been transfigured into exercises in the philosophy of art.[71]

Should this indeed be the case, one would have to raise a question that does not seem to interest Danto much, namely, why should this sort of narcissistic

navel-gazing be of interest to anyone other than those concerned with the on-
tology of artworks. But over the years Danto's thesis evolved into something else.
In its most recent formulation it became a thesis about the kind of stories we tell
about art,

> a somewhat dramatic way of declaring that the great master narratives which
> first defined traditional art, and then modernist art, have not only come to an
> end, but that contemporary art no longer allows itself to be represented by
> master narratives at all. Those master narratives inevitably excluded certain
> artistic traditions and practices as 'outside the pale of history'—a phrase of
> Hegel's. . . . Ours is a moment, at least (and perhaps only) in art, of deep plu-
> ralism and total tolerance. Nothing is ruled out.[72]

It should be clear that Danto's thesis is now not so much about art as about
the history of art, about the end of the present and future desirability or possi-
bility of constructing a plausible all-embracing narrative of art's development.
Using Lyotard's terms, we might say that Danto diagnoses the present condition
of art as "postmodern" in the sense that we are no longer able or willing to
search for a narrative of this sort. Both Lyotard and Danto may well be correct
in thus diagnosing the present pluralist mood. But Danto's thesis leaves the ques-
tion that interests me here, the question of the uses of art, intact: in the new post-
historical era art's uses remain as they always were. The Hegelian version of the
thesis raised at least a suspicion that perhaps we might want to move from art to
other, more worthy, pursuits. Not so Danto's version: if art was ever worth our
while, it remains no more and no less worthy of attention today.

d. Art, Religion, and the State

History, art, science, philosophy. What is conspicuously missing from our kit of
cultural tools is religion. Where does religion fit within the grid of representa-
tions (of the actual and of the fictional) and arguments (about what is and about
what should be)?

It is the purpose of religion to make sense of what is most intractable in our
experience, of evil, suffering, and death, and to do so by placing the negative
within a divine, nature-transcending order. From the standpoint of our grid, the
actually existing religious traditions are most impure, mixing as they do all four
elements. In the Judaic and Christian traditions, at least, the central document
is the Book, and this, to a secular mind, appears to consist of all four elements
unevenly mixed, with a strong preponderance of representations over arguments.
Is there a difference between the representations of a religious tradition and
those of a secular history and art? Art in particular has for centuries had an es-
sentially religious content. Until at least 1500, the most impressive architecture,
sculpture, painting, and music created in Europe had religious subjects and func-
tions, and through at least the middle of the eighteenth century religious content
continued to be of major significance to the European arts. Is there a difference
between art and religion? Or, to formulate the question with more precision, is

there anything distinctive about historical and artistic representations when their content belongs to a religious tradition?

The main difference, it seems to me, is that a religious tradition claims for its representations a special and exclusive authority and importance, authority and importance that are binding for the whole religious community. (On this view, "religion" is not a category of the same sort as "history," "art," or "philosophy;" it is, rather, a kind of use one makes of history, art, or philosophy.) For us, secular inhabitants of the West, the representations of the Bible exist on a par with a great many other historical and artistic representations. For a religious Jew and Christian, they are the single most important representations and all others are subordinate to them. This preeminence of religious representations stems from the fact that they found the sense of identity and direction not just for this or that individual, but for the whole religious community. These are the stories that allow members of the community to answer the questions of who they fundamentally are and what they most badly want. Secular persons may also have canons of representations that help them to define themselves. But typically, these are their private canons, rather than one canon a specific community shares, and hence they are more flexible and changeable, sharing various components with members of various intersecting communities.

The secularization of European art, its gradual abandonment between the late fifteenth and late eighteenth century of exclusively religious content in favor of a more flexible and varied repertoire of subjects, is one of the most fundamental processes that defines modernization. It is clearly an aspect of the larger historical process whereby we gradually acquired the possibility of defining ourselves to a certain (growing) extent on our own, rather than always having to be born to our identities. The premoderns and the moderns (admittedly, ideal types, rather than literally historical realities) differ in that the former inherited their identities, while the latter have gradually increased the scope within which they may choose who they are. We, liberal heirs of the Enlightenment, may, and should, embrace this process of modernization with enthusiasm as it enlarges the realm of human liberty, increases the area of free choice, allows us to be, to a greater extent than before, the authors of our own life stories. But we cannot be entirely deaf to the cries of discontent coming from those this process makes unhappy, the communitarian heirs of Romanticism, because their discontent is well justified. Modernization entails not only gains, but losses, the main one being the loss of safety that inherited and unquestioned individual and collective identities bring. Liberty is exhilarating, but it also breeds anxiety. And the most profound sources of this anxiety have to do with the increased social fragmentation, with the disappearance, or at least the erosion, of a clear and unquestioned sense of collectively shared values.

Art, as we have seen, is, together with philosophy, our most potent tool of self-invention. If modernization implies secularization, the abandonment of religion as the exclusive or most authoritative source of representations defining our communal identity, it is understandable that the role of art would become more

rather than less important in the modern period (Hegel's thesis needs to be modified here also). It is also understandable that art was bound to be repeatedly tempted to step into the shoes abandoned by religion. Here Nietzsche saw more clearly than Hegel:

> *Animation of art.* —Art raises its head where the religions relax their hold. It takes over a host of moods and feelings engendered by religion. . . . The wealth of religious feelings, swollen to a torrent, breaks forth again and again and seeks to conquer new regions: but the growth of the Enlightenment undermined the dogmas of religion and inspired a fundamental distrust of them: so that the feelings expelled from the sphere of religion by the Enlightenment throw themselves into art; in individual cases into political life as well, indeed even straight into the sciences. Wherever we perceive human endeavours to be tinted with a higher, gloomier colouring, we can assume that dread of spirits, the odour of incense and the shadows of churches are still adhering to them.[73]

(Indeed, the few decades that preceded Hegel's lectures on aesthetics team with artistic attempts to invent private and semi-private mythologies and symbolic systems, or to modulate the public ones, whether Christian or Masonic, in individual ways. *The Magic Flute,* the work of Blake, the unrealized *Zeiten* cycle of Philipp Otto Runge, all inhabit a halfway house between premodern religious art and modern secular art.) But from this perspective, art's record in the last two centuries is mixed. To put it most schematically (and nothing more than a schema will be attempted here), modern art has been most successful when it underpinned the private search for individual identity. After all, as I have argued throughout this chapter, this is a proper role for art. But as soon as art attempted to usurp religion's position as the source of the most authoritative and important, rather than merely optional, representations defining our collective sense of direction, it began to breed, or at least support, monsters. In particular, the experience of this century suggests that art begins to play with fire as soon as it enters a pact of mutual support with the state.

The current quarrel between individualist liberals and communitarians (itself the late twentieth-century version of the continuing quarrel between the Enlightenment and Romanticism) is unlikely to end anytime soon with a clear victory for either side, since both speak for authentic human needs that have to be satisfied and kept in balance in some way. We are unlikely, and would be unwise, at this point to want to abandon the modern gains in individual liberty and to let others tell us who we are. But we are also unlikely to forget the hunger for a community, for collectively shared values. The real challenge is not to choose between these authentic needs, but to balance them properly. Communitarians are surely right to remind us that most virtues worth cultivating can only be cultivated in association with other humans, that we can fully develop our potentialities and flourish only in communities held together by shared images and beliefs. Liberals are just as surely right in claiming that the only communities we need and can safely afford will have the character of flexible civil-society as-

sociations mediating between families, on the one hand, and the state, on the other, associations we can form or join, dissolve or abandon, at will. They are particularly right in warning us against giving the status of a community to the modern state. The lesson of twentieth-century totalitarianisms is clear in this respect. One thing we must not forget, after the Nazis, is that, given the immense power that modern technology and bureaucratic organization confer on the state, we would be foolish to invest the nation-state ever again with the dignity of a community.

Now, in the past two hundred years, those cases where art managed to usurp the status of religion most successfully were precisely the cases where art served the cause of nationalism. Lewis Namier correctly called nationalism "the passionate creed of the intellectuals" (and on our account, artists, like all creative users of cultural media, are intellectuals). Indeed, nationalism as a substitute for religion seems custom-made to appeal to intellectuals in search of a secular creed, since it provides them with an exceedingly flattering self-image. Nationalism is at bottom a peculiarly modern way of providing the power of the state with legitimacy by claiming that it is exercised in the name of a nation. In much of nineteenth- and twentieth-century Europe and elsewhere, nations have been defined in terms of their cultures, and culture is the intellectuals' dominion. As a result, nationalism provided the intellectual class with the flattering self-image of a legitimizing priesthood, not different in kind from earlier priesthoods, one of whose roles was to legitimize the power of premodern rulers as deriving from God.[74] As long as the nation in question is an underdog struggling for political independence and self-determination, the intellectuals who provide it with its sense of identity and direction are figures with whom it would be hard not to sympathize. Such are the exemplary cases of Chopin and Poland, or early Verdi and Italy. The case of art serving an already established nation-state is more problematic, increasingly so the more powerful and well-established the state is. Nietzsche was quick to sense that this might become the case of Wagner, when in 1888 he called Wagner *reichsdeutsch* ("What did I never forgive Wagner? That he *condescended* to the Germans—that he became *reichsdeutsch*."[75]) and observed that "it is full of profound significance that the arrival of Wagner coincides in time with the arrival of the '*Reich*': both events prove the very same thing: obedience and long legs."[76] In 1888, this was blatantly unfair. (Brahms's *Triumphlied* is more overtly *reichsdeutsch* than anything Wagner ever wrote.[77]) But with the wholesale appropriation of Wagner's work by the next Reich, Nietzsche's words acquired a prophetic ring.

My claim, in short, is this. We need images and representations, we need above all stories, to give ourselves an identity and to give our existence a depth of significance. Without representations of history and art with which to compare our own experiences, our world would be appallingly flat, one-dimensional, and impoverished, the world deserving Henry James's bleak characterization (in *The American Scene*): "what you see is not only what you get, it is all there is." The advantage of a religion is that its stories unite a whole community. Its

disadvantage is its built-in exclusivity and intolerance of other, alternative stories. Art is safer: it keeps our world from becoming totally "disenchanted," flat, and devoid of significance, maintains the depth that stories impart to our existence and to our world and thus allows us to preserve the premodern seriousness in our attitudes to ourselves and the world, without giving up on what is attractive about modernity—namely, a clearsighted, critical, empirical-scientific attitude. Art and history give us a multilayered world in which what we see is only a small part of what there is. And they do this without the adverse effects brought on by the dreams of metaphysics, dreams of "another world" beyond the world of appearances, or the exclusive authoritarianism of religion.

There is nothing wrong with art that represents a content with moral or political significance. On the contrary, to represent such a content is one of the central functions of art. There is, however, something profoundly sinister in an art elevated by the modern nation-state to the position of a state religion. Mussolini misappropriating Verdi's *Aida* to celebrate the rape of Abyssinia, Hitler holding a most willing Bayreuth in his embrace, above all Stalin enforcing a wholesale nationalization of the arts—these grim lessons of the century should not be forgotten. Max Weber's diagnosis of 1918 is still worth considering:

> The fate of our times is characterized by rationalization and intellectualization and, above all, by the 'disenchantment of the world.' Precisely the ultimate and most sublime values have retreated from public life either into the transcendental realm of mystic life or into the brotherliness of direct and personal human relations. It is not accidental that our greatest art is intimate and not monumental, nor is it accidental that today only within the smallest and intimate circles, in personal human situations, in *pianissimo,* that something is pulsating that corresponds to the prophetic *pneuma,* which in former times swept through the great communities like a firebrand, welding them together. If we attempt to force and to 'invent' a monumental style in art, such miserable monstrosities are produced as the many monuments of the last twenty years. If one tries intellectually to construe new religions without a new and genuine prophecy, then, in an inner sense, something similar will result, but with still worse effects. And academic prophecy, finally, will create only fanatical sects but never a genuine community.[78]

One of the principal reasons this diagnosis sounds plausible was identified early on by Benjamin Constant, who, in the aftermath of the French Revolution, famously argued that the there was a fundamental difference between the ancient and modern understanding of liberty.[79] In ancient republics, Constant claimed, liberty was "political" rather than "civil;" it meant not the freedom of each citizen from social oppression, but rather his ability to participate in the government. Because the number of citizens was relatively small, each citizen "had politically a great personal importance. . . . If the social power was oppressive, each associate consoled himself by the hope of exercising it."[80] The liberty of the moderns, by contrast, is civil rather than political. In modern states with their great number of citizens, the great mass can excercise sovereignty only at

the time of elections. "The people cannot be but enslaved or free; they can never be governing. The happiness of the majority does not lie anymore in the enjoyment of power, but in the individual liberty."[81] In short, "the liberty of the ancient times was all that assured the citizens the greatest part in the exercise of social power. The liberty of modern times is everything which guarantees the independence of the citizens from the power."[82] It is not that we did, or should, stop caring about political liberty. It is, rather, that, for us, it is, or should be, less an aim in itself than a means of guaranteeing our individual liberties.[83] If Constant's claim that the private sphere matters much more to the majority of the moderns than the public one, that they seek their happiness in the former rather than the latter, is correct, it would explain why modern art is so much more successful in giving expression to private individualities and concerns than to public duty or political virtue.

Lenin, Stalin, Hitler, Mao, Pol Pot: recent attempts to re-enchant the public, political sphere, to make the state divine, produced suffering and destruction on a scale unprecedented in recorded history. At the end of this unlamented century, we cannot be sure that "the ultimate and most sublime values" have indeed once and for all "retreated from public life either into the transcendental realm of mystic life or into the brotherliness of direct and personal human relations," but we must ardently hope that they have. The practical and difficult tasks of safeguarding security, liberty, and justice for every citizen, and of getting the balance between the creation of wealth and social justice right, will provide our politics and our states with all the dignity and grandeur they will ever require. We must wish for a completely disenchanted and shallow politics and satisfy our hunger for enchantment and depth in the private and semi-private spheres of family and civil society.[84] Matters of ultimate import should remain for us separate from the state. And if we are lucky enough that they do, Hegel's diagnosis of the end of art will have to be reconsidered in this respect, too, for our most profound self-understandings may well continue to require representations and not only arguments for their embodiment, and the representations of art no less than those of religion.

At the beginning of the third act of *Die Meistersinger von Nürnberg,* the shoemaker-poet Hans Sachs meditates on the remarkable ease with which outwardly well-ordered peaceful communities, like his beloved Nuremberg, can fall apart and succumb to civil strife: "Where do I look inquiringly, in city and world chronicle, to find out the cause why people torment and oppress one another to the quick in useless furious rage?"[85] The answer to this Why is the eternal human folly: "Folly! Folly! Everywhere folly!" Since nothing happens without this irrational force ("it is just the old folly, without which nothing may happen"), the task, the politician's and poet's, Sachs's, task, is subtly to steer it so that it might serve the community, not destroy it: "Now let us see how Hans Sachs does it that he can subtly steer the folly to do a noble work."

How does Sachs do it? When later in the day the whole of Nuremberg gathers on an open meadow to celebrate the feast of St. John and "the people" greet

their dear poet with many a resounding "Heil!," the motionless Sachs, who, "as if rapt in thought," as the remarkable stage direction tells us, "has been gazing far away over the crowd, at length turns his eyes with kindly expression on them and begins" (act 3, scene 5).[86] His speech opens the singing contest, during which he manages to steer the respective follies of the contestants and the people with so much subtlety that the strife that had threatened to pull the community apart the previous night ends in a general reconciliation, albeit one in which no room can be found for one of the contestants, the utterly humiliated Beckmesser, who "rushes away in fury and loses himself in the crowd."[87] (Carl Dahlhaus perceptively remarks: "The C major jubilation of the close of the work, after everything that has come before it, is not so serene, after all, to an ear that has been tuned musico-dramatically. It is no accident that the motive that blends with the final chord is that to which the crowd mocked Beckmesser."[88] For some "Others" there is simply no room in this homogeneous community.)

Sachs's final speech spells out, then, the firm foundations on which a community ever threatened by irrational folly should be built. In bad times, he tells the people, when political independence is lost to foreign powers, "if the German people and empire were first to disintegrate, soon, in false French majesty, no prince would understand its people anymore and they would plant in our German land French humbug with French trumpery." In such times, "no one would know any more what is German and genuine, if it did not live in the glory of German masters." The guild Sachs speaks for here is surely not that of shoemakers. It is, rather, the guild of the intellectuals, the "masters," the secular priesthood whose glory is to define, express, and preserve the nation's identity. And the moral? Sachs's final words, enthusiastically repeated by the people, make it explicit: "honor your German masters! Then you will spell-bind good spirits; and if you favor their work, even if the Holy Roman Empire were to dissolve into thin air, we would still have the holy German art!" "Nietzsche's tenet that art is the only thing that justifies life . . . summarizes the theme of *Die Meistersinger*," concludes Carl Dahlhaus in interpreting these lines.[89] This seems to me very wide of mark. In Sachs's vision, it is not art that justifies life, but the reverse, art is justified and valued, because, and if, it serves life (whether of individuals, or of whole national communities) well.

Sachs, let us recall, does not want to eradicate "the old folly," since he understands that the blind irrational force (which bears an uncanny resemblance to the Schopenhauerian will) is not only destructive, but also creative. He just wants it to serve life, not destroy it. Once you accept the Schopenhauerian metaphysical insight that the only reality behind the veil of appearances is the blind irrational will, there are indeed only two ways to go. The truly radical and heroic way is to embrace annihilation, but this road is accessible only to the exceptional few (such as Tristan, Isolde, or Brünnhilde). For the rest of us, for Sachs, there is the second best way, the way of resigned wisdom. In the sexual sphere, Sachs wants for Eva neither a passionless union with Beckmesser, nor an all-too-passionate elopement with Walther. He wishes, rather, for a love-marriage, passionate, but

also sanctioned by the community. In art, he wants neither Beckmesser's blind and desiccated attachment to traditional rules, nor Walther's blind and anarchic passion (as he tells Walther, "indeed, with such poetry and fire of love one seduces daughters to adventure; but for blessed matrimony one found other words and melodies" act 3, scene 2) and youthful inspiration that could not be sustained through a lifetime. Rather, he wants a marriage of common poetic rules and inspired individual dreams, a creativity sufficiently rooted in traditional practice not to burn out quickly and sufficiently inspired to be able to extend the tradition: "Learn early the master rules, that they may accompany you faithfully and help you to preserve well that which, in the years of youth, with sacred drive, spring and love placed in your unconscious heart." But Sachs also wants this sort of art, an art capable of harnessing "the old folly" in the service of life and preventing it from destroying individuals and families, to serve a larger national community, to provide it with a sense of shared identity and destiny, a glue that would bind it together and prevent it from falling apart in civil strife or from disintegrating under a foreign domination: "even if the Holy Roman Empire were to dissolve into thin air, we would still have the holy German art!"

Skillfully developing brilliant insights of Nietzsche and Adorno, Dahlhaus has demonstrated how the music of *Die Meistersinger* manages to sound archaic and modern at the same time ("it sounded so old and yet was so new," as Sachs muses about Walther's Trial Song at the beginning of the second act).[90] No less than its music, the opera's politics also sound so old and yet are so new. By the time they all assemble at the meadow, the community of Nuremberg burghers has metamorphosed into the German people. Wagner articulated Germany's deeply ingrained and long-enduring self-image of disunity and decline from the greatness of her medieval empire in the very years of Bismarck's inexorably successful empire-building (*Die Meistersinger* was written and composed between 1861 and 1867 and premiered in 1868). The artist's remedy for the decline was different from the statesman's. What Wagner offered was not the hard-nosed reality of political action, of new unity forged through diplomacy and war, but the magic of art as the foundation of national unity. Had Bismarck been less, or more, successful, we would today see Wagner's nationalism in a light similar to that in which we see Verdi's, as an exemplary relic from an era when art usurped for itself the mantle abandoned by religion, the era when artists, together with the rest of the intellectual class, the educators, the historians, commonly saw themselves as providers of images and beliefs that would give cohesion to a society increasingly uprooted from traditional conditions of life by the pressures of the modern industrial order (and the reader already knows that all the optimistic proclamations of the coming of the postmodern age do not suffice to assure me that that earlier era is truly over). The black magic of Hitler, combining and caricaturing the remedies of Wagner with those of Bismarck, taught us to see, instead, the dangers inherent in taking art for religion.

"The holy German art" as a substitute for "the Holy German Empire" sounds benign enough. What Sachs forgot to warn his people about is the disgrace of

the same art becoming the successful and aggressive empire's state religion. In 1868, the celebration of the artist's megalomania might have seemed harmless. Today it is difficult to contemplate Sachs on his Nuremberg meadow, "motionless, as if rapt in thought, . . . gazing far away over the crowd," with the enthusiastic "people" swirling around him like planets around the fixed sun and acclaiming him with their "Heil!," without superimposing on the scene the images of that other festival on a Nuremberg meadow, the 1934 *Parteitag* as staged in Leni Riefenstahl's *Triumph of the Will* (1935), with its indelible images of the motionless, abstracted Führer caught by the camera constantly gyrating around him. (Music itself plays a role in this superimposition: the soundtrack accompanying the opening sequence of the film has the prelude to *Die Meistersinger* march effortlessly into the *Horst Wessel Lied.*) Thus death imitates art. Weber's prophetic diagnosis stands: in modern conditions in which the state can easily acquire the power to crush everything that stands in its way, art as state religion can only breed monstrosities.

But if we should mistrust art that supports the state, is the opposite also the case? Is there anything wrong with state support for the arts? In a perhaps unexpected way, the comparison of art and religion can be made relevant to our thinking about this question too. Bruce Ackerman has argued that the liberal tradition is split on the issue of whether or not the state should support the arts. On the one side there are the Jacobin heirs of the anticlerical French Enlightenment who want to enlist the support of the state in their cultural war against what they consider to be religious superstition. On the other side there are the more thoroughgoing liberals who, like Ackerman himself, argue for a radical disestablishment between the state and culture to complete the separation of church and state. In the modern world, they point out, religion and art are engaged in an ongoing contest over our ultimate convictions and identities, over no less than the meaning of life. "As much as possible," writes Ackerman,

> the liberal state should be neutral on such matters, leaving it to each citizen to determine whether he should give his financial support to the Church of Rome or the one at Bayreuth. . . . This Neutralist liberal philosophy strives to prevent either side in the ongoing culture war from using the state's coercive powers of taxation as a weapon in the struggle for men's souls. . . . After all, if the state ostentatiously takes sides in this conversation, it cannot avoid denigrating the ultimate convictions of many of its dissenting citizens.[91]

While I fully accept Ackerman's neutralist principle, I also think that his conclusion that the state should stop subsidizing opera (and, I suppose, all other kinds of artistic practices) is only one of the two conclusions one can derive from it. The other one, equally consistent with the neutralist principle, is that the state should support all sides in the cultural debate in a neutral fashion. To be sure, this does exclude direct state subsidies to artistic or religious institutions: it does not seem possible to devise a way of fairly dividing the total appropriated for the cultural conversation, since the number of participants in the debate, to say noth-

ing of their needs, constantly changes. State management of the arts in this re-
spect resembles state economic planning and is more than likely to produce
similarly dismal results. It is not that the employees of the Ministry of Culture
are necessarily less smart or imaginative than private donors or foundations. It
is rather that the mistakes of the latter can be promptly rectified by other donors
and foundations, while the mistakes of the state monopolist are much more dif-
ficult to correct.

But indirect state support, neutrally administered, is certainly possible. It would
be enough to grant nonprofit or tax-exempt status to both religious and art or-
ganizations, to establish a tax deduction for charitable contributions, and to
allow such contributions to be made to both religious and art organizations. This
way the state's coercive powers of taxation would clearly be enlisted on behalf
of cultural conversation, but each citizen would be left free to determine which
particular institution he would want to support. (The difficulties would begin
only if we wanted to redistribute the funds and support the cultural practices of
those who could not afford to support them themselves. But these difficulties
would not be insurmountable in a society that accepted in principle that redis-
tribution may be just. It is here that the state would have a useful role to play, as
it usually has when minorities need to be protected.)

A rigorous liberal might object at this point that the state should not be in the
business of supporting the quest for the meaning of life, even when this support
is indirect and neutral, since it would then be using the powers of taxation to co-
erce those who see no need to engage in such a quest. But the fact is that for a
liberal the involvement of the state in any area becomes controversial, once the
most elementary external and internal security needs and the administration of
justice have been provided for. The state's support of health services or educa-
tion is no less in need of a democratic debate and decision than its support of re-
ligion or art. But once such a debate has taken place and the decision has been
made, even the most rigorous liberal conscience can be at peace with itself. And
one can well imagine a society that decides that the quest for the meaning of life
is as essential to civilized living as, say, the provision of universal health services
or education, and that it (the society) has a custodial obligation to make its cul-
tural heritage available to the next generation (how can they be expected fruit-
fully to engage in a debate over the meaning of life if they do not know what has
already transpired in this debate?) at prices even its less fortunate members can
afford. This book is in part an attempt to provide arguments in favor of such a
conclusion.

e. Pleasure

The conclusion that there is nothing wrong with an art that represents a content
with moral or political significance is likely to raise some eyebrows in the more
orthodox aestheticist circles. On our account so far, art's cultural function is
sternly cognitive and ethical: art is the instrument of self-knowledge and self-
invention, it is there to improve (*prodesse*). But what about the second half of

the Horatian formula? Is art there also to please (*delectare*)? The claim I shall be making in this section is that pleasure is at least as central a purpose of art as education. The central importance of pleasure deserves to be stressed explicitly, because the fact that I have much less to say on the subject of pleasure than on the subject of edification might create the undesirable impression that I consider the former somehow less pertinent.

Indeed, given the intense pleasure that art-lovers associate with their passions, any account of the uses of art that did not consider pleasure would be seriously impoverished. But, at the beginning of our inquiry, we promised to search for the function of art that would be culturally important or, better yet, indispensable, and that could be fulfilled only by art, including much of the art that already exists. The educational function identified above meets these criteria. Pleasure, however, may appear to fail to meet them: it does not seem to be something that only art can give us; and its cultural importance or indispensability has yet to be established. What I shall try to do now is to show that, in fact, pleasure fits our bill just as well as improvement does.

That we derive pleasure from many kinds of things and activities is undeniable. But it is possible to argue that there exists a family of pleasures that are specifically afforded by art, pleasures traditionally subsumed under the concept of "aesthetic pleasure." The nature of aesthetic pleasure was most influentially analyzed by Kant in 1790, when, in *The Critique of Judgement,* he claimed that "the delight which determines the judgement of taste [that is, aesthetic judgement] is independent of all interest," that is, it is not connected "with the representation of the real existence of the object" and, therefore, does not involve "a reference to the faculty of desire."[92] Kant could thus distinguish aesthetic pleasure, delight in the beautiful, from sensuous gratification, "delight in the agreeable," which "is coupled with interest" in the object,[93] since this object "provokes a desire for similar objects [and] consequently the delight [in it] presupposes, not the simple judgement about it, but the bearing its real existence has upon my state so far as affected by such an Object."[94] Similarly, Kant could distinguish aesthetic pleasure from rational esteem, or "delight in the good," which is also "coupled with interest," since it implies the concept of an end or purpose of the object ("to deem something good, I must always know what sort of a thing the object is intended to be") "and consequently the relation of reason to (at least possible) willing, and thus a delight in the *existence* of an Object or action."[95] "Of all these three kinds of delight [in the beautiful, the agreeable, and the good], that of taste in the beautiful may be said to be the one and only disinterested and *free* delight; for, with it, no interest, whether of sense or reason, extorts approval."[96] Kant concluded: "*Taste* is the faculty of estimating an object or a mode of representation by means of delight or aversion *apart from any interest.* The object of such a delight is called *beautiful.*"[97]

We may take the aesthetic pleasure in a real object or an imaginary representation. What demarcates this sort of pleasure from other kinds of delight is that it is independent of the dictates of our appetites or reasons and thus remains

unconnected with our desires ("disinterested" and "free"). The delight in the agreeable or the good necessarily generates a desire that the object of our delight be real and be ours, and it, potentially at least, also generates an action designed to satisfy the desire. The aesthetic pleasure ends in itself, not in a desire or an action. Kant's analysis is persuasive in so far as we can, and do, on occasion take pleasure in objects without their having to satisfy any of our sensuous desires or rational purposes. No one with a serious passion for painting or music could be persuaded that his frequent visits to galleries or his regular playing of Bach's fugues on the piano serve only to satisfy his wish to distinguish himself from his less fortunate and less educated fellows, even if he readily admits that such a wish may enter into his artistic interests. And similarly, only professors of literature can seriously entertain the notion that an addiction to reading novels or poetry cannot be anything else than a craving for illusory satisfactions of more or less hidden desires, although one does not have to profess literature to admit that indeed reading may also serve such purposes. To claim that aesthetic pleasure is the only legitimate and actual use one makes of art would be as patently false as to claim that there is no such thing as a pleasure which is "disinterested" in Kant's sense. (Later on, in the epilogue, I shall explain why I think it unlikely that the pleasure we derive from the practice of the arts is ever purely aesthetic.)

But to identify a specifically aesthetic pleasure is not the same thing as to show that only art can provide it. On the contrary, Kant himself clearly had nature rather than art in mind at this stage of his discussion ("flowers, free patterns, lines aimlessly intertwining—technically termed foliage"[98] were his preferred examples) and, indeed, we have seen that aesthetic pleasure may be taken not only in an imaginary representation, but also in a real object. At most, we might suppose that, if it is characteristic of aesthetic pleasure that it is independent of any thought concerning the real existence of the object, an imaginary representation might support such a pleasure better than a real object: with a real object, it may be more difficult to achieve genuine independence from any thought concerning its real existence. And this is, indeed, all that we can claim here. It is surely not only art that can give us aesthetic pleasure, but art has the advantage over nature that it is specifically designed to provide pleasure of this kind (in addition to its other uses, of course) and hence may provide it more efficiently than anything else (with the possible exception of sports, another great source of aesthetic pleasure and a close cousin of the arts).

But even if we are persuaded that art can be a source of aesthetic pleasure, can we also claim that providing such pleasure is a culturally important or indispensable function? In thinking about the possible worth of pleasure, we might consider a rather lofty view that might be directly derived from Kant's analysis. As Kant emphasized, aesthetic pleasure is "disinterested" and "free," independent of our appetites or reasons, unconnected with our desires. It serves none of our sensuous or practical interests. What could the possible worth of such a useless idle pleasure be? Simply this that, to the extent that we value human freedom, we must also value activities in which the possibility of such freedom

is most clearly and characteristically demonstrated. The very fact that we can take pleasure in something that serves none of our sensuous or practical interests shows that we can on occasion rise above the realm of necessity to the realm of freedom. "The beautiful prepares us to love something . . . apart from any interest: the sublime to esteem something highly even in opposition to our (sensible) interest," says Kant.[99] As Carl Dahlhaus has pointed out, this line of defense of aesthetic pleasure connects the aesthetic ideology of the modern German educated middle class with the premodern tradition of "liberal arts," the arts deserving to be cultivated by free men.[100] (Indeed, Paul Oskar Kristeller has shown how, from the sixteenth to the eighteenth century, the modern system of fine arts evolved from the premodern one of liberal arts: what the two systems had in common was an emphasis on leisurely contemplation rather than useful labor.[101]) The contemplation of Beethoven's symphonies takes over from the contemplation of the mathematical order of the cosmos as the activity paradigmatically demonstrating what Aristotle considered to be the content of happiness in the highest sense, namely, the contemplative life of philosophic wisdom. The contemplative activity alone, Aristotle taught, is leisurely and "would seem to be loved for its own sake; for nothing arises from it apart from the contemplating, while from practical activities we gain more or less apart from the action."[102] Given the increasingly obvious practical fruits of modern science, the contemplation of beauty fulfills the need for an activity worthy of free men even better than the contemplation of truth.

All of this might seem persuasive until one notices that a couch potato enjoying his game on TV might not be the most compelling example of the realization of human freedom and happiness in the highest sense. It is understandable that philosophers, or aesthetes, would be of the opinion that theirs is the highest human activity, but there is no reason to take such self-serving claims too seriously. The argument that might be derived from Kant is in essence that aesthetic pleasure reminds us that we are free and that its worth is intertwined with our sense of dignity as free beings. But do we really need to be reminded of our freedom at this point? Isn't it, rather, that no matter how hard we try, we moderns cannot but consider ourselves free to a certain extent, that it seems to be quite impossible to think and act entirely consistently with the strict determinist doctrine? And if we do derive a sense of dignity from the consciousness of our freedom, isn't this consciousness sufficiently supported by any activity we freely choose to undertake, whether disinterested or not?

A less high-minded but more persuasive argument showing the value of aesthetic pleasure would simply say that pleasure, any pleasure, unless it is harmful, is self-evidently valuable and does not require any further arguments in its favor. Now, the only harm a disinterested pleasure might possibly do to us or to others is that its pursuit, like any other activity, consumes our time and other resources and, consequently, might prevent us from pursuing other, more worthy activities. This objection, however, while valid enough, is hardly damaging, since it is true of any virtuous (or vicious) activity we might chose to engage in. We can, and

have to, negotiate a middle course between the ridiculously exaggerated aes-
theticist position which elevates the pursuit of aesthetic pleasure to the role of
the highest activity available to us, and the puritanical rejection of all pleasure
as the work of the devil, or of whatever social or political enemy one thinks to
be the devil's progeny.

To be sure, on this less high-minded account, aesthetic pleasure has been re-
duced to a kind of amusement, a close cousin of the pleasures we derive from all
sorts of games. There is no harm in that: we need to be amused, even if we are
rightly unwilling to elevate amusement to an exaggeratedly high position among
the goods. Here we might take another cue from Aristotle. Happiness, Aristotle
taught, "does not lie in amusement," for happiness is an end and "to exert one-
self and work for the sake of amusement seems silly and utterly childish. But to
amuse oneself in order that one may exert oneself . . . seems right; for amuse-
ment is a sort of relaxation, and we need relaxation because we cannot work con-
tinuously."[103] It makes, of course, quite a difference whether one considers aes-
thetic pleasure to be a contemplative component of the end of life, or a mere
amusing means of relaxation, a needed but inessential detour on the way to what
truly matters. But even on the more modest account, the great pleasures that the
cultivation of the arts gives us are nothing we need to dismiss or despise. Besides,
amusement and other, higher, uses of the arts do not exclude one another. For
Aristotle, music was a source of amusement, but also of moral education, and
even of intellectual contemplation, all at once: "Of the three things mentioned
in our discussion, which does it [music] produce?—education or amusement or
intellectual enjoyment, for it may be reckoned under all three, and seems to share
in the nature of all of them."[104] It has to be admitted, however, that we would
not want to spend our time writing, or reading, books about art, if *all* that art
provided was amusement.

We can nevertheless recapture the Horatian *delectare* side by side with the
prodesse and maintain that the provision of pleasure is as legitimate a function
of art as edification. Moreover, if Hegel is right to think that in the modern world
art no longer expresses our highest ideals and that they can be found more fully
expressed in philosophy, it would follow that in the modern world the impor-
tance of aesthetic pleasure is likely to increase in relation to the importance of
education as the function of art. Such a quintessentially modern phenomenon
as the emergence and growth of aestheticism seems to confirm the prediction.
But, while the exact balance between pleasure and improvement will have to be
negotiated anew with each individual period, art, artist, and work even, it is likely
that a prolonged estrangement of art from either one of its two functions would
impoverish and cripple it. Art that ceases to give pleasure runs the risk of de-
generating into dreary didacticism or, worse, insidious propaganda. But art that
permanently gives up on its educational function is in danger of becoming friv-
olous, empty of significant content, and ultimately sterile, a mere game that is
pleasing enough, but does not engage our most profound interests and concerns.
Even so, the relationship between pleasure and edification is an unequal one.

The thought of an art that is only useful is most unappealing. It is not so with art that is merely pleasing. This might not answer our highest conception of what art is capable of, but it is certainly not offputting. On the contrary, the objections of puritans notwithstanding, to enhance people's lives by providing aesthetic pleasure is an entirely honorable occupation.

But the most important point about the pleasure of art has not been made yet. We should keep in mind that not all, or most, of the pleasure we derive from art is aesthetic and that, consequently, edification and pleasure are not as neatly separated as I have pretended them to be here. Also pleasure can have a cognitive dimension (and learning can be pleasurable).

Much of the pleasure we take in art is not of the aesthetic kind, but, rather, falls somewhere between the disinterested and interested. What often happens is that we find entering a fictional world pleasurable (or displeasing), because we imagine ourselves belonging to this world and we find its various objects appealing (or repellent, or both, as the case may be). (Thus, like Madame Bovary, we may enjoy imagining ourselves with heroes of romantic fiction, leading the life of leisured passion.) The pleasure in such cases can hardly be considered disinterested: it is certainly not unconnected with our desires. It is much more like delight in the agreeable or the good: it generates a desire that the object of our delight be real and be ours. But the object is neither real nor ours, and the pleasure can never be identical with that of the satisfaction of an empirical desire by its real object. Rather, the pleasure consists in experiencing an empirical desire and imagining what it would be like to satisfy it. We and our desire are real enough, but the object and the satisfaction remain imaginary.

It is obvious why this sort of pleasure can be provided only by art, only by representations of fictional worlds. But what is the value of such pleasure, if any? For the aesthete such pleasures are suspect, because they are, well, nonaesthetic. We may safely ignore these suspicions: the identification of art with the aesthetic, or rather, the limitation of art to the aesthetic, is an unjustified act of post-Kantian usurpation and we have already seen that art is, and should be, more than just a purveyor of aesthetic delights.

But then, there are also stern moralists who see in nonaesthetic pleasures derived from fictions nothing more than a reprehensible escape from reality into a dream-world of illusory fulfillments. The danger they see is real enough. It is possible to use fictions as opium and to seek in them consolations one does not dare to pursue in real life, that is, to use them to fool oneself. But this is surely not all we do with daydreams. When we derive this sort of pleasure from the imaginary experiences art provides, we have the opportunity to learn something about ourselves. We can discover what it is that gives us pleasure, that is, what it is that we might really desire. Here pleasure gets us back to knowledge, but now the object of knowledge is not a fictional personage who is like us, but we ourselves. In this sense, the nonaesthetic pleasure of art may become an instrument of self-discovery, an instrument that allows us to see something about ourselves that had been hidden from our view.[105] (Thus Francesca, the wife of

Gianciotto, and Paolo, his younger brother, both of whom Dante meets in the second circle of hell among "the carnal sinners, who subject reason to desire,"[106] discovered their real passion in the represented one of Guinevere, King Arthur's queen, and Lancelot, his knight. When Dante asks Francesca "but tell me, . . . by what and how did Love grant you to know the dubious desires?",[107] she identifies as "the first root of our love"[108] their reading of the Lancelot romance together: "A Gallehault [a go-between] was the book and he who wrote it."[109] It is not that they were corrupted by bad example. Rather, the example opened their eyes to their unacknowledged mutual love so effectively that "that day we read no farther in it."[110]) Reflective children and younger people, in particular, use fictions this way all the time, and so do we all, at least from time to time. For us, pleasure *is,* or can be, edification.

Escapism, however, is not the only, or even the primary, danger moralists see in the nonaesthetic pleasures of art. More threatening still, they think, is the seduction and corruption by pleasures of an incorrect sort, whatever they may be, pleasures the addiction to which would foster qualities they find undesirable in their fellow citizens. To those who take this danger seriously, some form of censorship seems inevitable. Plato's *Republic* articulated this position very clearly. Fictional personages may act virtuously or viciously and hence bring us lessons virtue or vice. Moreover, fictions provide us not only with models of acting and feeling well or badly, but also appeal to our desires; even if, unlike Plato, we are not convinced that the latter appeal must always be corrupting, it clearly can be corrupting sometimes, when the aroused desire is incompatible with virtue (the desire to act cruelly, say). Since fictions have these powers, the conclusion seems inevitable that, if we want to foster good characters and hinder evil dispositions, we should not allow fictions that show vicious actions or excite vicious desires.

> Shall we, then, thus lightly suffer our children to listen to any chance stories fashioned by any chance teachers and so to take into their minds opinions for the most part contrary to those that we shall think it desirable for them to hold when they are grown up?
> By no manner of means will we allow it.
> We must begin, then, it seems, by a censorship over our storymakers, and what they do well we must pass and what not, reject.[111]

And further: "the first stories that they hear should be so composed as to bring the fairest lessons of virtue to their ears."[112] Moreover, it is not only the poets that should be so controlled:

> Is it, then, only the poets that we must supervise and compel to embody in their poems the semblance of the good character or else not write poetry among us, or must we keep watch over the other craftsmen, and forbid them to represent the evil disposition, the licentious, the illiberal, the graceless, either in the likeness of living creatures or in buildings or in any other product of their art, on penalty, if unable to obey, of being forbidden to practice their art among us,

that our guardians many not be bred among symbols of evil, as it were in a pas-
turage of poisonous herbs, lest grazing freely and cropping from many such
day by day they little by little and all unawares accumulate and build up a huge
mass of evil in their own souls.[113]

When it comes to the education of children, Plato's argument has to be taken
seriously, and it occasionally is. Colin McGinn has argued recently that, since
"an evil character is one that derives pleasure from pain and pain from pleasure
[of another],"[114] "we should be concerned about the psychological effects of
violent entertainment. There are real risks in conjoining killing and fun."[115] The
platonic call that society (or parents) exercise some control over the fictions it
allows its children to hear and watch is surely justified. Aristotle, who rarely
agreed with Plato otherwise, was of the same opinion concerning this particular
issue: "The Directors of Education, as they are termed, should be careful what
tales or stories the children hear, for all such things are designed to prepare the
way for the business of later life, and should be for the most part imitations
of the occupations which they will hereafter pursue in earnest."[116] And further:
"But the legislator should not allow youth to be spectators of iambi or of com-
edy until they are of an age to sit at the public tables and to drink strong wine;
by that time education will have armed them against the evil influences of such
representations."[117]

But treating adults like children is another matter. If we want to extend to
grown-ups the courtesy of treating them with the dignity that morally responsible
agents deserve, we have to consider the likelihood that censorship might do more
harm than good. Plato himself was too great an artist not to be uncomfortable
with his radical conclusions. In a famous passage in book 10 of the *Republic,* he
suggested that the philosophical distrust of poetry preceded his own work and
he issued a challenge to his successors:

> Let us, then conclude our return to the topic of poetry and our apology, and
> affirm that we really had good grounds then for dismissing her from our city,
> since such was her character. For reason constrained us. And let us further say
> to her, lest she condemn us for harshness and rusticity, that there is from of old
> a quarrel between philosophy and poetry. . . . But nevertheless let it be declared
> that, if the mimetic and dulcet poetry can show any reason for her existence in
> a well-governed state, we would gladly admit her, since we ourselves are very
> conscious of her spell. . . . And we would allow her advocates who are not poets
> but lovers of poetry to plead her cause in prose without meter, and show that
> she is not only delightful but beneficial to orderly government and all the life
> of man. And we shall listen benevolently, for it will be clear gain for us if it can
> be shown that she bestows not only pleasure but benefit.[118]

The picking apart of Plato's argument has been going on, explicitly or im-
plicitly, at least since Aristotle's *Poetics*, with its attempt to show why the expe-
rience of tragedy may be edifying rather than corrupting. More generally, the
obvious objection to Plato is that a mature person can derive a useful lesson from
a representation of vicious actions (a lesson concerning a dimension of human

potentiality) without wanting to imitate such actions. Children need lessons of this sort too, since moral education requires the use of examples not only of what one should want, but also of what one should avoid. And the situation of art arousing incorrect desires is not different from the situation of art representing evil: no doubt, some may be corrupted by the example of such representations, but others will learn about evil hidden in themselves and their fellows. Recall what Nietzsche said on the subject of "dangerous books:"

> *Dangerous books.* —Somebody remarked: 'I can tell by my own reaction to it that this book is harmful.' But let him only wait and perhaps one day he will admit to himself that this same book has done him a great service by bringing out the hidden sickness of his heart and making it visible.[119]

But regardless of whether such arguments against censorship are compelling or not, there is one frequently made argument we should abandon, even though it is politically efficacious. We should stop defending fictions threatened with censorship with the argument that they should be left alone because they are Art. If pornography, in particular, deserves protection, it deserves it under the First Amendment, like other forms of expression, and not because of its specifically artistic qualities.[120] In taking this latter line of defense, we tell the jury, in effect: "True, the content of the world represented here offends the norms of this community, but look how beautiful its form is." Thus, Janet Kardon, the curator of an exhibition of Robert Mapplethorpe's photographs, some of which became the centerpieces of the well-publicized 1990 obscenity trial in Cincinnati, in her testimony in front of the jury "pointed to Mapplethorpe's sensitive lighting, texture, and composition, calling 'a self-portrait of Mapplethorpe with the handle of a whip inserted in his anus "almost classical" in its composition.'"[121] (For Robert Hughes, this testimony represents "the kind of exhausted and literally de-moralized aestheticism that would find no basic difference between a Nuremberg rally and a Busby Berkeley spectacular, since both, after all, are examples of Art Deco choreography."[122]) "As the jury listened to witness after defense witness claim that the Mapplethorpe photographs were works of art," reports Wendy Steiner, "and as the initial shock at the images was replaced by a vast web of aesthetic interpretation, the jury members were forced to concede to the experts."[123]

That juries are willing to listen is a touching testimony to the continuing prestige of Art. Unfortunately, it is also a testimony to how utterly irrelevant to any serious ethical or political concerns art is considered to be. In a post-Kantian fashion, the argument assumes that art's only proper function is to provide aesthetic pleasure and it implicitly denies that art can also be an instrument of self-knowledge. In the short run, it may protect this or that endangered work from censorship. In the long run, it does art more harm than good, since it tells artists, in effect: "You can do what you want, since no matter what you do, it does not much matter to us."

CHAPTER 3 ⌁

AESTHETICS III.
THE GENEALOGY
OF MODERN EUROPEAN ART MUSIC

I have no fear that the poetry of democratic peoples will be found timid
or that it will stick too close to the earth. I am much more afraid that it
will spend its whole time getting lost in the clouds and may finish up by
describing an entirely fictitious country. I am alarmed at the thought of
too many immense, incoherent images, overdrawn descriptions, bizarre
effects, and a whole fantastic breed of brainchildren who will make one
long for the real world.

<div align="right">Alexis de Tocqueville, Democracy in America</div>

In any case, it looks as if our present time might be marked in the annals
of art mainly as the age of music. . . . With the development of conscious
living, men loose all plastic gift. At the end even the sense of color is
extinguished, since this is always tied to a definite drawing. The heightened
spirituality, the abstract realm of thought, reaches for sounds and tones in
order to express an inarticulate effusiveness, which is perhaps nothing
other than the dissolution of the whole material world: music is perhaps
the last word of art, just as death is the last word of life.

<div align="right">Heinrich Heine, Lutetia</div>

What is happening? Where have the splendid, red-blooded, stunning beef
steaks such as Goethe, Beethoven, evaporated to from our artistic kitchen?
How can we make art stop being an expression of our mediocrity and
again become an expression of our greatness, beauty, and poetry? This is
my program: *Primo,* to realize, in the most painful way, what milksops we
are. *Secundo,* to discard all aesthetic theories produced during the last fifty
years that are working furtively to weaken the personality. This whole
period is poisoned by striving for the leveling of values and people—away

with it! *Tertio,* having done away with the theories, to turn to people, to
the great personalities of the past, and in covenant with them to recover
in our own persons the eternal wellsprings of imagination, inspiration,
panache, and grace. For there is no democracy in which some kind of
aristocracy, some species of superiority, would not be attainable. *Dixi.*

Witold Gombrowicz, *Diary, Volume 3*

Two sins are endemic to philosophically minded art theory. First, one speaks
ahistorically, as if art (or, rather, Art) were a permanent unchanging feature of
human nature, rather than a historically evolving cultural practice or family of prac-
tices. (This is not always so, certainly not with Hegel. But most Anglo-American
analytical philosophers, with the important exception of Danto, talk about art
without giving any indication that they know that art in the specific sense in
which they analyze the concept is perhaps no more than two centuries old.) And
second, one speaks of Art, rather than concrete specific arts, even though more
often than not one actually does have one specific art, and not Art in general, in
the back of one's mind. (Thus, when Dewey speaks about art, he usually means
painting, just as Heidegger usually means poetry.) So far, I have sinned like a true
philosopher. I have been talking about art in general and in discussing the ques-
tion of its uses ahistorically, I've asked what these uses should be, rather than
asking what they have been and are. I am, however, not a philosopher, but a
musicologist, that is, someone more used to thinking in historical terms, about
things as they are or were, rather than as they should be. It is, therefore, time to
stop, if only for the duration of this chapter, and refocus the discussion on ac-
tual historical uses of art and, moreover, on one specific art only, music.

The need to refocus the discussion from philosophy to history at this point
should be obvious. We need a reality test. Having presented arguments for a spe-
cific answer to the question of what art should be for, I should now see whether
at least one of the arts has ever actually served such aims during the course of its
history. If we were to find that the aims I think art should pursue were in fact
consistently ignored in those centuries that gave us our greatest examples of what
art can be and what it can accomplish, common sense would suggest that some-
thing went badly wrong not with art but with my theory. We have known from
the beginning that what we want is to find a worthwhile function for art as it
already is, not for some as yet nonexistent practice for which we illegitimately
appropriate the name of art. Thus the present historical excursus is not optional,
it is of the essence. Another way of putting it would be to say that my theory of
art aspires to the peculiarly Hegelian mixture of philosophy and history, of es-
sentialism and historicism, succinctly characterized by Danto:

As an essentialist in philosophy, I am committed to the view that art is eter-
nally the same—that there are conditions necessary and sufficient for some-
thing to be an artwork, regardless of time and place. I do not see how one can
do the philosophy of art—or philosophy *period*—without to this extent being
an essentialist. But as an historicist I am also committed to the view that what

is a work of art at one time cannot be one at another, and in particular that there is a history, enacted through the history of art, in which the essence of art—the necessary and sufficient conditions—are painfully brought to consciousness.[1]

But why music when any specific art would do? One simple reason is that, as a professional music historian, I know much more about it than about any other art and, consequently, hope to be able to talk about its evolution in an informed fashion and to say something about it that has not been said before. But there is a further reason why music is particularly appropriate for the reality test we now need, better than either literature or painting would be. This reason is rooted in the relatively abstract character of the art. Music, I shall presently claim, went abstract more than a century before the visual arts. Moreover, and the two developments are not unrelated, no other group of artists now active have lost as much of their former public as have twentieth-century composers of art music: Bartók, Stravinsky, and Berg, all born in the 1880s, were the last composers to have acquired an unmistakably canonic status, surely an alarming situation when compared with that of poetry (which in the late twentieth century is flourishing) or even painting (which is not). To a much greater extent than the other arts, during the last fifty years contemporary art music has been abandoned even by the highly educated and left as the nearly exclusive province of the professionals. One hundred and fifty years ago, Chopin, Delacroix, and Sand shared the same audience. Many of the people who read Trakl and appreciated Schiele also wanted to see and hear *Wozzeck*. The very same people whose spiritual life continues to be informed today by the new painting and poetry, who flock to a retrospective of Lucian Freud and who insist on buying the collected works of Philip Larkin, leave most contemporary music premieres to the professionals. It is not that music is unimportant for these people, far from it. But their sensibilities, the ways they experience the world, is shaped either by popular music, or by art music of the past, by Monteverdi or Debussy, Schubert or Mahler, not by their contemporaries.

Hans Belting has recently raised the specter of "the end of the history of art":

> In non-Western cultures, such as those of the Far East, we find a highly developed awareness of the limits of a tradition of art, of the early completion of a canon. Indeed, one of the questions which the condition of contemporary art raises is whether we have run up against the limits of the medium of art in Western culture. . . . If this is so, then not only would the 'internal critique' of art of which we have spoken make perfect sense, but also a reevaluation of the history of art: a history which suddenly becomes available as an achieved entirety.[2]

No such possibility could be seriously entertained today with regard to poetry. Auden, Merrill, Celan, Miłosz, Herbert, Zagajewski, Brodsky. . . : there can be little doubt that, in several languages, the period after Auschwitz is a great age of poetry. With painting and with music one hopes that the idea of "the early completion of a canon" will be proven wrong. But if the idea can even be put

forward by an art historian in the face of such strong late twentieth-century contenders for the canonic status as Balthus, Bacon, or Kiefer, how much more plausible is it with regard to music. Music, therefore, represents the situation and dilemmas of art today in a particularly radical, acute, and clear fashion.

a. Social Practices and Their Histories

A historian who experienced the end of the Cold War and the exhilarating acceleration of history during the late 1980s will be naturally drawn back to some of the fundamental questions history raises. How does the normal process of gradual change differ from a revolution in the history of the practice one studies? And does the alternating rhythm of gradual changes and revolutions provide the history of the practice with an overall temporal shape akin to a musical form? Can we ascribe to the history of European music a shape of its own, instead of inscribing this history into shapes derived from histories of other practices, political, social, economic, or cultural?

As we have seen, the business of historians is to represent and understand human beings acting and suffering under the circumstances in which they find themselves, circumstances largely not of their own making. Thus, individual actions and the general circumstances in which they are undertaken are the two fundamental levels of a historical description and interpretation. The two levels can be separated conceptually, but actually they are strictly interdependent: an individual action can make sense only against the background of the antecedent circumstances, and the circumstances are the result of innumerable individual actions.

But if circumstances are at bottom the result of earlier individual actions, they can become more than just that. They can begin to form an ongoing social practice. The specific sense given the term "practice" by Alasdair MacIntyre will be relevant here. A practice, MacIntyre writes, is

> any coherent and complex form of socially established cooperative human activity through which goods internal to that form of activity are realized in the course of trying to achieve those standards of excellence which are appropriate to, and partially definitive of, that form of activity, with the result that human powers to achieve excellence, and human conceptions of the ends and goods involved, are systematically extended. Tic-tac-toe is not an example of a practice in this sense, nor is throwing a football with skill; but the game of football is, and so is chess. Bricklaying is not a practice; architecture is. Planting turnips is not a practice; farming is. So are the inquiries of physics, chemistry and biology, and so is the work of the historian, and so are painting and music.[3]

Two aspects in particular define a social practice thus understood, distinguish one practice from another. First, a practice is characterized through the "goods" it realizes. Second, the relative success, or lack thereof, in the realization of the relevant goods is measured by the practice's "standards of excellence." To

describe and understand a practice would involve, then, specifying the goods it attempts to bring about and the standards of excellence in terms of which such goods are evaluated.

If an individual action is a part of an already established ongoing social practice, a historian cannot hope to understand it, or even to describe its relevant features correctly, without a reference to the goods and standards of the practice in question. (Someone without the slightest notion of what the goods and standards of football playing or symphonic music-making are might see and hear what you and I see and hear at a game or a concert but would have no idea of what was really going on.) Practices constitute the general presuppositions, premises, conditions, constraints in the terms of which particular actions do, or do not, make sense. One might say that practices relate to individual actions like languages relate to individual utterances: a practice is the language an agent speaks.

To be sure, our understanding of the goods and standards of a practice may, and very often does, remain largely practical and implicit, that is, embodied in our ability to act in an appropriate fashion in particular situations, rather than theoretical and explicit, that is, embodied in our ability to say what the relevant goods and standards are. (Our stadiums and concert halls would be quite empty if only the theoretically sophisticated were to be admitted, yet it would be intellectually pretentious to claim that most people have no idea of what is going on in such places.) But historians will naturally want to make the goods and standards of practices they study as theoretically explicit as possible. Even if they prefer to emphasize the level of action rather than that of practice in their work, an explicit understanding of the background practice will make their descriptions and interpretations of an action so much the more secure. Thus, a clear bias of twentieth-century historians in favor of the study of practices rather than actions has deeper roots than a simple mistrust of witnesses to and participants in mass societies in any individual's ability to make much of a difference, to make history. Even historians of an artistic practice for whom specific actions of individual human beings are naturally of central interest will not be able to disregard the background structures of goods and standards that make such actions intelligible.

We have learned from MacIntyre that to describe and understand a practice involves specifying the goods it attempts to make and the standards of excellence in terms of which such goods are evaluated. The stress here has to fall on the goods rather than the standards: the latter may in theory be independently formulated, but actually they are simply embodied in the former. In other words, a description and understanding of a practice primarily involves specifying its fundamental aims.

Let it be added in passing that a historian should, of course, want to go beyond MacIntyre and enrich the description of the aims with a consideration of the means used by those who realize these aims and of the institutions that make the realization of the aims possible. To describe the practice of nineteenth-century symphonic music, one would have to do more than explain its aims. One would

also have to describe the means all those engaged in the practice (composers, performers, audiences, publishers, critics) had at their disposal. One would, in other words, have to say something about the compositional and performing means used directly by the musicians to produce their goods and by audiences to use them (means such as the harmonic and thematic logic, the symphony orchestra, or the concert hall). And one would also have to say something about the institutions that support the activities of the producers, consumers, and intermediaries (institutions such as the middle-class public concert, the publishing house, or the press). In short, one should consider the paradigm of a practice as a configuration involving not only the practice's aims (the goods it wants to achieve and the standards by which such goods are to be evaluated), but also its means (the means used directly by those who make and use the goods in question), as well as the institutions supporting the activities of the makers and users.

A practice as conceived by MacIntyre is necessarily characterized by two features: it possesses a degree of autonomy in relation to other practices; and it has a history of its own. A practice is autonomous, rather than heteronomous or functional, that is, subordinated to another practice, because it is a form of social activity that realizes "goods internal to that form of activity" and because it applies "standards of excellence which are appropriate to, and partially definitive of, that form of activity." Goods are internal to a practice, MacIntyre tells us, when, first, "we can only specify them in terms of" this practice "and by means of examples from" it, and second, when "they can only be identified and recognized by the experience of participating in the practice in question."[4] In other words, a practice is autonomous because it has aims of its own, it does not derive its aims from elsewhere, from another practice, that is, because its aims can be realized only by this, and not by any other, practice.

Needless to say, any practice can also serve to produce goods external to it. But this in no way legitimizes the widespread and crude reductionism according to which the production of such external goods is what at bottom the practice is all about.[5] MacIntyre's clarification of the difference between the internal and external goods is useful:

> It is characteristic of what I have called external goods that when achieved they are always some individual's property and possession. Moreover characteristically they are such that the more someone has of them, the less there is for other people. This is sometimes necessarily the case, as with power and fame, and sometimes the case by reason of contingent circumstance as with money. External goods are therefore characteristically objects of competition in which there must be losers as well as winners. Internal goods are indeed the outcome of competition to excel, but it is characteristic of them that their achievement is a good for the whole community who participate in the practice. So when Turner transformed the seascape in painting or W. G. Grace advanced the art of batting in cricket in a quite new way their achievement enriched the whole relevant community.[6]

A second necessary feature of a practice in addition to autonomy is that it is not simply *in* history, but, rather, has a history of its own. It is a result of a practice, MacIntyre tells us, "that human powers to achieve excellence, and human conceptions of the ends and goods involved, are systematically extended." The standards of excellence by which its goods are evaluated are not given independently of these goods, but rather are embodied in them. Consequently, our understanding of what these standards are is extended and modified with each new genuine achievement of the practice. And, similarly, even our understanding of what the goods brought about by the practice are might be modified and extended in this way.

In other words, the aims of the practice are not fixed once and for all theoretically and independently of the practice, but rather are embodied in the practice itself; consequently, understanding of these aims is likely to evolve and to be modified with each genuinely new achievement. And if the aims can evolve, so, naturally, can the means that serve these aims. It follows that a practice can be radically transformed as it evolves. If it does not lose its identity in the process, it is presumably only because not everything, both aims and means, changes at once. But if, as I have proposed, a description and understanding of a practice primarily involves a specification of its fundamental aims, a truly profound transformation of these aims would have to mark a revolution in the history of the practice. A change of the most basic presuppositions of a practice would constitute, then, what Thomas Kuhn, in *The Structure of Scientific Revolutions,* called a "paradigm shift."[7]

Let me digress again. We have established that the paradigm of a practice is a configuration involving not only the practice's aims, but also its means, as well as the enabling institutions. Thus, if we wanted to write a full history of a practice, we would have to describe it in terms of the changes this configuration undergoes. In doing this, we should make no assumptions about the causal priority of any of the elements of the configuration. In particular, the question whether changes in the conception of the aims drive the changes in the means employed or the reverse has to be answered separately in each specific case, on the basis of detailed empirical investigation, and there is no reason to assume that the answer will always be the same. In fact, it might be advisable to leave the question of what causes what aside at first and begin just by describing how the three elements are correlated at any moment and how they change.

But while all three elements of the configuration (aims, means, and institutions) are important if we want to have a full picture of the practice, and changes in any one of them can cause changes in the others, they are not all important in the same way. A simple definition of a practice, for instance, requires that we introduce its fundamental aims and means, but not the enabling institutions. That a practice cannot be fully defined by aims alone, but only by a combination of aims and means, becomes clear when we reflect on the fact that in the seventeenth century, under the impact of the ruling mimetic theory expressed in such slogans as *ut pictura poesis,* visual depiction and literary description shared their

aims and differed in their means only. And neither can a practice be fully defined by its means alone: language is the means for both historians and novelists. But the enabling institutions, unlike the aims and means, are not necessary to define a practice, since they can change without the practice changing its identity: the practice of symphonic music does not need to be redefined when the recording company supplements or replaces the concert as its enabling institution. Thus, we may claim that in terms of the logic of definition, the aims and means of a practice are fundamental and the institutions are subordinated to them. But we have to keep in mind that this hierarchy is dictated only by the logic of definition and carries no implications as to the causal relations among the elements of the configuration.

Moreover, even though the aims and means are equally important from the standpoint of the logic of definition, they are not equally important from the standpoint of the logic of description. In this case, the aims dictate the means and are independent from them, rather than the reverse. (The narratives of music history, as well as those of other artistic practices, have more often than not concentrated on means. A history of music is usually told as a history of style and its traditional periodization is stylistic. What we should consider is the possibility of a music history centered on aims, with a periodization obeying the internal rhythm of the development of music's aims.) But, again, we need to keep in mind that this is only the descriptive, not causal logic. It simply makes sense to describe the aims without talking about the means, but not the reverse. And this is what I shall do here as I pick up the main thread of the argument again.

Before I do this, however, the reader should be warned. My panorama of the history of European music is of necessity going to be painted with a broad brush, with many details that might complicate the picture simply omitted and with contrasts and antitheses overdrawn. Historical reality is never as neat and tidy as it will appear here. This should not matter. All that my task requires is to get the main features of the landscape right so that we can see the road we have traveled, our present situation, and future perspectives.

b. Functional and Autonomous Music

Modern European art music is a kind of social practice, or perhaps better, a family of interrelated practices, in precisely the sense proposed by MacIntyre, a social activity with its own internal aims on which its claim to relative autonomy rests. This much will probably be quite uncontroversial. Controversy flares up, however, as soon as we attempt to define the starting point. The birth of the modern age has, after all, been dated anytime between the fifth and the late nineteenth century, and the starting point of the modern era in music has been variously located around 1600, 1740, or 1910. At which point did European music acquire the unmistakable characteristics of an autonomous practice? A practice is autonomous, we have learned, because it has aims of its own and does not derive them from another practice. At which point, then, did European music acquire internal aims?

The contrast between autonomous and functional music, that is, between music made and heard for its own sake and music that is nothing but a means of some other practice, is the contrast between "ideal types" that rarely, if ever, actually appear in their pure form.[8] Most of the music as actually practiced in Europe over the centuries falls somewhere between these two poles. Thus, if we confused the autonomy we are looking for with the arrival of the self-conscious theory of aesthetic autonomy in late eighteenth-century Germany, we would have to eliminate from our purview a lot of music which, while embedded in extramusical processes and serving extramusical functions (such as those of liturgy, political representation, or conviviality), has a claim to a partial, or relative, autonomy. (After all, even such a paradigmatic genre of autonomous music as the late eighteenth-century string quartet might with good reason be claimed to have served a function of conviviality not different in kind from that fulfilled by the Italian madrigal in the late sixteenth century.) Rather than expecting to find the point at which the era of autonomous music began, we should look for features of partial autonomy in all music, features that cannot be explained by extramusical functions and that testify to the music's having been made in part for its own sake, that is, features that give the music an artistic character ("artistic" and "autonomous" being synonyms in this case). (It is precisely the continuity of music's internal aims, as opposed to its external functions, that made possible the retrospective inclusion of works of Bach, Monteverdi, and Josquin in the canon of great art music even though the external functions of their music changed.)

Some genres of European music exhibit such features unmistakably at least as early as the thirteenth century, that is, when musicians significantly advanced in transforming polyphony from being a way of embellishing liturgical chant in performance into a method of composition whose products outlast a single performance. The isorhythmic motet of the fourteenth and early fifteenth centuries is arguably the first major genre of art music in the tradition. The central prerequisite for music's acquisition of an artistic character was the emergence of composition as a process of music-making distinct from performance, a partial separation much aided, in turn, by the development of notation, which allowed the products of composition to persist independently of performance. A composer, not being forced to make music in real time, can afford to experiment, to try things out, to risk making mistakes, to an incomparably greater degree than even the most skillful performer and thus can make music whose artistic character is potentially much greater. And the written text of a composition makes it available for study, and hence also for imitation and emulation, which, again, is independent of real time and thus can be much more detailed and multifaceted.

With the invention and development of the basic elements of pitch notation initiated in the early ninth century and completed in the early eleventh, and with the invention and development of the basic elements of rhythmic notation initiated in the early thirteenth and virtually completed in the early fourteenth century, it became possible to fix in writing relative pitches and durations, the two primary parameters of musical thinking until the middle of our own century.

Writing was not absolutely indispensable for the separation between composition and performance to occur: many composers have been known to be able to do a lot of work in their minds rather than in writing, and it is possible to transmit a work orally to the performers. The importance of writing resides, rather, in the fact that the written text makes it possible for music to become an object available for scrutiny independently of the real time of a performance. Thus, thanks to the written text, music can acquire the character of an object ("work" in the traditional sense of the term) distinct from its performances.

The gradual recognition that composing is a distinct part of music-making, different from performing, can be traced in the increasing frequency with which names of composers appear in sources preserving their music. This custom, still exceptional in the thirteenth century, becomes the norm in the fourteenth. By 1477, Johannes Tinctoris, a Flemish chapel master at the Neapolitan court, found it entirely natural to distinguish "composers" (*compositores*) from "singers" (*concentores*) and to talk of musical "works" (*opera*) as something one not only "heard" (*audio*), but also "examined" (*considero*). For Tinctoris, the works of admired composers were worthy of being treated as models for imitation no less then the classical works of poetry. In a famous passage of his *Liber de arte contrapuncti* he declared:

> there does not exist a single piece of music, not composed within the last forty years, that is regarded by the learned as worth hearing. Yet at this present time, not to mention innumerable singers of the most beautiful diction, there flourish . . . countless composers, among them Jean Ockeghem, Jean Regis, Antoine Busnoys, Firmin Caron, and Guillaume Faugues, who glory in having studied this divine art under John Dunstable, Gilles Binchoys, and Guillaume Dufay, recently deceased. Nearly all the works of these men exhale such sweetness that in my opinion they are to be considered most suitable, not only for men and heroes, but even for the immortal gods. Indeed, I never hear them, I never examine them, without coming away happier and more enlightened. As Virgil took Homer for his model in that divine work the *Aeneid,* so I, by Hercules, have used these composers as models for my modest works, and especially in the arrangement of the concords I have plainly imitated their admirable style of composing.[9]

For Tinctoris, the object of imitation and emulation was a composer's style of counterpoint rather than an individual work. By the sixteenth century, the normal way of making a new polyphonic mass had become to base it on the motivic and contrapuntal ideas derived from a specific polyphonic model, a motet or a song, of an admired predecessor, a process of composition technically labeled "imitation" (*imitatio*), or—by those wishing to show off their Greek— "parody" (*parodia*). But already for Tinctoris, what gets imitated is what composers, not singers, have made.

The full recognition that composing results in works whose character is different from that of performances can be first found in 1537 in the widely distributed music primer by the Lutheran cantor Nicolaus Listenius. Where earlier

writers on music, following the Aristotelian notions of "contemplating" (*theoria*) and "acting" (*praxis*), distinguished the "theoretical music" (*musica theorica/ theoretica*), that is, the liberal art dedicated to the scientific contemplation of pitch relations, from the "practical music" (*musica practica*) dedicated to various aspects of the craft of making music, Listenius introduced yet another category, modeled on the Aristotelian notion of "making" (*poiesis*), namely, that of "poetic music" (*musica poetica*), and thus distinguished the theory of composition explicitly from that of performance. Poetic music, Listenius explained, "consists in making or producing, that is, in such labor which even afterwards, when the craftsman is dead, leaves a perfect and absolute work" (*opus perfectum et absolutum*).[10]

The development of modern European art music would be unthinkable without this partial separation of composition and performance in the process of music-making and without the survival of the products of composition independent of performance. These are the defining features that distinguish art music from popular music traditions, at least as these terms will be used here. We would get it all wrong, however, if we insisted on too strict a separation of art and popular music. In particular, we should not imagine that the emergence of art music led to a complete disappearance of popular music. Rather, we should think of European music since at least the late thirteenth century as involving a complex interaction between the two, a precarious, highly unstable, ever changing balancing act. In other words, we should keep in mind that "art music" and "popular music" are no more than heuristically useful ideal types and that much music-making in Europe mixed both types in various proportions.

Let us take another look at our ideal types. I have suggested that its artistic character is the basis for music's claim to autonomy, which implies that, while art music is autonomous, popular music is functional. I have proposed further that the separation of composition from performance and the survival of the products of composition as written texts independent of performances are the two defining features of art, as opposed to popular, music. Popular music exists in real time, in performance; its mode of existence might be called a process. Art music exists in this way too, but it also exists as an object that may be independently surveyed, as a written text that is the result of composition; that is, it has its own peculiar mode of existence that at least since the fifteenth century has been called a "work" (in a sense different from the one in which this term has been used in chapter 1 above, a sense synonymous with my "text"). Note that the symmetry between the two types is less than perfect: music can exist as a process without existing also as a work, but when it does exist as a work it also has to exist as a process, since a written text is also a set of instructions for how to make a performance. One might say that, while it is natural for music to exist as a process, it is something artificial, something requiring an effort, an achievement, for it to exist as a work.[11]

Process and work, music's two contrasting modes of existence, encourage in turn two different modes of experiencing music. With a musical process one

tends to identify, either by participating in the performance, or at least by closely following and identifying with what the performers are doing. The emphasis on events happening in real time invites one either to follow the events closely or to follow them intermittently in a distracted fashion, but in any case to be drawn by them in an attitude of passive identification with the music in those moments when one pays attention to it at all. By contrast, a work objectifies the music, encourages an attitude not of passive identification, but rather of active contemplation from a certain distance. Thanks to the possibility of being studied independently of real time, at one's own leisure, music objectified into a work gains the ability of being taken as a whole, that is, as a form, not as a sequence of loosely related or unrelated successive individual moments, but as a temporal configuration in which each individual moment has a function in the creation of the whole of which it is a part. Even when experienced in real time, a work calls for a mode of experience in which a current moment is heard and understood in relation to its anticipated consequences and recollected antecedents, with the form of the music emerging as a closed whole not so much in the actual experience itself, as in the memory thereof. Note that there is a systematic connection between the idea of artistic autonomy and the idea of the products of an art objectified into works. As a form, that is, a closed whole, a work wants to be contemplated for its own sake rather than being seen as a part of a larger whole or process. In the experience of music, the only thing that really exists is the individual moment we have associated with the popular mode of hearing. This, however, is poignantly transitory, ephemeral, death-bound. The form as a whole is capable of transcending death and achieving immortality, but only at the expense of reality. The form as experienced is not real, but only recollected, imagined. But this dialectic of ephemeral reality and imaginary transcendence characterizes not only our experience of music, but all of our temporal experience. The experience of music thus prefigures the experience of our own existence. "Autonomous art is a piece of enacted immortality, utopia, and hubris all at once," says Adorno.[12]

(It was Heinrich Besseler who introduced the useful distinction between the popular functional practice of "everyday music" [*Umgangsmusik*], in which everybody was an active participant in music-making, and the artistic autonomous practice of "presentation music" [*Darbietungsmusik*], which separated the musicians from listeners; he also developed Hugo Riemann's contrast between the active and passive modes of hearing.[13] My use of these categories differs from Besseler's in so far as I see in them components of ideal types rather than historical realities. I correlate passive hearing with functional music and active hearing with art music, while for Besseler the two types of hearing also separated the Classical and Romantic ages of art music.)

In short, our two ideal types involve, on the side of functional popular music, the mode of existence of music as a performed process happening in real time and the mode of experiencing it in an attitude of passive identification with its individual loosely related or unrelated successive moments, and, on the side of

autonomous art music, the mode of existence of music as a composed work independent of real time and the mode of experiencing it in an attitude of active contemplation of its form, a whole in which the individual moments do not appear independently, but rather as related by the functions they have in making up the whole. But it is crucial to remember that in actual practice the two types appear mixed in various proportions and that, even as an ideal type, art music presupposes popular music as its other: the actively contemplated work is achieved with effort against the underlying background of the process with which one passively identifies.

It has been established above that a description and understanding of a practice primarily involves specifying its fundamental aims and that a truly profound transformation of these aims would have to mark a revolution, a paradigm shift, in the history of the practice. It will be my claim now that with each successive paradigm shift in the history of modern European art music the specific relation and proportion between its artistic and popular components changed.

c. The Rise of Mimetic Music

Unlike architects, sculptors, or poets, modern European musicians knew no classical examples of ancient music with which to compare their own products. The "ancient music" they did know was the heritage of classical ideas about music transmitted in Plato's *Republic* and *Timaeus,* in Aristotle's *Politics* and *Poetics,* in Macrobius' early fifth-century *Commentary on the Dream of Scipio,* and in Boethius' early sixth-century *Fundamentals of Music,* among many other, less influential, texts. What they found in those texts were two basic ideas about the nature and aims of music: the idea that music was the sensuous embodiment of intelligible harmony (*harmonia*) and the idea that music was capable of making humans feel various changeable passions (*pathos*) and thus capable of forming a person's enduring character (*ethos*).

From the *Timaeus,* a text known in the Latin West throughout the Middle Ages, one learned that both the cosmic and the human soul were similarly composed of their constituent elements according to the same proportions, the ratios of the Pythagorean tuning they shared with a musical *harmonia,* a diatonic octave scale. In the "Dream of Scipio" that Cicero described in the last book of his *Republic,* the tones of the diatonic octave scale are produced by the eight celestial spheres surrounding the earth. Macrobius' widely disseminated *Commentary* made the notion of the music of the spheres an enduring commonplace. The same intelligible harmony of simple numerical ratios is thus embodied in the structures of the world, man, and music in what Boethius, throughout the Middle Ages the single most influential authority on music, will call *musica mundana, humana, et instrumentalis.* Plato was also a major source of the belief that specific scales, rhythms, and instruments can affect human passions in specific ways and thus form character. Thus it is not surprising to find in Boethius' opening chapter, entitled "Music is related to us by nature and can ennoble or corrupt the character,"[14] the following words: "of the four

mathematical disciplines, the others are concerned with the pursuit of truth, but music is related not only to speculation but to morality as well. Nothing is more characteristic of human nature than to be soothed by sweet modes and stirred up by their opposites."[15]

In the pronouncements of music theorists, these two ancient ideas about the aims of music, the idea of music as the sounding embodiment of the intelligible harmony of simple numerical ratios, the same harmony embodied in the structure of the cosmos, and the idea of music as capable of stirring human passions and forming character, presided over the development of the art during the Middle Ages and beyond. But it appears that, until the middle of the sixteenth century, the practice of vocal polyphony, which included all the most artistically developed genres, the mass and motet, in particular, was governed almost exclusively by the aim expressed in the idea of harmony. The ethical power of music was dutifully paid regular lip service in introductions to treatises on music, but it did not influence the actual content of *musica practica*. The theorists who described the practice of polyphony were not concerned with teaching musicians how to maintain or increase their sway over human passions. Rather, from the late thirteenth to the early sixteenth century, the principal aim of European art music, as both the surviving specimens of the practice and the contemporary theoretical reflection on it attest, was the achievement and perfection of harmony. (To avoid a possible misunderstanding, I hasten to add that in an age in which the idea of harmony reverberated with eternal, divine, cosmic overtones, its pursuit by the great masters of fifteenth- and sixteenth-century polyphony from Dufay through Lassus resulted in music of great expressive power, depth, and variety, music without which we might have only a very approximate idea of what it felt like to immerse oneself in fervent prayer, or in ecstatic contemplation.)

The sense of progress, of a practice approximating its aim ever more closely, is palpable in the writings of Tinctoris, who in 1477 dismissed all music of more than forty years of age as worthless. From the middle of the sixteenth century on, an opinion began to spread that this progress had attained its aim. For the Swiss humanist Heinrich Glarean, writing in 1547, the early sixteenth-century vocal polyphony of Josquin des Prez and his Franco-Flemish contemporaries represented the "perfect art to which nothing could be added" (*ars perfecta, qui nihil addi potest*).[16] For Gioseffo Zarlino, the Venetian student and eventual successor of the Flemish chapel master at St. Mark's, Adrian Willaert, the practice had finally been perfected by his teacher. Zarlino clearly echoed Glarean when he declared that the music of his day "has been brought to such perfection that one almost cannot hope for anything better."[17] Zarlino's monumental treatise of 1558, *Le Istitutioni harmoniche,* was generally and correctly considered to be the definitive theoretical treatment of the *ars perfecta* until well into the eighteenth century, when its position was challenged by *Gradus ad Parnassum,* the 1725 handbook of strict counterpoint written by the Viennese court chapel master, Johann Joseph Fux. (In the meantime, the late sixteenth-century Roman composer, Giovanni Pierluigi da Palestrina, whose music and style were canonized

in the repertory of the papal chapel, had displaced both Josquin and Willaert as the classic exponent of vocal polyphony.)

Like Glarean, whose praise for Josquin included the statement that "no one has more effectively expressed the passions of the soul in music than this symphonist,"[18] Zarlino was by no means oblivious to the ethical side of music. On the contrary, he found traditional reports of the miraculous emotional effects ancient musicians had achieved entirely credible and thought that "also at the present time music is not deprived of the power to achieve such effects."[19] But he considered the "effects," impressive and important though they were, not to be the central aim of music-making. The essence of music for him was harmony (the very title of his summa of theoretical and practical music, *The Harmonic Institutions,* announces this): "speaking universally, . . . music is nothing but harmony."[20] "Harmony" was traditionally defined as the "concord of discords, meaning a concord of diverse things that can be joined together,"[21] the concord being conceived as a proportion expressible by a simple numerical ratio.

In music, harmony was embodied in consonant relations between two or more sounds and especially between two or more simultaneous melodies. The two topics Zarlino discussed in depth in the practical part of his book were the modes and counterpoint. Evidently, he believed that the mastery of these two subjects gave the composer what he needed to know, if he wanted to ensure that his music be harmonious. The ideal aim of *ars perfecta* was the harmonious movement of simultaneous vocal melodies regulated by the doctrines of the modes and counterpoint. The proper employment of the modes safeguarded the harmonic integrity of the individual melodic lines in a polyphonic composition, and the proper employment of the contrapuntal rules safeguarded the harmonic integrity of the polyphonic whole. The doctrine of counterpoint was particularly important, since it established which vertical harmonies were legitimate and told one how to move correctly from one to another. Since dissonances presented the main threat to the consonant essence of "harmony," the core of the teaching had to lie in the strict regulation of dissonances. This core was supplemented by the elucidation of special contrapuntal techniques, the most important of which was called the "fugue" (*fuga*); it allowed one to use the same or similar melodic material in all the voices of a phrase, thus ensuring that, as Tinctoris had already put it, all singers would sing "with diverse (but not adverse) voices."[22]

But just as soon as Zarlino perfected its theoretical foundations, the practice of vocal polyphony based on the idea of music as the sounding embodiment of intelligible harmony of simple numerical ratios began to be challenged.[23] Between the middle of the sixteenth and the early seventeenth centuries, European art music experienced its first paradigm shift. In a nutshell, the rival ancient idea of music as capable of stirring passions and forming human character began to be taken seriously, without the idea of music as harmony being discarded altogether. When by the middle of the seventeenth century, the revolution was completed and a new practice stabilized, it found itself governed not by one, but by two competing aims, the embodiment of harmony and the representation of pas-

sions. The idea of music as an ethical force graduated from being an idea conventionally invoked in praise of music to an aim capable of shaping actual practice. And the balance between the two ancient ideas changed.

Perhaps the earliest theorist who unmistakably promoted the cause of the musical representation of passions was another Italian student of Willaert, and, beside Zarlino, the most substantial figure in the music theory of the 1550s, Nicola Vicentino. In his *L'antica musica ridotta alla moderna prattica* of 1555, Vicentino insisted repeatedly that music should express the meaning of the words, "show by means of the harmony their passions,"[24] and demanded that harmony be subordinated to passions: "music made upon words is made for no other purpose than to express the thought and the passions and their effects with harmony."[25] The concept of imitation linked in his thought the art of the poet and that of the composer, whom Vicentino called, in an expression reminiscent of Listenius, the "musical poet" (*Poeta Musico*).[26] A chain of imitation began with the passions and led through the words of the poet, the music of the composer, and the sounds of the singer to the listener in whom the imitated passions were to be aroused.

In postulating the imitation and arousal of passions as the most fundamental goal of music-making, Vicentino was no doubt inspired by the classical reports of the extraordinarily powerful ethical and emotional effects achieved by music in antiquity, reports so widely known in his time that Vicentino could refer to them simply as "those effects which, as the Authors write, were made in ancient times"[27] and safely assume that his readers would know precisely what he was referring to. His aim, programmatically announced in the very title of his treatise, *The Ancient Music Restored to Modern Practice,* was not an antiquarian restoration of the stylistic and compositional resources of ancient music. It was, rather, the recovery for modern musicians of the miraculous power of ancient music.

In other words, what needed to be restored, Vicentino claimed, were not the means but the aims of music. As for the means, these required not restoration, but further development, since their power to move diminished as one got used to hearing them. This point deserves our attention. In the period under discussion, the humanistically inspired reading of ancient pagan authors was, superficial appearances notwithstanding, likely to motivate progressive rather than conservative practice, the development of new musical resources and styles rather than the restoration of old ones. In the musical version of the "quarrel of the ancients and moderns" which Vicentino initiated and which lasted, as we shall see, until the middle of the eighteenth century, the "ancients," those who wanted musical practice to proceed under the banner of the imitation of passions, were likely to advocate stylistic change. The defenders of harmony were the defenders of the stylistic status quo. It is not difficult to see why this was the case. Harmony, whether cosmic, human, or instrumental, is immutable. Its laws may be progressively discovered and described, the musical practice embodying it may be perfected. But once it has been perfected (whether by Josquin,

Willaert, Lassus, or Palestrina) and once its rules have been properly formulated (by Zarlino), stylistic history has come to an end. It could resume again only when motivated by a different ideal, that of passions. Since the practice of vocal polyphony achieved perfection, the only way forward was to invent another, second practice.

If Zarlino spoke most eloquently for the "moderns," the most important spokesman for the "ancients," the theorist who formulated their program most forcefully and influentially, was not Vicentino, but Zarlino's pupil, the Florentine lutenist Vincenzo Galilei. In the 1570s and 1580s, Galilei played an important role as an authority on music theory in the discussions of musicians, poets, and amateurs who constituted the informal academy known as the Camerata of Count Giovanni de' Bardi, a group whose interest centered on a Vicentinian project of the revival of ancient Greek music. But unlike Vicentino, whose actual knowledge of ancient music theory was extremely limited, Galilei approached the task of understanding ancient music more seriously than any of his predecessors had and was lucky enough to get expert advice between 1572 and 1582 from the greatly learned Florentine philologist residing in Rome, Girolamo Mei. By the time Galilei initiated their correspondence, Mei was already intimately familiar with virtually the complete corpus of ancient Greek music theory, and it was Mei's understanding of ancient music, as well as his arguments for its superiority over modern practice, that decisively influenced Galilei and turned him away from Zarlino. The result was Galilei's *Dialogo della musica antica, et della moderna* of 1581, the Camerata's main theoretical statement.

Before corresponding with Mei, Galilei believed with Zarlino that music's aim was to provide pleasure by means of harmony. Mei showed him how a different aim might be envisioned, an aim that gave music ethical significance and thus was higher than mere sensuous pleasure, how modern music might be criticized from the standpoint of ancient practice. Music of the ancients, Mei claimed, aimed not just to delight the ear, like their contemperaries, but to arouse passions.

Having absorbed Mei's teaching, Galilei started to believe that the aim of modern practice would be suitable for instrumental music only, and that it was inferior to the ethical aim of ancient vocal practice. "The practice of music," he wrote in the *Dialogo,* "was introduced by men . . . first, . . . to express the conceits of the mind with greater efficacy . . . and second, to impress them with equal force upon the minds of mortals for their benefit and comfort."[28] The "conceits" that music is to express and impress are, primarily, the passions of the words, and the listeners' benefit is understood in the Horatian fashion not only as pleasure, but also as moral betterment, "not only as delightful to life, but also as useful to virtue."[29] These were the aims of ancient music and should be, but are not, the aims of modern practice too.

Modern practice, which Galilei identifies with polyphony, got under way some hundred and fifty years ago (Galilei's chronology is remarkably similar to that of Tinctoris) and (another echo of Glarean's *ars perfecta*) "from that time until

today, . . . it has reached the highest pinnacle of perfection man could possibly imagine."[30] Nevertheless, "no man of understanding thinks that they have brought it back to its ancient state."[31] The reason for this is that modern practice treats counterpoint as the aim in itself, forgetting, in the words of Giovanni de' Bardi, that "just as the soul is nobler than the body, so the words are nobler than the counterpoint."[32] In theory, Galilei thought, the task of restoring music to its ancient state had already been accomplished by Girolamo Mei. But the task of doing the same thing in practice remained to be accomplished.

The task involved turning away from Franco-Flemish polyphony. In his letters to Galilei, Girolamo Mei affirmed that the aim of ancient musicians "was not the sweetness of the consonances to satisfy the ear (since there is no testimony nor any evidence by the authors about the use of these in their singing) but the complete and efficacious expression of everything he wanted to make understood . . . by means and through the aid of high and low sounds . . . accompanied with the regulated temperament of the fast and slow."[33] Inspired by Mei, Galilei and his Camerata friends concluded that, if modern vocal music was to abandon the aim of sensuous pleasure for the higher one of ethical efficacy, it also had to abandon polyphony for monophony. Passions were represented in a melody by appropriately chosen vocal range and rhythm and tempo. Polyphony not only made words difficult to follow, but worse, it set the same words in contradictory fashion, giving them different ranges and rhythms in different voices.

In his late unpublished discourses, Galilei modified this radically antipolyphonic stance somewhat and began to advocate what came to be known as "monody," that is, vocal melody supported by the accompaniment of instrumental consonant harmonies. Instrumental consonances, he was now willing to concede, not only pleased the ear: "the musician, with variety of intervals and in particular of consonances communicates to the intellect all the passions of the soul, especially shaped appropriately by the text."[34]

In Italy, the ground for this sort of texture of instrumentally and chordally accompanied vocal melody was well prepared. Already in 1528, Baldassare Castiglione in his *Il cortegiano* advocated solo song with viol accompaniment (*il cantare alla viola*) as the most appropriate form of courtly vocal music. But the reforms stemming from the Camerata circle were more far-reaching, in that they went beyond a mere expression of preference for a particular mode of performance and resulted in viable new styles and genres of composition. Their permanent legacy was to provide even the most ambitious art music with a textural alternative to the classical equal-voiced polyphony of *ars perfecta*. Thus, the plurality of aims that was the most important achievement of the late sixteenth century involved a corresponding plurality of means and, not the least among them, a plurality of textures. The new genre of opera, the most important fruit of the Camerata discussions, became the main arena for the employment of instrumentally accompanied vocal melody and the most artistically ambitious genre to challenge the supremacy of the polyphonic mass and motet.

With Galilei's *Dialogo,* the new paradigm, already outlined in some detail by

Vicentino, is fully mapped out. There are two musical practices, the modern and the ancient. The modern aims at "nothing other then the delight of hearing"[35] and hence is adequately served by means of polyphony, by what Zarlino called "harmony." The ancient, by contrast, wanted "to lead another to the same affection one feels oneself,"[36] to be ethically useful, and hence it could not treat harmony as an aim in itself, but had to subordinate it to the passions of the words. Since ethical education is clearly nobler than mere pleasure, the aim of ancient practice is offered as an alternative, and higher, ideal for contemporary practice as well.

In the early seventeenth century, the new paradigm was succinctly and famously summarized by Claudio Monteverdi, the leading composer among the new "ancients." When in 1600 Giovanni Maria Artusi, a Bolognese canon and pedantic student and follower of Zarlino, subjected several excerpts from Monteverdi's then unpublished madrigals to a critical analysis in a book entitled *L'Artusi, overo delle imperfettioni della moderna musica* (excerpts that he significantly presented without their poetic texts), he gave Monteverdi an invaluable opportunity to formulate and defend his artistic goals in the prefatory letter in the Fifth Book of his Madrigals of 1605, a text the composer's brother, Giulio Cesare, glossed extensively in a "Dichiarattione" that appeared in Claudio's *Scherzi musicali* of 1607. To Artusi's accusation that some contemporary composers follow no other rule than "to satisfy their whims,"[37] Claudio Monteverdi responded "that I do not compose my works at haphazard"[38] and that, like his predecessors, the contemporary composer also "builds upon the foundation of truth."[39] It is this foundation, however, that has shifted. There were now two distinct musical practices, the older "first practice" (*prima prattica*), "finally perfected by Messer Adriano [Willaert] with actual composition and by the most excellent Zarlino with most judicious rules,"[40] as the composer's brother explained, and the newer, "second practice" (*seconda prattica*). The second practice differed primarily in its treatment of dissonances, introducing and resolving them in ways that Zarlino's rules of strict usage prohibited. The core of the *seconda prattica* consisted in a relaxation of these rules, a relaxation understood not as an abrogation whereby the rules were simply pushed aside as irrelevant, but as the introduction of licenses the expressive effect of which could be felt only against the remembered background of the strict usage. The second practice conceived of dissonance not as a threat to "harmony," a threat which had to be strictly controlled and subordinated to consonances, but rather as an independent expressive means, and expressive at least in part precisely because licentious.

In a famous passage, Giulio Cesare explained how the foundation of truth shifted, making room for the new licentious compositional techniques: "By First Practice he [Claudio Monteverdi] understands the one that turns on the perfection of the harmony, that is, the one that considers the harmony not commanded, but commanding, not the servant, but the mistress of the words. . . . By Second Practice . . . he understands the one that turns on the perfection of the melody, that is, the one that considers harmony not commanding, but com-

manded, and makes the words the mistress of the harmony."[41] Relying directly on Plato's *Republic* (398D), Giulio Cesare understood by "melody" the union of "the words, the harmony [that is, the tune], and the rhythm" (*oratione, harmonia, Rithmo*). He also quoted Plato's opinion that it was apt "if the rhythm and the harmony follow the words, and not the words these," the opinion that was clearly a major source of his brother's celebrated slogan. (Claudio Monteverdi, in turn, made clear that his aims were identical with the ancient ethical idea of music when he quoted the title of the first chapter of Boethius in the foreword to his *Madrigali guerrieri ed amorosi* of 1638: "this [to move our mind] is the purpose which all good music should have—as Boethius asserts, saying, 'Music is related to us, and either ennobles or corrupts the character'."[42])

The slogan itself expressed with paradigmatic clarity and force the most fundamental opposition underlying the new vision of what music was for, the opposition between the idea of music as the sensible embodiment of the imperturbable and eternal intelligible harmony obtaining in the universe God created, and the idea of music as the mimetic medium imitating the impassioned and protean intonations of human speech and enhancing the emotional power of the sung words. What was centrally at stake in the opposition was the status of harmony: on the one hand, harmony was understood to be the essence of music, autonomous and not subservient to anything else; on the other, it was subordinated to something more important, the imitation and expression of the passions of the singing character, passions whose nature and object was made clear through the text. It was no accident that Artusi presented the excerpts from Monteverdi's madrigals without the text: autonomous harmony was all that mattered to him. Nor was it surprising that the composer found this abstraction of harmony from the text objectionable.

For the second practice, the text was of the essence. It belonged to music by its platonic definition (according to which music was the union of the words, harmony, and rhythm), and because it explained and justified harmonic usages that did not make sense on their own. For the first practice, however, even vocal music was essentially "nothing but harmony," as Zarlino put it. The text was added to the music, but it was not the music, since the autonomous harmony obeyed its own logic. Galilei had a point when he suggested that polyphony was the appropriate means of purely instrumental music, though admittedly the point is easier to see from twentieth- or rather late eighteenth-century hindsight, since the instrumental music of Galilei's own time was simply no match for the artistic riches of the contemporary vocal polyphony. The contingent fact that the *ars perfecta* was vocal should not make us oblivious to the features it shared with what in the nineteenth century would have been called "absolute" music, to its relative autonomy not only from external functions (to be sure, the core of this music was liturgical, but the means it employed were to a considerable extent independent of liturgy), but also from language.

The dichotomy that emerged in the middle of the sixteenth century between the harmonic and mimetic aims of music, the result of the view that passions

might be taken seriously as an object of practical musical concern, that the demands of harmony and those of passions did not have to coincide, and that the primacy and autonomy of harmony might be challenged, remained in force at least through the third quarter of the eighteenth century. The idea which in the middle of the sixteenth century stirred the imagination of isolated humanistically inspired visionaries, the idea of music as a mimetic art, an art able to imitate passions, came to dominate opinion in more advanced circles by the last quarter of the century. It did so, however, without eliminating the idea of harmony altogether, so that from now on the two ideas had to coexist. And the tension between the two Monteverdian practices could be strongly felt as late as the middle of the eighteenth century, in Jean-Jacques Rousseau's polemic against the great harmonic theorist and the most significant French composer of his time, Jean Philippe Rameau.

Rameau's admiration for Zarlino, whom he regarded as his most important predecessor in harmonic theory, is well documented (Rameau quoted approvingly Brossard's opinion that Zarlino was "the prince of modern musicians"),[43] and the centrality of the idea of harmony to his thinking about music is announced in the very title of his seminal *Traité de l'harmonie* of 1722. What particularly provoked Rousseau was Rameau's Zarlinian identification of music's essence with harmony and the resulting subordination of melody to harmony. Rameau opened his treatise with these sentences:

> Music is the science of sounds; therefore sound is the principal subject of music. Music is generally divided into harmony and melody, but we shall show in the following that the latter is merely a part of the former and that a knowledge of harmony is sufficient for a complete understanding of all the properties of music.[44]

In his *Essai sur l'origine des langues* of ca. 1754–61, Rousseau argued that music and language had a common origin in human moral needs and passions, and then separated so that language could express the ideas of reason and melody the passions of the soul. But "to the degree that language improved, melody, being governed by new rules, imperceptibly lost its former energy, and the calculus of intervals was substituted for nicety of inflection. . . . That is also when it stopped producing the marvels it had produced when it was merely the accent and harmony of poetry and gave to it the power over the passions that speech subsequently exercised only on reason."[45] Having lost its intimate connection with speech and become identified with purely abstract harmony, music "found itself deprived of the moral power it had yielded when it was the twofold voice of nature."[46] It is imitation alone, Rousseau argued, that raises music to the level of a fine art, and what allows music to imitate passions is not harmony, not pure sounds and their intervallic relations, which can provide no more than sensuous pleasure, but melody, which follows the inflections of the impassioned speaking voice.

Thus Rousseau's polemic against Rameau recapitulates at a distance of some

hundred and seventy years the central themes of Galilei's strictures against Zarlino. Similarities between Rousseau's and Galilei's positions are no less striking than Rameau's more overtly acknowledged indebtedness to Zarlino. They extend to such mysterious details as Galilei's comparison, in his unpublished *Discorso intorno all'uso dell'Enharmonio,* of the function of vertical consonances in music to that of colors in painting, a topic Rousseau, who was unlikely to have read Galilei's discourse, developed in a most interesting way when he compared melodic lines with drawing and chords with coloring, claiming that in both music and painting only lines served the purpose of representation, while chords and colors provided mere sensuous pleasure. Rousseau's argument, developed in a chapter devoted to the crucially important topic of melody, deserves to be quoted at some length:

> Just as the feelings that a painting excites in us are not at all due to colors, the power of music over our souls is not at all the work of sounds. Beautiful, subtly shaded colors are a pleasing sight; but this is purely a pleasure of the sense. It is the drawing, the representation, which gives life and spirit to these colors. The passions they express are what stir ours; the objects they represent are what affect us. . . . The role of melody in music is precisely that of drawing in a painting. This is what constitutes the strokes and figures, of which the harmony and the sounds are merely the colors. . . . Music is no more the art of combining sounds to please the ear than painting is the art of combining colors to please the eye. If there were no more to it than that, they would both be natural sciences rather than fine arts. Imitation alone raises them to this level. But what makes painting an imitative art? Drawing. What makes music another? Melody.[47]

No less than the Galilei-Zarlino dispute, the Rousseau-Rameau polemic shows to what extent the newer mimetic view of music embraced by the often somewhat dilettantish intellectuals put the learned professional guardians of the traditional craft who espoused the older harmonic view on the defensive. In the seventeenth and eighteenth centuries one talked of music, but more often than not one meant the representational genre of opera. In this climate, it was natural for the "ancients" to score polemical points against the "moderns." The agenda laid out in Italy in the late sixteenth century remained valid in all of Europe for almost two hundred years, to be challenged only in the late eighteenth century by the new German thinking on instrumental music.

The legendary ethical power of ancient music is invoked by Rousseau no less than by Vicentino and Galilei to justify their advocacy of the ideal of music as a mimetic art, as imitative of passions. But, as we already know, legends testifying to this miraculous power were never forgotten and constituted a standard repertory of the topic of *laus musicae* throughout the Middle Ages without anyone drawing serious practical consequences from them. What happened in the mid-sixteenth century that allowed the representation of passions to challenge the embodying of harmony in a serious and practical way for the first time and to become the dominant aim of music-making? Without pretending to offer an

exhaustive explanation of such a profound shift, one that reorganized the aims and means of the whole musical practice, one might single out two important causes.

First, the sixteenth-century revolution in natural sciences was making the idea of cosmic harmony, to which the harmony of music supposedly corresponded, less and less secure. As Alexandre Koyré pointed out, modern science, with its implied separation of value and fact, was bound to undermine and eventually discard the use of value-concepts, such as harmony, Johannes Kepler's and Marin Mersenne's powerful rescue efforts notwithstanding. Zarlino could still believe in the analogy of musical and cosmic harmony, because he understood the harmonious concord of diverse elements to consist in both cases in proportions expressible in similar numerical ratios. But, even as he wrote, scientists were beginning to challenge the traditional Ptolemaic cosmology and offering new views of the mathematical structure of the universe, transforming the closed premodern cosmos into the infinite universe of modern science.

At the same time, empirical research into acoustics undertaken by the scientist Giovanni Battista Benedetti and later by Galilei demonstrated that the ratios of the just intonation on which Zarlino's view of musical harmony rested could not as a matter of fact be the basis of modern practice. The tuning, Ptolemy's syntonic diatonic, was greatly attractive to theorists of polyphonic harmony, since it made all consonances, perfect and imperfect, just; in the rival Pythagorean tuning, only perfect consonances were just, that is, only these were, strictly speaking, consonant, which created a discrepancy with the practice that recognized thirds and sixths as consonant. Ptolemy's syntonic diatonic was rediscovered by the first real humanist among music theorists, Franchino Gaffurio, in his *De harmonia musicorum instrumentorum opus* of 1518, and championed as the basis of contemporary practice by Giovanni Spataro in *Errori di Franchino Gafurio* (1521), Lodovico Fogliano in *Musica theorica* (1529), and Zarlino. Benedetti's proof, in a letter to Cipriano de Rore (ca. 1563) and in *Diversarum speculationum mathematicarum & physicorum liber* (1585), that the use of just intonation in polyphonic practice was bound to produce a lowering of pitch deprived polyphonic harmony of its theoretical foundations. Thus, the credibility of the analogy between celestial and musical harmonies was undermined on both ends. This "untuning of the sky" (to borrow John Hollander's paraphrase of Dryden's famous image) meant that music had to look for a new justification of its existence.

Second, just as scientific empiricism was beginning to erode the credibility of the correspondence between the musical and cosmic harmony, humanist reverence for ancient ideas and practices provided music with a viable alternative ethical role based on the subordination of harmony to words. We have already seen how Giulio Cesare Monteverdi justified the second practice by invoking the authority of Plato. The same passage from Plato's *Republic* in which the primacy of words over harmony and rhythm is asserted was used some seventy-five years earlier by Bishop Jacopo Sadoleto, a future member of the Council of Trent, in his *De liberis recte instituendis* of 1533 to support his, and later the Council's,

view that music should be guided by the text. (Sadoleto's book was known and quoted by Galilei.) The same passage from Plato served as an inspiration to those who wanted to subordinate the autonomous "harmony" of the Franco-Flemish polyphonic tradition to words, whether their main interest was in the reform of church music or secular music.

Two further developments reinforced the turn to the passions of the words. Late fifteenth-century Florence witnessed in the writings of the Neoplatonist philosopher and magician Marsilio Ficino the birth of an influential and coherent theory explaining how music might achieve its powerful magical effects. In the words of the foremost student of Ficino's musical magic, D. P. Walker, Ficino

> is the earliest Renaissance writer I know of to treat the effects of music seriously and practically, and not merely as a constituent of the rhetorical topic of the *laus musicae*. By providing them with a rational explanation, he removes them from the status of more or less legendary marvels, makes them into exciting realities, and, by his astrological music, indicates ways of reviving them.[48]

Zarlino was aware of Ficino's theories, as was, more tantalizingly, Monteverdi's champion, a certain L'Ottuso Accademico, who, in a letter published by Artusi (in *Seconda parte dell'Artusi overo delle imperfettioni della moderna musica,* 1603), quoted Ficino to explain how music influenced affections. By the middle of the seventeenth century, Descartes would provide the musical world with a new but related theory of the nature and mechanism of passions in his *Les passions de l'âme* (1649).

At the same time, the steadily increasing influence of Aristotle's *Poetics,* generally available only since 1498 when Giorgio Valla's Latin translation appeared, reinforced this platonic lesson by providing music, along with poetry, with a mimetic aim and by suggesting for it the role of a powerful amplifier of impassioned dramatic speech. We have heard Rousseau claiming the status of a fine art for music on the basis of its mimetic abilities. The Aristotelian notion of representation (*mimesis*) provided music with a ground on which it could be compared with poetry, eventually allowing it to enter, in the eighteenth century, the emerging modern system of fine arts. Thus the shift from harmony to passions meant also that, increasingly, it was to poetics and rhetoric, rather than to the mathematical disciplines of the quadrivium, that music theorists looked for sources of useful concepts and ideas. Step by step, music ceased to be a premodern liberal art allied with the quadrivium and became a modern fine art allied with other fine arts.

To summarize this part of our story, the new paradigm that began to emerge in the late sixteenth century and persisted through the late eighteenth pitted the older idea of music as a sounding embodiment of abstract harmony and the newer idea of music as a mimesis of human passions against one another. The mimetic idea represented a return to the ancient conception of music as consisting of

harmonia, rhythmos, and *logos,* and it made harmony subservient to the words that specified the represented passions and hence justified the harmonic means. The abstract idea saw the essence of music in *harmonia* alone and did not need words to justify the autonomous logic governing the choice of those simultaneously sounding tones and those intervallic progressions that made sense. In other words, the most important difference between the two ideas was that in the mimetic conception language was an essential component of music, while in the abstract conception it was not. The distinction, incidentally, should in no way be confused with the distinction between vocal and instrumental music. Artusi's untexted examples show that a first-practice musician understood even vocal music essentially in terms of abstract counterpoint. And by the early eighteenth century mimetic musicians heard even instrumental melody as if it implied a text that specified the represented passions, as Johann Mattheson made clear in his *Der vollkommene Capellmeister* of 1739.

The mimetic idea had an obvious ethical-political justification, in that the representations of passions could be seen as serving the purpose of human self-knowledge and moral betterment. The justification of the abstract idea was shown by its critics to be more precarious. For its defenders, the pleasure afforded by musical harmony had a profound metaphysical justification, since the intelligible harmony that music embodied was the same as that of the world God created, and hence music's harmony was a singularly suitable medium in which to praise God. (As Tinctoris put it in 1477, "the art of counterpoint . . . which, of the consonances declared by Boethius to govern all the delectation of music, is contrived for the glory and honor of His eternal majesty."[49]) But for its detractors the pleasure afforded by musical harmony was merely pleasure of the senses, "nothing other then the delight of hearing," as Galilei opined. The abstract idea of music was best served by means of the essentially abstract though vocally realized counterpoint of the sacred genres of mass and motet. The mimetic idea was best served by means of the essentially texted instrumentally accompanied vocal melody of the secular genre of opera.

The new paradigm fundamentally reconfigured the relationship between our two ideal types of art and popular music. The affinities between abstract and art music, on the one hand, and mimetic and popular music, on the other, are systematic. Mimetic music, music that represents and amplifies the passions of the singing personage, calls for the popular mode of hearing in which the listener passively identifies with the personage at any given moment, and it favors the popular mode of existence of music as a performed process in real time. Mimetic music is the performer's art; the success of an impersonation depends more on the performer than on the composer. Early seventeenth-century monodies, those of Sigismondo d'India, say, are tedious unless brought to life by a convincing singer. Carl Philipp Emanuel Bach linked mimetic music with the art of the performer explicitly when in his 1753 *Versuch über die wahre Art das Clavier zu spielen* he paraphrased lines from Horace's *Ars poetica* and claimed that a performer who wants to move others must himself be moved.[50] (More realistically,

Diderot argued in his 1773 *Le Paradoxe sur le comédien* the exactly opposite point: a great actor knows how to represent the outward signs of feeling, but is himself unmoved when he plays; otherwise, how could he play the same part twice?[51]) A century later, Eduard Hanslick, a great enemy of the "aesthetics of emotion" which he considered "putrefied," cogently argued that it was the aesthetics of the performer:

> The act in which the direct emanation in tones of a feeling can take place is not so much the fabrication as the reproduction of a music work. . . . To the performer is granted to release directly the feeling which possesses him, through his instrument, and breathe into his performance the wild storms, the passionate fervour, the serene power and joy of his inwardness. . . . The composer works slowly and intermittently, the performer in impetuous flight; the composer for posterity, and the performer for the moment of fulfillment. The musical artwork is formed; the performance we experience. . . . The same piece disturbs or delights, according to how it is animated into resounding actuality.[52]

And if mimetic music is the music of the performer, abstract music is the music of the composer. When music is conceived as an abstract logic of tonal relations, it calls for the artistic mode of experience in which one wants to go beyond isolated moments and to take in the form of the whole in active anticipatory and recollecting contemplation, and it favors the artistic mode of existence as a composed and written work relatively independent of real time.

European music culture of the seventeenth and eighteenth centuries unmistakably favored the mimetic and popular side of the new paradigm. The abstract heritage of *ars perfecta* was demoted from the central position it had occupied in the fifteenth and sixteenth centuries and became the domain of provincial, conservative, and pedantic, but often also learned and skillful, professional church musicians, whether Catholic followers of Palestrina or German Lutheran cantors. The center stage was now taken by opera and its cosmopolitan and urbane, progressive and often dilettantish intellectual devotees. (The decline in the volume of music publishing throughout Europe after 1620 which Lorenzo Bianconi noted and which he persuasively attributed to economic factors may perhaps also be a symptom of a decline in prestige that abstract art music suffered.[53]) But between, roughly, 1780 and 1820 another paradigm shift, as fundamental as that of the late sixteenth century, but occurring this time not in Italy, but in Germany, completely revolutionized the practice of music in Europe.

d. The Rise of Abstract Music

To understand this new revolution one has to realize that what brought it about was not an introduction of new aims, but rather a shift in the balance between the old ones. Abstract music once again became a viable field of innovative activity and thought, while mimetic music lost its predominance and, in some circles, suddenly began to seem old-fashioned and worn. Nothing could be

more emblematic of this revolution than the way it posthumously transformed an obscure Lutheran cantor from provincial Leipzig into the universal "composers' composer," the "progenitor of harmony" (*Urvater der Harmonie*) as Beethoven called him in 1801,[54] whose *Wohltemperiertes Klavier* and *Kunst der Fuge* distilled for the new era all the arcana of abstract polyphony, surely the most spectacular revaluation in music history.

(Note, by the way, that while this transformation was no doubt one-sided, ignoring as it did Bach's commitment to mimesis, it did not involve a complete falsification: Bach's own self-image was deeply rooted in the tradition of Glarean's *ars perfecta*. The concept of "perfection" is central to Bach's self-understanding as conveyed by Birnbaum. In the words of Christoph Wolff, "the reason for Scheibe's incomprehension and Bach's lack of compromise [in "the famous controversy . . . between Scheibe and Birnbaum (speaking for Bach)"] is actually founded on his work's claim to perfection. 'Perfection' is, in fact, often alluded to in Birnbaum's argumentation, culminating in the plural form in his terse reference to 'the Extraordinary Perfections of the Hon. Court Composer' (die sonderbaren [unmistakable, distinctive] Vollkommenheiten des Herrn Hof-Compositeurs). Bach's individualistic adherence to principle, utterly unsuited for debate, draws its legitimacy from his avowal of perfection."[55] And further: "Perfection implies the knowledge of 'the most hidden secrets of harmony.'"[56] The expression "the most hidden secrets of harmony" comes from the obituary published by Carl Philipp Emanuel Bach and Johann Friedrich Agricola.[57] And the concept of harmony is central to Bach's posthumous image. Thus Goethe writes to Carl Friedrich Zelter about the impression Bach's organ music made on him when he heard it at Berka in December of 1818: "it was there . . . that I first obtained some idea of your grand master. I said to myself, it is as if the eternal harmony were conversing within itself, as it may have done in the bosom of God just before the Creation of the world. So likewise did it move in my inmost soul, and it seemed as if I neither possessed nor needed ears, nor any other sense—least of all, the eyes."[58])

We would not do justice to the situation after 1800, however, if we imagined that the idea of mimetic music simply disappeared to be replaced by something else. On the contrary, the idea remained the guiding principle of the cosmopolitan operatic culture, and for many, perhaps most, musicians and listeners it continued to represent the natural and obvious way of thinking about music's aims. Even instrumental music continued to be heard by those people as it was by Mattheson, as if the gestures of the music carried an implied text that identified its expressive content. The popularity of program music in the second half of the nineteenth century shows that the mimetic conception of music as necessarily containing an implied or explicit linguistic component continued to be a force even in the most self-consciously advanced circles of the New German school. But if the revolution of around 1800 did not make the idea of mimetic music disappear, it did provide it with a formidable opponent by giving the idea

of abstract music a new vitality and moving it from provincial organ lofts into the center of aesthetic debate.

Thus the rebirth of the idea of abstract, that is, nonmimetic, music (or, as Wagner was to name it in 1846, "absolute music"), the emergence of the new German "metaphysics of instrumental music" (to use a favorite phrase of its foremost student, Carl Dahlhaus), was the central element in the paradigm shift around 1800. The key documents of this rebirth were the two essays by Ernst Theodor Amadeus Hoffmann, "Beethoven's Instrumental Music" ("Beethovens Instrumentalmusik" of 1813, but based on two reviews published in 1810 and 1813) and "Old and New Church Music" ("Alte und neue Kirchenmusik" of 1814). Building on the earlier writings of Jean Paul (*Hesperus,* 1795), Wilhelm Heinrich Wackenroder (*Herzensergiessungen eines kunstliebenden Klosterbruders,* 1797), and both Wackenroder and Ludwig Tieck (*Phantasien über die Kunst für Freunde der Kunst,* 1799), Hoffmann presented in these essays a persuasive argument for reinterpreting instrumental music, considered by enlightened opinion to be a poor, mimetic relation of vocal music ("more a matter of enjoyment than of culture," in Kant's famous Rousseauist phrase),[59] as, rather, a medium capable of giving expression to an essential metaphysical region inaccessible to language. In the fifteenth and sixteenth centuries, the dignity and value of abstract counterpoint rested on the belief that it embodied something more substantial than tones alone, the intelligible harmony, with its cosmic and divine significance. With the scientific revolution, this notion lost much of its credibility and luster. Hoffmann's essays show clearly that the rebirth and new vitality of the idea of abstract music involved finding something comparable to the notion of harmony, something capable of giving mere sounding metaphysical or religious import.

"When music is spoken of as an independent art, does not the term properly apply only to instrumental music, which scorns all aid, all admixture of other arts (poetry), and gives pure expression to its own peculiar artistic nature?"[60] Thus Hoffmann begins his essay "Beethoven's Instrumental Music." In vocal music, "the poetry suggests precise moods through words."[61] There are even some "poor instrumental composers who have laboriously struggled to represent precise sensations, or even events."[62] But this has little to do with the "peculiar nature of music."[63] It is not music's role to represent specific passions, sensations, events. Music's "only subject-matter is infinity."[64] "Music reveals to man an unknown realm, a world quite separate from the outer sensual world surrounding him, a world in which he leaves behind all precise feelings in order to embrace an inexpressible longing."[65] And Hoffmann turns the tables even more radically on those who would hear instrumental music mimetically by claiming that, on the contrary, even in vocal music the representational powers of the poetry are overcome by music's ability to go beyond the specific passions toward the realm that is inaccessible to language: "In singing, where the poetry suggests precise moods through words, the magical power of music acts like the philosopher's miraculous elixir. . . . Any passion—love, hate, anger, despair, etc.—presented to us in an

opera is clothed by music in the purple shimmer of romanticism, so that even our mundane sensations take us out of the everyday into the realm of the infinite."[66]

"Infinity," "an unknown realm, a world quite separate from the outer sensual world"; in the post-Kantian age, Hoffmann's readers were bound to recognize here the Kantian noumenal realm of the thing-in-itself, a realm utterly unknowable, but underlying the distinct and knowable phenomenal world of human experience. Mimetic arts cannot penetrate beyond the phenomena, but abstract instrumental music can. And if it is this noumenal realm beyond the phenomena that music reveals, then a suitable substitute for cosmic harmony has been found to underwrite the dignity and worth of abstract, nonmimetic, music.

Six years after Hoffmann, Arthur Schopenhauer explicitly identified the "unknown realm" to which music, but no other medium, gave voice as Kant's noumenal region of the thing-in-itself and, in a move that would surely make Kant wince, further characterized it as will (*Die Welt als Wille und Vorstellung*, 1819). "[W]e must attribute to music," Schopenhauer wrote, "a far more serious and profound significance that refers to the innermost being of the world and of our own self."[67] "[M]usic is as *immediate* an objectification and copy of the whole *will* as the world itself is."[68] Like Hoffmann, Schopenhauer claimed that even vocal music should not be heard as mimetic. When music is joined with words or pantomime, it does not imitate them, but rather they "stand to it only in the relation of an example, chosen at random, to a universal concept."[69] Similarly, Hegel would claim in his lectures on fine art that "the text is the servant of the music and it has no worth other than creating for our minds a better idea of what the artist has chosen as the subject of his work."[70]

For the less philosophically inclined, as Hoffmann's essay on "Old and New Church Music" shows, the metaphysical and religious dimensions could be closely intertwined. For Hoffmann himself, metaphysics seems to have been the religion of the post-Christian age. "Sound audibly expresses an awareness of the highest and holiest, of the spiritual power which enkindles the spark of life in the whole of nature, and so music and singing become an expression of the total plenitude of existence—a paean to the Creator! By virtue of its essential character, therefore, music is a form of religious worship."[71] The old church music was perfected by Palestrina, whose art was pure harmony:

> Without adornment and without the impetus of melody, chord follows upon chord; most of them are perfect consonances, whose boldness and strength stir and elevate our spirits with inexpressible power. That love, that consonance of all things spiritual in nature which is promised to the Christian, finds expression in chords which only came into existence with Christianity; thus chords and harmony become the image and expression of that communion of spirits, of that bond with the eternal ideal which at once embraces and reigns over us.[72]

In short, Palestrina's "really is music from the other world."[73] The decline of the old church music set in when "music migrated from the church to the theatre

and then, with all the empty ostentation it had acquired there, moved back into the church."[74] But, in any case, "it is simply impossible for a composer today to write in the same way as Palestrina. . . . Those times, particularly when Christianity still shone forth in all its glory, seem to have vanished from the earth for ever."[75] However, even in recent times, "the bewildering spectacle presented by men sundered from all holiness and truth" did not prevent "the more perceptive soul" from recognizing "the existence of the spirit."[76] "Our mysterious urge to identify the workings of this animating natural spirit, and to discover our essence, our other-wordly abode in it, which gives rise to the pursuit of knowledge, lay also behind the haunting sounds of music, which described with increasing richness and perfection the wonders of that distant realm. It is quite clear that in recent times instrumental music has risen to heights earlier composers did not dream of."[77] Haydn, Mozart, and Beethoven, in particular, are the "composers, in whom the spirit was so gloriously manifest."[78] New church music might develop only on the basis of the "new art" they have evolved.[79] But Beethoven's symphony appears already to be the Palestrina mass for the times when Christianity no longer shines forth in all its glory, the new revelation of "the other world," the realm of the spirit.

Thus German romantic poets and philosophers found in the variously named absolute revealed by music a viable substitute for harmony, a conception capable of justifying abstract, nonmimetic music's claim to dignity and value, an answer to Kant's dismissive verdict ("more enjoyment than culture"). Two factors made this conception credible and gave it its impressive staying power. First, the idea of absolute music, instrumental music free of text, program, or function, was music's perfect answer to the demand newly raised by German aesthetic theory that art must be independent of all social functions. The seminal treatise of Karl Philipp Moritz, *Über die bildende Nachahmung des Schönen* of 1788, presented a plea for an autonomous art centered on a perfect and self-sufficient work, and Kant's *Critique of Judgment* (1790), in particular, was widely read (and perhaps partly misread) as a defense of the aesthetic autonomy of art.

The emergence and popularity of this new theory of artistic autonomy, in turn, has been impressively correlated with changes in the structures of artistic patronage and the resulting change in the social position of the artist that occurred in eighteenth-century German lands. The supplementing of traditional church and court patronage with more anonymous market institutions such as the public concert or the music publishing house made the freelance artist simultaneously more independent and more insecure than his colleagues in church or court service. Martha Woodmansee, for example, has argued in *The Author, Art, and the Market* that the idea of autonomous art was introduced in late eighteenth-century Germany as an attempt to stem the commercialization of literature under the conditions of a market economy: "the chief goal of this philosophy was to sever the value of a work from its capacity to appeal to a public that wanted above all to be diverted."[80] Moreover, the theory of the internal

perfection of the artwork transferred to the work a property of the divine: "In its origins the theory of art's autonomy is clearly a displaced theology."[81]

There can be little doubt that ideas can and do have social and economic roots and, perhaps more important, gain influence and resonance more easily in certain social and economic environments. We should be under no illusion, however, that we have said everything worth saying about these ideas when we have identified their socioeconomic origins. Whether an idea is persuasive or not in the long run is quite independent of its original function. More to the point, the fact that a theory of autonomous art emerged in late eighteenth-century Germany should be taken to mean neither that art was not autonomous earlier and elsewhere, nor that it really became autonomous in Germany then. As I have suggested earlier, we would do better to consider the contrast between autonomous and functional music as the contrast between "ideal types" and to see most of the music as it was actually practiced in Europe over the centuries as falling somewhere between these two poles. All the same, it cannot be denied that the new aesthetic theory strengthened artistic autonomy considerably by making it conscious of itself and providing it with a rationale.

The second factor that made the idea of absolute music credible and influential was that, by the time Hoffmann wrote his essays, a sizable repertory of artistically impressive instrumental music had already come into being in the works of the Viennese classics. Mozart's and Haydn's orchestral and chamber music of the 1780s, the international recognition of Haydn's symphonies epitomized by his London triumphs of the 1790s, and the impression made by Beethoven's symphonies in the following decade made the idea that instrumental music could be more than mere enjoyment entirely believable. By presenting instrumental discourses of considerable size, discourses the internal coherence and sense of which were based on the harmonic and motivic logic of tonal relations, mature Viennese symphonies and string quartets demanded to be taken seriously as objects of aesthetic contemplation.

Thus, the new paradigm that emerged around 1800 involved a productive interaction and tension between the well-established and somewhat old-fashioned but still vital idea of mimetic music and the Italo-French culture of opera it supported (a culture aristocratic in origin, enlightened and cosmopolitan in attitude, seeking pleasure and finding it in sensuous beauty, at ease with convention, a culture close to our ideal type of popular music) and the avant-garde idea of abstract absolute music and the Austro-German culture of symphonic music which was based on it (a culture close to our ideal type of art music, middle-class in origin, romantic and nationalist in attitude, aiming at edification and the contemplation of an ultimate sublime reality beyond the sensuous one, worshipping originality). The two cultures were brilliantly and invidiously confronted in 1888 in Nietzsche's *The Case of Wagner*, where they were subjected to a critique in terms of flourishing—as in *Carmen*, the music whose beauty gives pleasure and makes one fertile—and decadence—as in *Parsifal*, the music whose sublimity preaches and increases exhaustion. That the two ideas interacted and

that their conflict was productive through the nineteenth century is best shown by such phenomena as what might be called the "mimeticization" of the symphony in Berlioz's and Liszt's program music and the "absolutization" of opera in Wagner's music drama.[82] Until about the First World War, the mimetic idea managed to hold its own, while the abstract idea maintained and even increased its avant-garde sheen. It was given a second life when, in 1854, Wagner discovered Schopenhauer and enlisted his theory in the service of the music drama. Thanks to Wagner's prestige in advanced art circles, and thanks to Nietzsche's own adoption of Schopenhauer's theory of music (minus the pessimism) in *The Birth of Tragedy* of 1872 (a book that became the bible for many artists around 1900), the romantic idea of absolute music maintained its full credibility through the first decade of the twentieth century.

e. The Cold War of Mimesis and Abstraction

Today, we are still making music under the premises of the post-1800 paradigm. But the paradigm, involving as it does a competition between two distinct views of the aims of music-making, is inherently unstable and did not survive the First World War intact. Rather, the tendencies it harbored from the beginning went through a period of very rapid intensification and radicalization between, roughly, 1908 and 1924, a period the full consequences of which were not felt until after the Second World War, when the "zenith of modernism" (to borrow the title of a recent study of one of the central musical institutions of the time) was reached.[83] Specifically, in the early twentieth century the trend toward privileging the abstract idea of music at the cost of the mimetic one intensified to such an extent that, by the 1950s, the productive interaction there had been between the two ideas during the nineteenth century was deeply disturbed and at times completely ceased.

Two developments, in particular, characterize the situation that arose during the twentieth century. First, the idea of abstract music, which throughout the nineteenth century defined itself by its avant-garde opposition to the mimetic status quo, triumphed so completely in art music circles that by the mid-twentieth century the mimetic idea stopped being taken seriously even as something one needed to be against. Second, the understanding of abstract music changed once more, so that it was now seen as the embodiment of neither harmony nor the absolute. Instead, it was understood as simply itself, the pure sounding form, not pointing to any transcendent meaning. We need to take a closer look at these two developments, one by one.

Mimetic music, we shall recall, considers language, whether explicitly present or implied, to be the essential component of music, on a par with harmony, and not as something added to music. It is language that names the object of musical representation. In the twentieth century, this idea became so completely disreputable in art music circles that in recent decades it required something of an effort of historical imagination and sympathy to understand how it could ever have been taken seriously. Art music has contemptuously turned its back on the

idea of representation and left it as the nearly exclusive property of popular musicians. With only a slight exaggeration, one might claim that by the middle of our century, only popular song and film music dared to be frankly mimetic, without shame or apology.

The symptoms of this development were the rejection of ways of hearing instrumental music as if it encoded a hidden program, ways still widespread in the early twentieth century; the related demise of program music; and evidence that even vocal music was now being heard without much regard for the text. The program for "musical hermeneutics" advanced by Hermann Kretzschmar in the early years of the century (in "Anregungen zur Förderung musikalischer Hermeneutik" and "Neue Anregungen zur Förderung musikalischer Hermeneutik: Satzästhetik" that appeared in *Jahrbuch der Musikbibliothek Peters* of 1902 and 1905), in essence a program for deciphering the affective content of instrumental music, failed to catch on and came to be regarded as a last-ditch attempt to preserve the discredited modes of hearing from the nineteenth- and even eighteenth-century past. In a revealing essay on "The Relationship to the Text" which appeared in 1912 in Kandinsky's and Marc's *Der blaue Reiter,* Arnold Schoenberg explained why proposals such as Kretzschmar's were unacceptable: "Wagner . . . , when he wanted to give the average man an indirect notion of what he as a musician had looked upon directly, did right to attach programs to Beethoven's symphonies. Such a procedure becomes disastrous when it becomes general usage. Then its meaning becomes perverted to the opposite; one tries to recognize events and feelings in music as if they *must* be there."[84] Schoenberg's position depends on the Schopenhauerian premise according to which music does not represent something that can also be specified in language, but, rather, copies a reality language cannot reach, but can only indirectly and imperfectly exemplify (and indeed we read a few sentences earlier that "Schopenhauer . . . says something really exhaustive about the essence of music"[85]). By 1939–40, in his Norton lectures at Harvard on the *Poetics of Music,* Igor Stravinsky derided the Soviet "revolutionary and romantic cult . . . dedicated to Beethoven" as based on "the ideas of Romain Rolland, who, as you know, heard 'saber-clashings,' the noise of battle, and the lamentations of the vanquished in the 'Eroica.'"[86] In a similar spirit, various forms of program music, guided mainly by the Schopenhauerian thought that one might hear instrumental music as exemplified by a verbal program, still seriously contemplated by Mahler, Debussy, and Strauss, became unacceptable to the composers of the following generation. As for paying attention to the verbal text, Schoenberg's testimony in his 1912 essay is characteristic:

> A few years ago I was deeply ashamed when I discovered in several Schubert songs, well-known to me, that I had absolutely no idea what was going on in the poems on which they were based. But when I had read the poems it became clear to me that I had gained absolutely nothing for the understanding of the songs thereby, since the poems did not make it necessary for me to change my conception of the musical interpretation in the slightest degree. On

the contrary, it appeared that, without knowing the poem, I had grasped the content, the real content, perhaps even more profoundly than if I had clung to the surface of the mere thoughts expressed in words.[87]

This tendency toward what might be called abstract listening was noted a century earlier by Hegel in his lectures:

> We find a similar phenomenon again in the case of listeners too, i.e. the public, especially in relation to dramatic music. . . . In this case the contents are double: the external action and the inner feeling. . . . The listener easily frees himself from this subject-matter [the action] . . . and sticks simply to what is really musical and melodious. . . . People . . . only attend . . . to the strictly musical parts which in that case are enjoyed purely musically. It follows from this that the composer and the public are on the verge of liberating themselves altogether from the meaning of the words and treating and enjoying the music on its own account as independent music.[88]

Most significantly, Schoenberg connects these abstractionist tendencies in music with the birth of abstraction in painting:

> When Karl Kraus calls language the mother of thought, and Wassily Kandinsky and Oskar Kokoschka paint pictures the objective theme of which is hardly more than an excuse to improvise in colors and forms and to express themselves as only the musician expressed himself until now, these are symptoms of a gradually expanding knowledge of the true nature of art. And with great joy I read Kandinsky's book *On the Spiritual in Art,* in which the road for painting is pointed out and the hope is aroused that those who ask about the text, about the subject-matter, will soon ask no more.[89]

One reads in an 1814 note found among Schopenhauer's papers: "It is the aim of every art to become like *music.*"[90] Kandinsky's book and development in those years indeed confirmed this diagnosis and Schoenberg was quick to recognize this.[91] The abandonment of mimesis was now something music could share with painting.

We do not yet fully understand the causes of this abandonment. Nor can we even be sure that we know how to distinguish causes and effects in this case. Some causes, however, are not difficult to fathom. It is understandable that the unprecedented traumas inflicted on her societies by criminal politicians between 1914 and 1989 would induce some of Europe's artists to seek refuge in a realm of art hermetically sealed off from the rest of the world, a realm in which esoteric languages understood only by the initiates to the self-enclosed mysteries of art are spoken. It is also clear that any account of the causes would have to include the continuation and intensification of the socioeconomic process that attended the birth of the philosophy of aesthetic autonomy in the late eighteenth century. As it became increasingly clear that, under the conditions of a market economy, art music had no chance of winning the competition for the entertainment-craving public with popular music, the former had to justify its existence by claiming to pursue different aims, and since the mimetic idea was governing the

production of popular music, it was natural for art musicians to want to abandon it. Nothing is more characteristic of this situation than the snobbish scorn that Theodor W. Adorno, at mid-century the most vocal spokesman for the ideas of abstract music and aesthetic autonomy, heaped on the "entertainment industry," the "commodified" and "fetishized" popular music it produced, and the "regressive" popular modes of hearing it encouraged. The diagnosis of his *Philosophy of New Music* of 1949 is clear: "The liberation of modern painting from objectivity . . . was determined by the defensive against the mechanized art commodity—above all, photography. Radical music, from its inception, reacted similarly to the commercial depravity of the traditional idiom. It formulated an antithesis against the extension of the culture industry into its own domain."[92]

But the abandonment of musical mimesis was only one half of the new twentieth-century situation. The other half involved a radical change in the way one understood musical abstraction. The main document of this change appeared surprisingly early, in the 1854 "contribution towards the revision of the aesthetics of music" by Wagner's antagonist, Eduard Hanslick, entitled *On the Musically Beautiful.*

Hanslick conceived his book as a polemic against the still powerful mimetic understanding of music, and right at the outset he made an assumption which deprived the mimetic idea of all credibility, the assumption, namely, that music is essentially instrumental and that in vocal music the text is extramusical. With this assumption, the argument against those who claimed that music represented emotions was easily won. As we have already seen, Aristotle, in his analysis of emotions in *Rhetoric* (book 2, chs. 1–11), shows that emotions are not simply irrational, since every specific emotion, in addition to being a feeling or state of mind, also has a cognitive component, in that it has what would be called an intentional object today, is felt toward someone, and consequently is subject to reasons, can be justified or not: if we get angry with those who slight us, we will have grounds to stop feeling anger when we learn that the slight was imagined or involuntary. Similarly, Hanslick suggested that a specific emotion, in addition to being a sensation, a feeling, must also have a cognitive component, a thought of the intentional object. Schopenhauer claimed that music is very good at conveying the component of sensation, but cannot represent the cognitive component:

> it [music] never expresses the phenomenon, but only the inner nature, the in-itself, of every phenomenon, the will itself. Therefore music does not express this or that particular and definite pleasure, this or that affliction, pain, sorrow, horror, gaiety, merriment, or peace of mind, but joy, pain, sorrow, horror, gaiety, merriment, peace of mind *themselves,* to a certain extent in the abstract, their essential nature, without any accessories, and so also without the motives for them.[93]

Later on, Schopenhauer elaborated: "From its own resources, music is certainly able to express every movement of the will, every feeling; but through the addition of the words, we receive also their objects, the motives that give rise to that

feeling."[94] Hanslick agreed, and since language has been excluded from music by definition, he could safely and convincingly conclude that music does not represent specific emotions.

In a passage that reverberated with echoes of the late sixteenth-century musical quarrel of the ancients and moderns and that reads as if Hanslick was answering Rousseau or even Galilei (a passage that might appear astonishingly anachronistic until we recall that Hanslick's book closely followed Wagner's treatises projecting a rebirth of ancient tragedy), Hanslick explained why the modern abstract conception of music was superior to the ancient ethical one:

> [O]ur moralists . . . [tell us] how 'even the animals' yield to the power of music. . . . But is it really so commendable to be a music lover in such company? After the animals have performed their numbers, the old human chestnuts come onstage, mostly in the manner of the story about Alexander the Great. . . . There can be no doubt at all that, for the ancients, music had a much more immediate effect than it has now, since humankind only just in its primitive stage of development is much closer to and more at the mercy of the elemental than later, when consciousness and self-determination come into their own.[95]

The exclusion of language from the domain of music led naturally to the theory of the "specifically musical . . . inherent in the tonal relationships without reference to an extraneous, extramusical context."[96] Musical beauty "consists simply and solely of tones and their artistic combination."[97] In a celebrated formula, Hanslick asserted that "the content of music is tonally moving forms."[98] "The form (as tonal structure), as opposed to the feeling (as would-be content), is precisely the real content of the music, is the music itself."[99]

But what about Rousseau's and Kant's suspicion that music so purified is empty, mere enjoyment? Hanslick's answer is different from that of the romantics. He does not claim for music the power to disclose the "absolute." Instead, he sees the dignity of abstract music simply in its being a product of a creative human mind. "It is a splendid and significant thing to follow the creative spirit."[100] It is this that allows him to conclude that "music is play [*Spiel*] but not frivolity [*Spielerei*]."[101] In fact, as Carl Dahlhaus noted,[102] Hanslick took pains in subsequent editions of his book to remove all passages that still spoke the language of the romantic metaphysics of absolute music, in particular, the closing passage which in the first edition contained the following sentences: "Music affects him [the listener] not merely and absolutely through its own beauty, but also as the sounding copy of the great cosmic motions. Thanks to the deep and mysterious relations with nature, the meaning of tones grows far beyond them themselves and allows us always at the same time to feel infinity in the work of human talent."[103] It is no wonder Hanslick was persuaded to remove such sentences, because what his whole theory actually affirms is that there is no transcendent meaning in tonal forms beyond their being creations of the human spirit. Thus Hanslick accepts the romantics' conception of music as essentially abstract,

nonmimetic, but not their justification of such music's worth and dignity. For-
malism is romanticism minus the metaphysics.[104]

Ironically, 1854, the year when *On the Musically Beautiful* appeared, was also
the year Wagner discovered Schopenhauer. Hanslick's little treatise was imme-
diately widely read and discussed, but for half a century it had to compete
with the Schopenhauerian metaphysics of absolute music. It was only around the
First World War that the latter was finally abandoned (in music theory, its last
significant document was probably Ernst Kurth's 1926 book on Bruckner) and
Hanslick's formalist interpretation of abstract music became the norm. By 1925,
one of this century's most influential theorists of harmony, Heinrich Schenker,
had adopted Hanslick's celebrated formula and stated that "*music is the living
motion of tones in the space given in Nature:* the composing-out (the rendering
in melodic line, the linearization) of the Nature-given sonority," without suggest-
ing that this "living motion" embodies the noumenal will or anything else.[105]
(One could not claim that Schenker left *all* metaphysics behind, but that is
another story.) A position similar to Hanslick's was also taken up by Stravinsky
in his Harvard lectures, which treated "the phenomenon of music as a form of
speculation in terms of sound and time."[106] Stravinsky asked his audience the
formalist's standard rhetorical question: "Do we not, in truth, ask the impossible
of music when we expect it to express feelings, to translate dramatic situations,
even to imitate nature?"[107] And he gave the standard formalist answer, not for-
getting to embrace vocal music in his conception: "From the moment song as-
sumes as its calling the expression of the meaning of discourse, it leaves the realm
of music and has nothing more in common with it."[108] As for a justification of
the worth of the abstract musical form, for Stravinsky, as for Hanslick, it appears
to be that "music . . . will make us participate actively in the working of a mind
that orders, gives life, and creates."[109]

To be sure, a nonformalist interpretation of musical abstraction survived
through the middle of the century in Schoenberg's circle. Schoenberg himself,
as we have seen, expressly endorsed Schopenhauer's theory and combined it
with a characteristic prophetic messianism. In an essay on Gustav Mahler, he
affirmed: "there is only one content, which all great men wish to express: the
longing of mankind for its future form, for an immortal soul, for dissolution into
the universe—the longing of this soul for its God."[110] And as late as 1950 he
was claiming that "music conveys a prophetic message revealing a higher form
of life towards which mankind evolves."[111] In 1918, this sort of utopian inter-
pretation of music was advanced, again on explicitly Schopenhauerian premises,
by Ernst Bloch, who called music the "first township of the holy land."[112]
Adorno's case is more complex. It would perhaps not be fair to accuse Adorno
of more than residual attachment to the romantic metaphysics of instrumental
music. But neither would it be correct to call his interpretation of musical ab-
straction formalist. Adorno is closer to Hoffmann than to Hanslick in believing
that the significance of abstract musical form transcends the form itself, that the
form intimates a totality larger than itself. But, unlike for Hoffmann and Schoen-

berg and Bloch, for Adorno the locus of this totality was not another world, but the actual social world of the composer. "The deepest currents present in this [new] music proceed . . . from exactly those sociological and anthropological foundations peculiar to that [contemporary] public. The dissonances which horrify them testify to their own conditions; for that reason alone do they find them unbearable."[113]

Adorno's view is neither less nor more convincing than Hoffmann's or Schopenhauer's. Half a century later, it is difficult to understand how anyone could have found it believable, but many people did: it must have met a deeply felt need. But in spite of the undeniable resonance that Adorno's interpretation of musical abstraction as an intimation of the social totality found among the European avant-garde of the 1950s, it was the formalist interpretation that remained dominant in the twentieth century and that triumphed in the United States among composers. (The performing musicians and their audiences thought otherwise and kept the older paradigms alive.) Hanslick's transformation of the romantic metaphysics of instrumental music into formalism and the ascendance of formalism in our century represent a change in the interpretation of musical abstraction as profound as the one that occurred in the late sixteenth century. In both cases, abstract music was deprived of a grand justification, of metaphysical significance. And in both cases, one has to look beyond the evolution of musical practice to find some of the causes, such as, respectively, the scientific developments around 1600 which undermined the idea of cosmic and musical harmony, and the antimetaphysical turn taken by philosophy in the mid-nineteenth and again in the early twentieth century. Neither embodying the intelligible harmony nor intimating the absolute, abstract music now had to survive on its own, as nothing but itself, a pure sounding form with no transcendent meaning.

By 1854 music could afford this antimetaphysical turn: there was so much great instrumental music around that the practice no longer needed philosophical or religious crutches to justify itself. Of the two developments that jointly shaped the practice of art music in the twentieth century, the near-abandonment of mimesis to popular music and the replacement of the metaphysical with a formalist interpretation of abstraction, it was the former that reflected and reinforced what from the perspective of our own fin de siècle appears to have marked this practice most profoundly. But both facilitated the acceptance of the idea that the abandonment of tonality by art music was necessary and inevitable, the idea which by the 1950s had hardened into dogma to such an extent that even Stravinsky felt the need to convert to serialism. At first glance, the claim that the nearly universal acceptance of atonality by art music composers was facilitated by the antimimeticism and formalism might seem puzzling and paradoxical: atonality originally served the hyperexpressionist aims of capturing the workings of a severely disturbed mind thrown into an out-of-joint world (not for nothing is Berg's *Wozzeck* of 1917–22 the key masterpiece of this original period). But in fact atonality, especially in its second, cool and objective, formalist, dodecaphonic phase, was an excellent tool for those who wanted to keep representation at bay.

Recall that it is tonality (together with meter) that makes us hear in the real sounds of which the music is made the imaginary lines of directed motion and that, consequently, the suppression of tonality is needed if one does not want any imaginary world to arise on the foundation of the real work. A tonal work may be abstract, but it is still representational (what is represented in it is an abstract object). This cannot be satisfactory to those who want to follow the antimimeticist formalist impulses to their radical conclusions. Only the abandonment of tonality promises any success, if the goal is to banish all representation, even the representation of abstract objects, to have a work in which what you hear is all you get (because it is all there is).

The separation of mimetic popular music and abstract art music reached its most rigorous form at Darmstadt in the early 1950s and coincided, as Richard Taruskin has observed, with the most rigorous phase of the Cold War.[114] Inge Kovács has recently shown in some detail how much the program policy of the international summer courses for new music at Darmstadt was influenced by the East-West Cold War confrontation.[115] For Kovács, the wish to give the avant-garde a space free of all social pressures was a reaction against the Stalinist cultural policies in 1948–49.[116] Andrei Zhdanov's speech of January 1948 called for "realist" music destined for the masses and condemned the individualist "formalism." Formalism in music was also condemned in the Central Committee Resolution of February 10, 1948. (For Zhdanov and his colleagues on the politburo, "formalism" stood first and foremost for the antimimetic impulse, since it privileged "form" at the expense of "content.") "Against this historical background," concludes Kovács,

> it is striking that the West European avant-garde increasingly propagated and represented precisely this which was subject to repression on the Stalinist side. Thus its development around 1950 should be understood within the setting of the Cold War, which should not exclude other attempts at explanation, in particular, the context of just having lived through the National-Socialist dictatorship and the Second World War. And the reverse, one may observe that nothing that the Soviets demanded of music has played any role in the Darmstadt of the early 1950s. . . . One concentrated on thinking about the problems internal to music.[117]

Similarly, Adorno's convoluted defense of artistic autonomy and musical abstraction was conducted against the background of not only the encroachments of the "entertainment industry," but also the official position of the Soviet Communist Party. Nor were these developments confined to Western Europe or to music only. It should be recalled that the American art-for-art's-sake aestheticism of the late forties and fifties had its roots in the New York Left's anti-Stalinism of the late thirties. Clement Greenberg and Harold Rosenberg, arguably the most influential critics promoting new American painting after the war, embraced precisely the kind of modernist art that was attacked by the Stalinists. As for the visual arts in Europe, the similarity between the postwar situation described by Jean Clair and the musical developments described here is uncanny. In Clair's

scenario, the role of Darmstadt is played by the Cassel *documenta,* created in 1956 with the express intention "to demonstrate to the West, in a town close to the curtain which divided Europe in two, that Germany has never stopped being the country of modernity."[118] The new orthodoxy of the late 1950s promoted abstract art to the role of a universal language: *Abstrakte Kunst eine Weltsprache* as the title of an influential German book of 1958 had it.

> Werner Haftmann, one of the first directors of the *documenta,* . . . proclaimed [this orthodoxy] in the catalogues and on the posters: 'Abstract art is the idiom of the free world.' [!] Since the sense failed, since it has been perverted [by the totalitarian regimes], it was proper to propose for all an art washed clean of all sense, an art without figure, without memory and without the past. . . . Germany, heavy with an imposing military presence which marked its landscape and its everyday life, became the bridgehead of the American culture in Europe, and in particular Berlin: the Tiergarten and the Gropius Bau, a few hundred meters away from the Wall, were the sites of the great festivals of modernity.[119]

The wish to keep a distance from the trivialities of socialist-realist or commercial art was understandable, but, as long as it remained entirely negative and reactive, it could not by itself provide a sufficient program for worthwhile art production. This became obvious after Stalin's death, as the ruling parties in some of the communist countries, most notably Poland, realized that the Darmstadt-style musical avant-garde was politically harmless. No sooner was serialism licensed, it was almost immediately abandoned, as the most significant composers moved beyond avant-gardism (a move for which Penderecki's *Passion* remains an emblem). Meanwhile, in the West the avant-garde settled into the comfortable role of the officially sponsored artistic establishment (doubly comfortable, because combining official support with the flattering self-image of antibourgeois subversiveness), the role of what used to be called in the nineteenth century academic art.[120] Future research will show whether and to what extent state sponsorship of the avant-garde in post-war Europe was driven by the explicit and fully conscious policy of showcasing Western liberties and contrasting them favorably with Soviet regimentation of the arts. It is already clear, however, that the decline and terminal exhaustion of the avant-garde coincided very precisely with the final phase of the Cold War, that is, with the erosion and disappearance of a central argument for its social and political significance. (In the United States, where direct state sponsorship of the arts is much less acceptable than in Europe, the musical avant-garde became both literally and metaphorically thoroughly academic by settling early on into tenured positions in the universities, where it has now reached retirement age.) "If you were to ask what really brought down the Berlin Wall," writes Roger Scruton, "the answer would surely include some reference to American popular culture, which had so captivated the hearts of the young that their impatience to join that enchanted world would brook no further delay."[121] It is unlikely that the answer would also have to include a reference to the artistic production of Darmstadt and this is just as well: the

biblical precedent notwithstanding, we should not demand of music that it bring down walls (and, in any case, heavily amplified popular music will be much better at it than art music). Darmstadt's cultural politics, however, with its defense of the artist's autonomy, would deserve an honorable mention.

Adorno's argument in the *Philosophy of New Music* of 1949 was in one respect a reiteration of Hegel's profound diagnosis of the situation of modern music in his lectures on *Aesthetics* of the 1820s. (Indeed, Adorno's interpretation of musical abstraction as pointing toward a social totality has all the marks of a desperate attempt to justify the absolute music he loved and, at least in part under the spell of Hegel, felt to be threatened by meaninglessness.) Hegel, no friend of the romantics and unimpressed by their metaphysics of instrumental music, but aware of the importance of the recent emancipation of instrumental music, recognized a contradiction that drove the evolution of contemporary music. He acknowledged that the liberation of music from language was the prerequisite for its unprecedented development as an art. At the same time, however, he did not believe, as Hoffmann and Schopenhauer did, that precisely the freedom from conceptually defined content enabled music to intimate a world beyond the world. On the contrary, he warned that the very freedom that allowed music to evolve as an art threatened it with what he called the "loss of metaphysical substance." And since for Hegel the highest purpose of art was to give a sensuous embodiment to the divine, to the religious substance of the age, the emancipation of instrumental music spelled for him music's demise as Art and re-emergence as mere art. At the very moment that music is able to develop its artistic means to the highest pitch of refinement, it is threatened with a loss of significance, with meaninglessness.

> Especially in recent times music has torn itself free from a content already clear on its own account and retreated in this way into its own medium; but for this reason it has lost its power over the whole inner life, all the more so as the pleasure it can give relates to only one side of the art, namely bare interest in the purely musical element in the composition and its skillfulness, a side of music which is for connoisseurs only and scarcely appeals to the general human interest in art.[122]

And further:

> [A]mongst all the arts music has the maximum possibility of freeing itself from any actual text as well as from the expression of any specific subject-matter, with a view to finding satisfaction solely in a self-enclosed series of the conjunctions, changes, oppositions, and modulations falling within the purely musical sphere of sounds. But in that event music remains empty and meaningless, and because the one chief thing in all art, namely spiritual content and expression, is missing from it, it is not yet strictly to be called art. Only if music becomes a spiritually adequate expression in the sensuous medium of sounds and their varied counterpoint does music rise to being a genuine art, no matter whether this content has its more detailed significance independently ex-

pressed in a libretto or must be sensed more vaguely from the notes and their harmonic relations and melodic animation.[123]

The lesson for contemporary composers Hegel drew from his diagnosis was this: "Music is therefore more profound when the composer gives the same attention even in instrumental music to both sides, to the expression of a content (true, a rather vague one) and to the musical structure."[124]

At mid-twentieth century, Adorno found the Hegelian diagnosis drastically confirmed by the situation of contemporary art music, though he departed from Hegel in seeing the growth of artistic autonomy as driven by market forces. "In the process of pursuing its own inner logic," he wrote in the *Philosophy of New Music,*

> music is transformed more and more from something significant into some-thing obscure—even to itself. . . . The strictness of musical structure, wherein alone music can assert itself against the ubiquity of commercialism, has hard-ened music to the point that it is no longer affected by those external factors which caused absolute music to become what it is. . . . Advanced music has no recourse but to insist upon its own ossification without concession to that would-be humanitarianism which it sees through . . . as the mask of inhumanity. Its truth appears guaranteed more by its denial of any meaning in organized society . . . than by any capability of positive meaning. . . . Under the present circumstances it is restricted to definitive negation.[125]

But even this negation turns out to be an empty, if heroic, gesture: "The fulfill-ment of freedom of mind occurs simultaneously with the emasculation of the mind. . . . Undoubtedly, such [nonconforming] music preserves its social truth through the isolation resulting from its antithesis to society. The indifference of society, however, allows this truth to wither."[126] Consequently, "modern music sees absolute oblivion as its goal. It is the surviving message of despair from the shipwrecked."[127]

Thus Adorno accepted Hegel's verdict that modern abstract art music devel-ops under the ever growing threat of meaninglessness, but found Hegel's advice that equal attention be paid to the spiritual content as to the abstract tonal struc-ture unacceptable, as it entailed a compromise with, for him, utterly unredeem-able contemporary society and its commercial culture. Now, one does not need to embrace this uncompromising (and, in my view, quite silly) position to allow that both Hegel and Adorno at least addressed a feature in the situation of mod-ern music which is of central importance and which can be ignored, but not wished away. The radical separation of abstract art music and mimetic popular music in our century does indeed threaten the former with a loss of significance, just as it threatens the latter with triviality.

Can this threat of meaninglessness be successfully overcome? The dichotomy between the abstract and mimetic aims of music-making in terms of which I have proposed to read the history of modern European art music suggests two

distinct strategies for countering music's loss of significance. First, one might hope for the emergence of yet another conception grounding abstract music's dignity in some sort of an ultimate reality, a conception to replace the discredited notions of intelligible harmony or noumenal world beyond the world of appearances. While it is not the task of a historian to engage in prophecy, I must confess that the prospect of a strategy of this kind succeeding in our resolutely postmetaphysical age seems to me most remote and, in any case, undesirable, precisely because one hopes that the age will remain postmetaphysical. A second strategy, and one with much better prospects, would have to involve, then, some form of rapprochement and accommodation between the abstract and mimetic ideas, a refertilization of abstraction with mimesis. In the case of instrumental music, such refertilization would necessarily mean putting the music back into a context that language can name: a figurative title, a program, an "archetypal plot" (to use Anthony Newcomb's term),[128] a quotation or allusion to other music, an invocation of a style that once had a function (a dance, say), an anthropomorphic gesture suggesting a speaking, singing, moving, or dancing body, anything of this kind would do.

(Note, by the way, that a mimetic gesture can play a similar role in abstract painting. E. H. Gombrich writes: "It seems to me no accident that the one twentieth-century pioneer who understood the role of representation in the composition of near-abstract configurations was Paul Klee, who was also a musician. Though the pattern came first in his building from elements, he assigned it a title, a direction, a potential weight or scale by taking some element from the visual world. . . . [Thus] the shapes fall into place, our interpretation is guided, we can empathize and feel the thrust of the direction together with its emotional impact."[129] Matisse understood this at least equally well. His paintings between 1907 and 1917, one of the truly classic repertoires in the art of the twentieth century, involve a far-reaching emancipation of both line and especially color from the function of representing. But the paintings are never wholly abstract. Rather, they retain representational signposts, not unlike the mimetic gestures or titles in instrumental music, signs that serve as props, that guide interpretation of what is in essence an abstract play of lines and colors. *Piano Lesson* is the title of one of the most beautiful of those paintings [1916; The Museum of Modern Art, New York], but they all are one great music lesson, a lesson for painters and composers alike, a lesson in how to balance abstraction and mimesis.)

One can, indeed, read the last few decades of music history as exhibiting precisely this very tendency, the gradual erosion of the musical Cold War between abstraction and mimesis, an erosion for which the canonization of Mahler in the 1960s might serve as an emblem. In composition, where it was clearly noticeable already in the early 1960s, this tendency manifests itself in such diverse phenomena as the reappearance of poetic imagery as integral to instrumental composition in the work of Ligeti and Penderecki, the dramatic terms in which instrumental form is reconceived by Carter and Lutosławski, the new interest in quotation and collage in the work of Berio, above all in the international reap-

pearance of interest in tonality as a viable compositional option and in the increasing recognition of the evident artistic (as opposed to commercial) banality of technology. (In recent painting, a particularly compelling case of a complex marriage of abstraction and mimesis has been provided by the oeuvre of Anselm Kiefer.) In musicology, the same trend became noticeable in Germany in the 1970s and in the United States in the 1980s in the increasingly common attempts to move beyond strictly formalist modes of interpreting musical texts, to reinvent musical hermeneutics, and, above all, to recontextualize the interpreted musical practices and abolish all limits on contexts deemed legitimate.

These trends inspire hope that the canon of art music has not been closed with the generation of the 1880s. The perspectives of new music seem brighter today than at any point in the last fifty years, as the hunger for art carrying a spiritual significance reasserts itself and as the mid-century Cold War conditions become a faint memory. On the one hand, the political justification of the avant-garde as the showcase of Western freedoms is no longer sufficiently interesting and one expects from a creative artist more than a simple demonstration of independence. Being merely against (against Stalin, or commercialism, or tradition . . .) is no longer enough. On the other hand, the fear that mimesis might be manipulated by political power has become less acute than it was in the age of totalitarian parties. At the same time, the beliefs, once widespread in more enlightened music circles, that atonality and serialism are the inevitable outcome of the "historical process" rather than contingent stylistic developments, and that only more time and exposure are needed for a majority of classical music lovers, as opposed to the professionals, to canonize the output of the academic avant-garde appear less and less credible with each passing year. The former evaporates together with the belief in any kind of historical inevitability, and the latter simply with the realization that all the time and exposure this music has already had do not seem to have made much difference. What becomes increasingly more likely, instead, is that the best composition today will attract more than the professionals and the canon will expand again, because the most ambitious and talented composers will no longer see any need to continue the self-mutilating ban on mimesis and tonality, no longer feel that they must speak an artificial Esperanto or not be heard at all. Being allowed to speak the natural language again, they will be able to renew the dialogue with the past masters of this language and thus to renew the tradition.

Thus there is still hope for European music, as there is for Europe in general as she emerges from the short but uncommonly destructive twentieth century (1914–89). But before we succumb completely to a complacent optimism, we should keep in mind that the precarious balance between popular and art music will be as difficult to achieve and maintain as ever. Unless the rehabilitation of mimesis is coupled with a commitment to a compelling abstract order, unless expressive depth meets structural complexity, there is little chance that the music of the future, no matter how powerfully expressive, will be able to escape the suspicion of lightweightedness and extend the tradition whose standards

of excellence have been defined by great craftsmen from Dufay to Stravinsky. I have argued here that the popular mode is music's natural, normal way of being, in contrast to the art mode, which is always something of a precarious achievement in need of justification. Thus, it is not the future of popular music that is really in question, but rather the future of art music. And the question remains open because the idea of abstract order does not have today, and is unlikely to get in the future, a grand metaphysical justification of the kind it used to have in art music's greatest periods. We can only hope that Hanslick's modest justification (in terms of the pleasure one takes in following the activity of a creative mind) is all that is required here. (The pervasive impact of technology on the current situation offers no clue as to what the future holds, because it is ambiguous: on the one hand, film and TV encourage the popular mode of intermittent and distracted hearing; on the other, however, the recording medium, which gives us Wagner's "invisible orchestra," can be the tool of the most concentrated and undistracted artistic hearing imaginable.)

As it now turns out, even Adorno was all along harboring secret thoughts of "rescuing" program music. In the recently published posthumous book on Beethoven, one finds the following haunting note:

> The issue of whether music is capable of representing something specific or is only a play of forms set in motion by sounds is really beside the point. The phenomenon can be compared rather to dreams whose form music is in many respects so close to, as romanticism well knew. In the first movement of Schubert's C-major Symphony, at the beginning of the development section, one has the impression of being for a brief moment at a peasant wedding; a story even seems to be unfolding, but it is gone in an instant, drowned by the rushing of the music, which, once replete with that image, proceeds according to a quite different pattern. Images of the material world appear in music only in a desultory, eccentric fashion, flashing before us and then vanishing; yet they are *essential* to it precisely in their decaying, consumed state. The program is, as it were, the waking memory of music. —We are *in* music in the same way we are in dreams. We are at the peasant wedding, and are then pulled away by the stream of the music, God knows where (perhaps it is the same with death, perhaps this is music's affinity to death). —I believe the passing images are *objective,* not merely subjective associations. . . . It is along the lines of such a theory that one could attempt to *rescue* the idea of program music.[130]

Could one ask for a clearer sign that even at mid-century the dream of musical mimesis was not entirely extinguished? Adorno's vision is one of restitution of the intricate interplay of abstraction and mimesis that fertilized music in what for him was its most creative moment.

f. The Significance of Abstraction

The gradual achievement of autonomy from traditional social functions, the achievement that extended over several centuries and came to self-awareness in late eighteenth-century German aesthetic theory, is commonly seen as the cen-

tral defining feature of the modernization of art. It is indeed striking that not only literature, painting, and music, but even such an unlikely candidate as architecture all sooner or later went through the process of autonomization. So far as the latest, and for obvious reasons most reluctant, member of the club of autonomous arts, architecture, is concerned, Witold Rybczynski comments on the list of "the most important buildings in the last hundred years" chosen by the readers of *Architectural Record* in 1991:

> What was particularly striking about the list . . . was that most of the buildings the architects thought were important would be unknown to the public or, if known, would be recognized as notable works of art but not as important places. . . . That a building with absolutely no social, civic, or cultural significance could be considered an important piece of architecture . . . would have been unimaginable in the past. The models of important architecture—the cathedrals, the county court houses, the seats of government—were also the important public places. . . . It is only in the modern period that a building's aesthetic achievement has been divorced from its actual function.[131]

It is not my purpose to deny that autonomy is an important feature of modernization. But the picture that has emerged in this book suggests that autonomization, the process of abstracting art from the context of its traditional social functions, should be seen as one aspect of the more general trend, the turn toward abstraction. It is this general abstract turn, of which autonomization is but an aspect, that defines artistic modernity. The fate of modern music is exemplary, because music, being a medium to which abstraction comes more naturally than to literature or the visual arts, and which can be divorced from social functions with much greater ease than architecture, took the decisive abstract turn much earlier than other arts. But painting's similar turn in our own century shows that more is at stake here than simply a natural development of music's inherent tendencies. In the histories of both arts the emergence of abstraction is a relatively late development, the emancipation of purely instrumental genres from the periphery to the center of the art occurring only in the late eighteenth century (although, as I have argued above, already the *ars perfecta* of the premodern masters of vocal polyphony was to a considerable extent abstractly conceived) and the birth of abstract painting at the beginning of our own. Indeed, one might be justified to interpret the latter birth as the realization of painting's aspiration towards the condition of music, the aspiration that Walter Pater ascribed to all art in 1877 ("All art constantly aspires towards the condition of music").[132] We have already seen that Kandinsky's 1912 manifesto, *Concerning the Spiritual in Art,*[133] would support such a reading and in fact was immediately interpreted in this way by Schoenberg.[134] Gombrich writes: "In turning away from the visible world, art may really have found an uncharted region which waits to be discovered and articulated, as music has discovered and articulated it through the universe of sound."[135] And he adds: "all or most of it [twentieth-century art] tries to represent the world of the mind where shapes and colors stand for feelings."[136]

Moreover, in the recent development of both arts, the abstract turn has proven not so much a single revolutionary event, as rather an ever more intense radicalization, an important stage of which was the achievement of complete abstraction, a point at which the distinction between the work and the world of art collapses and the artist's ambition is to make nothing but real objects (to use the terms defined in chapter 1). This ambition, surprisingly difficult to realize because of our ingrained viewing and listening habits, which make us expect to see and hear a world in a work, virtually defines one strand in the visual and musical avant-garde of the second half of this century, that in which Marcel Duchamp and John Cage were central figures and in which many artists undertook epic struggles to reduce painting to the differentiated flat surface only. Thus, Michael Fried writes:

> [Frank Stella's early work] can be fitted neatly into a version of modernism that regards the most advanced painting of the past hundred years as having led to the realization that paintings are nothing more than a particular sub-class of *things,* invested by tradition with certain conventional characteristics (such as their tendency to consist of canvas stretched across a wooden support, itself rectangular in most instances) whose arbitrariness, once recognized, argues for their elimination. According to this view [a view that Fried makes clear is repugnant to him], the assertion of the literal character of the picture-support manifested with growing explicitness in modernist painting from Manet to Stella represents nothing more nor less than the gradual apprehension of the basic 'truth' that paintings are in no essential respect different from other classes of objects in the world.[137]

Danto quotes Fried and comments:

> And, paradoxically enough, if the paintings were to be understood as saying, about themselves, that they were only things in the world, the fact that they said it would refute them: an apple does not commonly assert that it is just an apple. In one sense nothing could be more easy and more difficult at the same time than to create a work that only was to be identical with its own physical support, since the latter would *ipso facto* be the subject of the work, whereas physical supports logically lack subjects. The problem is analogous to that in which contemporary artists struggled to achieve a surface that was flat; for while nothing seemed easier—the surfaces *were* flat—the task was impossible in that, however evenly paint was applied, the result was a piece of pictorial depth of an indeterminate extension.[138]

Because of the nature of its medium, literature would seem to be resistant to abstraction, the French *poésie pure* of the late nineteenth century notwithstanding.[139] But the "expressivist turn" taken by Romantic poetry in the late eighteenth century, the turn from the representation of the objective world to the expression of subjectivity analyzed by M. H. Abrams in his classic *The Mirror and the Lamp*[140] and interpreted by Charles Taylor in *Sources of the Self,*[141] should be seen as yet another aspect of the same general tendency toward abstraction. In the late eighteenth century, writes Taylor, "our representational

powers came to be seen not only or mainly as directed to the correct portrayal of an independent reality but also as our way of manifesting through expression what we are. . . . This expressive revolution identifies and exalts a new poietic power, that of the creative imagination."[142] In a moment it will become clear why subjectivization and abstraction belong together, why the expressivist turn is not simply a shift from representing the outer to representing the inner world, but rather a withdrawal, an abstraction, from the objective world. But it is the case that the nature of language guards literature from the kind of complete and permanent withdrawal that is a realistic possibility for music and even for painting.

Note, by the way, that the modern turn toward abstraction is by no means the exclusive property of the elite taste. On the contrary, it has shaped certain aspects of the popular culture of our time no less profoundly than it has transformed the culture of the intellectuals. Think of this peculiar phenomenon, the cult of celebrities. In our century, the earlier veneration of "heroes," men and women admired for their extraordinary achievements, was at first supplemented and then gradually supplanted by the veneration of "celebrities," men and women admired for being admired ("famous for being famous").[143] Where the name or image of a hero stands for a concrete, definite value or content (the saintliness achieved, the battle won, the symphony finished), the name or image of a celebrity *is* the only concrete value or content there is there and stands for nothing else. It is a blank check which the broad admiring public is invited to fill in with a myriad of values it fancies, an abstraction to be concretized following the individual desires of the consumers of the image. In this sense, the journalistic photograph of a celebrity shares features with the abstract work of art.

If it is true, then, that what defines artistic modernity is the abstract turn, we need to ask now what are the reasons for, and what is the significance of, this pervasive tendency of modern art toward abstraction? The reasons seem to me to go much deeper than the already mentioned wish to escape commercialization that so many cultural historians and critics, more often than not influenced by Adorno, invoke. They have already been partly intimated here, but they should now be brought out explicitly.

The decisive clue comes from Hegel, the social theorist who, earlier than anyone else, discerned and named the defining features and dilemmas of modernity. According to Hegel, we moderns fundamentally differ from the ancients in our self-understanding. We think of ourselves as "free subjects," that is, beings whose lives can be meaningful only if they are shaped by our own freely made choices. "The right of the subject's *particularity* to find satisfaction," writes Hegel in his *Grundlinien der Philosophie des Rechts* of 1821, "or—to put it differently—the right of *subjective freedom,* is the pivotal and focal point in the difference between *antiquity* and the *modern* age. This right, in its infinity, is expressed in Christianity [that is, is expressed in Christianity as an ideal, an aspiration], and it has become the universal and actual principle of a new form of the world."[144] (Also Tocqueville, another great theorist of the modern age, clearly discerned the

Christian roots of modernity: "The profoundest and most wide-seeing minds of Greece and Rome never managed to grasp the very general but very simple conception of the likeness of all men and of the equal right of all at birth to liberty. . . . Jesus Christ had to come down to earth to make all members of the human race understand that they were naturally similar and equal."[145]) This thought runs through the *Grundlinien* like a leitmotif: "In Plato's republic, subjective freedom is not yet recognized, because individuals still have their tasks assigned to them by the authorities. In many oriental states, this assignment is governed by birth. But subjective freedom, which must be respected, requires freedom of choice on the part of individuals."[146] "[A]n 'I will' must be pronounced by man himself on the issue to be decided. This 'I will' constitutes the great difference between ancient and modern worlds."[147] "The principle of the modern world at large is freedom of subjectivity."[148]

We might rephrase Hegel's thought in terms related to those invoked in the preceding chapter and say that, while our premodern ancestors aspired to no more than to enact with skill traditional social roles and life stories assigned to them at birth, we moderns want to be not only the actors but also the authors of our own individually scripted life stories. Even when we opt for a traditional social role, we want this to be our own choice. For us, writes Hegel, "the question of which particular estate the *individual* will belong to is influenced by his natural disposition, birth, and circumstances, although the ultimate and essential determinant is *subjective opinion* and the *particular arbitrary will,* which are accorded their right, their merit, and their honour in this sphere."[149] And further:

> In this respect, too, in relation to the principle of particularity and subjective arbitrariness, a difference emerges between the political life of east and west, and of the ancient and modern worlds. In the former, the division of the whole into estates came about *objectively and of its own accord,* because it is rational *in itself;* but the principle of subjective particularity was at the same time denied its rights, as when, for example, the allocation of individuals to specific estates was left to the rulers . . . , or to birth *alone.* . . . Thus subjective particularity, excluded from the organization of the whole and not reconciled within it, consequently shows itself—since it likewise appears as an essential moment—as a hostile element, as a corruption of the social order. . . . But if it is supported by the objective order, conforming to the latter and at the same time retaining its rights, subjective particularity becomes the sole animating principle of civil society and of the development of intellectual activity, merit, and honour. The recognition and right according to which all that is rationally necessary in civil society and in the state should at the same time come into effect *through the mediation of the arbitrary will* is the more precise definition of what is primarily meant by the universal ideal of *freedom.*[150]

Thus, the respect for the right of subjective freedom is not simply a *differentia specifica* of the modern age. It is, rather, what makes the modern order potentially superior to the ancient one, for it makes it possible that a harmony between the subjective individual choices and the objective social order might arise.

But while the respect for the right of subjective freedom is the necessary condition if we moderns are to lead meaningful lives, it is far from a sufficient condition, since by itself it is incapable of providing our lives with meaningful content. We have to be able to choose the contents of our lives freely, but our subjective freedom cannot by itself provide us with any particular choices. These can only come from beyond the isolated free individual subjectivity, from the already existing objective social context of practices and institutions. (This is what makes plausible late Heidegger's insistence that we listen to the call of "Being," especially in Gadamer's demystifying translation of "Being" as "tradition." But early Heidegger is no less explicit: "historicality [the fact that it already is in a tradition] is a determining characteristic for Dasein."[151]) Using the term "state" in a misleadingly broad sense which embraces not only the political organization, but all social order, all social practices and institutions, including those of family and, above all, civil society, Hegel writes: "The determinations of the will of the individual acquire an objective existence through the state, and it is only through the state that they attain their truth and actualization. The state is the sole precondition of the attainment of particular ends and welfare."[152] (Hegel's occasional use of the term "state" in this broad sense embracing the whole objective social order, family and civil society included, is particularly unfortunate from our post-totalitarian perspective, since it works against our understandable distrust of the state in the strict narrow sense in which it is distinct from family and civil society. The danger Hegel, in his optimism, did not foresee was the possibility of the state devouring civil society, instead of securing the conditions in which it may flourish. In this respect, Hegel's understanding of the modern condition has to be supplemented by Constant's and Tocqueville's.)

Hegel, by the way, was hardly the first or last philosopher to argue along these lines. "The natural place of virtue," says Montesquieu, "is at the side of liberty; but it cannot be found at the side of extreme liberty any more than at the side of servitude."[153] In *The Morality of Freedom*, Joseph Raz writes: "The completely autonomous person is an impossibility. . . . An autonomous personality can only develop and flourish against a background of biological and social constraints."[154] "A person's well-being," Raz continues, " depends to a large extent on success in socially defined and determined pursuits and activities."[155] This is so because "some comprehensive goals require social institutions for their very possibility"[156] and because "an individual cannot acquire the goal by explicit deliberation," but only "by habituation."[157]

A peculiar danger we moderns face is what Hegel calls the "principle of atomicity," the danger that our self-understanding might be arrested at subjective freedom, that we might become so obsessed with this indispensable but abstract right and so afraid that any concrete choice we make would limit our infinite freedom (as it indeed inescapably would) that we will fail to realize and make concrete use of our right, to make an actual choice and commit ourselves to the cultivation of specific practices and care of specific institutions. We moderns, in short, are in danger of loving our subjective freedom so much that we might fail

to make it objective and actual and instead of living a meaningful life remain condemned to emptiness and meaninglessness. From his different perspective, Tocqueville discerned a similar danger in exacerbated individualism:

> Aristocracy links everybody, from peasant to king, in one long chain. Democracy breaks the chain and frees each link. . . . Thus, not only does democracy make men forget their ancestors, but also clouds their view of their descendants and isolates them from their contemporaries. Each man is forever thrown back on himself alone, and there is danger that he may be shut up in the solitude of his own heart.[158]

This danger, Hegel thought, reached its most palpable historical expression in his own lifetime, during the Terror phase of the French Revolution. The will, he writes, has "this *absolute possibility* of *abstracting* from every determination. . . . If the will determines itself in this way, . . . this is *negative* freedom." And further: "if it [the negative freedom] turns to actuality, it becomes in the realm of both politics and religion the fanaticism of destruction, demolishing the whole existing social order, eliminating all individuals regarded as suspect by a given order, and annihilating any organization which attempts to rise up anew."[159] But even apart from the political realm, the results are disastrous for the individual himself, since they threaten him with empty, meaningless existence. "A will which . . . wills only the abstract universal, wills *nothing* and is therefore not a will at all. The particular [thing] which the will wills is a limitation, for the will, in order to be a will, must in some way limit itself."[160] Thus it is not only the Terrorist revolutionary ready to use the guillotine to prevent any social order from arising, or the Gulag to cow civil society into total submission, that is a characteristic product of the peculiarly modern one-sided attachment to infinite subjective freedom. An equally characteristic product is the romantic artist with his aspiration "to be beautiful," to prevent the inward purity of the soul from getting soiled by actual living:

> A will which resolves on nothing is not an actual will. . . . The reason for such indecision may also lie in an over-refined sensibility which knows that, in determining something, it enters the realm of finitude, imposing a limit on itself and relinquishing infinity; yet it does not wish to renounce the totality which it intends. Such a disposition is dead, even if its aspiration is to be beautiful.[161]

As Kierkegaard's aesthete put it (with a nod to Socrates): "Marry, and you will regret it. Do not marry, and you will also regret it."[162] Old Montaigne, though also a modern, knew better:

> [S]o it is with minds. Unless you keep them busy with some definite subject that will bridle and control them, they throw themselves in disorder hither and yon in the vague field of imagination. . . . And there is no mad or idle fancy that they do not bring forth in this agitation. . . . The soul that has no fixed goal loses itself; for as they say, to be everywhere is to be nowhere.[163]

One aspect of the tendency toward abstraction in art, let us note in passing, is the parallel tendency toward interiorization, a turn away from the representa-

tion of the external world to the expression of internal states of mind. The reason why the two tendencies are intimately related should be obvious. The turn away from the external world is the turn away from any concrete determination of empty and abstract interiority. For Hegel, this interiorization is characteristic of modern "romantic" (that is, Christian) art in general: "The true content of romantic art is absolute inwardness, and its corresponding form is spiritual subjectivity with its grasp of its independence and freedom. This inherently infinite and absolutely universal content is the absolute negation of everything particular, the simple unity with itself which has dissipated all external relations."[164] And further:

> [T]he new task of art can only consist in bringing before contemplation . . . not the immersion of the inner in external corporeality but, conversely, the withdrawal of the inner into itself, the spiritual consciousness of God in the individual. . . . Content and form are not afforded either by the natural as such, as sun, sky, stars, etc., or by the beautiful group of the Greek gods, or by heroes and external deeds wrought on the ground of family obligations and political life; on the contrary, it is the actual individual person in his inner life who acquires infinite worth, since in him alone do the eternal moments of absolute truth, which is actual only as spirit, unfold into existence.[165]

Just as the Christian principle of free subjectivity had to go through arduous historical processes such as the Protestant Reformation and French Revolution to acquire social actuality, so the "romantic" interiorization of art's content was radicalized and deepened only in the late eighteenth century, the period in which historians of poetry, in particular, locate the decisive turn from the representation of the external world toward the expression of the internal states of mind. Music, which, as we have seen, is a medium particularly suited to embody the interior rather than the exterior world, was bound to be at the center of this turn. Not surprisingly, musical metaphors make their appearance at a decisive moment in Hegel's characterization of the romantic art:

> [T]he inner, so pushed to the extreme, is an expression without any externality at all; it is invisible and is as it were a perception of itself alone, or a musical sound as such without objectivity and shape, or a hovering over the waters, or a ringing tone over a world which in and on its heterogeneous phenomena can only accept and re-mirror a reflection of this inwardness of soul. . . . Precisely because the ever expanded universality and the restlessly active depths of the heart are the principle here, the keynote of romantic art is *musical* and, if we make the content of this idea determinate, *lyrical*. For romantic art the lyric is as it were the elementary fundamental characteristic, a note which epic and drama strike too and which wafts even round works of visual art as a universal fragrance of soul, because here spirit and heart strive to speak, through every one of their productions, to the spirit and the heart.[166]

I shall explore the notion of the "lyrical" more fully in chapter 5. The abstract turn of modern art, I would now like to claim, an aspect of which is the abstraction of various arts from their traditional social functions, has its deepest

root in the peculiarly modern tendency identified by Hegel, the reluctance of the infinitely free subject to impose any finite determinations upon itself, to give its life any actual objective content. It is one of the functions of art, I have argued here, to show us who we are, to provide us with self-images and self-understandings. More often than not, a modern artist makes himself into the main subject of his art, shows us not the world so much as his experience of the world. (Beethoven is his own subject to an extent that Bach, notwithstanding his penchant for encoding his own name within his music, would find distasteful, incomprehensible even.) Abstract art is a perfect image of infinitely free subjectivity, a subjectivity escaping all limiting determinations and intending instead the infinite totality. Recall Hoffmann's claim that music's "only subjectmatter is infinity," the Kantian noumenal realm. Recall also Schopenhauer's claim that "we must attribute to music a far more serious and profound significance that refers to the innermost being of the world and of our own self" and that "music is as *immediate* an objectification and copy of the whole *will* as the world itself is." In considering such claims we should not be put off by the no longer credible metaphysics they invoke. What matters, rather, is the correct recognition that, unlike mimetic art with its finite and determinate subject matter, the new abstract art intends the infinite totality, the world as a whole and the desiring self before its desire settles on anything in particular. And it makes no difference whether the accent falls on the world or on the self: as the noumenal infinite and completely indeterminate realms, both are equally ineffable.

Premodern artists by and large strove to represent in their various media contents they did not invent but found transmitted in the classical and Christian traditions. The modern artist, instead, invents the content of his work in the attempt to express his own unique self. It is not surprising that sooner (sooner, the more radically modern he is) or later he encounters the specter of sterility: pure self is empty, it acquires a content only when it comes into contact with something other than itself. And it is not suprising that music has been tormented by this specter longer and more profoundly than other arts.

One of the most intriguing claims in MacIntyre's *After Virtue* is the suggestion that the moral structure of a society is best captured in a specific narrative genre. Thus, for instance, the moral structure of the heroic society

> embodies a conceptual scheme which has three central interrelated elements: a conception of what is required by the social role which each individual inhabits; a conception of excellences or virtues as those qualities which enable an individual to do what his or her role requires; and a conception of the human condition as fragile and vulnerable to destiny and to death.... All three elements find their interrelated places only within a larger unitary framework. ... This framework is the narrative form of epic or saga.... Heroic social structure *is* enacted epic narrative.[167]

Abstract art, on the interpretation proposed here, is *the* form of modernity, a characteristic symptom of the modern condition diagnosed by Hegel, and hence

its contemporary situation reflects faithfully the larger dilemma we face. We want to safeguard our modern right of subjective freedom but not at the cost of never exercising this right, and we hope to find ourselves in an objective social world that will offer us worthwhile opportunities for exercising it, a world of social practices we might want to participate in and extend and of institutions we might wish to preserve and improve. Our art reflects this situation like a good mirror. At its most radical, it celebrates the modern infinitely free subjectivity, intending everything, committed to nothing. And, precisely at its most radical, it finds itself facing the very same loss of significance and the very same sterility that is faced by the subjectivity it celebrates. What it needs is to leaven subjectivity with objectivity, abstraction with mimesis, that is, something the best music of the last two hundred years has been doing supremely well.

POETICS AND HERMENEUTICS: THE CONTENTS AND INTERPRETATION OF ARTWORKS

POETICS I:
DIEGESIS AND *MIMESIS*.
THE POETIC MODES AND THE
MATTER OF ARTISTIC PRESENTATION

In part I, I attempted to answer the question, What should the function of art be, if art is to have a value for us? In the first two chapters of part II, I shall ask, How does art fulfill its functions? In other words, I shall turn now from the aims to the means of art. More specifically, I shall endeavor to show what the world represented in an artwork should consist of if it is to fulfill its functions. In chapter 4, I shall attempt to identify the elements that constitute an artworld. Chapter 5 will show how these elements may be formally arranged.

⌒◦

In the third book of the *Republic,* Socrates, having examined the subject matter of tales or the "what" of speech, went on to discuss the "how," the "diction" or "the manner of speech."[1] "Fabulists or poets," he said, "proceed either by pure narration (*diegesis*) or by a narrative that is effected through imitation (*mimesis*), or both." On some occasions, Homer "himself is the speaker and does not even attempt to suggest to us that anyone but himself is speaking." On other occasions, he "tries as far as may be to make us feel that not Homer is the speaker," but a personage in his tale. In the former case, he effects his storytelling through pure and simple narration, in the latter, through the imitation of another person's speech. Thus, "there is one kind of poetry and taletelling which works wholly through imitation, . . . tragedy and comedy, and another which employs the recital of the poet himself, best exemplified . . . in the dithyramb, and there is again that which employs both, in epic poetry and in many other places."

Aristotle, in the *Poetics,* took over the platonic distinctions. The representational arts, "epic poetry and tragedy, as also comedy, dithyrambic poetry, and most flute-playing and lyre-playing,"[2] but also others, such as dance[3] and perhaps even painting,[4] differ from one another in the means or media they use, in the objects

they represent, and in the manner or mode of imitation.[5] "Given both the same means and the same kind of object for imitation, one may either (1) speak at one moment in narrative and at another in an assumed character, as Homer does; or (2) one may remain the same throughout, without any such change; or (3) the imitators may represent the whole story dramatically, as though they were actually doing the things described."[6]

Following Plato and Aristotle, we may provisionally distinguish the two pure "modes" in which the content of a literary work may be presented, the "diegetic" mode (as I shall call it here in order to avoid the potentially confusing term "narrative"), in which the storyteller, the narrator, speaks, and the "dramatic" mode (again, the term "mimetic" might be confusing), in which the represented personages speak, as well as the third "mixed" mode combining the two pure ones. My aim here is to clarify the nature of the modes,[7] raise the question of their applicability outside the realm of literature, specifically to painting[8] and music,[9] and discuss the relationship between the author and the voices he employs in his work.

a. The Voices

When we use language, we speak (or listen to speech), write (or read), or silently think. Any use of language presupposes a speaker (and listener, even if the latter is the same person as the speaker), writer (and reader), or thinker. Since the differences between speaking, writing, and thinking are irrelevant here, I shall refer to the language-user implied by any act of speech as the "speaker" or the "voice."

A speaker can, of course, be a real person or an imaginary personage. And his existence, whether real or imaginary, may be merely implied by the very fact that something is said, or it may be brought into focus with various degrees of explicitness (just as my existence as the speaker of this text is presented much less explicitly here than it would be if this were an autobiography). In other words, while any speech act implies a speaker, some may do no more than that, leaving the question of the reality of the speaker entirely open and not explicitly asserting his existence.

A fundamental distinction one must make when thinking about the nature of literary modes (a distinction that, it seems to me, has never been made with sufficient clarity) is the one between a voice speaking immediately, that is, without the mediation of another voice, and a voice whose speech is reported by another, immediately speaking, voice. (Thought police searching for traces of the "metaphysics of presence" should relax upon learning that "an immediately speaking voice" does not mean here "a voice not embodied in a medium," but merely "a voice not mediated by another voice.") Note that a speech may be reported in another reported speech, which in turn may be reported in yet another reported speech, and so on, but at the end of the chain there must be an immediately speaking voice. Note also that the distinction between immediate and reported speech is not coextensive with the distinction between direct and indirect speech. In, "'We have,' said Haze, 'an excellent dentist. Our neighbor, in

fact. Dr. Quilty. Uncle or cousin, I think, of the playwright,'" Haze speaks directly, while in "They had, said Haze, an excellent dentist. Their neighbor, in fact. Dr. Quilty. Uncle or cousin, she thought, of the playwright," she would be speaking indirectly, but in both cases her speech is reported by another voice, the one that says "said Haze" and belongs to Humbert. Now a literary work, *any* literary work, must present its content by means of at least one voice, and it may employ many voices. All of the voices heard in a literary work may speak immediately, or only some voices may speak immediately, while others have their speech reported by those speaking immediately. When the work employs only one voice, it must speak immediately. When several voices are heard, they may all speak immediately and at least one of them must speak immediately.

Thus, if we want to classify literary works on the basis of the voices they use, we must first distinguish those that speak immediately from those whose speech is reported. Since only immediately speaking voices are necessary to any literary presentation, while the use of reported speech is optional, we may classify all literary works into those using only one immediately speaking voice and those using many such voices. In other words, we might distinguish the "monophonic" mode, in which there is only one immediately speaking voice (with all other voices, if any, having their speech reported) and the "polyphonic" mode, in which there are many immediately speaking voices (without excluding, or requiring, voices whose speech is reported). (Needless to say, the terms are used in a sense quite different from Bakhtin's, a sense much closer to their source in the vocabulary of music theory.[10]) But we should not prematurely conclude that our distinction between the monophonic and polyphonic modes is identical with the platonic distinction between the diegetic and dramatic modes.

When Plato introduced the concepts of *diegesis* and *mimesis,* what mattered to him was not the number of immediately speaking voices, but rather their nature. We might best be able to capture the essential difference he had in mind if we see it as depending on whether a speaker belongs to the world presented by his speech or not. A speaker may himself belong to the world his speech presents, he may be what we call a "character" or "personage" in this world. Or a speaker might tell us of a world to which he himself does not belong, he may be what we call a "narrator" of the presented world. The mode in which all the immediately speaking voices belong to the personages is the dramatic mode. In the diegetic mode, the immediately speaking voice belongs to the narrator.

The notion of a speaker belonging or not to the world presented by his speech requires some clarification, if it is not to be misleading. We need a criterion of the identity of a world, a criterion on the basis of which we can decide whether given persons belong to the same world or not. An unambiguous criterion will be found when we reflect on the relationship between the persons and the deictic temporal adverbs, words such as "now," "then," "today," "yesterday," or "tomorrow," they use. Two persons do not share a common world if it is possible that when they utter in some sense simultaneously the word "now" (or any of the deictic temporal adverbs) it might not have the same meaning (or, more precisely, might not refer to the same time). This is never possible for you and me and

hence we inhabit a common world. But when I hear Richard, Duke of Glouces-
ter announce "Now is the winter of our discontent . . . ," I know that his "now"
does not refer to the same time as my own "now," the "now" in which I hear him,
and that, therefore, we cannot belong to the same world. Similarly, since the
"now" of the narrator does not have to refer to the same time as the "now" of a
personage in the narrator's story, they belong to two different worlds.[11] To be
sure, a narrator might be telling a story that happens simultaneously with his
telling it. But this does not synchronize the "nows" of the narrator and person-
age necessarily and permanently, because it is always possible for the narrator to
retell the same story. The next time he tells it, the "now" of the personage will
be in the past of the "now" of the narrator. This is because the "now" of the per-
sonage in the story refers always to the same time each time the story is told, while
the "now" of the story-telling narrator refers to a different time each time he tells
the story.

Note that this is the case even when the narrator is a personage in the story
he narrates: since his "now" as the narrator is different from his "now" as the
personage, in his role as the narrator he belongs to a different world than the
one he narrates and to which he belongs in his role of a personage.[12] Note more-
over, that, while the lack of synchronization of the two "nows" is verbally ex-
plicit when the narrator uses the past tense—as is his wont, the asynchronism
obtains even in those stories in which the teller uses the present tense (which is
why one usually calls the tense the "historical present"). In cases of this sort
the reader must decide whether the speaker tells a story (and the author uses the
diegetic mode) or reports on what he currently observes (and the mode of the
text is dramatic). While the author may leave the reader without a clue, usually
a clue is provided. In Chekhov's dreary tale of "Gusev," the speaker sticks rig-
orously to the present tense, but by the time Gusev's dead body is thrown over-
board into the ocean and at a depth of over sixty feet is encountered by a shark
the reader realizes that this must be a story, it being most unlikely that anyone
would be observing such a scene directly. But if it is a story, the narrator's "now"
must differ from, be posterior to, the "nows" of the unfortunate Gusev and the
fortunate shark, since the narrator presumably knows the story's outcome in ad-
vance of the telling. Another kind of clue, this time explicitly verbal, is provided
in Goethe's 1782 ballad of the "Erlkönig." The narrating voice, heard only in the
first and last stanzas, uses the present tense throughout to report on the father's
hurried night ride home, his groaning son in his arms, but switches to the pre-
terite in the last verse to describe the outcome: "In seinen Armen das Kind war
tot" ("The child was dead in his arms"). Thus the narrating voice distances itself
suddenly and finally from the narrated world (the move paralleled by Schubert
in his celebrated setting when, for the last verse, he abandons the pianistic reen-
actment of the breathless ride for the suddenly distancing objective tone of the
recitative).

This asynchronism of the narrator's and the personage's "nows" results in
what is surely the single most essential feature of *diegesis*. A literary work may

present a narrator who, in turn, presents a world which is not his own. It follows that while the world presented dramatically in a literary work may be a single world, the world presented diegetically will consist of at least two distinct onto-logical levels, the immediately presented world of the narrator and the world mediated by the voice of the narrator. While the primary focus of the reader's at-tention is usually on this latter mediated world, structurally the narrated world is hierarchically subordinated to the world of the narrator. One might also say that the former is embedded in, or dependent on, the latter, since it is the exis-tence of the narrator's voice that makes the existence of the narrated world pos-sible, and not the reverse.

The four terms of the two modal dichotomies, that between monophony and polyphony and that between *diegesis* and *mimesis,* may occur in actual literary works in every possible combination: the diegetic mode is usually monophonic ("monophony" in the sense in which the term is used here would, of course, in no way prevent a work from being "polyphonic" in the sense introduced by Bakhtin), but a literary work may also employ several immediately speaking voices as narrators; the dramatic mode is usually polyphonic, but a literary work may also employ a single immediately speaking voice as a personage (as in the dra-matic monologue). A mixed mode, in which some of the immediately speaking voices serve as narrators and others as personages, is also conceivable. Moreover, we have already seen that a narrator can also be a personage (in a story told by himself or by another narrator), although as a narrator he will belong to a dif-ferent, more fundamental or primary, world than the one he belongs to as a per-sonage. Conversely, a personage can become a narrator in his own right, though again, as a narrator he will belong to a different, more fundamental, world than the world he presents in his narration.

Two observations should be made at this point. First, even though Plato and Aristotle concentrated on the "narrative" in the broad sense of the term, that is, on the literary presentation of events, of men in action, and disregarded what we call the "lyric," the kind of poem which does not present the actions one does, but the states one finds oneself in, the modal categories they introduced cut across the narrative-lyric distinction and are applicable to the whole realm of literature. (The distinction between the narrative and lyric will be the subject of chapter 5.) In other words, the applicability of modal categories does not de-pend on distinctions based on the object of presentation. Thus our two modal dichotomies are operative not only in the narrative text-type or form, but also in the lyric. A polyphonic lyric is conceivable, though a monophonic one is far more usual. And the lyrical voice may belong either to a personage (whether im-plied or explicit), making no difference between his own "now" and the "now" of the world of which he speaks, or it may belong to a narrator whose "now" is not that of the world of which he speaks (as happens when he uses the preterite).

Second, our two modal dichotomies are operative in texts regardless of whether the world portrayed in them is imaginary (as in works of fiction) or real (as in works of history). Note in particular that not only the novelist, but

also the historian presents in his work a narrator whose "now," and hence world, is different from that of the world which comes into being in the narrator's story. The historian may try very hard to keep the narrator as inconspicuous as possible, but he cannot make him disappear completely. The very choice of the topic, the arrangement of the material, the judgments passed on the actors and events of the narrated history allow us to catch a glimpse, however fleeting, of the narrator, imply what kind of a person he is, what his priorities and values are.

The results reached thus far may be summarized as follows. First, a literary work must present its content by means of at least one immediately speaking voice (monophony) and it may employ many such voices (polyphony). Second, an immediately speaking voice may belong to a personage, that is, a speaker who is himself a part of the world his speech presents (the dramatic mode), or it may belong to a narrator, that is, a speaker who tells us of a world of which he himself is not a part (the diegetic mode). Third, both the personage and the narrator belong to the world presented in the literary work, but while the world presented dramatically may be a single world, the world presented diegetically must consist of at least two distinct and hierarchically related ontological levels, the world to which the narrator belongs and the different, subordinated, world which he presents.

All the immediate (as well as, of course, all the reported) voices and their speakers are presented in the literary work. That is to say, they are not just the way in which the work's content is presented, the work's "how," as Plato would say, but also a component of this content itself, of the work's "what," or, to use Aristotle's terms, they are not only the whole of the mode, but also a part of the object of representation. To put it more precisely, the world which comes into being, is made present, in the work does not consist only of the represented "object," that is, the "material" existents, such as the acting (suffering) and speaking (listening, writing, reading, thinking) personages and the settings in which they act and speak, as well as the "formal" relationships among them. It consists also of the "mode" of representation itself, that is, the immediately speaking voices and their speakers. This is obviously the case in the dramatic mode in which all the immediately speaking voices belong to the represented personages. Less obviously, this is also the case in the diegetic mode: the narrating voice is not only a medium of presentation, but also a component of the presented world, even though the narrator may be realized with varying degrees of completeness, ranging from a fully rounded and explicit personage to an attenuated and disembodied voice, and even though the world of the narrator differs from the narrated world.

b. The Modes in Painting and Music

We have seen that in a literary work the mode and the matter of presentation overlap, but only in part: while all the immediately speaking voices, that is, the mode of presentation, are at the same time, as personages and narrators, a part of the presented matter, not all of the matter must also be the mode. In other

words, all of the voices that do the presenting are also presented, but not every-
thing that is presented is also engaged in presenting. Some or even all of the
personages may never become a part of the mode and none of the setting ever
does. It is precisely because the overlap between the mode and matter in a liter-
ary work is only partial that it is sometimes useful to distinguish between the two.
Now it is striking that in most painting and music the mode and matter seem to
overlap so completely that the distinction between them collapses. But in each
of these arts this happens in a somewhat different way. One might be tempted
to think, namely, that in painting the mode is absorbed by the matter, while in
music the matter disappears into the mode.

If one wanted to find in painting something analogous to the immediately
speaking voices of literature, one would have to enlarge the scope of the notion
of "voice" to include a person's way of communicating his meaning by address-
ing not only our sense of hearing, but also our sense of sight, that is, to include
not only his speech, but also his total aspect, especially the facial expression and
gestures. A literary personage communicates his meaning by means of speech, a
painted one by means of aspect. Once we have enlarged the scope of the notion
of voice to include not only speech but also appearance, however, we notice im-
mediately that a figure in a painting communicates in exactly the same way as
the setting does. In a literary work, the personage may present himself, but the
setting can only be presented (by a personage or the narrator). In a painting, the
setting presents itself just as much as a personage does. But if this is so, if—as
it appears—everything presents itself and nothing is merely presented, the dis-
tinction between the mode and the matter of presentation seems to lose all use-
fulness in painting.

By contrast with painting, in music it would be easy to talk about the mode
of presentation. But just as in painting, also in music it seems to be impossible
to distinguish the mode from the matter of presentation. The concept of mode
fits music in a most natural way, because the notion of voice has been very much
at home in music theory for centuries. This was only to be expected, so long as
the most sophisticated art music (the kind that was most likely to become the
object of theorizing) was predominantly or exclusively vocal. A "voice" in a
composition was simply a melodic line. If there was only one such line, the com-
position was "monophonic," if there were two or more simultaneous lines, it
was "polyphonic." The gradually increasing importance and independence of
instruments did not bring any essential change in this respect, since a melodic
line can be carried by an instrument just as well as by a human voice. It did in-
troduce, however, a new textural possibility ("homophony"), in which a fully
integral melodic line is given an "accompaniment," a kind of a soundscape set-
ting which does not quite attain the full integrity of shape and continuity that an
independent line possesses, but can have a degree of motivic definition of its own.
Much of the textural interest of music written after 1780 lies in the fact that the
boundary between a line and its accompaniment may become blurred, that a me-
lodic motif can join the accompaniment and the reverse, an accompanimental

motif can be melodically thematized. On occasion it is even impossible to decide whether what we hear is a melody or an accompaniment; the music can be heard both ways. But even when such possible ambiguities have been taken into account, everything that we hear in a piece of music is either a line, or its accompaniment, or both. However, like in painting in which all matter seems always to present itself, also in music both the line and the accompaniment seem always to present themselves and never to be merely presented. (Another way of making this point might be to say that the pictorial and musical voices, unlike the literary ones, seem to be able to use only the first-person pronouns, "I" and "we.") But if this is so, then—again—it appears that the distinction between the mode and the matter of presentation loses its usefulness also in music.

Note in this context that Adorno's claim "that [Mahler's] music performs itself, has itself for the content, narrates without the narrated"[13] loses its air of paradox when music stops being compared with literature (where we normally expect a voice to present something other than itself in addition to presenting itself) and is compared with painting instead (where we do not expect a "voice" to present anything other than itself). Music's lack of "referentiality" will stop troubling us when, instead of expecting it to behave like language, we notice that in this respect it is more akin to painting. A depicted figure does not "refer" to anything, it simply appears. Like a musical voice, it says something without our being able to tell what it says, or, more precisely, without our being able to distinguish its appearance from what it says. If this does not trouble us when we think about painting, there is no reason why it should when music is our subject.

Incidentally, it probably goes without saying that the claim that in painting and music everything seems to present itself and nothing to be merely presented should not be construed to mean that the matter presenting itself may never bring to mind something other than itself. This is obviously not the case in painting, where one invariably sees the painted figures and settings in the context, so to speak, of those we know from other sources—painted, written, or real. But even in abstract instrumental music, the lines and accompaniments often bring to mind something other than themselves, if they have previously been associated with this "something other," previously, that is, in the course of the cultural tradition (the way fanfares sound military and menuets aristocratic), or in the course of a particular work (in the manner of a Wagnerian leitmotif). The claim that in painting and music everything seems to present itself and nothing to be merely presented means only that in these two arts, unlike in visual or aural traffic signs or in language when it is reduced to its referential function, what presents itself cannot be bypassed without a loss of something essential.

However, the claim that in painting and music everything presents itself and nothing is merely presented, while generally correct, has to be revised if we are to account for some significant phenomena. Let us consider how the categories of elements that constitute, singly or in any combination, the world presented in the literary work (namely, the setting, the personage, and the narrator) compare with those constituting the worlds presented in paintings and musical works. My

claim will be that while we may easily find analogues for the setting and the personage in painting and music, a true narrative voice is more difficult to locate and may be something of a rarity in these two arts. Normally, the setting and the personage, or their analogues, exhaust the list of categories of elements that constitute the worlds presented in a painting or musical work.

We have observed above that the only way to make the notion of "voice" or "speaker" applicable not only to literature and music but also to painting, was to enlarge its scope to include not only speech but also appearance. Once we do that, we can see that in figurative painting the presented human figure is the exact analogue of the literary personage and the natural or man-made surroundings of the figure become strictly analogous to the literary setting. In such genres as landscape or still life, the setting can emancipate itself from the human figure and be an independent theme, just as in some portraits the setting may be left almost entirely indistinct. But in any case, the personage and the setting are the only categories of elements of the world normally presentable in figurative painting.

The analogues that can be found in abstract painting for setting and personage are much less exact. We have already learned that much abstract painting is a species of representational painting. Now one can find inexact analogues of the personage and the setting even in abstract painting, because the imaginary world presented in it must consist of the figure(s) and the more or less distinct (back)ground against which it is (they are) seen. To be sure, just as in instrumental music since the late eighteenth century it is occasionally impossible to decide whether what we hear is a melody or an accompaniment, so in painting of our own century (and not only abstract works—think of cubism) it is often impossible to decide whether what we see is figure or ground; the painting can be seen both ways. But even when such possible ambiguities have been taken into account, everything that we see in a painting, whether figurative or abstract, is either figure, or ground, or both. The painting being abstract, the figure cannot be identified as human, or as any other kind of recognizable object. But since the line dividing the abstract from the figurative painting is blurred, the figure may be anthropomorphic, or—more generally—it may, but does not have to, resemble to a degree any kind of visual object.

So much for the analogues of the personage and setting in painting, whether figurative or abstract. To turn now to music, the use of voices uttering texts is what literary works and pieces of vocal music have in common. It follows that in vocal music (whether accompanied by instruments or not) the exact analogue of the personage's voice is the melodic line carried by the human voice. A singer of such a line is doing exactly what an actor does when he recites his part; they both impersonate. If there is an accompaniment, its function is analogous to that of the setting, namely, to provide an environment for the personage, a background against which he may appear.

These analogies are maintained, although less exactly, in purely instrumental music as well. As Kendall L. Walton has pointed out, "most or even all music will likely have to be considered representational" for reasons analogous to those

brought forward by Richard Wollheim in support of his thesis that both figurative and abstract painting are species of representational art.[14] Also in music we make a distinction between the melodic lines and the accompaniment, or—more generally—between figures and a more or less distinct ground against which they appear. Since a piece of instrumental music, no less than a vocal one, presents a world consisting of figures heard against a more or less distinct ground, one can find inexact analogues of the personage (the line) and the setting (the accompaniment) even in instrumental music. The analogues are less exact than in vocal music, because the line may be so far removed from the vocal style of melody and from any kind of movement a human body might make that we would not want to attribute it to a human source. But the reverse is also true: the line may be strongly anthropomorphic; it may preserve to some extent a vocal character, or the character of a stylized human movement, and hence also an intimation of a human utterance or appearance, even when it is carried by an instrument rather than a voice. One might say that vocal and instrumental music differ in the degree of abstraction of the concepts under which we bring what we hear. In vocal music we usually attribute the melodic line to a human personage. In instrumental music, or in vocal music with independent (*obbligato* is the technical term) instrumental line(s), the instrumental line can sometimes be attributed to a source that resembles to a certain degree a human person or another object we could name, but it can also remain so abstract that we will not be tempted to attribute it to a human or any other kind of recognizable source. (Incidentally, it will not have escaped us by now to what extent the relationship between vocal and instrumental music resembles the one between figurative and abstract painting.) "Understanding music," writes Roger Scruton, "involves the active creation of an intentional world, in which inert sounds are transfigured into movements, harmonies, rhythms—metaphorical gestures in a metaphorical space. And into these metaphorical gestures a metaphorical soul is breathed by the sympathetic listener."[15]

However, while we could find with little difficulty more or less exact analogues of the literary personage and setting in painting and music, it is less easy to identify a narrator in either of these two arts. Let us recall that a literary work that employs the diegetic mode must present its content by means of at least one immediately speaking voice belonging to a narrator, a speaker who tells us of a world of which he himself is not a part; the world presented diegetically must also consist of at least two distinct and hierarchically related ontological levels, the world to which the narrator belongs and the different, subordinated, world which he presents. Thus the diegetic mode involves first, the hierarchical relationship between the world of the narrator and the presented world, with the latter embedded so to speak in the former; second, the immediately speaking voice of the narrator; and third, the presented world mediated by the narrator's voice. We should ask now whether any of these three features of *diegesis* is possible in painting and in music.

To begin with painting, there can be little doubt that something very much

akin to the first feature of *diegesis* is possible there. The world presented in a painting may be split into two hierarchically related levels when the painting presents a picture-within-a-picture. (We should not consider here those late medieval panels that simultaneously present several episodes from the life of a saint when they are not hierarchically related but simply juxtaposed, since such panels may have been intended to be taken serially, like a comic strip, rather than as a single picture.) A picture-within-a-picture presents a secondary, ontologically less fundamental, dependent world embedded in the primary, independent, fundamental one. The simplest case is a painting that presents a room with a painting hanging on the wall. (In spite of intriguing similarities, a mirror, or a window, would not quite do, since what it reflects, or opens to, is the primary world of the painting, not a secondary one.) More complex and possibly ambiguous cases may arise when the internal frame separating the picture-within-a-picture from the rest of the main picture is not explicitly marked but only implied by, say, the different scale of the objects presented within it. The situation is still more ambiguous, hopelessly so, in abstract painting. An internal frame is, of course, entirely possible there, but it may be that if we are ever inclined to see the world within the frame as different from the one outside, it is only by analogy with and in reminiscence of the figurative paintings we have seen. And the ambiguity is hopeless, because we can never decide whether the internal frame reminds us of one delimiting a picture hanging on the wall, a mirror, or a window. Nevertheless, if the contrast between what is within and what is outside the internal frame is sufficiently great, we may be tempted to interpret the world within the frame as different from the one outside.

Something like the second feature of the diegetic mode, the immediately speaking voice of the narrator, may also appear in painting, provided we accept our earlier observation that we have to enlarge the scope of the notion of "voice" to include not only speech, but also appearance. A human figure presented in a painting may gesture towards the picture-within-a-picture and thus function like the narrator, the immediately speaking voice presenting a world of which he himself is not a part. St. John the Baptist who points toward martyred Jesus and says "Behold the lamb of God" (as in Roger van der Weyden's *Braque Triptych* in the Louvre, or in the Crucifixion panel of Mathias Grünewald's *Isenheim Altarpiece* of 1515 at Colmar) acts as a narrator, since, not having been present at the crucifixion, he cannot belong to the world toward which he directs our attention. For obvious reasons such a figure cannot appear in abstract painting. But we should remember that also in literature the narrating voice may be almost completely disembodied, that the source of this voice does not have to come into focus as a personage. Thus we may have something like the narrating voice in painting even without the explicitly presented human figure gesturing towards the picture-within-a-picture, since the world outside the internal frame may be said to present in a sense the world within the frame. In a representation of an empty room with a painting hanging on the wall, it is the room itself—of which the painting on the wall, understood as a "real" object, is a part—that presents

the world of the painting on the wall. Without the room, specifically without the painting on the wall understood as a "real" object, as a part of the room's furniture, the world presented in the painting on the wall could not appear, just as the world presented by the narrating voice could not appear without this voice.

This observation has an interesting but potentially misleading corollary. It might be concluded, namely, that the fundamental structure of any work of art is in a certain sense always "diegetic," since the work is always a real object (an object existing in the "now" of the real world) that mediates an "imaginary" or "intentional" presented world (with its own, different, "now"). This is correct, but the crucially important point to keep in mind here is that the work as the real object is *outside* the presented world, while the narrative voice must be *within* it.

And here we have already crossed over to the third feature of the diegetic mode. If the observations made above are correct, it must be possible to have in painting a presented world mediated by the narrating voice, since the world of the picture-within-a-picture is necessarily mediated or presented by the world outside the internal frame. Note that the latter two features of *diegesis* are in a sense redundant, since they are already implied by the first feature. Thus the hierarchical relationship between two worlds, or two ontological levels, is all we need to identify the presence of the diegetic mode. But if we want the narrating "voice" to become explicit as the personage of the narrator, we must have a human figure gesturing towards the picture-within-a-picture.

One might be tempted to object here that we have overlooked an important distinction between painting and literature. If in a figurative painting presenting a picture-within-a-picture we take away the internal frame and everything outside of it, we will be left with a presentation in the purely dramatic mode and no trace of any *diegesis,* without having to repaint anything within the internal frame. If, on the other hand, in a literary work presented in the diegetic mode we take away the voice of the narrator, it might require considerable rewriting to obliterate all traces of *diegesis* and transform the presentation into the dramatic mode. This is, of course, a correct observation. Its significance, however, should not be overestimated. When transforming a literary presentation from the diegetic into the dramatic mode, we are forced to rewrite what remains after the narrating voice had been removed only if indirect speech was used. We then have to put everything the personages say into direct speech. All that our observation means is that indirect speech is possible only in literature and not in painting. This, however, cannot constitute an objection to our showing how the diegetic mode can arise in painting, since also in literature we can have *diegesis* without the use of indirect speech.

The conclusions we have reached concerning painting are immediately relevant to an understanding of the diegetic potential of music. Since in a vocal line the text usually imposes its mode on the music, the voice of the narrator is, of course, entirely possible there (think of the Evangelist in a Bach Passion). But is it also possible when the text has been subtracted from the melodic line, or was never attached to it, in instrumental music, or in the *obbligato* instrumental

voices of vocal-instrumental works? The key question, we have just seen, is whether one might be able to present in an instrumental line two hierarchically related worlds, one embedded in the other. To ask this question in a more precise, and potentially more fruitful, way, can an instrumental voice, in addition to presenting itself, mediate another voice (or accompaniment), belonging to a different world, without simply becoming this other voice? Now it is important to realize that the way an instrumental voice maintains its identity in a piece is crucially dependent on the identity of the instrument (or, in the case of the orchestral rather than soloistic or chamber-music texture, instruments) that perform it. As Adorno put it, in the orchestral texture "the sound alone presents a We as the musical subject."[16] In the case of instruments capable of polyphony, such as the organ or piano, it is the register within which the voice moves that is crucial. (To be sure, the situation is further complicated by the fact that actually used instruments may combine into imaginary "super-instruments" to such an extent that even a whole orchestra might be conceived of as a single multicolored "super-instrument." Moreover, it may on occasion be impossible to decide whether the music is played by a single imaginary "instrument," or by many such "instruments"; the music may be legitimately heard in several different ways.[17] But this added complication does not crucially affect our argument here.) Once this is understood, we can see that an instrumental voice can maintain its identity while mediating another voice, because the identity of the instrument (or instruments, or register) may be preserved, even when what the instrument plays belongs in some sense to someone else, to another voice.

But how can an instrumental voice appropriate the "speech" of another voice? This can happen only when what the instrument plays has been "said" or played earlier, by someone or something else, in the same piece or in a different one, in or outside of music, that is, when the instrumental voice literally quotes from, or less-then-literally alludes to, someone else's "speech." Also in literature, quotation and allusion, like all mediated speech, are intrinsically and inescapably diegetic: I *presently* quote or allude to (mediate) what someone else said in the *past*. A quotation or allusion comes always with the explicit or implied diegetic tag: "said X." Through the gates of quotation and allusion the narrator's preterite enters musical discourse, separating the "now" of the immediately heard instrumental voice from the anterior "now" of the mediated voice.

The less literal the allusion, the more ambiguous its status. The borderline between allusion and nonallusion is not razor-sharp, and in interpreting what a voice says we should resist the temptation of trying to decide the undecidable cases. It is useless, for instance, to appeal to the author's intention, since, on the one hand, an allusion may be involuntary and, on the other, it may be unsuccessfully realized.

Both quotation and allusion—that is, one voice's appropriation of another voice's specific individual utterance—must be distinguished from the much more common, inescapable even, use of generalized features of a language, style, or genre by the voice. The latter does not have the diegetic structure. Whether in

language, painting, or music, there is no such thing as a perfectly individual utterance. In speaking, we must always use a language which is not of our own making. It does not follow that, as Heidegger seems to suggest on occasion, it is not we but language that speaks, that an utterance can never be individual (we can and do sometimes say something new and we can even, rarely, extend the limits of the language), but only that the individuality can be no more than relative.[18] But neither should we draw from Bakhtin a conclusion his work does not warrant to the effect that every voice (in the prose of the novel, at least) is "double-voiced," or "dialogized," or "heteroglot" to the same degree, that we could make no distinctions concerning the relative explicitness or implicitness with which a given voice uncovers or hides a multiplicity of voices it makes use of.[19] Every individual utterance must make use of generalized features of a language, style, or genre, but only some utterances quote or allude to other specific individual utterances and thus acquire diegetic structure.

Thus far we have considered only one voice's appropriation of another voice's "speech." But, in literature at least, self-quotation and -allusion are also possible and they too have a diegetic structure: I quote "now" what I said in another "now." Are they also possible in music? Let us observe that in cases of both literary and musical self-quotation or -allusion the matter quoted or alluded to would have to be internal to the given work (though this might consist of several parts or movements), since the "speaking self" retains its identity only within the boundaries of the work; it would make little sense to claim that the narrator of one novel is "the same" as that of another novel, or that the first violin represents "the same voice" in all string quartets. (One might think that a literary voice that portrays a real person constitutes an exception, since here the identity of the speaker might be taken to transcend the limits of the work. But in fact it is the identity of the portrayed model that transcends the limits of the work, not the identity of the speaker.) This distinction apart, self-quotation and -allusion are no different in character from other kinds of quotation and allusion and are equally possible in music as they are in literature.

The big difference between the two arts in this respect is quantitative. Music tolerates and thrives on an incomparably greater amount of immediate repetition, recapitulation (the return of the same or similar material after an intervening discourse), and elaboration (such as variation or development) of the material than literature. In a sense, music recompensates in this way for its lack of those features (such as the tenses or deictic temporal adverbs) that commonly establish the diegetic mode in literature.

One might object here that to treat, say, an immediate and exact repetition of a phrase as a case of (self-)quotation and to attribute to it the diegetic structure stretches both the notion of quotation and that of *diegesis* beyond acceptable limits. And yet, whether or not we call such a case quotation, its diegetic structure is undeniable. Even the simplest immediate repetition of a statement (whether in music or literature) differs fundamentally from the original state-

ment in that, while the latter calls only for the recognition that something is said in the "now" of the present speaker, the former additionally requires that we recognize that this something has already been said before in the "now" of the then-speaker (again, it does not matter whether the two speakers are the same or two different voices).

Because the practices of repetition, recapitulation, and elaboration are so widespread in music, musical voices very frequently would seem to acquire the narrating character: in addition to speaking and presenting themselves "now," they would seem to mediate something said (by themselves or by other voices) in another "now," that is, to present themselves as well as something belonging to a world different from the one they themselves belong to. The important task for a critic is to distinguish truly interesting cases of diegetic utterance in music from these ubiquitous and hence rather trivial practices. The return of the exposition themes in the recapitulation of a sonata movement is expected and hence does not advertise its diegetic character. The situation is different when the thematic recall is not dictated by the established formal and generic conventions. When in the light-hearted Allegretto finale of Beethoven's String Quartet in Bb, Op. 18 No. 6, the music of the introductory Adagio "La malinconia" is unexpectedly recalled just before the coda, the effect is that of a mind drawn from its present carefree state to a remembrance of the melancholy experienced in the past. As Charles Rosen has observed, "Beethoven is the first composer to represent the complex process of memory—not merely the sense of loss and regret that accompanies visions of the past, but the physical experience of calling up the past within the present."[20] Indeed, one of Beethoven's great discoveries was that music is capable of the past tense, in the sense that it can represent a mind abandoning its present concerns in favor of a recollection of something in the past.[21] Such moments of withdrawal from the here and now are possible, however, only when the normal musical discourse is ruptured in some way. Unlike literature, instrumental music contains moments of significant *diegesis* only rarely and did not seem to have any at all before Beethoven.[22]

Our discovery of the diegetic dimension of quotation and allusion forces us to backtrack for a moment and consider whether they are also possible in painting. Here literal quotation or less-then-literal allusion have the structure of someone or something appearing immediately in the picture and at the same time mediating the appearance of someone or something else, someone or something belonging to a different world, someone or something that had appeared before somewhere else, in another picture, or in reality. Thus in Manet's *Portrait of Émile Zola* (1868, Musée d'Orsay), the reproduction of the painter's *Olympia* (1863, Musée d'Orsay) attached to the wall of Zola's study is a quotation: the rectangular piece of paper marked with lines and colors that immediately appears in the portrait mediates the image we may have seen before. The image of the Parisian prostitute herself, as it immediately appears in Manet's *Olympia,* alludes to (mediates) a specific earlier image of the Olympian goddess

of love, in Titian's *Venus of Urbino* (1538–39, Uffizi). As always, the distinction between quotation and allusion is not razor-sharp. It is, rather, the difference in the degree of literalness with which an earlier image is mediated by a later one.

Five observations are in order here. First, while what a quotation or allusion refers to may be by itself outside the world of the work, the quotation or allusion induct it, so to speak, into the world of the work. If in interpreting this world we do not notice, or disregard, the quotation or allusion, we miss a feature of the world we interpret, not something external to it. "Intertextuality" is not an optional feature of reading, it is of the essence. A reader who, upon scanning a *Wall Street Journal* headline "April is the cruelest month," thinks only of the recession bottoming out notices less of what is out there than one whose thoughts of the recession are accompanied by a grander vision of a decaying civilization.

Second, a portrayal of a real person or object is clearly a species of "quotation/ allusion" in the enlarged sense in which these terms are used here. It differs from the other kind of quotation/allusion in that what it quotes or alludes to exists in reality rather than in the pictorial tradition. In this sense, in Manet's *Zola* the image of the writer himself is no less a quotation than is the image of the painter's *Olympia*. By the same token, also a literary portrayal of a real person, event, or object (as in a work of a biographer or historian) is a species of quotation/ allusion: here also someone or something present in the world of the literary work mediates the appearance of someone or something else that belongs to another, real world. Music may similarly quote or allude to sounds of the real world (think of the revolver shots or the clicking of the typewriter in Erik Satie's *ballet réaliste* of 1917, *Parade*).

Third, just as in literature and music, also in painting, the quotation or allusion mediates a specific individual appearance, not a stylistic or generic type. In Western painting a reclining female nude inscribes itself into the tradition of representations of Venus, but only some of these images have a diegetic structure, namely, those that, like Manet's *Olympia,* allude to a specific individual image within the tradition, and not to the tradition in general.

Fourth, not only a part of a picture, but the picture as a whole can evoke a quotation or, rather, allusion (a literal quotation in such cases would be no more than a copy or reproduction). Francis Bacon's obsessive variations on the subject of Velázquez's great Roman *Portrait of Pope Innocent X* (1650, Galleria Doria-Pamphili) belong here. The phenomenon can also occur in a variety of forms in other arts (think of Beethoven's *Diabelli Variations,* Liszt's transcriptions of Schubert's songs, even of the transformations the *Odyssey* undergoes in Joyce's *Ulysses*). Note also that, at least in painting and literature, a "quotation/ allusion" can refer not only to another artwork, but also to a fragment of the real world: this is the case of Velázquez's portrait itself as well as of any historical narrative.

Fifth, in painting, self-quotation or -allusion can occur only when the same figure or object appears in the picture or series of pictures more than once and we have reason to believe that the figure or object truly "is the same" rather than

merely "looks the same." Identical columns of a painted facade do not quote one another, but a figure of a saint in a series of pictures illustrating his life does refer to other appearances of the same figure in other pictures of the series. (Similarly, identical accompanying figures of the so-called Alberti bass do not quote one another, but a recapitulated musical theme does refer to other, earlier, appearances of the same theme within the work.) Clearly, self-quotation/allusion is incomparably less common in painting than it is in music or even literature.

We may come back now for a moment to the question we had been pursuing a while ago: can an instrumental voice narrate? We have seen that the diegetic mode does not require that the narrative voice comes into focus as a human figure. All that is needed is the hierarchical relationship between the two presented worlds. In thinking about the diegetic potential of instrumental music further, beyond what is implied by quotations and allusions, we should take a hint from painting. It is here that we may learn to distinguish truly interesting cases of diegetic utterance in music from the relatively trivial ones produced by the widespread practices of repetition, recapitulation, and elaboration. What is certainly possible in instrumental music is the effect of an internal frame separating the discourse into two parts, one outside and the other within the frame. Composers have at their disposal a whole range of punctuating devices, such as cadences of various strengths, with which to articulate their musical discourses. They can easily interrupt a discourse with an interpolation of any length only to resume the main train of thought later.[23] However, just as in abstract painting, also in instrumental music, it is impossible to decide with complete certainty whether what we have outside and within the internal frame are two different worlds or a single one. All we can say is that the more interpolations of this sort differ from the discourse they interrupt, the stronger the suggestion of the diegetic mode. In Liszt's piano transcription of Schubert's setting of the "Erlkönig," the final recitative contrasts so strongly with the preceding gallop that, even without Goethe's text in our ears, we are likely to read it as an appearance of a new world suddenly pushing the old one into a distance. But without Goethe's "war" ("was") instead of "ist" ("is"), we cannot be absolutely sure that what has been introduced is a truly new ontological level. Let us keep in mind, however, that we are not compelled to sacrifice illuminating interpretations of artworks to the inappropriate requirement of complete certainty.

Thus, with some ingenuity, we can find analogues of the diegetic mode in painting and music. Specifically, we have just seen that, in both figurative and abstract painting, quotation/allusion—understood in the broad sense introduced above—make the pictorial "voice" diegetic; otherwise, in figurative painting the diegetic mode is possible (if we have a picture-within-a-picture) and so is the personage of the narrator (if we have a human figure gesturing towards the picture-within-a-picture); in abstract painting the diegetic mode is, strictly speaking, not possible (though an internal frame may bring it to mind) and neither in any case is the narrator; in both vocal and instrumental music, quotation/allusion make the musical voice diegetic; otherwise, in vocal music both the diegetic mode and

the narrator are possible, imported directly from literature with the text; and in instrumental music the diegetic mode is, strictly speaking, not possible (though, again, an internal frame may bring it to mind) and neither is the narrator. Thus not only in literature, but also in painting and music, we are apt to encounter personages and settings, or—more abstractly—figures and grounds, as well as narrators. But it has to be kept in mind that in painting and music truly significant and interesting cases of *diegesis* are exceptional and rare.

Note that in all three arts all the immediately speaking voices, that is, the mode of presentation, are at the same time—as personages, settings, and narrators (or their analogues)—at least a part (or all) of the presented matter. It follows that there is nothing that we might say about the mode of an artwork that we had not already said about its matter (assuming we had described the latter precisely). Thus, at the end of our analysis of the modes of artistic presentation, the modes themselves dissolve into the matter. This is not to say that the distinction between the presenting voices and the presented matter is invalid, but only that once the presented matter has been correctly and precisely described, the presenting voices have too.

Nevertheless, whether we consider them "modal" or "material," the following two distinctions are of fundamental importance. First, the presence (or absence) of the narrating voice imprints an indelible mark on the text and the world it presents. Diegetic texts are self-reflexive to a different degree than dramatic ones.[24] The essential way for a drama to become self-reflexive is to present a theatrical performance on stage (theater-within-theater), thus to become self-referential, and invite reflection on its own nature. Shakespeare is the master of dramatic self-reflexivity of this kind, in *Hamlet* and, above all, in *The Tempest*.[25] A picture-within-a-picture has clearly the same potential import, and so does music-within-music; they invite reflection on the nature of visual and aural presenting as well as on seeing and hearing. This kind of explicit self-reflexivity is, of course, available also to diegetic texts. But if the dramatic self-reflexivity is explicit and optional, the diegetic splitting of the presented world into two ontological levels introduces its own kind of implicit or explicit, but not optional, self-reflexivity, simply because it necessarily presents us with a world-within-a-world, the narrated world embedded within the world of the narrator. The more prominently the world and the figure of the narrator step forward, the more explicitly self-reflexive is the narrative. This is why the narrative self-reflexivity reaches its zenith in autobiography, whether "historical" (St. Augustine, Rousseau, Goethe) or "fictional" (Dante, Proust), where reflections on the narrating self and on the act of narrating are inextricably enmeshed. At the same time, the presence of the narrating voice introduces distance between the reader/viewer/ listener and the presented world, makes the latter less immediate, because—literally—mediated by the narrating voice. This diegetic distance is the obverse side of the diegetic self-reflexivity. Its result is to make the mediated—that is, imaginary—nature of the presented world more explicit. In thus laying their cards on the table diegetic texts are inherently less illusionistic and potentially

more truthful than dramatic ones, not necessarily more truthful to the portrayed reality, to be sure, but more truthful about their own mediated nature. Hence it is no wonder that the diegetic mode is favored by historians.

Second, the presence (or absence) of the personage within the world of the artwork makes a difference to the nature of this world. The figure and the ground, the personage and the setting, belong together and define one another. It is obvious that the setting can never be truly completely absent, though it may be extremely attenuated and implicit; the figure has to emerge from somewhere, though this "somewhere" may be the indistinct dark background of a portrait or the silence against which one hears the melodic lines of unaccompanied polyphony, or the voice of the lyric "I" speaking of nothing but its own state of mind. It would seem, however, that the personage can be absent, most commonly perhaps in such pictorial genres as the still-life and the landscape, but also in literary descriptions that involve no personages, or in music that dispenses with lines. But is it truly absent, or—like the setting at times—only attenuated and implicit? Is it possible that not only the figure implies a ground, but also the reverse? The admittedly speculative claim I would like to make is that those presented worlds from which a personage is absent present, precisely though paradoxically, an absent personage. The claim cannot be tested and is unfalsifiable and hence unprovable. It can be understood only as an interpretative postulate or wish designed to ensure that even the presented worlds from which personages are absent can serve art's aim of human self-presentation, -imagining, and -knowledge. We want the presented world to be not just any world, but *Lebenswelt,* the human world. A still-life is full of human fingerprints, the presented objects bear witness to human purposes, use, and solicitude. A landscape, even one presenting a wilderness, is a potential scene of human dwelling and acting, even when this acting takes the highly refined form of the contemplation of natural beauty.

In thus implying (presenting) an (absent) personage, artistic presentations of the setting come close in their cultural significance to the nonrepresentational arts, first and foremost to architecture. While the meaning of the architectural work cannot be reduced to its utilitarian function, it can be grasped only if the work is seen as a potential setting for humans, for a particular way of life, a scene of human actions and passions the full range of which, while not unlimited (the range of behavior appropriate at Grand Central Station is clearly different from that befitting the San Carlo alle Quattro Fontane), cannot be delimited and specified with any precision in advance.[26] The only difference between a *Lebenswelt* presented, say, in a painting from which figures are absent and one designed by the architect is that while the former is, precisely, presented, that is, imaginary and hence apt to be peopled by the spectator with imaginary figures, the latter is real and hence provides a setting for real people, the spectator included. But let us not misjudge the exact significance of this difference. When we experience and interpret a building as a suitable scene for certain ways of life (that of a suburban commuter, say, or a metaphysical poet), we people the building with

more or less distinctly imagined figures, that is, figures no less imaginary than those that might have just left the scene of a Chardin still-life. The difference is only that, somewhat more directly than the representational arts, architecture invites us to imagine ourselves as pursuing certain ways of life, to put on masks and rehearse imaginary roles. For a dizzying moment afforded by aesthetic experience, the work of architecture, the most real of all artistic objects, invites us to shed our own reality and to transform ourselves into imaginary beings. But the difference with the representational arts is one of degree only, and a small degree at that. The imaginary worlds presented by poets, painters, and composers also invite us to enter them; they are only somewhat less insistent, or make it less easy for us to accept the invitation.

In the preceding chapter, I have argued that the significance of the characteristic tendency of modern art toward abstraction lies in its celebration of the modern infinitely free subjectivity which intends everything, but commits itself to nothing. Now I am suggesting that those artworlds from which personages are absent may imply absent personages, that is, may be read as scenes of potential, though not actual, human acting and suffering, and that this brings them close to the artwords presented by nonfigurative art. Tocqueville may have been the first to recognize this transitional significance of landscape, its position between the art of premodern aristocratic societies representing and elaborating traditional myths and the art of modern democratic societies celebrating a human subjectivity freed from all traditional roles and attachments:

> When scepticism had depopulated heaven, and equality had cut each man to a smaller and better known size, the poets, wondering what to substitute for the great themes lost with the aristocracy, first turned their eyes to inanimate nature. Gods and heroes gone, they began by painting rivers and mountains. . . . But [this is] . . . only . . . a transitional phenomenon. In the long run I am sure that democracy turns man's imagination away from externals to concentrate it on himself alone. Democratic peoples may amuse themselves momentarily by looking at nature, but it is about themselves that they are really excited. Here, and here alone, are the true springs of poetry among them.[27]

c. The Author, Implied and Real, Dead and Alive

It has been claimed here that the setting, the personage, and the narrator exhaust the list of categories of elements that may constitute, singly or in various combinations, the world presented in the work of art. Two additional candidates for inclusion on the list are the real author of the work and its so-called "implied author," and their claims should be considered now.

Let us call the real author of the work simply the "author" and disregard the questions of whether the author is known or anonymous, a single person or a collective. In written literature and music, as well as in painting, the author is, obviously, he the creator of the immediately speaking "voices" he employs to present the world of his work, but, less obviously, he himself does not belong to this world. That he does not is shown by the fact that his "now" is not the same

as the "now" of the "speakers." Note that this is the case even in the most scrupu-
lously honest autobiography or autoportrait: the real world of the real author is
not the same as the world of the narrator the author presents, just as the world
of the narrator is not the same as the world of the personage the narrator pres-
ents in his story. The act of writing or painting fixes the narrator's "now" forever
in the steadily receding past of the real world to which the author belongs. (Oral
literature, like improvised music, raises in this respect special problems for po-
etics, problems that will not be addressed here.[28])

There is only one sense in which the author may enter the world presented in
his work. He can do it in the same way as any real person or object can, namely,
as the model of a portrait, that is, by becoming a personage, or the narrator, or
both. In other words, the author may use a personage, narrator, or both as a ve-
hicle for a portrait, including an autoportrait. In the same way, a real place may
serve as the model for the setting. The questions of whether any part of the real
world is portrayed in the work and whether the portrait is accurate are empiri-
cal and we have to answer them individually in each specific case as best we can.
But even for a portrait or autoportrait, no new category needs to be added to
our list over and above those of the setting, personage, and narrator.

Those, however, who claim that the author is a part of the work's world have
much more than a portrait in mind. For them, the world presented in the work
implies in some way a consciousness from whose point of view this world is seen.
This voiceless, implicit but not explicitly presented and heard, consciousness is
often referred to as the "implied author."[29] Two arguments for postulating its
existence are commonly put forward.

First, it is claimed that only the existence of the implied author can account
for texts that imply something other than what their voices explicitly say. In
particular, in those demonstrable cases where the narrator is unreliable, we can
become aware of this unreliability, so the argument goes, only because the nar-
rator's norms are different than those of the implied author who is the source
of the norms of the text as a whole. I believe, however, that we do not need to
invoke the existence of the author, implied or real, to account for such cases. A
speaker (whether a real person, or a presented narrator or personage) is unreli-
able when we cannot take what he says at face value, and we cannot take it at
face value when we have reason to believe that he knowingly lies, unknowingly
makes a mistake, or is ironic. We become aware that the speaker may not be
telling the truth (whether knowingly or not) when we realize that what he says
about some aspects of the world he speaks of is internally inconsistent, or in-
consistent with what we otherwise know about these aspects, or implausible
in view of what we otherwise know about comparable aspects of comparable
worlds. And we recognize that the speaker may be ironic when we are aware that
he or a person of this kind would not be likely to say in earnest what he has just
said. In all of these cases we need only to place what the speaker says in an ap-
propriate context, a context provided by what we otherwise know about him and
the world he speaks of, or about people like him and comparable worlds. We

certainly do not need to postulate in addition the existence of an implied authorial consciousness.

The second argument in favor of the existence of the implied author is based on the observation that even a work created by a group of real people may seem to present its world from a single vantage point. The claim is that the consistency of the point of view can be explained only when we assume that the text implies a single authorial consciousness. This argument, however, is even less convincing. The alleged consistency of the point of view is simply identical with the consistency of the presented world. In fact, there is no hope that we could ever separate fruitfully the world presented in the work from the point of view from which it is presented. The world presented in the work does not exist anywhere apart from the work, that is, it is given always only together with the perspective from which it is presented and cannot be seen from any other. We have no way of finding out independently of the work how many children Lady Macbeth had, just as we shall never learn whether Cézanne's apple had been bitten on the other side.

To be sure, one could convincingly argue that the world of the work and the standpoint from which it is seen may be differentiated, because the world, although unique and existing nowhere else but in the work, is sufficiently similar to the real world of our everyday experience and to the worlds we know from other works to make it possible for us to imagine what it would be like to look at it from another perspective. This is shown by the fact that, while we cannot answer the questions about Lady Macbeth's children or Cézanne's apples, we can coherently, if idly, entertain them, and we are understood, though not necessarily commended, when we do. Beyond its explicit content, the work engages the reader's (spectator's, listener's) general experience of other worlds, real and presented. The implicit perspective from which the world of the work is seen can be recognized as, precisely, a perspective because, and only when, the reader's general experience of other worlds is activated. We can recognize the perspective only because we could imagine another, because we know from experience that things might be seen from a different angle. But it is precisely the dismally idle quality of all such imaginings that tells us that the separation of the presented world from the point of view can never be fruitful. By saying that Lady Macbeth "is seen by her implied author as" evil we express nothing that we had not already conveyed when we said simply that she "is" evil. Even if it is true that the world of the work is presented from a perspective, there is nothing we can say in describing the perspective that we do not also and more simply say in describing the world. It is not the Sophoclean perspective but the world of *Antigone* that is tragic.

Thus, for all practical purposes, the consistency of the point of view from which the world of the work is presented is identical with the consistency of the presented world. Now we clearly do not need to assume the existence of the implied author to understand how the latter sort of consistency was achieved. The real author of the work may choose to aim at achieving it or not, and he may

prove successful at his chosen task or not, regardless of whether he is an indi-
vidual or a collective creator. If anything, the fact that a collective real author is
occasionally successful at presenting a consistent world demonstrates how little
relevance our knowledge of the author has for our knowledge of the presented
world. Once again, the existence of the implied author turns out to be a theo-
retical fiction with no useful task to perform. Ostensibly, its task was to *explain*
the consistency of the presented world, but in fact it turns out to be simply *an-
other name* for this consistency. The need to invoke this name is likely to have
religious roots.

It should be noted, incidentally, that the author, whether individual or col-
lective, is greatly aided in the task of presenting a consistent world by the reader/
spectator/listener (the real, not implied, one). The unity of the work may be no
more than an assumption the reader makes and tests in the process of reading.
The assumption, however, is not optional, but necessary. If the reader's experi-
ence is to have any coherence and unity at all, if it is to be a single (though not
necessarily simple) experience rather than a series of completely unrelated ex-
periences, it must refer to a single (though not necessarily simple) object. The ul-
timate unity of the work, no matter how difficult to establish or how precariously
maintained, is an assumption the reader/spectator/listener must make and the
work must in some way, however reluctantly, partially, or imperfectly, confirm.
If we assume that what we read/view/hear is a single work and not a collection
of several unrelated works, then it is self-evident that what the work presents
must be at the most fundamental level a single world.[30] (To be sure, we have
seen that this world can have different ontological levels, different subworlds, if
you will. But precisely because these different levels are hierarchically related,
together they constitute what is ultimately a single world.) The unity of the work
and the unity of the world presented in it are inextricably linked. The unity of
the work consists, precisely, in the fact that the work presents an ultimately single
world. By definition, a single work cannot present several worlds; if it does, it is
not a single work. In other words, since the work in a sense *is* the world it pres-
ents, a single work must present a world which at the most fundamental level is
also one. No matter how multilayered or fragmented the presented world is, so
long as the reader believes that he reads a single work rather than a collection
of works, he must assume that the work presents what at the most fundamental
level is a single world. As Richard Rorty observed, the coherence of the text is
not something that exists independently of its descriptions.[31]

In sum, we have established that the setting, the personage, and the narrator
are the only elements that constitute, singly or in various combinations, the world
presented in the work. The only kind of author whose existence is implied by the
work is the real one. The latter figure, however, like the *Deus absconditus* of
the Jansenists, does not enter the world presented in his work, though, like any
other part of the real world, he can serve as the model of a portrait, that is, be-
come a personage, or narrator, or both. This, I believe, allows us to separate
truth from exaggeration in the century-long critical tradition proclaiming, in the

phrase of Roland Barthes, "the death of the author."[32] The notion of the implied author was one of those characteristic devices that from Flaubert to New Criticism and beyond served to keep the real author and real history at bay, to decontextualize the text and the work. By putting this notion aside, we make room for the real author and we return the text, the work, and its world to the messy contexts of actual historical worlds in which they came into existence and in which they continue to function. The real author may not enter the world of the work, but, as we shall see in the last chapter, he has a useful role to play in our interpretation of this world.

Finally, let me add that just as the work implies the existence of the real author, it also implies the existence of a potential real reader the author addresses. This, again, is a figure that does not enter the world of the work, though a specific potential reader/viewer/listener may be portrayed in it. And, again, this is a figure with a useful role to play in our interpretations of this artworld. St. Dominic or St. Peter the Martyr, either of whom is present in many Gospel scenes that Fra Angelico and his assistants painted in the monks' cells of the convent of St. Mark in Florence (1439–45) are clearly not participants. They are, rather, readers of the scenes, in several cases literally so, as the book in the hands of the saint reminds us. The saints show their fellow Dominicans how they should read sacred history. They encourage them to enter imaginatively and with sympathy the represented world, as St. Dominic does when he flagellates himself on observing Jesus bound to the column, or when he weeps together with Mater Dolorosa under the Cross. Similarly, the arias and chorales that interrupt the Evangelists' narratives in Bach's Passions represent individual and collective reactions to the narrated events and thus by example instruct Bach's congregation how to take the Gospel story to their hearts, how to make its words resonate and live in their minds as Jesus's "Es ist vollbracht!" resonates in the mind of the pious Christian impersonated by the alto in the St. John Passion, No. 30.

But even when the work does not portray the reader, it may sometimes suggest his existence. La vecchia of Giorgione (ca. 1508, in the Venetian Accademia) seems to look intently into a mirror the surface of which parallels the surface of the painting. The peculiar expression of her face, a mixture of surprise ("Is this really me?"), ironic amusement, despair, and exhaustion, tells of her mixed feelings toward what she sees, a face ravaged by time ("col tempo," "with time," says the inscription she holds, this is what happens to a human face with time). But there is no mirror there. What is there, where the mirror should be, is my own face as I look at the old woman. It is my face she sees. It is my face I see as I look into the mirror of the painting.

CHAPTER 5

POETICS II.

NARRATIVE AND LYRIC: THE POETIC FORMS
AND THE OBJECT OF ARTISTIC PRESENTATION

There are only three pure natural forms of poetry, the plainly narrating,
the enthusiastically excited, and the personally enacted: epic, lyric, and
drama. These three poetic forms can function together or separately. One
finds them often mixed together in the smallest poem and just because of
this union within the narrowest space they produce the most wonderful
effect, something of which the most estimable ballads of all nations make
us clearly aware. Likewise, we see all three united in the older Greek
tragedy, and they separate only after a certain period of time.

Goethe, "Notes and Studies Toward a Better
Understanding of the *Westöstlicher Diwan*"

We have seen that the "what" and "how" of art, the questions of what is the con-
tent presented and experienced in an artwork and how is this content presented
and experienced, lead inescapably to the concepts of material, matter, and form.
If an artwork is to exist at all, its content must be embodied in a perceptible ma-
terial, such as stone, pigment, sound. As long as the work exists in the artist's
imagination only, the material, too, may be imagined, but if the work is to be
publicly available, its material must be real. In either case, there is no such thing
as disembodied content or meaning (just as there is no such thing as a disem-
bodied human being).

We have also seen that, while the material is real, the content or object of
presentation is not; it is, rather, imaginary. In the preceding chapter, the matter
of which this object is made, the categories of elements the presented world con-
sists of, have been found to be reducible to just the setting, the personage, and
the narrator (appearing in a given artworld singly or in various combinations).
Now the concept of matter is inextricably linked with that of form. The question

to be pursued presently is what kinds of formal relationships can arise between the elements of the matter of the presented object.

These, then, are the two things I intend initially to accomplish here: first, I would like to clarify the essential nature of the two fundamental poetic forms of composition, those of the narrative and the lyric; and second, I would like to show how these two forms, if understood in a sufficiently general way, can be seen to operate not only in the art of literature, but also in painting and music.

a. Narrative and Lyric

It is most useful to think about the concept of form as involving the interrelated concepts of the whole and its parts. Only an object which is a whole and is articulated into distinct parts can be said to possess form. Its form consists in an intelligible relationship between the parts and the whole. The relationship is intelligible when one can perceive the contribution each part makes to the establishment of the object as a whole rather than a mere heap of unrelated elements. It is not necessary but certainly most natural for the parts to be organized hierarchically: just as an object may enter into intelligible relationships with other objects by becoming a part of a larger whole, so may a part be articulated into its own parts and become a lesser whole in its own right. To understand the form of an object is to understand how it is divided into parts and how the parts are related to one another and to the whole, that is, what function each part has in the makeup of the whole.

Traditionally established fine arts generally differ in the kinds of material they use, though, of course, some kinds of material may be shared by several arts (the way timbre or meter are shared by literature and music, or stone by sculpture and architecture) and artworks, contemporary as well as traditional, may straddle the boundaries between the arts (think of the symbiotic relationship of word and tone through most of European music history). Just like kinds of matter, however, form, as an intelligible relationship between parts and whole, is common to all arts. There is, of course, no limit to the number of ways in which form may be realized in concrete artworks. But it is possible for certain general kinds of form to be shared by many artworks in different media. Thus, for instance, a poem, a piece of music, a painting, a facade, and a whole building may all realize the tripartite, symmetrical form (ABA).

I propose to understand "narrative" and "lyric" as the most general and fundamental kinds of form which artworlds may possess. This understanding represents a radical extension of the accepted meanings of the terms, and we will have to take a brief look at these accepted meanings in order to appreciate the exact sense of the extension. Literary theorists do not think of narrative and lyric as forms at all, but consider them modes or genres instead. The ways in which the modal and generic components have been intertwined and confused in the history of these terms have been traced by Gérard Genette in his *The Architext*.[1] Since the story he tells is very relevant to my concerns, I will summarize it briefly here.

Plato (in the third book of the *Republic*) and Aristotle (in the *Poetics*) thought of poetry as the representation of events, or men in action, and were interested in the object of representation (the "what") and the mode of representation (the "how"). The fundamental classification of poetic texts was based on the mode of enunciation which Plato divided into the *diegesis* (narrative mode), in which the storyteller, the narrator, speaks, and *mimesis* (dramatic mode), in which the represented personages speak. Superimposed on this was the secondary classification into genres which was based essentially on the "what" rather than "how," on the object or content rather than mode, although the Aristotelian genres combined the thematic (that is, content-related) and modal categories. The system left beyond consideration all "nonrepresentational" poetry (the qualification is Genette's, not mine), that is, it disregarded what we today call the lyric, the kind of poem which does not represent any action, but rather announces the ideas or sentiments of the speaker. Systematic efforts to make room at the side of the narrative and drama for the third realm of the lyric in poetic theory date only from the early seventeenth century on. From the time of German Romanticism until our own day the triad of epic, drama, and lyric dominates literary theory. The triad makes a combination of modal and thematic categories inevitable and in practice invites their constant confusion: narrative and drama are modes of representation of human action, while lyric does not represent actions at all, but rather mental states, thoughts, emotions, situations. The difference, then, between narrative and drama is in the mode of presentation, while the difference between both these and lyric is in the presented object. The confusion between modal and thematic categories can be avoided, Genette tells us, if we return to the Aristotelian system (enlarged by the inclusion of "nonrepresentational" poetry), crossing *n* thematic classes with *p* modal classes to produce *np* genres.

The classification of genres, however, is not my aim here. Instead, I would like to free the concepts of narrative and lyric from all "modal" connotations and stress their "thematic" or "objective" dimension. It should be immediately apparent that this conflates epic and drama into a single class (which, following current usage and for want of a better term, I will call "narrative," even though used in this sense the term is potentially confusing, since it is the presence of the narrating voice that distinguishes *diegesis* from *mimesis;*[2] in the current usage one can have a "narrative" without a narrator) and replaces the Romantic triad of epic, drama, and lyric with the dyad of narrative and lyric. What is less apparent, but will emerge in the course of this discussion, is that the classification is based not merely on the object of presentation, but more specifically on the formal relationships between the material elements of the object, that is, that narrative and lyric are not merely kinds of content, but more specifically kinds of form.

In disregarding the "modal" dimension, in conflating epic and drama, and in calling the result narrative, I follow closely the most penetrating investigation of the concept of narrative we have today, that presented by Paul Ricoeur in his *Time and Narrative.*[3] Ricoeur, while basing his analysis on Aristotle's *Poetics,*

does not hesitate to develop and extend its concepts to suit his own purposes. He concedes that

> there is something apparently paradoxical in making narrative activity the category encompassing drama, epic, and history, when, on the one hand, what Aristotle calls history (*historia*) in the context of the *Poetics* plays the role of a counterexample and when, on the other hand, narrative—or at least what he calls diegetic poetry—is opposed to drama within the single encompassing category of mimesis.[4]

What makes it possible to consider narrative as the common genus of which epic and drama are the species and, moreover, to see this as justified by Aristotle's text, is the primacy in the *Poetics* of the "what," or the object of representation, over all other dimensions of composition, including the "how," or the mode of representation, that is, the primacy of what Genette would call the "thematic" over the "modal" dimension.

This primacy results from the following consideration.[5] The end of tragedy is representation of action (*mimesis praxeos*), and this can be identified with plot (*muthos*), which is the most important component of the "what," the object of representation. Thus, even if in principle the dimensions of means (such as language or melody), mode, and object are equal, in actual analysis in the *Poetics* the whole weight is on the "what." In other words,

> the equivalence between mimesis and muthos is an equivalence by means of the "what." And in terms of its plot, epic closely follows the rules of tragedy. The essential thing is that the poet—whether narrator or dramatist—be a "maker of plots."[6]

The difference between epic and drama is based on mode. In both, the author acts as the storyteller, but in the former the storyteller speaks directly (diegetic composition) and in the latter he speaks indirectly through his personages (dramatic composition). Aristotle himself attenuates in various ways the modal opposition and, in any case, the opposition "does not affect the object of imitation, the emplotment."[7] Thus Ricoeur feels justified in disregarding the mode and concentrating on the object, "calling narrative exactly what Aristotle calls muthos."[8]

In short, Ricoeur defines narrative in terms of the emplotment. This definition simultaneously involves the presented object in general and specifically the form of the object. As the representation of human action, the plot is identical with the content presented in a narrative. But the emplotment is also a formal operation with general features that are common to all narrative compositions.

Ricoeur's analysis of the operation of emplotment, the Aristotelian *muthos,* should be summarized here.[9] The plot organizes or synthesizes the events into a system characterized by wholeness, appropriate magnitude, and completeness. If I may be allowed to do to Ricoeur what we have seen him a moment ago do to Aristotle, I should say that even though in principle the three characteristics

are equal, in actual analysis in both the *Poetics* and *Time and Narrative* the entire weight is on wholeness. In fact, both the appropriate magnitude and completeness can be easily seen as aspects of wholeness. As Aristotle puts it,

> a whole is that which has beginning, middle, and end. A beginning is that which is not itself necessarily after anything else, and which has naturally something else after it; an end is that which is naturally after something itself, either as its necessary or usual consequent, and with nothing else after it; and a middle, that which is by nature after one thing and has also another after it. A well-constructed Plot, therefore, cannot either begin or end at any point one likes; beginning and end in it must be of the forms just described.[10]

The appropriate magnitude and completeness can be seen as aspects of wholeness; the former is a size which makes the articulation of the whole into intelligibly related parts possible (that is, a size large enough so that the whole may be articulated into parts and small enough so that the parts may be intelligibly related), and the latter is indistinguishable from the characteristic of having an end.

In commenting on Aristotle's analysis of the notion of wholeness, Ricoeur correctly points out that the accent is put on the requirements of necessity or probability governing succession. "One after the other is merely episodic and therefore improbable, one because of the other is a causal sequence and therefore probable."[11] The function of the operation of emplotment is to transform a simple succession of events (Aristotle's *pragmata*) into a meaningful story, an intelligible whole, a configuration in which the succession is necessary or probable. It is the necessary or probable succession that synthesizes the events into a whole with a beginning, middle, and end. By virtue of the poetic composition, "concordance," that is coherence, triumphs over "discordance," the threat of incoherence:

> The art of composition consists in making this discordance appear concordant. The "one because of the other" thus wins over "one after the other." The discordant overthrows the concordant in life, but not in tragic art.[12]

In short, the operation of emplotment which defines narrative synthesizes manifold events into the unity of one temporal whole, with a beginning, middle, and end, by making the succession of the events necessary or probable.

So much for Ricoeur's analysis of the concept of narrative. It should be immediately apparent that, given my sense of "form" as an intelligible relationship between parts and whole, narrative is a kind of form. The relationship is intelligible, I have explained, when one can perceive the contribution each part makes to the establishment of the object as a whole rather than a mere heap of unrelated elements. To understand the form of an object is to understand how it is divided into parts and how the parts are related to one another and to the whole, that is, what function each part has in the makeup of the whole. Narrative is clearly a whole (plot) with intelligibly related parts (events) which constitute the whole by performing the functions of the beginning, middle, and end.

We have already seen how central the notion of the whole is to the Aristotelian understanding of *muthos*. The importance of the concepts of the whole and its parts as well as of the intelligibility of their relationship, all notions defining the idea of form proposed here, emerges with particular clarity in Aristotle's discussion of appropriate magnitude as an essential feature of the plot:

> Again: to be beautiful, a living creature, and every whole made up of parts, must not only present a certain order in its arrangement of parts, but also be of a certain definite magnitude. Beauty is a matter of size and order, and therefore impossible either (1) in a very minute creature, since our perception becomes indistinct as it approaches instantaneity; or (2) in a creature of vast size—one, say, 1,000 miles long—as in that case, instead of the object being seen all at once, the unity and wholeness of it is lost to the beholder. Just in the same way, then, as a beautiful whole made up of parts, or a beautiful living creature, must be of some size, but a size to be taken in by the eye, so a story or Plot must be of some length, but of a length to be taken in by the memory.[13]

However, not all form is narrative. Narrative is a kind of form, I would like to propose now (also following the footsteps of Ricoeur here), in the constitution of which the essential role is played by time. It is nothing other than the temporal form. The temporal form is the kind of form in which the whole consists of a number of "phases" or parts which succeed one another in a determined order. To understand the temporal form is to understand how an object is divided into successive phases and how the phases are related to one another and to the whole, that is, what function each phase has in the makeup of the whole, in the transformation of a mere succession of unrelated elements into a configuration of intelligibly related phases. If the successive phases are to enter into intelligible relationships, if a succession is to be transformed into a configuration, earlier phases must not only precede but also in some way cause the appearance of later ones, and these in turn must not only succeed but also follow from the earlier ones, that is, the "one after the other" must become "one because of the other." For this to happen, the phases must perform such functions as those of being the beginning, middle, or ending. The beginning phase is the one which does not require any earlier phase, but which does require and in some way causes the appearance of another, later phase or phases. The ending phase, conversely, does not require any later phase, but requires and in some way follows from an earlier one or ones. And the middle phase requires and follows from an earlier phase or phases as well as requires and causes a later one or ones. Needless to say, the relationships of causing or following from may but do not have to obtain only between immediately adjacent phases. The more complex and sophisticated temporal forms exhibit a large number of nonimmediate, long-range relationships between phases. In short, what distinguishes the narrative or temporal kind of form from other kinds is that its parts succeed one another in a determined order and that their succession is governed by the relationships of causing and resulting by necessity or probability.

The traditional division of the whole literary field into epic, drama, and lyric

and the subsumption of the former two under the class of narratives leaves us now with the task of examining the narrative's "other," the lyric. In Genette's terms, the distinction between narrative and lyric is "thematic" rather than "modal," that is, it is in the first place the distinction between the kinds of objects or contents presented in the literary work. Unlike the narrative, the lyric does not represent men in action, but rather announces the ideas or sentiments of the speaker, that is, it represents (presents, literally, makes present) not actions, but mental states, thoughts, emotions, situations, not the actions one does, but the states one finds oneself in. But this thematically based classification implies a formal classification as well, that is, not only narrative, but also lyric is a kind of form.

This form, however, can be defined at first only in negative terms, as what it is not. The lyric is the nonnarrative, that is, it is the atemporal form, the kind of form in the constitution of which time plays no essential role. The reason for this is that while time is the indispensable element of the actions one does, it is not the necessary constituent of the states one finds oneself in. (Neither is space: the "systematic" temptation of calling lyric the "spatial" form should be resisted.) Note that while time is not of the essence, neither is it necessarily excluded from the constitution of a lyric form: it simply does not matter whether its parts exist simultaneously or successively, but if they do exist successively, the succession is a mere succession, is not dominated by the necessary or probabilistic causality.

But all this does not mean that we cannot say anything positive about the lyrical form. The crucial question to ask about any kind of form is what governs the relationship between the parts and the whole, what glues the parts together into a whole? We have seen that in the narrative form this was a sort of necessary or probable *causation*. Now, causation is an asymmetrical, or, more precisely, irreversible, relationship in which time plays an indispensable role: an earlier *a* causes a later *b*, but *b* does not cause *a*, it results from it. The parts of an atemporal whole cannot be related in this way, of course, but they can and must be by a symmetrical, or reversible, relationship of necessary or probable *mutual implication* in which time plays no indispensable role (without being necessarily excluded, either): an *a* (whether earlier or simultaneous, it does not matter) implies in some way a (later or simultaneous) *b*, while the *b* implies the *a*. What "implication" means here is something like this: if a whole is to be constituted from these parts, then the presence of part *a* makes necessary or probable the presence of part *b*, and the reverse. In other words, if there are only two parts (and more complex cases can be extrapolated from this simplest one), a whole will result only if the parts imply one another in some way, if the presence of one implies, necessarily or probably, the presence of the other. What glues the parts together in the lyric form, is the reversible mutual implication (\leftrightarrow; if *a*, then *b*, and if *b*, then *a*). What glues them together in the narrative form is the irreversible causation (\rightarrow; if *a* earlier, then *b* later), which necessarily introduces the temporal dimension lacking in the mutual implication. Thus we arrive at a positive definition of the lyrical form: what distinguishes the lyrical from the narrative form

is that its parts, whether existing simultaneously or succeeding one another, are governed by a relationship of necessary or probable mutual implication.

It should be clear by now that the narrative-lyric distinction is not at all identical with the distinction between artworks that develop in time (as literary or musical works do) and those that do not change (say, paintings or buildings), that it is not the distinction between the so-called temporal and spatial arts. This is not simply because, as Dewey argued at length, the experience of art always has a temporal character.[14] The concepts of narrative and lyric are concerned neither with modes in which artworks exist in the real world, nor with modes in which they are experienced. Rather, what is at stake with these concepts is the structure, temporal or atemporal, of the world which comes into existence in the work, the world which the work makes present. A lyrical description of a room exists and develops in time and it is experienced in time by the reader. But it may be structured in such a way that the specific order in which the furniture of the room comes into being does not matter, just as it does not matter when a room is depicted in a painting (and even in a painting we have to survey the contents of the room in *some* order). Conversely, a representation of human action will have a temporal structure whether the action is described or depicted, simply because the structure of human action is necessarily temporal.[15]

b. The Forms in Painting and Music

Narrative and lyric, as these terms are understood here, are fundamental poetic forms of composition, not genres. Actual works of literature may represent these forms in their pure state. Usually, however, the two forms coexist in various, often unexpected proportions. The so-called "narrative" genres, in particular, are rarely pure narrative (think of the growing presence of the lyric in the novel, a presence which reaches such overwhelming proportions in some modern representatives of the genre that Genette could famously summarize the plot of *À la recherche du temps perdu* in one brief sentence: "Marcel becomes a writer"[16]). The usefulness of the concepts does not lie in their classificatory power, but rather in their power to illuminate jointly aspects of actual works or genres. In any case, the applicability of these two categories to literature, whatever the specific terms used to name them, is evident and will not concern us here.[17] Instead, I would like to show that the understanding of the concepts I have proposed is sufficiently general to open the way to their being applicable to, and able to illuminate, not only literature, but also painting and music.

In her book on Dutch art in the seventeenth century, Svetlana A¹pers gave new life to the traditional dichotomy between Italian and Northern painting.[18] The Italian Renaissance, she argued, conceived of the picture as a framed window through which a viewer looked at a world inhabited by human figures performing significant actions known to the viewer from texts that were the vessels of poetic, religious, and historical traditions. It was a narrative art guided by the modern conversion of the Horatian slogan of *ut pictura poesis*. By contrast,

seventeenth-century Dutch art was concerned with "describing" the surface of the seen world rather than "narrating" the actions of men and women.

Note that Alpers's dichotomy of narrating and describing is based fundamentally on the content of the represented world: in painting, one can "describe" anything visible, but one can "narrate" only human actions. To my mind, the most important corollary of this dichotomy is that narrative painting, unlike its descriptive sister, must be guided by the paradoxical ambition to show the invisible. It is not just that, as Alpers argues, narrative painting uses the visible actions of the body, that is, gestures and facial expressions, to present the invisible states of mind of the painted figures. It is, in addition and even more crucially, that it must call up to the viewer's mind not only the present time of the painted scene, but also its past and future: human action is inescapably temporal, it simply cannot be understood in atemporal terms.

It follows that, as Alpers points out, Italian painting, by privileging narration, puts a great premium on knowledge and education. It paints something that cannot merely be seen but must also be known, and it requires that the viewer be educated in the religious, poetic, and historical traditions from which its subjects are drawn. By contrast, the descriptive Dutch painting does not go beyond the visible, that is, it contents itself with perception and relative ignorance (relative, because no perception can be completely free of knowledge). An aspect of this contrast between knowledge, on the one hand, and perception, on the other, is that narrative painting aims at the presentation of general human traits and truths, while its descriptive counterpart is concerned with the preservation of the individual identities of each person and thing.

A further important corollary of the distinction between narrative and descriptive art is that the former assumes an active and the latter a passive attitude on the part of the painter and viewer. To bring out this contrast, Alpers emphasizes the Italian art of perspective, the conception of a picture which presupposes a viewer actively looking out at figures whose appearance is a function of their distance from him, and opposes this to the Northern conception of a picture which claims to be part of passive vision and demands no such active role for the viewer. (Thus Italian art privileges human beings not only as the objects of representation, but also as its makers and viewers.) The contrast is one between the painter's and viewer's active making (ordering, possessing the world) and their passive absorption (just looking at the world). Alpers's suggestive observations on the essential role played by the frame in Italian, but not Northern, painting may be seen to follow from the contrast between the artists' active and passive attitudes: the frame is the fundamental device by means of which the painter orders the image.

But the systematic connection between the narrative-descriptive distinction, on the one hand, and the active-passive contrast, on the other, comes out most basically, I think, if we recall the relative importance knowledge has for narrative art, as opposed to the premium descriptive art puts on perception. The viewer

who has to complete the world that is visible in the picture with his own knowledge of the way human beings act in general and of the presented story in particular assumes a much more active attitude in front of the painting than the viewer of whom no such task is required. The contrast between knowledge and perception is, of course, relative, as is that between the active and passive roles of the viewer. As any reader of Gombrich's *Art and Illusion* knows, no perception is completely free of knowledge, and by the same token no perception can be completely passive.[19] But this does not invalidate the *relative* distinction between narrative art requiring the viewer's active and knowledgeable participation, on the one hand, and descriptive art assuming perception which in comparison appears quite passive, on the other.

The distinction between the two ways of picturing the world is not absolute in yet another sense. Since "narrative" art can never be entirely free of "description," and since, conversely, the presence of human figures in such "descriptive" genres as the landscape or portrait always threatens to engage the "narrative" viewing habits, both ways of picturing are often simultaneously present in a painting in various proportions and interacting in various ways. Thus the distinction is useful and illuminating not because of its classificatory power, but rather because it can help us see aspects of individual works or whole artistic cultures in a new light (consider the way in which the history of nineteenth-century French painting lends itself to a telling, now enshrined in the Musée d'Orsay, in terms of a complex and subtle struggle between the "narrative" art of the academy and the "descriptive" art of the avant-garde).

Alpers's distinction between narrative and descriptive picturing can clearly be divorced from the chronologically and geographically specific cultural fields (the Italian Renaissance and the Dutch seventeenth century) to which she has applied it and used to interpret any area of representational painting. Thus generalized, the distinction may be seen as a transposition of my distinction between narrative and lyric from the literary to the pictorial domain. What makes the transposition possible is that both distinctions are based fundamentally on the classification of the content of the presented world: they both rely on what I have termed the distinction between "actions one does" and "states one finds oneself in." In the domain of painting, the representation of the latter must be coextensive with the representation of the visible world, while the attempt to represent the former, by introducing temporality, is the attempt to show the invisible. As a result, we have seen that narrative painting engages the knowledge of the viewer to a much greater extent than descriptive painting does and thus demands a much more active stance. It is clear that abstract painting, even when understood—as here—as a species of representational art, can be only descriptive, and not narrative. Borderline cases, however, are possible, since anthropomorphic figures can intimate human action.

At the same time, in both the literary and pictorial domains, the narrative-lyric distinction involves not merely the content of the presented world, that is, the object of presentation, but more specifically the form of this object, that is,

the relationships between the material elements of the presented world. In paint-ing, not less than in literature, narrative and lyric are kinds of form. What synthesizes the parts of a descriptive picture into a whole—that is, what makes elements of the world which the picture presents into, precisely, a world—are the relationships of mutual implication. A narrative painting involves, in addi-tion, the synthesizing relationships of causing and resulting. It is this supplement of narrativity that abstract painting usually lacks.

Can the categories of narrative and lyric be transposed also to the domain of music, when this is taken (as it will be here) in its purely instrumental guise?[20] (When music is taken together with the poetic word, dance gesture, or dramatic action, they tend to impose their form on the whole.) In the case of painting, it will be remembered, the transposition was based on the classification of the content of the presented world. In the case of an art which is representational only in the sense in which abstract painting is, that is, where we have no com-monly accepted criteria which would allow us to distinguish the representation of human action from the representation of anything else, this route of transpo-sition seems closed to us. But we can always consider the form of the presented object directly.

In his essay on musical hearing of the modern era, Heinrich Besseler made a distinction between the "active" or "synthetic" hearing of late eighteenth-century Viennese Classicism and the "passive" hearing of nineteenth-century Austro-German Romanticism.[21] The modern age of music, argued Besseler, began with the transition from "participation music" (*Umgangsmusik*), in the making of which all took part, to "presentation music" (*Darbietungsmusik*), which differentiated the musicians from the listeners. In spite of the survival of the participatory attitude in some genres, from the mid-eighteenth century on, the essential stance one took toward music was that of a listener. But hearing itself could be active or passive.

Active-synthetic hearing developed gradually during the seventeenth and eigh-teenth centuries to reach a high point in the two decades preceding 1800. Music of the seventeenth and eighteenth centuries was constructed from successive parts, but while the earlier music was composed and heard additively, section after section, so that at most only the successive sections could be related to one another, in the eighteenth century one began to synthesize the successive phases so that larger and larger spans of music were affected until the whole movement was turned into a unified whole. The unity was realized and grasped primarily by means of the initial theme returning at the end and often also re-curring throughout the work. By the 1780s, the thematic work and sometimes even the derivation of the secondary theme from the main one guaranteed the unity of the whole movement.

Formal unity was then simultaneously the unity of content or affective mean-ing. During the first half of the eighteenth century, affective meaning underwent a transition from the typical to the individual. The seventeenth-century theme was typical in that it represented an objective "affect" which could be shared by

many persons, just as the theme itself could be shared by many composers. By the 1780s, the theme became individual, personal, and original, expressing one unique personality and used by one particular composer in one particular work. Thus a work, unified by means of a main theme that retained its identity through all the vicissitudes of its development, was understood to express an enduring individual moral "character." This understanding lay behind Haydn's well-known remark to his biographer Griesinger that his symphonies often represented moral characters,[22] and it was explicitly formulated theoretically in 1795 by Christian Gottfried Körner.[23] The unity of form and of meaning both depended on the synthesizing powers of hearing.

After 1800, Besseler continued, the Romantics were familiar with active-synthetic hearing but placed it in a subordinate position, favoring instead a new ideal of a passive hearing. The listener's role was no longer, or at least not primarily, to grasp the work as an object in front of him in active synthesis. The very distinction between the subject and object in musical experience was challenged in favor of a primordial unity preceding the differentiation of the two. The listener was to become in some way identical with the music, experiencing it immediately, passively drowning in it. The compositional means promoting the new passive hearing were developed by Schubert in his turn to the lyric; they consisted primarily of new instrumental and harmonic color and, even more importantly, of ostinato accompanimental figures the repetitive rhythms of which invited the listener to allow himself to be carried by the "rhythmic stream," inducing a trancelike state.

Hand in hand with the new ideal of hearing and the new compositional means to realize it went a new content. The central theme of Romantic music was neither the Baroque affect, nor the Classical character, but "mood" (*Stimmung*). Leaning indirectly on the pathbreaking work of his teacher Martin Heidegger, who assigned an important role to the category of mood in his fundamental analysis of human being in *Sein und Zeit* of 1927,[24] and directly on Otto Friedrich Bollnow's useful 1941 book on the essence of moods,[25] Besseler explained that while an emotion always has its intentional object (it is, say, a fear *of* something), a mood is rather a state, a specific complete "coloring" of our being in which the body and the soul, the man and the world, are as if attuned to the same pitch. Moods are so primordial that they precede the differentiation into the subject and object, man and world. Hence, what is characteristic of them is the unity of the inner and outer. Moreover, a mood cannot be changed at will, it has the character of something that "fills" and masters us. It can, however, be awakened in us through proper means. We can "give in" to a mood when we allow the means which bring it to work on us. No wonder then that the art which made mood into its central object required passive receptivity, "giving oneself away" to the mood in hearing, wanting to be "filled" with, the music.

As should be clear from the above summary, Besseler places ways of hearing, active or passive, explicitly at the center of his dichotomy. But the logic of the concepts he uses, the manner in which these concepts are connected with one

another, suggests a different center. The most fundamental distinction he makes is, I think, the one having to do with the content of the world which comes into being in the work. A work can present either a "character" or a "mood." All other distinctions depend on this one. The choice of the presented object dictates the choice of the musical form the composer will use and both together determine the attitude required of the listener. The presentation of an individual moral character enduring through the life story of the represented person requires a form unified by a main theme that retains its identity through the whole story of its exposition, development, and recapitulation within the work; its adequate reception calls for active hearing to synthesize successive parts of the work into a whole. The presentation of a mood or state of mind in which one finds oneself requires a form unified by the rhythmic stream of a repetitive accompanimental figure, as well as by the harmonic and instrumental color; its adequate reception calls for passive hearing in which the listener allows himself to be filled with the music and thus to be attuned to the mood it evokes.

From the standpoint of our aims here, the main lesson to be drawn from Besseler's essay is that not all musical form must be truly temporal, just as not all literary form must be temporal. To be sure, all music (and all literature) develops in time. But we have to recall that the notion of form which is at issue here involves neither the modes in which artworks exist in the real world, nor the modes in which they are experienced, but rather the structure, temporal or atemporal, of the presented world. Only some kinds of musical form (paradigmatically, the Classical sonata form) fully capitalize on the fact that music develops in time by making the order in which the phases of the work succeed one another as well as the causal logic of the relationships between the phases matter centrally. While no tonal music can disregard its development in time completely (think of the necessary succession of the tonic after the dominant in a cadence), Besseler directed our attention to the existence of music (such as the Romantic piano lyric) in which the overall ordering of the parts, or even the question of whether the work contains such parts, or whether its parts exist simultaneously (the way, say, melody and accompaniment in the homophonic texture, or several different melodies in the polyphonic one, do), is relatively unimportant, where different forces matter and relate the parts to one another.[26]

A musical form which, like that of a Classical sonata allegro movement, is a whole divided into successive parts held together primarily by the main theme retaining its identity throughout its metamorphoses within the work, and which calls for a hearing capable of grasping the successive parts of the work as a whole, is clearly a temporal form. It is a kind of a narrative in the sense in which the term is used here, that is, the kind of form in which time plays the essential role, because the parts of the whole succeed one another in a determined order and their succession is governed by the relationships of causing and resulting. One cannot begin to understand a sonata allegro if one does not have some comprehension of how the musical discourse is divided into successive phases and how the phases imply and are derived from one another. A musical form which, like

that of a Romantic piano lyric, is a whole held together primarily by the rhythmic stream of a repetitive accompanimental figure as well as by the harmonic and instrumental color, and which calls for a hearing in which the listener allows himself to be filled with the music, carried by its rhythmic stream, and thus to be attuned to the mood it evokes, is clearly a form in which temporality does not matter much. It is a kind of a lyric in the sense in which the term is used here, that is, it does not much matter whether the parts of the whole exist simultaneously or successively, and, if successively, in which order, and the parts are related to one another by mutual implication. The musical lyric is guided by the paradoxical, and, it should be stressed, never completely realizable, ambition to neutralize time, to render it irrelevant. Its temporal form is usually deliberately simple, not to say simple-minded, because what matters for its comprehension is not the recognition that its phrases form an ABA or a similar pattern, but rather the recognition of the mutual appropriateness of the melody and accompaniment, of the motivic, rhythmic, and harmonic details, to one another.

Just as in literature and painting, so also in music, the distinction between the narrative and lyrical forms is relative rather than absolute. A musical work, or at least a work of tonal music, can never be entirely atemporal: large-scale sections may follow one another with no discernible logic, but the order of smaller-scale events—phrases, chords—can never be completely random. Conversely, even in the most rigorously argued sonata, the temporal order and causality cannot be relevant to every aspect of the work, nor is it easy to free a musical work entirely of hypnotic, time-arresting features. Besseler himself recognized that in nineteenth-century music the passive and active types of hearing coexisted. One can go further and claim that the two kinds of form coexist in various proportions and interact in diverse ways in most musical works and genres. Just as in the domains of literature and painting, in music the usefulness of the dichotomy lies less in its power to classify works and genres and more in its ability to illuminate individual works and whole musical cultures in new and interesting ways (an ability convincingly demonstrated by Besseler's own history of hearing).

Thus relativized, generalized beyond the chronologically and geographically specific cultural fields to which Besseler had originally applied it, and used to interpret the whole domain of music, the dichotomy can be seen as a potentially fruitful transposition of the narrative-lyric distinction from the literary to the musical domain.

c. Action and Passion

"[T]he human shape and what it expresses and says, whether human event, action, or feeling, is the form in which art must grasp and represent the content of the spirit," says Hegel.[27] Thus far I have argued that the basic kinds of elements that make up, singly or jointly, an artworld are the setting, personage, and narrator, and that the basic kinds of form one can fashion of these elements are narrative and lyric. But it was apparent throughout the discussion above that narrative and lyric are also correlated with two kinds of contents, of represented objects.

Narrative, the temporal form, is suited for representing human actions because of their inescapably temporal character. It is not just that an action takes time. It is also that we cannot experience and understand our own or our fellows' actions except as narratively configured, as plots with beginnings, middles, and ends. Human actions differ from other kinds of behavior in that they cannot be described as a mere sequence of events: first he lifted his hand, than he scratched his head. Rather, they have to be described with reference to the agent's motives and intentions, to the initial state of affairs one wants to alter, and to the final state of affairs one wants to achieve: he lifted his hand and scratched his head because he wanted to relieve the itching. As David Carr argued, we do not experience and understand human actions as mere sequences of events on which we subsequently and optionally impose narrative structures, but as already configured sequences, as temporal wholes the individual phases of which have distinct functions such as that of a beginning, a continuation, and an ending.[28] Along the same lines, Ricoeur writes of his

> basic hypothesis that between the activity of narrating a story and the temporal character of human experience there exists a correlation that is not merely accidental but that presents a transcultural form of necessity. . . . *time becomes human to the extent that it is articulated through a narrative mode, and narrative attains its full meaning when it becomes a condition of temporal existence.*[29]

And further, we have to "accord already to experience as such an inchoate narrativity. . . . We tell stories because . . . human lives need and merit being narrated."[30] A similar point has been made by MacIntyre:

> I am presenting . . . human actions . . . as enacted narratives. Narrative is not the work of poets, dramatists and novelists reflecting upon events which had no narrative order before one was imposed by the singer or the writer. . . . In successfully identifying and understanding what someone else is doing we always move towards placing a particular episode in the context of a set of narrative histories, histories both of the individuals concerned and of the settings in which they act and suffer. . . . We render the actions of others intelligible in this way because action itself has a basically historical character. It is because we live out narratives in our lives and because we understand our own lives in terms of the narratives that we live out that the form of narrative is appropriate for understanding the actions of others. Stories are lived before they are told.[31]

Thus the form of the narrative and the content of acting humans go together: "man is in his actions and practice, as well as his fictions, essentially a story-telling animal" (MacIntyre again).[32] But humans are not always active. Just as often they are passive. Then, they do not change the state of affairs they find themselves in, do not act but suffer. Passion, as opposed to action, is not inescapably temporal, and hence the form properly suited to represent it is the atemporal lyric, the form we reach for when what we want to make present is not an action, but a mental state (whether one of cognition, volition, or emotion, or some mixture thereof). The form of the lyric and the content of suffering humans go together.

Action and mental state. Together, these two exhaust the ways in which we humans are in the world. We are the sort of beings who are aware of how they feel and think about the state of affairs in which they find themselves and who, from time to time, attempt to change this state of affairs. The interplay of narrative and lyric, then, not only maps the complete field of artistic forms. Because of the correlation of these forms with kinds of content, with action and passion (or mental state), it also maps the complete field of human ways of being in the world, that is, of everything that one might want to represent in art if one treats art as an instrument of human self-revelation. The eighteenth-century *opera seria* is the artistic genre in which the separation and interplay of narrative and lyric, of action and passion, crystallized with particular clarity: the organization of an operatic *scena* into a representation of an action accompanied by a speech-like recitative of the participating personages followed by the representation of a passion, the state of mind of the protagonist of the just completed action, expressed vocally by means of a musically fully developed singing, the protagonist's aria, is a monument of early modern rationalism (rather than an "exotic and irrational entertainment," as Dr. Johnson would have it).

It might be tempting to think of action and passion as being, respectively, outer- and inner-oriented, or objective and subjective. True, when we act, we direct our attention to the objective world, the world beyond the confines of our minds (wherever these may be), we try to affect and change our environment, while when we suffer, we concentrate on the subjective world, the world of our feelings and thoughts, we are aware of the environment only in so far as it affects us. But too rigid a separation of the two in those terms would be a mistake: action has its subjective aspect and passion has an objective dimension. An action, we have just reminded ourselves, has to be described with reference to the agent's motives and intentions, to the initial state of affairs one wants to alter, and to the final state of affairs one wants to achieve. Thus, a specific action has an inner, subjective, dimension, constituted by the agent's motives and intentions. I kick a ball (and thus affect my environment), because I want to score a goal (and my wanting it, or anything else, does not happen in my environment, but "in" my mind). And the reverse: a specific state of mind, whether involving cognition, volition, or emotion, has its intentional object; it is about something. I think about scoring a goal and am glad to have succeeded.

It appears, however, that it is possible to have a state of mind divorced from any specific intentional object. To be sure, I rather doubt that this is possible in the case of cognition or volition, that we might be able to think about, or want, nothing. But it does seem to be possible in the case of emotion which, when deprived of its intentional object, ceases to be an emotion and becomes a mood.

From Aristotle, we have learned that emotion is not quite as irrational as Plato thought. Rather, an emotion has its irrational and rational components: the component of sensation, the way it feels to be in a particular emotional state, the pain or pleasure of the person affected by the emotion, on one hand, and the intentional object of the emotion, as well as the grounds on which the emotion is felt,

on the other. Now, when the component of sensation appears alone, without any accompanying intentional object or any reason for feeling the sensation, the state of mind is not an emotion but a mood. Let me come back to Besseler's sources. Heidegger made us aware of this fundamental structure of moods when he analyzed the phenomenon of "mood" (*Stimmung*) in section 29 of *Being and Time*. Heidegger's awareness of, and admiration for, Aristotle's analysis of emotions is explicitly acknowledged in this section:

> It is not an accident that the earliest systematic Interpretation of affects that has come down to us is not treated in the framework of 'psychology'. Aristotle investigates the *páthe* [affects] in the second book of his *Rhetoric*. . . . This work of Aristotle must be taken as the first systematic hermeneutic of the everydayness of Being with one another. . . . What has escaped notice is that the basic ontological Interpretation of the affective life in general has been able to make scarcely one forward step worthy of mention since Aristotle."[33])

While we do not always feel an emotion, we are always in some mood: "in every case Dasein always has some mood."[34] "And furthermore, when we master a mood, we do so by way of a counter-mood; we are never free of moods."[35] A mood is more primordial than any act of cognition or volition, it is prior even to any distinction between the self and the world which such acts presuppose. It is the most primordial way in which our being in the world is disclosed to us. "A mood makes manifest 'how one is, and how one is faring'";[36] "ontologically mood is a primordial kind of Being for Dasein, in which Dasein is disclosed to itself *prior to* all cognition and volition, and *beyond* their range of disclosure."[37] Again:

> A mood assails us. It comes neither from 'outside' nor from 'inside' [it is prior to any such distinction having been made], but arises out of Being-in-the-world, as a way of such Being. . . . *The mood has already disclosed, in every case, Being-in-the-world as a whole, and makes it possible first of all to direct oneself towards something.*[38]

Thus our interactions with this something, with our environment, our world, are always colored by the underlying mood. Our primordial attunement with the world resonates through all our mental states. A mood is a "basic way in which Dasein lets the world 'matter' to it."[39] It discloses the world as something, "as something by which it can be threatened, for instance."[40] An affect such as fear is possible only because the "Being-in-the world, with its state-of-mind," had "already submitted itself to having entities within-the-world 'matter' to it in a way which its moods have outlined in advance."[41] And the difference between an emotion such as fear and the mood of anxiety which makes fear possible is that while fear must have an intentional object (I am afraid of something), anxiety does not have any such object:

> *That in the face of which one has anxiety is Being-in-the-world as such.* What is the difference phenomenally between that in the face of which anxiety is anxious and that in the face of which fear is afraid? That in the face of which one

has anxiety is not an entity within-the-world. . . . That in the face of which one is anxious is completely indefinite. . . . What oppresses us is not this or that, nor is it the summation of everything present-at-hand; it is rather the *possibility* of the ready-to-hand in general; that is to say, it is the world itself.[42]

And again: "Fear is occasioned by entities with which we concern ourselves environmentally. Anxiety, however, springs from Dasein itself."[43]

Heidegger's understanding of moods as, first, something essential and inescapable rather than something that affects us only occasionally ("in every case Dasein always has some mood") and, second, as the most fundamental level defining and coloring all the rest of our mental life was critically taken up and developed in a less ontological and more anthropological direction by Bollnow in *Das Wesen der Stimmungen.* For Bollnow, as for Heidegger, moods differ from emotions in that they have no intentional objects.[44] "In the mood, the world has not yet become objective, as in later forms of consciousness, in particular, in cognition. Rather, the moods live still entirely in the undifferentiated unity of self and world, subjecting both to a common mood-coloring."[45]

A mood represents the most fundamental level of mental life, a "basic disposition" (*Grundverfassung*) which colors all of our mental states. A specific underlying mood gives all our experience a definite direction, making certain kinds of experience possible and precluding other kinds.[46] "In each mood the world is already 'interpreted' in a quite definite way and all understanding is already led in advance by this original interpretation of life and of the world in the mood."[47] It would not be possible to produce a complete classification of moods. One might, however, divide all moods into two general groups of high and low (or elevated and depressed) ones.[48] All the same, there are some moods, such as the moods of devotion, solemnity, or festivity, which cannot be located between these two poles.[49]

Above, I have claimed that actions and "passions" (states of mind) exhaust the ways in which we humans are in the world. The importance of Heidegger's and Bollnow's analyses is that they force us to recognize that there is yet another kind of mental state, in addition to those involving the activities of cognition, volition, or emotion, namely, mood, a feeling divorced from the cognitive and rational activities, a feeling without an intentional object and without justifying reasons. Moods underlie, give direction, and color our more complex states of mind.

A person, Bollnow thought, tends to be dominated and defined by a basic mood or a family of such moods,[50] to have not only passing, transitory moods, but also what we might call, to keep the musical metaphors going (in German, a *Stimmung* is not only a mood, but also a tuning), a definite "temperament." (And just as it was not possible to produce a complete classification of moods, the great variety of human temperaments could not be reduced to a simple classification, the traditional quartet notwithstanding.) I might add that our enduring temperament differs from our more transitory moods in a similar way as our enduring character, consisting of our virtues and vices, our more or less firm dis-

positions to act in certain ways, differs from our transitory actions. Note, namely, how similar are the relationships between the temperament and mental states of a person, on the one hand, and between his character and actions, on the other. Just as the temperament underlies, colors, and gives direction to a person's states of mind, the character underlies, colors, and gives direction to his actions. And just as we come to know a person's character by observing his actions, we learn what his temperament is by observing his passions.

The notion of mood is of central importance if we want to understand the nature of the content of abstract art, and in particular, of instrumental "absolute" music (that is, music which has no function other than being the object of contemplation, no text, and no program). It allows us, namely, to counter Hanslick's hitherto unassailable argument against the traditional mimetic claim that feelings or emotions constitute the content of such music. We have already seen that the argument presented in chapter 2 of *On the Musically Beautiful,* a chapter bluntly entitled "The representation of feeling is not the content of music," has an Aristotelian ring to it. Feelings, Hanslick claims,

> depend upon ideas, judgments, and (in brief) the whole range of intelligible and rational thought, to which some people so readily oppose feeling. What, then, makes a feeling specific, e.g., longing, hope, love? Is it perhaps the mere strength or weakness, the fluctuations of our inner activity? Certainly not. These can be similar with different feelings, and with the same feeling they can differ from person to person and from time to time. Only on the basis of a number of ideas and judgments (perhaps unconsciously at moments of strong feeling) can our state of mind congeal into this or that specific feeling. . . . If we take this away, all that remains is an unspecific stirring, perhaps the awareness of a general state of well-being or distress. Love cannot be thought without the representation of a beloved person, without desire and striving after felicity, glorification and possession of a particular object. Not some kind of mere mental agitation, but its conceptual core, its real historical content, specifies this feeling of love. Accordingly, its dynamic can appear as readily gentle as stormy, as readily joyful as sorrowful, and yet still be love. This consideration by itself suffices to show that music can only express the various accompanying adjectives and never the substantive, e.g., love itself. . . . Music cannot . . . render concepts. . . . Is the result of all this not psychologically irrefutable? It is that music is incapable of expressing definite feelings; indeed, the definiteness of feelings lies precisely in their conceptual essence.[51]

Music can present not the content of feeling, but only the motion, and motion "is just one attribute" of feeling.[52] "Motion is the ingredient which music has in common with emotional states."[53]

Hanslick's argument seems, indeed, correct. With its nonexistent or, at best, very limited representational powers, music is incapable of bringing to mind the intentional object of an emotion, and its lack of logical powers makes it an unsuitable medium in which to present reasons for or against an emotion. All it can do, and it does this supremely well, is to make palpable the dynamic properties

of the sensation which is but one of the three components of an emotion. But, precisely because it can do this, it is indeed "incapable of expressing definite feelings," but just as surely capable of expressing moods. The discovery that moods constitute a layer of mental life distinct from emotions and consist of feelings divorced from intentional objects or reasons allows us to blunt the counterintuitive edge of Hanslick's conclusion. The musical metaphor of "attunement" is singularly apt. Better perhaps than any other medium, abstract, "absolute" music discloses various ways in which self and world can resonate in one another, various tunings in which the mind may find itself as it experiences the world, various underlying colorings (to mix the metaphoric palette somewhat) that permeate all mental states, various moods.

It is something like this that Hegel might have had in mind when he claimed that

> the proper task of music is to vivify some content or other in the sphere of the subjective inner life. . . . Music's purpose . . . must be limited to making the inner life intelligible to itself. . . . The inner life in its abstraction from the world has as its first differentiation the one that music is connected with, namely feeling, i.e. the widening subjectivity of the self which does proceed to have an objective content but still leaves this content remaining in this immediate self-sufficiency of the self and the self's relation to itself without any externality at all. Therefore feeling remains the shrouding of the content, and it is to this sphere that music has laid claim.[54]

In other words, music's domain is that of feeling, and feeling does have an objective content (its intentional object), but as feeling (sensation) it is purely subjective, a state of consciousness (mood) suffusing the self without any reference to any kind of externality. Another passage in Hegel's lectures shows that for him, too, music by itself was the art of moods and that it required another medium to be transformed into the art of definite feelings:

> The soul's pure feeling of itself . . . is in the last resort merely a mood and so too general and abstract, and it runs the risk of . . . becoming purely empty and trivial. But if grief, joy, longing, etc. are to resound in the melody, the actual concrete soul in the seriousness of actual life has such moods only in an actual context, in specific circumstances, particular situations, events, and actions, etc. . . . In this way a further task is imposed on music . . . , namely the . . . task of giving to its expression the . . . particular detail. For music is concerned not with the inner life in the abstract, but with a concrete inner life. . . . The details of the content are precisely what the *libretto* provides.[55]

Nietzsche, a lifelong passionate musician and a sporadic composer (to put it kindly), thought that he had succeeded in capturing something of fundamental importance in his *Hymnus an das Leben,* "the only thing of my music that should remain, a kind of a confession of faith in tones."[56] In a draft of a late 1887 letter to Felix Mottl concerning this piece he explained its importance: "I would wish

that this music might enter to provide a supplement where the *word* of a philosopher must necessarily remain unclear, as the word will. The affect of my philosophy is expressed in this hymn."[57] (The score of the hymn, by the way, like countless other scores, does not show the full courage of this conviction and, just in case, supplements the music with a verbal clarification of the intended mood, "Determined; with an heroic expression" ["Entschlossen; mit heroischen Ausdruck"], to say nothing of the text.) I doubt that in this particular case the mood embodied in the music captures the mood of the philosophy better than words. It is the stylistic register of a text, its rhythm, tempo, and sonority, the choice of vocabulary and syntax, the way the text is uttered, the tone of voice, the accompanying gesture, that embodies the kind of mood conveyed, whether elevated or depressed, tragic or comic, one for which we have already coined a name or one which is as yet nameless (or one for which we will be able to do no better than to refer to it as "Nietzschean"). Like Rousseau, Nietzsche was far more skillful with words than with tones, and his music is no match for his literary style in capturing the "affect" of the thought. But in principle, if not in fact, Nietzsche was right. Music can and does convey a mood, a fundamental attitude in which one faces being in the world and living. What is embodied in a movement of a Mozart piano concerto is a whole way of life.

To be sure, thanks to a variety of stylistic means, language can do this job too. Heidegger, for whom the paradigmatic art was not music but poetry ("*All art . . . is . . . essentially poetry*"[58]), stressed the mood-disclosing potential of language: "Being-in and its state-of-mind are made known in discourse and indicated in language by intonation, modulation, the tempo of talk, 'the way of speaking'. In 'poetical' discourse, the communication of the existential possibilities of one's state-of-mind can become an aim in itself, and this amounts to a disclosing of existence."[59] It is only when it attempts to *name* the mood, rather than to *express* it, that the word "must necessarily remain unclear" where the tone is definite and precise. But this should not mislead us, the way it did mislead many a romantic, into believing in the doctrine of music as a "language beyond language," a language capable of saying what natural languages cannot say. Moods can be given expression not only in music, but also in other media. Language is less definite and precise than music only when it attempts to name the mood of the music, but this tells us something about the nature of language, not of music. Moods, like artworks or persons that embody them, are unique and individual and hence, like everything individual, ultimately ineffable. At the same time, they also exemplify kinds or genres and hence can be named, however imperfectly. Language's attempt to name the particular is always frustratingly imprecise when compared with a direct experience of the particular, because the name brings the particular under a general concept, associates it with many other particulars, and thus blunts the sharp edges of its particularity. But, again, this tells us something about the nature of language, not of music. The necessary (and useful) imprecision of naming, as opposed to expressing or embodying, is the imprecision of

language, not of moods, or of music, or of anything in particular that gets named. The content of music is not any more ineffable than the content of any particular experience.

In a well-known letter of 15 October 1842, Mendelssohn wrote to Marc André Souchay:

> People complain usually that music is so ambiguous, that it is so doubtful what they should think with it, while words are understood by anyone. But for me it is exactly the other way around. And not just with whole speeches, also with individual words; also these seem to me so ambiguous, so indefinite, so easily misunderstood in comparison with true music. . . . What a piece of music which I love tells me are for me not thoughts that are too indefinite to be grasped in words, but ones too definite. Thus I find in all attempts to express these thoughts in language something right, but also something insufficient . . . because a word does not mean for one what it means for another, because only a song [without words] can tell one the same thing it tells another, can awaken in him the same feeling, a feeling, however, which does not express itself in the same words.[60]

This is exactly right. (A similar thought can be found among Nietzsche's private notes: "In *relation to music,* all communication by means of *words* is of a shameless sort; the word makes thin and dumb; the word depersonalizes; the word makes the uncommon common."[61]) But what is true of music is true of any particular whatsoever, this table, this dog (and tell a dog lover that the word "dog" perfectly captures the individuality of his beloved creature!). It is not that music discloses a region that cannot be reached by any other means, pictorial or linguistic. The much less exciting truth is that whatever a piece of music (painting, poem, human face, tree) discloses is captured only imperfectly by a name.

But if we reject the romantic topos of music as a language beyond language, a related romantic doctrine, the doctrine of music as the language of the "infinite" (to speak with E. T. A. Hoffmann) is a good deal more plausible. Music's historical edge over painting or poetry consists only in this, that, with its inherent tendency toward abstraction, it was able to provide moods without the admixture of anything else earlier than the other arts were. And moods show a peculiar affinity with abstraction. A mood, after all, is a feeling devoid of any positive content, any specific representation or thought, a "key" in which the content of a cognitive, volitional, or emotional mental state will be experienced. In this sense, while undeniably specific, each particular mood also has its abstract side: it is an empty resonating vessel waiting to be filled with a definite content. Hoffmann's celebrated claim, cited in chapter 3, that the content of instrumental music is not provided by any definite emotions, that music's "only subject-matter is infinity," becomes quite believable when it is stripped of its usual metaphysical pretensions, of any suggestion of the "noumenal" or the Schopenhauerian Will, and seen in the context of the emotion-mood distinction. While vocal music can represent definite emotions, "absolute" music embodies a mood, or a scenario of successive moods (an abstract "archetypal plot," to use a term of

Anthony Newcomb's), and each mood may be filled with a content the scope of which, while not exactly "infinite," is certainly very broad and indefinite. In the very different language of Mikel Dufrenne,

> although nothing is revealed to me [in music] except a light, I know that the real can appear through it. . . . I know that the real can be seen in this way. . . . There is joy, and it is of little importance which particular objects manifest it. . . . [Dufrenne is that rare philosopher for whom music does not always have to be sad.] The privileged character of pure music is to reveal what is essential in the real without my having to anticipate the objects which give it a body. Pure music brings me the signification in advance of the signs, the world in advance of things.[62]

In this way, instrumental music becomes the first language of choice of the modern self, the language envied and subsequently imitated by other abstract arts aspiring to music's status. Abstract art, as I have argued in chapter 3, perfectly matches and expresses the modern aspiration to infinite freedom, the reluctance of the infinitely free subject to impose any finite determinations upon itself, to give its life any actual objective content. And it does so by presenting pure moods, abstract mental states divorced from objects or reasons and waiting to be filled with a more specific content.

It might be recalled, incidentally, that the expression of ineffable mental states has been identified with remarkable frequency as the central task of art by a great many twentieth-century theorists of otherwise most diverse philosophic persuasions, from Croce through Collingwood, Langer, and Dufrenne, all the way to Danto. The notion of mood allows us to specify more closely what the content of this expression might actually be. Moods, as we have just seen, are about as close as we ever get to abstract subjectivity. No wonder that their expression, and hence the expression of abstract subjectivity, becomes the central task of art for so many modern theorists. But what they take for the essence of art in general, is rather just one component of art, albeit one made centrally important by art's, and our, modern situation. Instead of working out with ever greater subtlety the implications of the paradigm that emerged in the late eighteenth century, however, we might prefer to doubt the eternal validity of this paradigm and to look for answers to the question that Heidegger was probably the first to raise with full force, "the question [in Gadamer's words] of how one can do justice to the truth of aesthetic experience and overcome the radical subjectivisation of the aesthetic that began with Kant's *Critique of Aesthetic Judgment.*"[63] Experiencing the work of art, Heidegger claimed in his 1935 lecture on "The Origin of the Work of Art," "does not reduce people to their private experiences, but brings them into affiliation with the truth happening in the work."[64]

In short, if we want to use art as a means of human self-presentation, actions and states of mind are all there are to represent. The presented actions and passions are those of the personages that belong to the represented world, not those of the author or reader. When all that is represented is a setting with no

personages in it, the implied actions or passions may be those of personages absent from, but not unthinkable within, such a setting. When the represented world is wholly abstract, it may still embody a mood or a scenario of moods, an abstract state of mind or an abstract plot devoid of any subject or object.

Otherwise, sonata, do not waste my time.

6 ⌒⌒⌒⌒

HERMENEUTICS.
INTERPRETATION AND ITS VALIDITY

> But nothing's lost. Or else: all is translation
> And every bit of us is lost in it
> (Or found—I wander through the ruin of S
> Now and then, wondering at the peacefulness)
> And in that loss a self-effacing tree,
> Color of context, imperceptibly
> Rustling with its angel, turns the waste
> To shade and fiber, milk and memory.
>
> James Merrill, "Lost in Translation"

a. Interpretation: Metaphor and Metonymy

Works of art present fictional worlds. At this late stage in our discussion, it can almost be taken for granted that these worlds need to be interpreted. To be sure, in the first place an artwork needs to be experienced, and one might be tempted to believe that all that an artwork asks for is to be experienced, that the experience is the only interpretation that matters. An artwork, that is, a real object in which an imaginary experience has been encoded, must be experienced-decoded if it is to reveal an artworld, and to experience is to interpret, to see the paint on canvas as a face, to hear the sounds of the piano as a dominant chord resolving to the tonic, and so on. "All reading that is understanding," says Gadamer, "is always a kind of reproduction and interpretation. . . . If this is the case, then the consequence is unavoidable that literature . . . has just as original an existence in being read, as the epic has in being declaimed by the rhapsodist or the picture in being looked at by the spectator. According to this, the reading of a book would still remain an event in which the content presented itself."[1] Even the most simple experience is not simple, it is not just an exact repetition

of something that occurred before. Since the world is decoded by me, with all my personal idiosyncrasies and history, it will not be identical to the one decoded by you. In each case, something else will be unnoticed and something else emphasized. But there are no viable alternatives: meaning lives only in such acts of decoding, it is never simply and immediately given. As Frost should have said, and as Merrill did say in the great poem from which I have borrowed the epigraph for this chapter, poetry (and all meaning) is what gets lost *and found* in translation. All we ever have access to are translations; the originals are not available.

But the interpretation I am mainly concerned with here is not the fairly rudimentary one that transforms a work into a world. It is, rather, a much more complex interpretation of this imaginary world itself. That we need this latter interpretation follows from what we know about the proper uses of art. If an artworld is to be more than amusing, if it is to fulfill its edifying potential, it must be brought into contact with the world beyond its own confines, with the world of our interests and concerns. Moreover, as we shall discover later on in this chapter, even if an artworld is to develop only its entertaining potential to the fullest, it needs to be compared with other artworlds of the same kind. The pleasure afforded by a visit to Sant'Andrea al Quirinale, considerable in itself, will be much enhanced once the visitor notices the extent to which Bernini's interior is a creative transformation of that of the Pantheon, with a side glance at Borromini's San Carlino up the street. Similarly, our appreciation of the achievement of Francis Bacon will be enhanced when we realize that he gave a new life to one of the most central subjects in the visual arts, the human body, by representing it as butchered meat, as flesh tortured and entrapped, and when we place his vision not only within the historical context of post-Auschwitz Europe, but also within the artistic context of the Crucifixion genre. Such confrontation of different worlds is, precisely, the job of interpretation.

"Every work of art, not only literature, must be understood like any other text that requires understanding . . . ," says Gadamer. "Aesthetics has to be absorbed into hermeneutics."[2] The need for interpretation is particularly pressing today since so much of the art that interests us was produced in distant places and times. That "our art" is only the art being produced here and now may seem plausible if one considers art exclusively from the standpoint of its makers. But from the standpoint of those who use, rather than make, art, Titian and Manet are no less "our art" than Bacon and Rauschenberg. The users of art are expressed by the art they use, or, more precisely, are expressed by the way they use this art, much more than by the art simply produced by their contemporaries and fellow citizens. For many of us today, Schubert's or Mahler's music is also more profoundly "ours" than the music of Stockhausen or Glass. This situation is not unprecedented. Montaigne's spiritual world was inhabited by Plutarch and a number of Roman authors to an incomparably greater extent than by most of his contemporaries. The situation seems new perhaps only for those arts that began to acquire canonic repertories relatively recently, so that the memory of times when

contemporary products did not have to compete with those of the past is still relatively fresh, as is the case for art music, which started to develop a canon of classical works only around 1800, to say nothing of jazz or film.

Above all, this situation should not be taken for an unhealthy symptom of decadent historicism. Rather, it should be recognized as consistent with the nature of art. For Gadamer "art is never simply past, but is able to cross the gulf of time by virtue of its own meaningful presence."[3] The ability to speak across temporal, spatial, and cultural distances is one of the most characteristic and essential features of art. If an artworld comes into existence only when an artwork is decoded, that is, interpreted, the act of interpretation is never exactly contemporary with the act of creation. The temporal distance is there right from the beginning. Art exists only in so far as it is interpreted, and what is interpreted is always the art of the past. This is why Schubert's art can be as much "ours" as Stockhausen's. Gadamer claims with good reason that

> 'contemporaneity' forms part of the being of the work of art. It constitutes the nature of 'being present'. . . . Contemporaneity . . . here means that a single thing that presents itself to us achieves in its presentation full presentness, however remote its origin may be. Thus contemporaneity is not a mode of givenness in consciousness, but a task for consciousness and an achievement that is required of it.[4]

But if the fictional worlds of art need to be interpreted, how should this be done? And how do we distinguish valid interpretations from invalid ones? To begin with, the interpretation of art is not much different from the interpretation of anything else. To interpret an object, to spell out its meaning, always involves placing the object within a context. When we interpret an object in front of us as a "chair," we bring it within the context of other objects one might bring under this concept. Our interpretation is correct if the object turns out to be usable as a chair, incorrect if it cannot be so used, if on closer inspection, say, it shows itself to be far too high for a chair, but just right to be called a "table." Either interpretation might be the correct one, depending on a still larger context. Perhaps in a world of giants the object might pass for a serviceable chair, while in ours it can serve only as a table. Thus, even the simplest sort of interpretation quickly forces us to bring the object into a larger and larger context, the context of a whole world. When we say about the object in front of us that it is a chair, we really mean to say that it is a chair in a world like ours, though it might be something else, a table, in a world of gnomes. An object is never given to us simply and singly. It comes with other objects like it, objects that can be subsumed under the same concept, and it comes with its world, the world in which it is the object it is. In interpreting it, we usually take the assumed relevant world for granted and focus on comparing the object with other objects like it.

The point that interpreting inevitably involves comparing the object with other objects like it is worth stressing, since it brings out a paradoxical feature of the whole enterprise. An interpreter concentrates on an individual object. It is this

one object that he wants to grasp in its unique individuality. But he cannot do this unless he is willing to see the object as the very opposite of an individual, as a member of a kind, species, genre. To capture the individual features of this particular chair (portrait, sonata, comedy), I need to recognize that the object in question is a chair (portrait, sonata, comedy) in the first place. As Gadamer argued when criticizing the abstraction of the modern aesthetic consciousness, "abstraction until only the 'purely aesthetic' is left is obviously a self-contradictory process."[5] Aristotle, writes Gadamer,

> has shown that all aesthesis tends to a universal. . . . The specific perception of something given by the senses as such is an abstraction. In fact we see what is given to us individually by the senses in relation to something universal. . . . Now 'aesthetic' vision is certainly characterized by its not hurrying to relate what one sees to a universal. . . . But that still does not stop us from seeing relationships. . . . Every perception conceived as an adequate response to a stimulus would never be a mere mirroring of what is there. For it would always remain an understanding of something as something. . . . This . . . is also valid for aesthetic consciousness, although here one does not simply look beyond what one sees, . . . but dwells on it. . . . Pure seeing and pure hearing are dogmatic abstractions. . . . Perception always includes meaning.[6]

Moreover, objects are not correlated with generic concepts on a one-to-one basis. On the contrary, there seem to be no conceivable limits to the number of concepts under which a given object might be brought. Some of these concepts may be hierarchically related: this is a piece of furniture, but also a chair, and even a Chippendale chair. Some might pick out unrelated aspects of the object: this is a chair for me, a bed for my cat, a source of timber for all of us in a particularly harsh winter. The choice we shall make from among those limitless possibilities will depend on our interests and concerns.

It is, thus, the first step in an interpretation to choose the generic concepts under which we want to consider the object. And it is the second step to consider the object under these concepts, comparing it with other objects that fall under them, and thus bringing out both the generic and the individual features of the object in question. There is little that can be said in general about the skills involved in performing the second step. Obviously, one will need both a talent and some experience to perform it well. At the very least, one will need to have a broad knowledge of objects that might fall under a given concept and to be perceptive. But the best guidance in this area comes not so much from general rules and precepts as from good models and practice. A student of this aspect of interpretation can do no better than observe Michael Baxandall as he looks at Florentine *quattrocento* paintings, Marc Fumaroli as he contemplates Poussin, Charles Rosen as he listens to Chopin, John Freccero as he reads Dante, or Jean Starobinski as he interrogates Rousseau.[7] More can be said about the skills required to perform the first step.

When the object to be interpreted is an artworld, a represented fictional world, the interpretation involves comparing this world with other worlds like it. The

interpreter's skill here consists, precisely, in being able to pick up appropriate worlds for comparison. In principle, there are no preordained limits on what might be found appropriate. But if one wants to stay within the realm of fictional worlds, the most immediately and obviously appropriate worlds to choose for comparison will be those belonging to the same artistic genre. An artist, no matter how modern, emancipated, and autonomous, always works within the framework of an already established and ongoing artistic practice. What he makes always belongs to a kind, a species, a genre, whether it be a genre as general as "art" or as specific as "Spanish court portrait." It makes sense both as a matter of simple courtesy and of practical economy of interpretative efforts that one would want to consider the artist's products under the generic concepts under which they have been produced, concepts the artist and his audience shared and understood. We may eventually go beyond such generic concepts. A genre is, after all, constituted in an act of interpretation by the very fact that we bring different objects together for comparison and we know something the artist and his audience did not know, namely, the subsequent development of the artistic practice in question. We might, thus, want to bring new concepts, concepts the artist and his audience could not know, to bear on the work. It may illuminate not only Liszt's but also Chopin's work if we consider together and compare Chopin's ballades and Liszt's symphonic poems, even though Chopin could know nothing about the symphonic poem. But it would be impolite and unwise to bypass the interpretation based on the artist's own concepts altogether. Rather, we begin with the concepts the artist and his audience knew and then we move on to those they could not know.

It follows that this part of the interpreter's skill which consists in choosing appropriate fictional worlds with which to compare the interpreted artworld involves art-historical knowledge. A knowledge of the history of the relevant artistic practice is a necessary part of any critic's equipment, and this for three reasons. First, without it, we could not identify the artist's generic intentions, his and his audience's shared generic concepts. Second, we need to know "what happened next," what later works and genres might be usefully brought in for comparison. Third, a knowledge of the historical development of the genre is a prerequisite for any attempt to identify both the generic and the original features of an individual specimen of this genre. An art critic also needs to be an art historian.

But the interpreter need not, and should not, limit the range of the worlds chosen for comparison to fictional worlds only. On the contrary, if an artworld is to educate and not only to please, it must at some point be confronted with the actual world in which we live. Here the interpreter's skills cease to be purely artistic, whether analytical or historical, and begin to resemble practical wisdom. The intellectual virtue of practical wisdom, we shall recall, is the skill we need in order to apply general principles to particular situations. We practice this skill on examples of particular situations. And we have the skill in part when we can recognize which examples belong together. Thus, a good interpreter will need a

rich repertoire of examples drawn not only from art, but also from life. Here we may also want to begin with worlds the artist and his audience knew and thus explore the range of possible meanings the work might have carried for them. And we may and should then move beyond the worlds known to the artist and his audience and explore the range of possible meanings the work might have carried for later audiences, including ourselves. Broadly based historical, and not just art-historical, knowledge forms the necessary equipment of the critic.

Notice, moreover, that no matter whether the worlds chosen for comparison are fictional or actual, both the interpreted artworld and the worlds with which we compare it are imaginary representations. The actual world cannot be had and handled raw. It needs to be grasped as a representation before it can be compared with anything at all. The only difference, in my terms, is that in one case the comparison-worlds are artistic (that is, fictional), and in the other they are historical (that is, actual). Both art and history, I have claimed throughout, represent men and women acting and suffering in particular circumstances which limit their choices, circumstances largely not of their own making. The difference between the two, I have claimed further, is only the difference between the fictional or actual nature of what gets represented. This is why we are able to bracket off for the time being our awareness of this difference and bring historical worlds into the full repertory of the worlds with which we compare the interpreted one.

Art and history share the object (the "what") of representation. The basic matter of their worlds consists of narrators, personages, and settings, and the basic forms are narrative and lyric. The same goes for further subdivision into genres: tragedy and comedy (or farce, to speak with Marx), for instance, are fundamental ways of representing human action, whether this action is fictional or actual. An act of interpretation involves comparing the interpreted artworld or an element or aspect thereof with another represented world or its element or aspect, whether artistic or historical, comparing narrators, personages, settings, actions, and passions.

At bottom, all that an interpreter can do is to say "a is like b" (which is a shorter way of saying "a is in certain respects like b and in others unlike it") and hope that this will illuminate a for someone who already knows b, that seeing a in the light of b will enable one to notice aspects of a one might not notice otherwise. A useful interpreter will make comparisons which are genuinely illuminating, that is, neither obvious nor merely eccentric, but rather at once unexpected and bringing out something that is truly there, something hidden but deserving notice.

Moreover, in an act of interpretation the light travels both ways. The confrontation of a with b can also bring out previously unnoticed aspects of b. In this way both the image of Odette and Botticelli's *Youth of Moses* were mutually transformed for Swann once he noticed his beloved's resemblance to the figure of Zipporah, daughter of Jethro, in the Sistine Chapel fresco: "and, albeit his admiration for the Florentine masterpiece was probably based upon his discovery

that it had been reproduced in her, the similarity enhanced her beauty also, and rendered her more precious in his sight."[8] We do have a choice whether we want to use contexts to throw light on the artworks, or the reverse. Needless to say, this is a matter of relative emphasis, not an absolute opposition. If we do our job well, both the work and the context will look new. But we may legitimately emphasize one or the other goal in our investigations: we may use Wagner's *Ring* as a piece of evidence in a study of the evolution of the Central-European revolutionary intelligentsia in the postrevolutionary age; or we may use the latter to elucidate the tortuous history of Wagner's revisions of the *Ring*'s conclusion. Both emphases are equally legitimate. Art (music, literature) critics may be institutionally prone to prefer to use historical contexts to illuminate texts, rather than the other way around. This is because they might think that the latter is the proper job for historians. To accept this line of reasoning, however, would be to make a bookkeeping error. If art is to serve life, if its edifying function is to be taken seriously, it is clearly not enough for the critic to use life in order to illuminate art. It is equally important that one show how art throws light on life.

In short, to interpret is to invent new metaphors, metaphors that are neither stale (these would tells us something true but obvious), nor forced (these would tell us something less obvious but untrue). (To be sure, "a is like b" is a simile, but a metaphor is nothing but a simile with the "like" suppressed but understood.[9]) "Metaphor," Aristotle taught, "consists in giving the thing a name that belongs to something else."[10] Their function is to tell us something that is simultaneously new and true: "it is from metaphor that we can best get hold of something fresh. . . . But the metaphors must not be far-fetched, or they will be difficult to grasp, nor obvious, or they will have no effect."[11] They "must be fitting, which means that they must fairly correspond to the thing signified"[12] "must be drawn . . . from things that are related to the original thing, and yet not obviously so related."[13] To find fitting metaphors requires a talent for noticing similarities where no one has noticed them before, an art that cannot be taught: "But the greatest thing by far is to be a master of metaphor. It is the one thing that cannot be learnt from others; and it is also a sign of genius, since a good metaphor implies an intuitive perception of the similarity in dissimilars."[14]

An interpreted artworld is a metaphor.[15] Recall from chapter 1 Hegel's distinction between sign, where the connection between the signifying and the signified is external and arbitrary, and symbol, where the signifying is identical with the signified. When the signifying is not an individual sign, but a whole represented world, the proper traditional name for the former relationship is that of allegory. A symbol represents content that cannot be represented in any other way. An allegory, on the other hand, refers to content that might be referred to in a variety of ways. On my account of interpretation, an artworld partakes of the nature of both symbol and allegory, without being either. If an interpreter were to treat an artworld *a* as a symbol, all he could say would be: "*a* is *a*." To say this, however, would be to say something true but completely unilluminating and hence not worth saying. An artworld is a symbol, it cannot be translated

without a loss and distortion. Nevertheless, it demands interpretation and, once interpreted, it stops being only a symbol, it becomes a metaphor. If the interpreter were to treat the artworld as an allegory, he would have to say: "*a* is *b*" and really mean it (as opposed to meaning "*a* is like *b*"). To say this, however, would be untrue, precisely because an artworld cannot be completely translated without any loss and distortion.

To be sure, in certain historical periods, some artworlds or elements thereof may be treated as either symbols or allegories. If we are to believe Hans Belting, divine beings were literally thought to be present in premodern religious images such as Byzantine icons, and the purpose of making such images was to allow the divinity to intervene in the real world.[16] In cases like this, a premodern image is transformed into a modern artwork precisely when it stops being taken for a pure symbol. Similarly, the art of the Baroque is full of allegories. But even then, an artworld, in so far as it is art at all, is more than merely a pure allegory. If it deserves to be contemplated at all, it cannot simply serve as a vehicle that transports us to a meaning and can be discarded on arrival. What an interpreter should be saying, therefore, is "*a* is (like) *b*," and we should hope that he has talent enough to choose a *b* that will allow us to notice something about both *a* and *b* we had not noticed before, something that is truly there and worth noticing.

It is the nature of metaphorical interpretation that it is simultaneously required and resisted, required for reasons already spelled out, resisted because *a* is only *like b*, it is not literally *b*, and therefore it is also *unlike b*. (Not for nothing does Nelson Goodman say that "a metaphor is an affair between a predicate with a past and an object that yields while protesting."[17]) Nowhere does this resistance appear more clearly than in the case of the interpretation of music. Ever since E. T. A. Hoffmann and Schopenhauer, verbal interpretations of music, including the interpretations afforded by the text of a song or the libretto of an opera, were correctly considered no more than exemplifications, chosen from among many possible ones, of the music's meaning. Recall Hoffmann's claim, quoted in chapter 3, that "any passion . . . presented to us in an opera is clothed by music in the purple shimmer of romanticism, so that even our mundane sensations take us out of the everyday into the realm of the infinite." And recall Schopenhauer's formula that words or pantomime stand to music "only in the relation of an example, chosen at random, to a universal concept." (As Scott Burnham recently put it, talking of the relationship between the *Eroica* Symphony and various programmatic and analytical narratives devised over the years to show its content, "we must not for a moment think that the symphony is about these narratives, for it is precisely the other way around: the narratives are about the symphony."[18])

But the Romantics and their heirs (Nietzsche comes to mind here[19]) were wrong to think that music is unique in this respect. On the contrary, the metaphorical relationship between music and verbal text is not different from the metaphorical relationship established between *a* and *b* in any act of interpretation, whether *a* is music, literature, a chair, anything. Painting and literature, no

less than music, simultaneously cry for, and resist, metaphorical interpretation. When leaving Harold Pinter's *The Birthday Party,* we are right not to avoid naive questions like, Who are these two intruders? and, Where do they take Stanley?, but we know that any specific answers to these questions will be only partly satisfactory, exemplifying rather than exhausting the significance of the spectacle. The representations that we draw from art or life when we attempt to understand an artworld can do no more, and should do no less, than to exemplify the meaning, without ever exhausting it.

There is yet another, related, sense in which an interpreted artworld is more than just the artworld on its own. In an artworld, a fragment discloses, or rather suggests, a larger whole, a whole world. Vermeer's view of a little street of his home town (in the Rijksmuseum) implies much more than what meets the eye, a whole way of life, of acting and experiencing, the way of life of a Dutch burgher, and thus it suggests a larger world of which the visible one is only a part, a world the painter captured on the greatest of his canvasses, the *View of Delft* (at the Mauritshuis in The Hague). The refined nonchalance with which Charles I holds a glove in the Van Dyke portrait (at the Louvre) similarly condenses several centuries of aristocratic manners. All artworks are like the "nocturnes" of Georges de La Tour in which the area of physical and spiritual illumination is always surrounded by a much vaster area of darkness. A representation of an action is always more than simply a representation of this particular action, because it brings to mind other actions like this one. In this sense, every specific narrative exemplifies a general sense of how one might act. A representation of a state of mind, similarly, is always more than simply a representation of how this particular mind experiences the world, because it suggests other minds experiencing their worlds in similar ways. Thus, every specific lyric exemplifies a general sense of how one might experience one's world.

Much of the ethical and political significance of art depends on this ability of a fragmentary artworld to intimate a whole world and way of life. It is to such a whole way of life, we have seen, that we make our fundamental commitment when we give our freedom a content; our specific choices are made from within this general commitment. It is the job of the critic to bring this hidden whole that is only suggested out in the open, to spell out the implied way of life, manner of acting and suffering. The torso of Apollo implies the whole body of the god, and the body, a whole, Apollonian, way of life. This is why Rilke could issue his famous injunction when in the "Torso of Apollo" (from the *Neue Gedichte*) he demanded that a work of art should change our life. And this is why Heidegger was right to stress in his essay on "The Origin of the Work of Art" the essential tension between the emergence and the hiddenness (or "world" and "earth" in Heideggerese) in an artwork, the interplay between what is revealed and what is concealed in it.[20] (And not only in an artwork: "Each being we encounter and which encounters us keeps to this curious opposition of presence in that it always withholds itself at the same time in a concealedness. The clearing in which beings stand is in itself at the same time concealment. Concealment, however,

prevails. . . . At bottom, the ordinary is not ordinary; it is extra-ordinary, uncanny. The nature of truth, that is, of unconcealedness, is dominated throughout by a denial."[21])

In other words, an interpreted artworld is not only a metaphor, but also a metonymy. The difference between inventing metaphors and inventing metonymies is that in the former one moves from one world, *a,* to another, *b,* and claims that *a* is like *b,* while in the latter one remains within the same world and claims that the appearing part is, precisely, part of a hidden whole. Otherwise, however, the skills required to invent successful, that is, illuminating, metaphors and metonymies are quite similar. In both cases, it is the matter of having a broad art-historical and especially general historical knowledge, what might be called the knowledge of the world, and a sense of what fits with what. Moreover, not only the metaphoric, but also the metonymic interpretation is simultaneously required and resisted, required, because there is always more to the represented world than what actually appears, there are always aspects hidden from view, and resisted, because we can never be sure that our guesswork that brought the hidden aspects into the open has been fully successful. In either case, whether we invent metaphors or metonymies, what we bring to the interpreted artworld is never more than an exemplification of the kinds of things one might bring to it.

It should be clear now why an artworld is potentially inexhaustible and why the task of interpretation never ends. For one thing, the vast area of darkness in which the represented world is metonymically submerged cannot have clearly defined limits. For another, new contexts in which the artworld metaphorically takes on new significance, constantly and unpredictably emerge. No lover of Venice could have predicted a century ago how the location of the city on the map of the European imagination would be slightly adjusted by two visitors from St. Petersburg, Stravinsky and Brodsky. It is something like this potential inexhaustibility of the represented world that Kant may have tried to capture in his very different terms when he claimed that art is the vehicle for presenting aesthetic ideas:

> But by an aesthetic idea I mean that representation of the imagination which induces much thought, yet without the possibility of any definite thought whatever, i.e. *concept,* being adequate to it, and which language, consequently, can never get quite on level term with or render completely intelligible. —It is easily seen, that an aesthetic idea is the counterpart (pendant) of a *rational idea,* which, conversely, is a concept, to which no *intuition* (representation of the imagination) can be adequate.[22]

Just as reason comes up with concepts, such as God, which cannot be applied to any perceptions since they refer to infinities, so art, conversely, comes up with representations for which no adequate concept can be found since they are potentially inexhaustible.

In most general terms, the provisional and inexhaustible character of interpretation stems from its inescapably circular nature, from the famous "hermeneu-

tic circle" that thanks to Heidegger has been the subject of much fruitful reflection in this century.[23] In Gadamer's words,

> the whole hermeneutical and rhetorical tradition . . . regards as an essential ingredient of understanding that the meaning of the part is always discovered only from the context, i.e. ultimately from the whole. . . . It was always clear that this was logically a circular argument, in as far as the whole, in terms of which the individual element is to be understood, is not given before the individual element. . . . Fundamentally, understanding is always a movement in this kind of circle, which is why the repeated return from the whole to the parts, and vice versa, is essential. Moreover, this cycle is constantly expanding, in that the concept of the whole is relative, and when it is placed in ever larger contexts the understanding of the individual element is always affected. . . . [Hence] the inner provisional and infinite nature of understanding.[24]

For those whose standards of what counts as knowledge are derived from hard sciences, the picture of interpretation painted here may look disappointingly fuzzy. Well, it is a bit fuzzier than physics, and quite a bit fuzzier than mathematics. But, as Aristotle repeatedly observed, different domains of knowledge require different standards of precision. "Our discussion will be adequate," he says close to the beginning of *Nicomachean Ethics,*

> if it has as much clearness as the subject-matter admits of, for precision is not to be sought for alike in all discussions, any more than in all the products of the crafts. . . . It is the mark of an educated man to look for precision in each class of things just so far as the nature of the subject admits; it is evidently equally foolish to accept probable reasoning from a mathematician and to demand from a rhetorician scientific proofs.[25]

If we want to interpret things, metaphors and metonymies are all we have got. But this is not a situation peculiar to art interpretation. All interpretation, whether of art, chairs, or fossils, is like that. And there is no need to worry about this. Metaphors and metonymies do the job of interpretation very well, with just as much precision as the subject matter at hand requires.

In particular, we should not delude ourselves into believing that there are ways of interpreting that escape the need to use metaphors, that there is such a thing as a literal description, whether it takes the form of what musicologists call analysis or what literary critics call close reading. Musical analysis, which is as precise a method of description or paraphrase as we get in the arts, is metaphorical through and through, in so far as it captures music at all. A chord can be simply labeled, to be sure. But to say that this is a C-major triad is not yet to grasp the musical meaning of what we hear. It is merely to offer an alternative notation. The understanding rather than labeling or notating of music begins when we say what the tonal function of this triad in this piece is, when we say, for instance, that this is the tonic. We then claim that it serves as the center of tonal attraction, the goal of tonal motion, for all other chords. Dominant and tonic, the *Urlinie,* you name it, are not simple labels for something that is objectively

out there in the music. They are optional metaphors designed to capture the way we experience the music, optional, because, as we have seen in Chapter 1, the experience of directed motion that tonal music affords can be conveyed by means of several sets of alternative metaphors.

At best, we can distinguish metaphors that are strongly entrenched and those that are more tentative and provisional. Metaphors used in tonal analysis are of the former kind, because, even though we have several sets of those at our disposal, we have to use one if we are to capture the experience of tonal "motion" or "gravitation" at all. Metaphors used by musical hermeneutics, whether old or new, that is, metaphors that involve claiming that the abstract tonal motion is like a less abstract motion of some sort (say, the motion of galloping horses, or of male sexual desire), are necessarily more provisional, because they can be offered only as exemplifications of how an abstract shape might be concretely interpreted, if one chose to interpret it concretely at all. In short, "analysis" and "hermeneutics" are equally metaphorical. The difference is that, while the metaphors of analysis are entrenched because inescapable (if not this, than another metaphor of this kind has to be invoked if we are to understand the music at all), the metaphors of hermeneutics are truly optional (we may choose not to invoke them at all and still legitimately claim that we understand the music). But, while we can choose not to use them, if we do so, we have no way of making a connection between the music and the world, between art and life.

We might conceive of the steps involved in the interpretation of art as follows. The most primitive level of interpretation is something that might be called analysis (or close reading). Here we stay, to the extent that it is at all possible and without deluding ourselves that it is completely possible, within the confines of the interpreted artworld itself and elucidate its internal structure, that is, we list the elements that constitute the artworld, we consider the relationships among them, we show how the whole that is this world is articulated into parts, if it is so articulated, and what function, if any, each part plays within the whole. The interpretation proper, which was the subject of the discussion above, is the next step, in which the results of the analysis are confronted and compared with other represented and interpreted worlds, artistic and historical.

But we should be aware that the distinction between the two levels of interpretation is very fuzzy and merely pragmatic. It is impossible to keep contexts entirely at bay when one considers a text. Even as simple an operation as deciding that a chord is the tonic introduces the implicit comparison between the behavior of this particular chord in this particular piece and the behavior of countless other chords in other pieces. The very fact that a work is made of the language that went into the making of many other works brings the work into contact with matters external to it. The distinction between the two levels of interpretation is thus more a matter of degree or of emphasis, on the text or on its relation to a context. And it is surely not the case that only one of these levels involves the use of metaphor or metonymy while the other is free of figurative language and describes the analyzed artworld literally.

What does seem to be the case, however, is that analysis is more fundamental than, and prior to, the interpretation proper, and for two reasons. First, analysis is a prerequisite for interpretation because we need to make some sense, however preliminary and sketchy, of the internal content of the artworld before we can go on to confront it with other worlds. It is an illusion to think that we can skip analysis and proceed directly to interpretation, an illusion resting on the fact that an experienced art critic or historian does a lot of preliminary analytical work almost automatically in the course of becoming acquainted with the artworld he is about to interpret. To analyze is nothing else but to read with understanding, to read closely. Second, we may choose to arrest our involvement with artworlds on the level of analysis and go no further. There is, as we have seen, a steep price to be paid for such a limitation, but at least the limitation is possible, while we could not limit ourselves to the interpretation proper even if we wanted to, because without analysis there would be nothing to interpret.

In the current methodological discussions internal to the humanistic disciplines that study the arts, the concept of "historicity" (good) is often presented in contrast to "formalism" (bad). The commonly told story (in my admittedly crude caricature) goes like this. In the bad, repressive, Cold War, modernist 1950s, the academic criticism of the arts in the United States was "formalist" (or "New Critical"), that is, interested in elucidating formal relationships internal to the artwork itself, divorced from any historical context. In the good, liberated, post-Cold War, postmodernist present we know better, recognize formalism for what it is (a sterilizing strategy designed to neutralize any critical power that an artwork might possess), and study artworks in their rich and thick historical contexts.

What we actually should want, however, is to have it both ways, to have both the analysis and the contextual hermeneutics which goes beyond the analyzed works to other works and that even transcends the confines of art and embraces history. And we should want to have the two kinds of interpretation, internal analysis and contextual hermeneutics, connected with one another. Luckily, this is precisely what the best critics-historians of the arts give us. Without the analysis, our grasp of the interpreted artworld will be vague and imprecise. Without the interpretation proper, the precise grasp that the analysis offers will remain pointless. We want to engage our entrenched metaphors and our optional metaphors and to play them off against each other. In any case, with a largely abstract art, like instrumental music, the musicological pendulum between analysis and hermeneutics is likely to swing back and forth, presumably synchronically with the movements between abstraction and representation in the slightly larger world of art music chronicled in chapter 3. Since the analytical metaphors are entrenched, there is a bias in their favor in those periods when one wants to be hard-nosed and precise. Since analysis remains enclosed within the charmed circle of the analyzed work (is "internal"), there is a bias in favor of hermeneutics in those periods when one wants to open the doors and let history in, whether gingerly in the form of art history, or all the way in the form of history *tout court*.

The interpretation of artworks is a task art critics and art historians share. But, while it is all that art critics do, art historians do more. Historians of an art, like historians of any practice or family of practices, interpret two kinds of objects. First, they may devote their efforts to interpreting specific individual actions of specific individual historical actors, that is, to the interpretation of individual "utterances." Second, they may also want to understand the general rules that governed the actions of those who engaged in the studied practice, to understand the "language" in which individual utterances were made. In the first case, they interpret artworks. In the second, they reconstruct the premises and conditions that governed the production and reception of artworks, the range or limits of what it was possible to make and do under the constraints of a given practice.

Even in the first case, however, the range of a historian's interest is larger than that of a critic, for the simple reason that the objects historians interpret have very often been made in the past and elsewhere. We have three general choices when we try to understand such objects. First, we may want to find out what this object (action, product, work) meant to those who made it and for whom it was made. Since the documents that would allow us to answer this question with any kind of certainty are often simply not there, especially in the case of works from a more distant past, this choice usually has to be taken in a more general sense: what we want to find out is not so much what *did* this work mean to those who made it and for whom it was made as what *might* it have meant in its own time and place to the people who used it. We might call historians interested in such questions "historicists." Second, we may want to find out what meanings have been ascribed to this work in the time that has elapsed between its origins and today. People who ask this question are often called "reception historians." Finally, we might also ask what does, or might, this work mean today. Above, I have been calling people who ask this question "critics."

Now, it is important to recognize that these three enterprises are all equally legitimate and that no one needs to feel obliged to choose among them. We do want to understand what the work might have meant to its original intended users. But at the same time, we need to be aware that no one's intentions and self-understandings can exhaust the full significance of his actions and works. This is because, as these actions and works are seen in new contexts, they reveal new meanings. In particular, for obvious institutional reasons, we academic historians of the arts need to be periodically reminded that the third enterprise, that of the "critic," is equally worthwhile as, and very likely more necessary to the properly functioning vital culture than, the enterprises of the "historicist" and "reception historian." History is not all one does, or should do, with the arts. We want the arts to speak to us, not only observe how they spoke to others. (Recall Nietzsche's cautionary tale about the uses and abuses of history.) Gadamer reminds us that "the essential nature of the historical spirit does not consist in the restoration of the past, but in thoughtful mediation with contemporary life."[26] We have observed earlier how in literary studies, art history, and musicology the tide has recently turned against formalism because one wanted to return the arts

to the real world. A good cause this, but we should not stop here. Historicism, new and old, may easily become a technique for neutralizing the power of art, for keeping art at a safe distance from us. (I should add that in music, as in other performing arts, this may be equally true of historicism in critical and in performing practice.)

Moreover, I would want to claim further that the results reached by our "historicist" and "reception historian" are not even a necessary prerequisite for the work of our "critic." We historians have no right to impose on critics any limits concerning the contexts within which they might want to place the objects they interpret. Critics may be illuminating and persuasive even when they disregard the historicity of the artwork. (And in music, as in other performing arts, the same goes for the performer. Our language is wise to cover what critics and performers do by a single term, "interpretation.")

Finally, it should be clear that my position on this issue does not presuppose, naively, that we ever have an "immediate" access to artworks. All knowledge and understanding is contextual and hence mediated. All I claim is that an appropriate context for an artwork can be "ahistoricist" (without thereby being "ahistorical"), can be *ours* rather than *theirs*.

In sum, then, interpreters of the arts face a number of choices. First, we must decide whether what interests us are individual "utterances" or collective "languages" in which such utterances are made, individual actions or social practices. As often, the choice here cannot be absolute, because practices cannot be independent of the actions that constitute them, while actions make sense only within the context of appropriate practices. The choice is, rather, a matter of emphasis. Second, if we decide to concentrate on individual works, we would do well to begin with a close reading of them, with internal analysis as a prerequisite of a contextual interpretation. We can then decide whether the contexts that we would want to explore should be artistic, historical, or both. Third, we should decide whether we want to be primarily "historicists," "reception historians," or "critics," whether what interests us in the first place is the significance the interpreted work might have had for its author and original audience, or for subsequent audiences, or for us today.

b. Validity: Persuasion and Legitimacy

How do we know that the interpretation we have been offered is valid, how do we distinguish sense from nonsense in this area? There are currently at least two competing views on what constitutes a valid interpretation. There is what might be called the "foundationalist" view, according to which we evaluate an interpretation by comparing it with the interpreted object and seeing how truthfully the interpretation represents the object. And then there is what might be called the "pragmatic" view, according to which a good interpretation is simply the one that allows the interpreted object to do for us the job that we want it to do.[27]

The dispute over the validity of interpretation is clearly a part or rather a version of a larger dispute over the nature of knowledge and truth and I shall do no

more here than to paint its outlines with the broadest possible brush. For the foundationalists, knowledge is a matter of the relationship between propositions and objects these propositions are about. Truth for them is the correct representation or correspondence between the representing propositions and the represented object. Thus, also, a valid interpretation for them will be the one that represents the interpreted object truthfully. For the pragmatists, knowledge is a matter of the relationship between propositions and other propositions from which the former are inferred. Truth is not a matter of the causal relationship between an object and a proposition, but rather of the logical relationship between propositions. A proposition is true if we are justified in believing it, have good arguments in its favor, and our belief is justified when it allows us to get things to work for us. Thus, a valid interpretation for pragmatists is the one that allows us to use the interpreted object best.

The foundationalist worries that if we give up his picture of what constitutes knowledge we will stop checking our propositions against the objects they are about and thus lose all ability to distinguish true from untrue propositions. The pragmatist persuasively counters that checking propositions against objects is something we cannot do in any case, because we have no immediate access to objects; they are always already mediated by propositions, already interpreted. Note that the pragmatist is not saying that propositions are all there is, that there is no *hors-texte.* On the contrary, there are objects out there and we do react to stimuli we get from these objects by behaving in various ways—among others, by producing propositions that help us use these objects, get them to work for us. Thus, there is such a thing as a reality test. Some propositions allow us to use objects we want to use better than others. New stimuli will make us change our minds, change the propositions we think are worth asserting. But we cannot compare our propositions with the objects. We can only compare them with other propositions about the objects. Thus, validity claims of knowledge and, by the same token, of interpretation (since knowledge *is* interpretation), cannot be supported by independent checking of the sentences in which this interpretation is expressed against the interpreted object. They can be supported only by arguments that persuade the relevant community because they are internally coherent and because the propositions they result in help the community to use the interpreted objects as it wants to use them. Consequently, the foundationalist's worries that we might lose all ability to distinguish true from untrue propositions are unfounded.

The pragmatist's position on this issue is persuasive because it exposes a fatal weakness in the foundationalist view and because it does describe realistically what actually happens when we try to interpret and to validate our claims. Even the simplest act of interpretation is, precisely, an act. When we interpret, we are active rather than passive. The object does not come carrying its meaning on its sleeve. Meaning is created by the interpreter the way any scientific theory is fashioned, through the framing and testing of hypotheses. To be sure, the interpreter

works under the constraints imposed by the object. Depending on the circumstances, hypotheses to the effect that the object is a chair or a table may be falsified, or they may be provisionally accepted as true. But the object cannot turn out to be anything the interpreter wants it to be. It may be a chair in our world, but not in the world of giants. Thus, while it is true that the interpreter creates the meaning, it is equally true that the interpreted object imposes constraints and limits on the interpreter's freedom. All the same, there seem to be no limits to the interpreter's freedom to consider the object as belonging to a variety of worlds. And we have already seen that any object can be brought under a great many concepts even in a single—our—world. Our interpretation (whether "chair" or "table") will be provisionally accepted by the community it addresses (provisionally, that is, until a better interpretation is offered) because it is consistent with other relevant things we say in this case and because it allows the community to use the object effectively.

One might put the dispute between the foundationalist and the pragmatist into yet other terms and say that while the former wants the interpretations to be legitimate (that is, authorized by the founding interpreted object), the latter is quite satisfied when they are persuasive (that is, accepted by the addressed audience). Thus put, the contrast reveals a historical dimension. The foundationalist is at one with those premoderns who located the ultimate source of authority in the transcendent realm beyond our own messy everyday human world, the realm of Ideas, say, or the City of God. The pragmatist pushes forward the project of the Enlightenment which Kant has famously characterized as "man's release from his self-incurred tutelage."[28] A religious tradition, especially one that centers on the Truth revealed by God and fixed in the Book, needs the contrast between legitimate and illegitimate interpretation, because it needs to distinguish what God wants us to know from claims put forward by heretics and impostors. A view of the validity of artistic interpretation that considers this validity as legitimacy has clear roots in the Judeo-Christian tradition of scriptural interpretation and belongs with the Romantic takeover by art of the functions traditionally fulfilled by religion. But once art abandons religious pretensions of this sort (and I have explained in chapter 2 why I think it should abandon them once and for all), we might think that we no longer need to cling to the view of validity as legitimacy. We might think, that is, that all we secular moderns need are interpretations of art that persuade us because, like interpretations we provisionally accept in all other domains, science included, they are consistent with lots and lots of other beliefs we hold and they allow us to use the interpreted artworld as we want to use it, to amuse and to edify us. Again, we need not worry that this opens the door to all sorts of nonsense. There might be no illegitimate interpretations, but there would sure still be plenty of silly ones and we would not have to be persuaded by them.

But is it really true that "there are no illegitimate interpretations"? I do not think so and would like to argue now that the pragmatist position embraced here

can be consistent with a defense of carefully circumscribed notions of legitimacy and textual authority. What I will claim, in brief, is that there are certain kinds of interpretation that have to be legitimate in order to be really persuasive.

Recall that interpreters may want to accomplish a number of distinct tasks. They may want to analyze the internal structure of, and the relationships within, the text in order to elucidate its meaning. They may look for the significance of this meaning for the text's author and for his actual or intended original audience. They may look for its significance for subsequent audiences. They may, finally, look for its significance for us today. Distinctions of this sort have been carefully worked out in the hermeneutic theory of E. D. Hirsch, Jr.[29] Hirsch began by observing that most word sequences can represent more than one meaning (consider irony or allegory, whose presence alters the whole meaning without changing a single letter of the text[30]), and he went on to distinguish the meaning represented by the text and the significance of this meaning. The meaning of a sign sequence is determined by the person using it. Preferably, it is determined by its author, it is what the author meant by its use. Otherwise, the meaning would have to remain indeterminate and it would not be possible to distinguish valid from invalid interpretations. Significance arises when the meaning is placed in a relationship with anything we want to relate it to. Thus the meaning is inherently stable, while the significance is not.[31] Meaning is the object of interpretation, significance the object of criticism (in traditional hermeneutic terms, of *interpretatio* and *applicatio,* respectively).[32] This is not to say, however, that in interpreting we can avoid all context. The interpreter's understanding of the meaning is codetermined by the interpreted sign sequence and his expectations arising from his conception of the genre being used by the author. The interpreter makes an imaginative guess, frames a hypothesis, concerning the genre and follows it with critical testing that involves all the relevant knowledge available to him.[33] This is why the claims of the interpreter can be evaluated and criticized: he may have disregarded some relevant evidence, or his argument may be logically flawed.[34] Finally, the interpreter paraphrases the meaning in terms his audience will understand.[35]

In criticism as opposed to interpretation, that is, in the construction of significance rather than meaning, we are not bound by the author's or anyone else's will. We can relate the meaning of a sign sequence to anything we want to relate it to. But, and this is the crucial point in Hirsch's conception, criticism presupposes interpretation. We must first construct the meaning, or else we will not have anything that might be related to anything else, nothing that might have significance.[36]

While much of this is unexceptionable and agrees well with the picture of interpretation painted above, there are two controversial moves in Hirsch's hermeneutics. First, his equation of meaning with the original authorial meaning is not a logical necessity and it will be particularly disturbing to all those who proclaim the death of the author, though by no means only to them. It is not logically necessary because if the meaning of a sign sequence is determined

by the person using it, this person may be anyone at all, the interpreter, for instance, and not only the original user, the author. Hirsch's position, and one with which I am in sympathy, is that the identification of meaning with the original authorial meaning is not a matter of logical necessity, to be sure, but it is a matter of ethical courtesy. Hirsch points out that when we use someone else's words for purposes of our own and disregard his intentions, it is not much different from our using another person instrumentally, for our own purposes and in disregard of his own aims.[37] I would make a similar point somewhat differently: instead of using an author's words for our own purposes, we would be more honest to use our own words and not pretend that we are interpreting his. Richard Rorty thinks, correctly, that it is "a mistake to think of somebody's own account of his behavior or culture as epistemically privileged. . . . But it is *not* a mistake to think of it as morally privileged. We have a duty to listen to his account, not because he has privileged access to his own motives but because he is a human being like ourselves. . . . But civility is not a method, it is simply a virtue."[38] Elsewhere, Rorty makes a useful distinction between what he calls "methodical" and "inspired" readings, between knowing in advance what one wants to get out of a text and allowing the text to surprise one, to change one's purposes and life.[39] But if it is the latter kind of reading one prefers, listening to the author before one begins to listen to oneself would certainly be advisable. In any case, as Hirsch observes, when we interpret someone's speech in everyday communication we routinely identify the meaning with the author's, rather than our own, and there is no good reason why we should behave differently when interpreting written or literary texts.

But the appeal to authorial intention as the criterion of validity in interpretation can be easily misunderstood. Let me briefly consider the most important among the various objections raised by its opponents, the celebrated "intentional fallacy" argument formulated by W. K. Wimsatt and Monroe Beardsley in their classic 1946 paper.[40] The author's intention is irrelevant to the interpretation of the artwork, they claimed, because the meaning of a text resides in the meaning of the words used and in its syntax. The meaning of a sentence is not a matter of any individual's decision, but a matter of the social semantic and syntactic conventions of the community in the language of which the sentence has been uttered. I find these claims convincing, but see them as offering not so much a refutation as a way to refine Hirsch's picture.

One problem with this picture is that it seems to threaten infinite regress: in order to understand the text we appeal to the author's intention, but this is available, if at all, only as another text, which in turn requires an interpretation, and so on, *ad infinitum*. But let us recall also that, for Hirsch, the interpreter's understanding of the meaning is codetermined by the interpreted sign sequence and his expectations arising from his conception of the "genre" being used by the author. Thus the author's intention can be taken to pertain to the text not directly but only indirectly and to pertain directly to the "genres" (that is, the social conventions of language) he uses. In this case, we would look not so much

for the author's declarations concerning what his intentions were when he wrote the text, but for the evidence concerning the social conventions that an author of this kind was likely to deploy in a text of this sort. "The individual author" becomes now nothing more than "a member of this particular linguistic community." This does not make the author and his intention disappear completely. When interpreting a word in a text by Shakespeare we would still be bound by the appeal to authorial intention to choose a meaning current around 1600 rather than one that did not make its appearance until Jane Austen's time. But we would avoid the problem of infinite regress. And our position would be compatible with that of the authors of the intentional fallacy argument. (To be sure, we would agree with them that the interpreted Shakespearean text also makes sense when the meaning chosen for the troublesome word arose only in the nineteenth century. But we would side with Hirsch in saying that in that case we would be more honest not to pretend that the text we interpret is Shakespeare's.)

In short, the only way to save authorial intention as the criterion of validity in interpretation in the face of the intentional fallacy argument is to understand the authorial intention as pertaining directly only to the social conventions deployed in the text. We invoke "the author," understood not as "this concrete individual" but rather as "a member of this concrete community," to validate the interpretation of meaning when we claim that a member of this community would be likely (or unlikely) to use these rather than those social conventions when making a work of this kind. In other words, the limits on valid interpretation of meaning are established not by what the individual author wanted to say, but by the rules and constraints of the discursive practice within which the utterance has been made. Hirsch was right to look for a principle of validity in interpretation, but he mislocated this principle at the level of the individual action or utterance, instead of looking for it at the level of social practice or language. And perhaps even Hirsch would be ready to concede this point: after all, he starts his discussion with the author's intention, but by the time he introduces the notion of the "genre" it becomes likely that the author's intention is not directly about the meaning of the text, but about the "generic" conventions the author wishes to invoke and use.

This view of the matter, by the way, also allows us to invoke the author when the author is anonymous or collective. One might think, after all, that one argument against our considering authorial intention as the criterion of validity in interpretation is that we do understand texts by authors about whom we know nothing, or about whose authorial intentions we know nothing. But in fact it is never so that we know absolutely nothing about these things, and even when we know nothing for sure we make informed guesses. If we guess that the author of the interpreted text was likely to have been an eleventh-century monk, we shall not attribute to him meanings that might have been intended only by a seventeenth-century libertine.

Hirsch's second controversial move concerns his insistence that interpretation is a prerequisite for criticism, that we must construe the meaning before going

on to construe multiple significances of the text. To show why this is controversial, I shall again contrast Hirsch's position with another view of the matter. In a 1985 paper on "Texts and Lumps," Richard Rorty put forward a rigorously pragmatist view of interpretation.[41] There are several things we can do, several distinct aims we can pursue, when we interpret a text (or a "lump": Rorty persuasively argues that not only man, but *anything* is, for purposes of being inquired into, 'constituted' by a web of meanings," that science is no less "hermeneutical" than the humanities, that "explanation of fossils is no less holistic than the explanation of texts—in both cases one needs to bring the object into relation with many other different sort of objects in order to tell a coherent narrative which will incorporate the initial object"[42]). We may want to tell a story about (a) what the author would say in answer to questions about the text which were put in his own terms; or (b) what he would say in answer to questions put in terms that were not his own but that he had learned to understand; or (c) the text's role in someone's view of the development of its genre; or (d) its role in someone's view of something other than its genre. Rorty's first two tasks agree with the aims of "the interpretation of meaning" as understood by Hirsch, while the last two correspond to Hirsch's "criticism of significance." Where Rorty departs from Hirsch is in his claim that there is no hierarchy among the different levels of meaning, that none of the levels is a prerequisite for any other.

On closer inspection, this second controversy reveals its close kinship with the first one and may in fact be the very same controversy. Before we can place the interpreted text or object into any sort of context to examine its significance, we have to have the text or object itself, and since we can never have an object unmediated by some sort of interpretation, since objects are given us always already interpreted, we cannot bypass meaning on our way to significance. We can, as we have seen, ignore the authorial "generic" intentions (that is, the linguistic conventions of his community) and still get something meaningful. But the problem that arises when we do this is that then we have no answer to someone who objects: Why do you pretend that you are criticizing someone else's text, instead of admitting that you are criticizing a new text of your own?

Recall, however, the lesson of Merrill: we cannot get the author's meaning otherwise than by losing and finding it in translation. What follows is that the very distinction between meaning and significance, between understanding the text in the author's own terms and understanding it in our terms, is at best fuzzy and relative, a matter of approximation and emphasis, not of a clear-cut either-or choice. Much as we want to respect, somehow, the author's meaning, in actual interpretative practice we have to go back and forth between meaning and significance, between his terms and our own, rather than get first the former and only then the latter.

Note, by the way, that there is no contradiction between our siding in interpretive-critical practice with a drastically reinterpreted Hirsch (whose particular intentions I have rudely disregarded), that is, invoking the linguistic conventions of the author's community as the criterion of validity and politely trying to

interpret the author's meaning before moving on to criticizing significance, on the one hand, and our embrace of the radically pragmatic, Rortyan, understanding of interpretation, on the other. In other words, it may be that little of practical importance is at stake in our fundamental understanding of interpretation, in our making a choice between the foundationalist and pragmatic positions. We may have an incorrect, foundationalist, conception of the nature of interpretation and still practice interpretation successfully, and the reverse. Luckily, we may also without contradiction follow Rorty in theory and a revised Hirsch in practice.

EPILOGUE

THE POWER OF TASTE

> Blessed are those who possess taste, even though it be bad taste! —And
> not only blessed: one can be wise, too, only by virtue of this quality; which
> is why the Greeks, who were very subtle in such things, designated the
> wise man with a word that signifies the *man of taste,* and called wisdom,
> artistic and practical as well as theoretical and intellectual, simply 'taste'
> (*sophia*).
>
> Friedrich Nietzsche, *Human, All Too Human*

> It didn't require great character at all
> our refusal disagreement and resistance
> we had a shred of necessary courage
> but fundamentally it was a matter of taste
> Yes taste
> in which there are fibers of soul the cartilage of conscience
>
> Zbigniew Herbert, "The Power of Taste"

One advantage of doing what we have done in this book, finding out what art
is, or should be, for, is that this allows us to evaluate. We are now in a position
to know not only what the value of art in general is, but also to discuss and com-
pare the relative worth of individual artworks and artistic traditions. In brief,
since we know what the functions of art are, we can examine how well individ-
ual works and traditions perform their functions.

It is clear that the edifying function can serve as a criterion in evaluation and
so can the function of providing the interested, nonaesthetic pleasure. In both
cases, better art will make us wiser. But can we actually use disinterested aes-
thetic pleasure as a criterion in this way? Isn't it, rather, that, in this case, *de*

gustibus . . . ? The activity that produces the aesthetic pleasure, it will be recalled, is the disinterested contemplation of an object, disinterested in the sense that the pleasure is not attendant on a desire satisfied or purpose fulfilled and does not result in either desire or action. It is difficult to see how one could argue about any artwork that it is a more or less suitable object of such contemplation, a better or worse source of pleasure. The only approach that seems open here is to find out empirically how well or badly the artwork fulfills this function.

What prevents us from arguing about the relative success of an artwork as a source of pleasure, according to Kant, is a further, not yet discussed, feature of aesthetic pleasure. Aesthetic pleasure, Kant claimed, is subjective, that is, "conceived independently of any concept of the object."[1] "Now a representation, whereby an object is given, involves, in order that it may become a source of cognition at all, *imagination* for bringing together the manifold of intuition, and *understanding* for the unity of the concept uniting the representations."[2] But in the case of the beautiful object, "the cognitive powers brought into play by this representation are here engaged in a free play, since no definite concept restricts them to a particular rule of cognition."[3] In other words, in an act of cognition whereby we get to know an object, the cognitive powers of imagination (that synthesizes "the manifold of intuition" given by the senses into an entity) and understanding (that brings this entity under a concept) are engaged like two gear wheels. But in an act of aesthetic contemplation, the two wheels spin without engaging and the cognitive mechanism runs on idle, since the understanding insists on no particular concept and hence the object of contemplation is a pure "this" with no further definition. Aesthetic pleasure is "in the harmony of the cognitive faculties,"[4] in "the quickening of both faculties (imagination and understanding) to an indefinite, and yet, thanks to the given representation, harmonious activity."[5]

Now, and this is the crucial point, since we do not bring the contemplated object under any definite concept, we cannot know what the purpose or end of the object is ("an end is in general that, the *concept* of which may be regarded as the ground of the possibility of the object itself").[6] Consequently, we also cannot estimate how well or badly the object fulfills its purpose. Therefore, "there can be no objective rule of taste by which what is beautiful may be defined by means of concepts. For every judgement from that source is aesthetic, i.e. its determining ground is the feeling of the Subject, and not any concept of an Object."[7]

Once it is conceded that the aesthetic experience involves no application of concepts, it is, indeed, difficult to escape the conclusion that no rational argument about the relative merit of an object as the source of aesthetic pleasure is possible. Now, it may perhaps be the case that the pleasure afforded by flowers is as pure as this, without our bringing any specific concepts to bear on our experience and without our thinking about the flower's internal end. As Kant put it: "Hardly any one but a botanist knows the true nature of a flower, and even he, while recognizing in the flower the reproductive organ of the plant, pays no attention to this natural end when using his taste to judge its beauty. Hence

no perfection of any kind—no internal finality, as something to which the arrangement of the manifold is related—underlies this judgement."[8] Even here, I am not entirely persuaded. Don't we have to bring the manifold at least under the concept of "flower," if we are to enjoy it at all? Is it not likely that otherwise, without the pleasing thoughts and associations that the concept of "flower" carries for us, when encountered in a jungle rather than a garden, we might find it threatening or repulsive rather than beautiful? More to the point, even if the existence of aesthetic pleasure as pure as Kant would have it is conceded in certain cases, it is highly unlikely that the pleasures we derive from the practice of the arts are ever so pure.

To be sure, Kant's severe position is softened somewhat when he recognizes that "there are two kinds of beauty: free beauty (*pulchritudo vaga*), or beauty which is merely dependent (*pulchritudo adhaerens*). The first presupposes no concept of what the object should be; the second does presuppose such a concept and, with it, an answering perfection of the object."[9] The examples of the former are "flowers, . . . many birds, . . . a number of crustacea, . . . designs *à la grecque,* foliage for framework or on wall-papers, . . . [as well as] what in music are called fantasias (without a theme), and, indeed, all music that is not set to words."[10] The examples of the latter are "the beauty of man (including under this head that of a man, woman, or child), the beauty of a horse, or of a building (such as a church, palace, arsenal, or summer-house)."[11] What I want to suggest is that the beauty of art, instrumental music included, unlike perhaps that of nature, is dependent, rather than free.

The pleasures experienced by the lover of the arts are much closer to those enjoyed by the participant in, or spectator of, a game than to those of Kant's absentminded botanist. The analogy between the kind of pleasure that attends upon aesthetic contemplation and the kind that results from participating in a game is very close indeed (and has been much explored, by Gadamer, in particular).[12] To be sure, an art cannot be reduced to a game, or a game raised to the status of an art, because it cannot be said of games, as it can of art, that they produce fictive representations (here I part company with Gadamer). An athlete's body does not represent anything other than itself, although we may look at it with the eyes of a Leni Riefenstahl, take it the way we take an abstract artwork, the moving body of a dancer in an abstract dance, say, and interpret it to represent suppleness, grace, power. But even if games differ from art, the pleasures that games provide are just like aesthetic pleasure in that they also can be "disinterested." However, while disinterested, they are far from subjective.

One cannot derive much pleasure from a game, even as a spectator, if one has no idea of what its point is, no sense whatsoever of the goals the players are pursuing and the rules they are, implicitly or explicitly, obeying. A game of football or baseball, the source of intense enjoyment to the connoisseur, is a tedious bore to someone who looks at it as if it were an abstract dance. The pleasure a game gives is, therefore, not subjective in Kant's sense. It involves our bringing the contemplated spectacle under a complex concept such as "soccer game," a concept

one is able to use only when one understands the overall point of the game as well as the purposes of the multitude of actions the players undertake. In this case, the enjoyment involves bringing the contemplated object under a concept and hence knowing the purpose of the object. The net result is that we can estimate how well or badly the object fulfills its purpose and hence, as every sports amateur knows, we can argue rationally about the relative merits of a particular game. A game is played according to its traditional rules, whether they are explicitly formulated or not, and whether they are followed entirely consciously or not. It is played in a particularly satisfying fashion, when the players do more than simply follow and obey the rules, when, rather, they negotiate these rules in a singularly inventive and elegant way. (Moreover, we might even be able to argue about the relative merits of various kinds of games. A plausible hypothesis, subject to empirical verification or falsification, of course, might be that games of greater complexity, ones that require more skill from the participants or spectators, will be more amusing in the long run to those capable of mastering them.)

In this respect, the arts are very much like games. Also here, the pleasure is at the same time disinterested and objective, that is, it depends upon our getting the point of the practice, and hence, here, too, rational arguments about the relative worth of a particular work are possible on the basis of how well, or badly, the work serves as an object of pleasurable contemplation. A practice of an art forms a tradition with its own codes and rules, written or unwritten. Most relevantly, an artwork is never entirely *sui generis*. Rather, it is always a member of a family of works of its kind, a member of a genre, and a genre can be conceived of as a set of generic rules, rules for making art within this particular tradition, for playing this particular game, the game of portraiture, say, or of string quartet composition. This gives us the chance to engage in a rational argument with someone who denies that a given work provides aesthetic pleasure. We can begin by telling him this: "I, and others like you and me, have had much fun playing this game, and so might you, if you took the trouble to master it." Once he begins to master it, we might go on to point out features of a particular work to him that, when seen against the background of the generic rules, are singularly unusual, unexpected, original, and hence particularly amusing. It is one of the tasks of art criticism to draw attention to precisely those amusing features of the work, the ones that fulfill the generic rules of the game, or even extend the rules, in a particularly inventive and elegant way.

What this suggests is that effective arguments about the relative worth of an artwork, arguments that would want to use the work's relative ability to provide pleasure as the criterion of value, will have to consider the work in the context of other works of its kind. It follows that critical arguments of this sort cannot be conducted in a historical vacuum, that a persuasive critic will have to be able to identify the genre that forms the relevant context for the work, and will have to take the historical development of this genre, the tradition of making an art of this kind, into consideration. Only against the background of the tradition can one see the interesting and amusing features of the work.

The closely related functions of edification and of providing non-aesthetic pleasure make room for different, and considerably more complex, arguments about the value of individual artworks. It has been claimed here that an artworld consists of fictive representations and that one of the uses of such representations is to allow us to compare the actual world with the world as it might be and thus to make us consider ways we have not yet taken. Art produces experiences of actions and passions that might be subject to justification and thus offers examples for how we might, should, or should not, act and feel. Ultimately, it helps us to find out who we are and how we should cope. Clearly, if we want to argue about the worth of a work on the basis of how well it fulfills its edifying, as opposed to pleasure-giving, role, we would have to place the work in the context of life rather than art. To demonstrate the worth of a work, in this case, is to show how and why it may help us live better.

A work may help us live better lives, if the world it represents either discloses an essential truth about our world that has been hidden or obscured, or suggests fruitful ways of coping that have not been suggested before. Greek tragedy disclosed with unprecedented clarity something that not even Aristotle, let alone Plato, realized, namely that our highest values and aspirations cannot always be harmonized, that tragic conflicts between the likes of Antigone and Creon may be inescapable. An argument about its value would have to take the form of an argument about its truth, about whether the disclosure that conflicts between ultimate worldviews are inescapable is persuasive and whether it tells us something we need to know, whether we shall live better once we are equipped with this knowledge. Similarly, *The Tempest* and *The Marriage of Figaro* tell us something about the value of mercy and reconciliation. Arguments about their worth would have to show that we are better off knowing what they have to tell us. Our evaluation of *Die Meistersinger*, which embodies a vision of the kind of passion worth embracing and the kind of art worth cultivating, would necessarily involve, in part, our own views on these matters.

In short, we cannot evaluate a work unless we place it within a context. But when we evaluate a work for the aesthetic pleasure it gives, we may remain within the limits of the relevant artistic practice, of the genre and its development. When we evaluate a work for its edifying potential, we must move beyond the limits of art into the much broader context of life and we must bring our own ultimate convictions into play. Roger Scruton argues that "if there are to be standards of critical judgment, then they cannot be divorced from standards of practical reasoning generally. . . . To show what is bad in a sentimental work of art must involve showing what is bad in sentimentality. To be certain in matters of taste is, therefore, to be certain in matters of morality: ethics and aesthetics are one."[13]

Art, we have seen, teaches us how to listen to, and come into conversation with, others, total strangers even. It enlarges our cultural repertoire and it flexes our sympathy. It is thus perhaps the main tool of the kind of multiculturalism worth having, the one that encourages us to listen attentively to what others have to say, and especially to those voices that have not been heard before. What

emphatically does not follow is that all art, all cultures and works, are incommensurable and hence equally valuable, equally deserving of not only an initial hearing, but also our repeated attention.

Given the tremendously high volume of production and availability of cultural goods today, and given that our individual and collective time and resources are limited, we need to distinguish voices we want to hear again because they have something particularly arresting and important to say from those we ignore after the initial hearing because what they are saying is trivial. Discrimination of one sort or another is simply inescapable, and we all practice it whether we admit it or not. Discrimination is involved in a scholar's decision to study Rembrandt just as it is in someone's decision to devote attention to comic strips or slasher movies. The only reprehensible kind of discrimination is that which silences certain voices before they have been heard. The same goes for that other scary word, elitism: our well-justified abhorrence of all forms of inherited privilege does not, and should not, entail the denial that hierarchies among cultural achievements are possible.

The refusal to discriminate among the voices one hears, to compare and evaluate them, is not only a practical impossibility, it is also wrong for deeper reasons. It is a form of aestheticist detachment whereby we allow the voices that we hear to entertain us, but not to challenge our most fundamental assumptions and thereby to change our lives. To engage in a genuine dialogue with others involves more than just politely listening to them. It involves comparing their views with other views, including our own. There can be no dialogue if we assume the superiority of either side, or if we assume that all views have equal validity; in both cases the possibility of anyone changing his mind, and life, is precluded in advance and all that remains is idle talk, amusing at best, but a source of neither genuine pleasure nor edification.

Incommensurability, the inability to measure values with precision, is one thing, incomparability is another and does not necessarily follow from the former. It is, of course, true that we cannot measure the relative rank of artworks, or artistic traditions, with any precision. But it is equally true, and I hope it has been demonstrated above, that we can argue about the value of artworks. If we can do this, it means that we can also compare artworks, as well as the artistic traditions from which they emerge, with one another and find some more worthy of our repeated attention than others. Such comparisons will not yield precise, measurable results, and they will certainly not yield stable, immutable, and incontestable canons. But they will allow us to claim, and to support our claims with rational arguments, that some works are comparable, that is, are in the same league, while others do not quite make it, and they will allow us to form ad hoc, flexible, constantly revisable canons. And these are the only results we need, if we want to separate the art that gives us pleasure and enriches our lives in an enduring fashion from the art that is comparatively trivial and ephemeral. The "cultivation of the universality of thought is the absolute value of *education*,"

says Hegel.[14] When "culture" is understood not in the sense given this term by anthropologists and identity politicians, that is, as an affirmation of a distinctive group identity, but rather in the opposite sense given to it by the Enlightenment and fully articulated by Hegel, namely, as the transcendence of narrow group identity through the formation of character and the education to a *relatively* and *comparatively* (key words) more universal, rational, and free point of view, comparisons are not only possible, but required. The greatest traditions and works are those that make the greatest contribution to culture in this enlightened sense, culture which makes us freer instead of imprisoning us in tribal prejudices, and whose aspiration to universality still resonates in the name of its chief custodial institution, the university.

There are, however, serious, nontrivial reasons why suspicion of the comparative evaluation runs so deep today. A liberal and egalitarian society is justifiably leery of the discrimination and elitism we associate with the aristocratic societies of the past. Liberals, in particular, argue that the state should keep out of the business of evaluating, that each individual and each group is entitled to their subculture with its associated tastes as long as they do not harm other individuals and groups, and that the role of the state should be limited to ensuring fair treatment of all individuals and groups. This is also my view. But what emphatically does not follow is that not only the state, but also individuals and groups should avoid comparative evaluating. The neutral state, separated from church and culture, can very well coexist with, and accommodate, lively debates over moral and aesthetic values as long as it does not produce and enforce the results. There is simply no good reason to assume that vulgarity and trashiness is the inescapable fate of art produced by modern, liberal and egalitarian societies. One should expect instead that these societies will witness vigorous competition over the sources of support for artistic practices and institutions that serve the whole spectrum of tastes, including the most demanding ones. Morally and politically, it makes no sense today to hanker nostalgically after the aristocratic culture of the past. It makes perfect sense, however, to make sure that art of the highest quality can also survive and flourish under modern conditions. Needless to say, democratic societies will produce lots and lots of artistic junk. They produce lots of gadgets of dubious quality too. But this makes discrimination all the more necessary. We discriminate when buying cars. Why should we not do the same when deciding which artistic institutions to support, or which books to read?

Over a hundred years ago, our ancestors (Dostoevsky, Nietzsche) used to call the refusal to discriminate, the rejection of all distinctions in value, by the name of "nihilism." We prefer to call it, despairingly or approvingly, "postmodernism." While a modernist myself, I see no reason to despair, because I do not believe that the habit of making distinctions of value is really likely to disappear. I have already explained why I think we cannot help discriminating whether we want to or not. I can only add that we should want to. If we lost the habit of

distinguishing moral good from evil, we would become quite defenseless in the face of evil. Aesthetic values are not identical with moral or political ones, but, as I have argued at length in this book, they are continuous with them. The making of distinctions when evaluating art is a good habit to have, as it supports and trains the other necessary habit, that of making moral distinctions.

It might be objected here that my favoring the enduring over the ephemeral bespeaks a classicist rather than modernist taste and thus ill befits modern art. Modernist temper is attuned to the ephemeral, as Baudelaire well knew, since he defined modernity as "the transient, the fleeting, the contingent."[15] It is the temper of the modern capitalist market, stimulating the appetite for the new and thus promoting obsolescence and consumption. (To be sure, even Baudelaire thought that the artist's aim was "to distill the eternal from the transitory."[16] Indeed, what constitutes the greatness of a painter like Manet is in part the ability to see the timeless in the ephemeral, a Venus in a modern courtesan. And it would be a mistake to suppose that only a modern artist can do this: recall how the biblical pastorals of Jacopo Bassano suffuse everyday profane reality with sacred significance.) Nevertheless, I believe that my classicist position is more than merely a case of unthinking traditionalism and can be defended within the context of my general argument. Recall Hegel's warning, discussed at length at the end of chapter 3, that we moderns are in danger of loving our right to subjective freedom so much that we might fail to make it objective in the only way in which freedom can be made objective, by making a commitment to particular aims. The danger inherent in the modernist taste for the ephemeral is precisely that it favors uncommitted "absolute" freedom and hence ultimately a meaningless and empty existence. Even Baudelaire, we have just seen, wanted more than a simple celebration of the ephemeral, wanted to distill the eternal from the transitory. In this sense, modernism needs to be leavened with classicism for the same reasons for which freedom needs to be situated and committed.

The modernist sensibility can create a Parisian *passage* or an American shopping mall, but it cannot make a home. We need to have a home, because only the context of a home can give meaning to our most fundamental experiences, to birth, love, suffering, death. We can be truly at home only in what endures, because only that can we leave and come back to. Moreover, only what can be home can be beautiful for us; beauty *is* what we can call home. The myriad fleeting impressions received by a *flâneur* in a great modern city are one of the genuine pleasures of life today, but they are pleasures accessible only to those who are at home somewhere: the homeless are not *flâneurs*.

We need a home, but we also need to be able to get out: home nurtures us, but it can also be stifling. What we need is to have it both ways. Just as we demand both the right to subjective freedom and the duty to make this freedom objective, so we need both the richness and flexibility of the ephemeral and the meaningful reassurance of the enduring. We moderns cannot afford to be one-sided here. The difficulty lies in getting the balance between the two sides right.

At the outset of his *Lectures on Fine Art,* Hegel announced:

Now, in this its freedom alone is fine art truly art, and it only fulfills its supreme task when it has placed itself in the same sphere as religion and philosophy, and when it is simply one way of bringing to our minds and expressing the *Divine,* the deepest interests of mankind, and the most comprehensive truths of the spirit. In works of art the nations have deposited their richest inner intuition and ideas, and art is often the key, and in many nations the sole key, to understanding their philosophy and religion. Art shares this vocation with religion and philosophy, but in a special way, namely by displaying even the highest [reality] sensuously, bringing it thereby to the senses, to feeling, and to nature's mode of appearance.[17]

It will not be a secret to the reader of this book that I share a vision of art as capable of giving sensuous embodiment and representation to our most profound needs and concerns. But being capable of such a task is one thing, realizing it is another. Art "fulfills its supreme task" only occasionally, and it is the job of the critic to distinguish these rare occasions from the more common ones and to celebrate them, just as it is the job of the critical historian to interpret them.

NOTES

Preface

1. Czesław Miłosz, "Baśń," *Piesek przydrożny* (Cracow: Znak, 1997), p. 223.
2. Primo Levi, *Survival in Auschwitz and The Reawakening. Two Memoirs,* trans. Stuart Woolf (New York: Summit Books, 1985), p. 113. See also Primo Levi, *The Drowned and the Saved,* trans. Raymond Rosenthal (New York: Summit Books, 1988), pp. 139–40. The recollected lines come from Dante's *Inferno,* canto XXVI.118–20, trans. Charles S. Singleton.
3. Levi, *The Drowned and the Saved,* p. 139.
4. Arthur C. Danto, *After the End of Art: Contemporary Art and the Pale of History* (Princeton, N.J.: Princeton University Press, 1997), p. 35.
5. The debate, which has been raging since 1991, has been recently summarized and developed further in Yves Michaud, *La crise de l'art contemporain: Utopie, démocratie et comédie* (Paris: Presses Universitaires de France, 1997). See also Jean Clair, *La responsabilité de l'artiste: Les avant-gardes entre terreur et raison* (Paris: Gallimard, 1997). On the margin of the debate, but with some distance the most substantial contribution to it thus far, is Marc Fumaroli, *L'État culturel: une religion moderne* (Paris: Éditions de Fallois, 1992).

Prologue

1. St. Augustine, *Confessions,* trans. W. Watts, bk. 11, ch. 14.
2. Ludwig Wittgenstein, *Philosophical Investigations* (London: Macmillan, 1953), I.67.
3. Norbert Elias, *Mozart: Portrait of a Genius,* trans. Edmund Jephcott (Cambridge, Mass.: Polity Press, 1993).
4. Cf. Wolfgang Welsch, *Unsere postmoderne Moderne* (Weinheim: Acta humaniora, 1987).
5. Jean-François Lyotard, *The Postmodern Condition: A Report on Knowledge,* Theory and History of Literature 10 (Minneapolis: University of Minnesota Press, 1984).
6. Charles Taylor, "Interpretation and the Sciences of Man," in *Philosophy and the Human Sciences. Philosophical Papers 2* (Cambridge: Cambridge University Press, 1985), p. 53.

7. Martha Woodmansee, *The Author, Art, and the Market: Rereading the History of Aesthetics* (New York: Columbia University Press, 1994).

8. Pierre Bourdieu, *Distinction: A Social Critique of the Judgement of Taste,* trans. Richard Nice (Cambridge: Harvard University Press, 1984).

9. Pascal, *Pensées,* no. 95 (ed. Lafuma) or no. 316 (ed. Brunschvicg), trans. Honor Levi (Oxford: Oxford University Press, 1995), p. 54.

10. Charles Taylor, "Social Theory as Practice," in *Philosophy and the Human Sciences,* pp. 93–111.

11. Alasdair MacIntyre, *After Virtue: A Study in Moral Theory,* 2d ed. (Notre Dame, Ind.: University of Notre Dame Press, 1984), p. 222.

Chapter 1

1. Giovanni Pico della Mirandola, "Oration on the Dignity of Man," trans. Elizabeth Livermore Forbes, in Ernst Cassirer, Paul Oskar Kristeller, and John Herman Randall, Jr., eds., *The Renaissance Philosophy of Man* (Chicago: The University of Chicago Press, 1948), pp. 224–25.

2. Plato, *Republic,* bk. 9, 578c, trans. Paul Shorey.

3. Johann Gottfried Herder, *Essay on the Origin of Language,* trans. Alexander Gode, in Jean-Jacques Rousseau and J.G.Herder, *On the Origin of Language* (Chicago: The University of Chicago Press, 1966), pp. 85–166.

4. Friedrich Nietzsche, *On the Advantage and Disadvantage of History for Life,* § 1, trans. Peter Preuss (Indianapolis: Hackett, 1980), pp. 8–9.

5. Martin Heidegger, "The Origin of the Work of Art," in *Poetry, Language, Thought* (New York: Harper & Row, 1971), p. 44.

6. Two recent essays stress the role of the imaginary in eating and in eroticism, respectively: Leon R. Kass, *The Hungry Soul: Eating and the Perfecting of Our Nature* (New York: Free Press, 1994), and Octavio Paz, *The Double Flame: Love and Eroticism,* trans. Helen Lane (New York: Harcourt Brace, 1995).

7. Sébastein Roch Nicolas Chamfort, *Products of the Perfected Civilization: Selected Writings,* trans. W. S. Merwin (London: Macmillan, 1969), p. 170.

8. The latter seems to be the case of the Chinese art of writing. According to Simon Leys, the appreciation of this art "does not reside in a literary appreciation of the contents, but in an imaginative communion with the dynamics of the brushwork; what the viewer needs is not to read a text, but to retrace in his mind the original dance of the brush and to relive its rhythmic progress." Simon Leys, "One More Art," *The New York Review of Books* 43/7 (April 18, 1996), 28.

9. Michel Foucault, *The Order of Things: An Archeology of the Human Sciences* (New York: Random House, 1970).

10. Charles Baudelaire, "Richard Wagner and *Tannhäuser* in Paris," in *Selected Writings on Art and Artists,* trans. P. E. Charvet (Harmondsworth: Penguin Books, 1972), pp. 330–31.

11. Arthur C. Danto, *Beyond the Brillo Box: The Visual Arts in Post-Historical Perspective* (New York: Farrar, Straus and Giroux, 1992), pp. 5–6.

12. Danto, *Beyond the Brillo Box,* pp. 39–40.

13. Hans-Georg Gadamer, *Truth and Method* (New York: Continuum, 1975), p. 141.

14. Heidegger, "The Origin of the Work of Art," in *Poetry, Language, Thought,* pp. 32–37.

15. Note, however, that not everyone will find even this example convincing. Danto, commenting on the struggle of contemporary artists to achieve a flat surface, writes: "while nothing seemed easier—the surfaces *were* flat—the task was impossible in that, however evenly paint was applied, the result was a piece of pictorial depth of an

indeterminate extension." Arthur C. Danto, *The Transfiguration of the Commonplace: A Philosophy of Art* (Cambridge: Harvard University Press, 1981), p. 87.

16. As quoted in Sandra LaWall Lipshultz, *Selected Works. The Minneapolis Institute of Arts* (Minneapolis: The Minneapolis Institute of Arts, 1988), pp. 220–21, where the painting is reproduced.

17. Richard Wollheim, *Painting as an Art* (Princeton: Princeton University Press, 1987), pp. 46, 62. Wollheim's argument is developed in Kendall L. Walton, *Mimesis as Make-Believe: On the Foundations of the Representational Arts* (Cambridge: Harvard University Press, 1990), pp. 55–56.

18. See Anthony Blunt, *Artistic Theory in Italy 1450–1600* (Oxford: Oxford University Press, 1962), pp. 53–55.

19. Alain Corbin, *The Foul and the Fragrant: Odor and the French Social Imagination* (Cambridge: Harvard University Press, 1986); Corbin, *Les cloches de la terre: paysage sonore et culture sensible dans les campagnes au XIX^e siècle* (Paris: A. Michel, 1994); Reinhard Strohm, *Music in Late Medieval Bruges* (Oxford: Clarendon Press, 1985).

20. E. H. Gombrich, *Art and Illusion: A Study in the Psychology of Pictorial Representation,* 2d ed. (Princeton: Princeton University Press, 1961), p. 281.

21. E. H. Gombrich, *The Sense of Order: A Study in the Psychology of Decorative Art* (Ithaca: Cornell University Press, 1979), p. 302.

22. For arguments to the effect that musical motion and time are semblances, see, among others, Susanne K. Langer, *Feeling and Form: A Theory of Art* (New York: Charles Scribner's Sons, 1953), pp. 107–18. More recently, Roger Scruton has repeatedly emphasized that musical motion is imaginary and that its description must necessarily involve the use of metaphor. See Roger Scruton, *The Aesthetics of Architecture* (Princeton: Princeton University Press, 1979), pp. 82–84; "Understanding Music," in *The Aesthetic Understanding* (London: Methuen, 1983), pp. 77–100; "Analytic Philosophy and the Meaning of Music," in R. Shusterman, ed., *Analytic Aesthetics* (Oxford: Basil Blackwell, 1989), pp. 85–96; and especially *The Aesthetics of Music* (Oxford: Clarendon Press, 1997), pp. 1–96. For Scruton, however, "movement and boundary are . . . intrinsic to the musical experience, and not peculiar to tonal music." (*The Aesthetics of Music,* p. 54). On the other hand, he does recognize that "the interest of more recent experiments in atonality often resides in novel sonorities, organized in ways which do not permit the experience of musical movement. Music then retreats from the intentional to the material realm." (*Ibid.,* p. 281).

23. Eduard Hanslick, *On the Musically Beautiful: A Contribution towards the Revision of the Aesthetics of Music,* trans. Geoffrey Payzant (Indianapolis: Hackett, 1986), pp. 29 and 93.

24. Langer, *Feeling and Form,* p. 109.

25. Langer, *Feeling and Form,* p. 125.

26. Roman Ingarden, *The Work of Music and the Problem of Its Identity* (Berkeley: University of California Press, 1986), pp. 77–78.

27. Cf. Fred Lerdahl, "Cognitive Constraints on Compositional Systems," in John A. Sloboda, ed., *Generative Processes in Music: The Psychology of Performance, Improvisation, and Compostion* (Oxford: Clarendon Press, 1988), pp. 231–59.

28. Søren Kierkegaard, *Either/Or,* ed. and trans. H. V. Hong and E. H. Hong, vol. 1 (Princeton: Princeton University Press, 1987), p. 64.

29. Arthur Schopenhauer, *The World as Will and Representation,* trans. E. F. J. Payne, vol. 1 (New York: Dover, 1966), § 52, p. 256.

30. Schopenhauer, *The World as Will and Representation,* vol. 1, § 52, p. 257.

31. Schopenhauer, *The World as Will and Representation,* vol. 1, § 52, p. 260.

32. G. W. F. Hegel, *Aesthetics: Lectures on Fine Art,* trans. T. M. Knox, 2 vols. (Oxford: Oxford University Press, 1975), p. 626.
33. Hegel, *Aesthetics,* p. 891.
34. Hanslick, *On the Musically Beautiful,* p. 50.
35. Immanuel Kant, *The Critique of Judgement,* trans. J. C. Meredith (Oxford: Oxford University Press, 1952), 330, p. 196.
36. Aristotle, *Politics,* bk. 8, ch. 5, 1340a-b, trans. Benjamin Jowett.
37. Plato, *Republic,* bk. 3, 401d, trans. Paul Shorey.
38. Hanslick, *On the Musically Beautiful,* p. 54.
39. Hanslick, *On the Musically Beautiful,* p. 54.
40. Friedrich Nietzsche, *Twilight of the Idols,* in *The Portable Nietzsche,* ed. and trans. W. Kaufmann (New York: Viking, 1954), p. 520.
41. *Firenze e dintorni,* Guida d'Italia del Touring Club Italiano, 6th ed. (Milan: T.C.I., 1974), p. 320.
42. Isaiah Berlin, *Personal Impressions* (New York: Viking, 1981), p. 193.
43. Hegel, *Aesthetics,* pp. 88–89.
44. Hegel, *Aesthetics,* p. 964.
45. Hegel, *Aesthetics,* p. 967.
46. The classic phenomenological study where this point is argued is Jean-Paul Sartre, *The Psychology of Imagination* (Secaucus, N. J.: The Citadel Press, n.d.), a translation of his *L'Imaginaire* (Paris: Gallimard, 1940). On the side of the analytical tradition, see in particular Roger Scruton, *Art and Imagination: A Study in the Philosophy of Mind* (London: Methuen, 1974).
47. Plato, *Sophist,* 263e, trans. Francis Macdonald Cornford, in E. Hamilton and H. Cairns, eds., *The Collected Dialogues* (Princeton: Princeton University Press, 1961), p. 1011.
48. See Steven Pinker, *The Language Instinct* (New York: HarperPerennial, 1995), pp. 55–82.
49. Jacques Derrida, *Of Grammatology,* trans. Gayatri Chakravorty Spivak (Baltimore: Johns Hopkins University Press, 1976), p. 7.
50. Derrida, *Of Grammatology,* p. 73.
51. Derrida, *Of Grammatology,* p. 11.
52. Derrida, *Of Grammatology,* p. 12.
53. Derrida, *Of Grammatology,* p. 18.
54. Jean-Jacques Rousseau, *Essay on the Origin of Languages,* trans. John H. Moran (Chicago: The University of Chicago Press, 1966), ch. 5, pp. 21–22.
55. Aristotle, *Poetics,* ch. 6, 1450b17–20, trans. Ingram Bywater.
56. Georg Wilhelm Friedrich Hegel, *Philosophy of Mind. Being Part Three of the Encyclopaedia of the Philosophical Sciences (1830),* § 458, trans. William Wallace and A. V. Miller (Oxford: Oxford University Press, 1971), p. 213.
57. Aristotle, *Politics,* bk. 1, ch. 2, 1253a, trans. Benjamin Jowett.
58. Ludwig Wittgenstein, *Tractatus logico-philosophicus,* 7, trans. D. F. Pears and B. F. McGuinness (London: Routledge & Kegan Paul, 1961), pp. 150–51.
59. Aristotle, *On the Soul,* 429a, trans. J. A. Smith.
60. Gadamer, *Truth and Method,* pp. 362–63.
61. Kant, *The Critique of Judgement,* 328, p. 194.
62. Hegel, *Philosophy of Mind,* § 459, pp. 213–14.
63. Hegel, *Philosophy of Mind,* § 459, p. 215.
64. See the excellent discussion in Pinker, *The Language Instinct,* pp. 189–91, from whom the example is taken.
65. Pinker, *The Language Instinct,* p. 191.

66. Recent examples of this literature are discussed in Lydia Goehr, *The Imaginary Museum of Musical Works: An Essay in the Philosophy of Music* (Oxford: Clarendon Press, 1992).

67. Gadamer, *Truth and Method,* p. 130.

68. Walter Benjamin, "The Work of Art in the Age of Mechanical Reproduction," in *Illuminations* (New York: Schocken Books, 1969), pp. 217–51.

69. St. Augustine, *Confessions,* bk. 6, ch. 3, trans. William Watts.

70. Seymour Chatman distinguished three "text-types," narrative, description, and argument, in his "Narrative and Two Other Text-Types," in *Coming to Terms: The Rhetoric of Narrative in Fiction and Film* (Ithaca: Cornell University Press, 1990), pp. 6–21. My distinction parallels Chatman's to the extent that my "representations" embrace both his "narratives" and "descriptions," while our "arguments" correspond with one another. The difference between our conceptions is that what for Chatman are "text-types" are for me "world-types."

71. Benedetto Croce, *Aesthetic as Science of Expression and General Linguistic,* trans. Douglas Ainslie, rev. ed. (London: Macmillan & Co., 1922), p. 31.

72. According to Arthur C. Danto, in *After the End of Art: Contemporary Art and the Pale of History* (Princeton: Princeton University Press, 1997), p. 18, n. 5, the first one thus to characterize Hegel's book was Josiah Royce.

73. Richard Rorty, "Is Derrida a Transcendental Philosopher?," in *Essays on Heidegger and Others. Philosophical Papers,* vol. 2 (Cambridge: Cambridge University Press, 1991), p. 123.

74. Aristotle, *On the Soul,* bk. 3, ch. 7, 431a, trans. J. A. Smith.

75. Aristotle, *On the Soul,* bk. 3, ch. 7, 431b, trans. J. A. Smith.

76. Croce, *Aesthetic as Science of Expression and General Linguistic,* p. 22.

77. Marcel Proust, *The Guermantes Way, Remembrance of Things Past,* trans. C. K. Scott Moncrieff, vol. 1 (New York: Random House, 1934), p. 1107.

Chapter 2

1. G. W. F. Hegel, *Elements of the Philosophy of Right,* ed. Allen W. Wood, trans. H. B. Nisbet (Cambridge: Cambridge University Press, 1991), § 4, p. 35.

2. G. W. F. Hegel, *Lectures on the Philosophy of World History. Introduction: Reason in History,* trans. H. B. Nisbet (Cambridge: Cambridge University Press, 1975), p. 47.

3. Isaiah Berlin, "Historical Inevitability," in *Four Essays on Liberty* (Oxford: Oxford University Press, 1969), pp. 70–73.

4. Jean-Jacques Rousseau, "Profession of Faith of the Savoyard Vicar," *Emile or On Education,* bk. 4, trans. Allan Bloom (New York: Basic Books, 1979), p. 272.

5. See Hans-Georg Gadamer, *Truth and Method* (New York: Continuum, 1975); Alasdair MacIntyre, *After Virtue: A Study in Moral Theory,* 2d ed. (Notre Dame, Ind.: University of Notre Dame Press, 1984); Martha C. Nussbaum, *Love's Knowledge: Essays on Philosophy and Literature* (New York: Oxford University Press, 1990); and Roger Scruton, *The Aesthetic Understanding* (London: Methuen, 1983).

6. Aristotle, *Nicomachean Ethics,* bk. 3, ch. 1, 1109b, trans. W. D. Ross.

7. Aristotle, *Nicomachean Ethics,* bk. 3, ch. 2, 1112a, trans. W. D. Ross.

8. Aristotle, *Nicomachean Ethics,* bk. 6, ch. 2, 1139a, trans. W. D. Ross.

9. Aristotle, *Nicomachean Ethics,* bk. 2, ch. 1, 1103a, trans. W. D. Ross.

10. Aristotle, *Nicomachean Ethics,* bk. 2, ch. 1, 1103b, trans. W. D. Ross.

11. Aristotle, *Nicomachean Ethics,* bk. 2, ch. 3, 1104b, trans. W. D. Ross.

12. Aristotle, *Nicomachean Ethics,* bk. 2, ch. 4, 1105b, trans. W. D. Ross.

13. MacIntyre, *After Virtue,* pp. 161–62.

14. Rousseau, "Profession of Faith," p. 286.
15. Rousseau, "Profession of Faith," p. 289.
16. Rousseau, "Profession of Faith," p. 294.
17. Colin McGinn, *Ethics, Evil, and Fiction* (Oxford: Clarendon Press, 1997), pp. 7–60.
18. McGinn, *Ethics, Evil, and Fiction,* p. 39.
19. McGinn, *Ethics, Evil, and Fiction,* p. 49.
20. McGinn, *Ethics, Evil, and Fiction,* p. 50.
21. Hegel's critique of Kant, together with the rest of his mature ethical and political philosophy, can be found in his 1821 *Elements of the Philosophy of Right.* For an excellent recent commentary, see Allen W. Wood, *Hegel's Ethical Thought* (Cambridge: Cambridge University Press, 1990).
22. Quoted in Gordon A. Craig, "How Hell Worked," *The New York Review of Books* 43/7 (April 18, 1996), 7.
23. Hegel, *Elements of the Philosophy of Right,* § 135, pp. 162–63.
24. Hegel, *Elements of the Philosophy of Right,* § 138, pp. 166–67.
25. Charles Taylor, *Sources of the Self: The Making of the Modern Identity* (Cambridge: Harvard University Press, 1989), p. 72.
26. MacIntyre, *After Virtue,* p. 222.
27. Friedrich Nietzsche, *On the Genealogy of Morals*, in *Basic Writings of Nietzsche,* ed. and trans. W. Kaufmann (New York: Modern Library, 1968), p. 555.
28. Alexis de Tocqueville, *Democracy in America,* ed. J. P. Mayer, trans. George Lawrence (Garden City, N.Y.: Anchor Books, 1969), pp. 493–95.
29. Isaiah Berlin, "The Concept of Scientific History," in *Concepts and Categories: Philosophical Essays* (New York: Penguin, 1981), p. 132.
30. Benedetto Croce, *Aesthetic as Science of Expression and General Linguistic,* trans. Douglas Ainslie, rev. ed. (London: Macmillan & Co., 1922), p. 26.
31. Plato, *Republic,* 377b, trans. Paul Shorey.
32. Aristotle, *Politics,* bk. 8, ch. 5, 1340a, trans. Benjamin Jowett.
33. Roger Scruton, *Art and Imagination: A Study in the Philosophy of Mind* (London: Methuen, 1974), p. 131.
34. Paul Ricoeur, *Time and Narrative,* vol. 1 (Chicago: The University of Chicago Press, 1984), p. 59. See also Ricoeur, *Oneself as Another,* trans. Kathleen Blamey (Chicago: The University of Chicago Press, 1992), p. 115.
35. Stendhal, *On Love* (New York: Universal Library, 1967), bk. 1, ch. 17, p. 44, n. 1. See Charles Baudelaire, "The Painter of Modern Life," in *Selected Writings on Art and Artists,* trans. P. E. Charvet (Harmondsworth: Penguin Books, 1972), p. 393; and Friedrich Nietzsche, *On the Genealogy of Morals*, in *Basic Writings of Nietzsche,* ed. and trans. W. Kaufmann (New York: Modern Library, 1968), p. 540.
36. Péter Nádas, *A Book of Memories,* trans. Ivan Sanders with Imre Goldstein (New York: Farrar, Straus and Giroux, 1997), p. 103.
37. Baudelaire, "The Painter of Modern Life," p. 402.
38. Aristotle, *Poetics,* ch. 9, 1451b1–11, trans. Ingram Bywater.
39. Martin Heidegger, "Letter on Humanism," in *Basic Writings* (New York: Harper & Row, 1977), p. 240.
40. G. W. F. Hegel, *Aesthetics. Lectures on Fine Art,* trans. T. M. Knox, 2 vols. (Oxford: Oxford University Press, 1975), p. 9. See also pp. 993–94.
41. Hegel, *Aesthetics,* p. 866.
42. Shakespeare, *Hamlet,* act 3, scene 2.
43. Richard Rorty, "Heidegger, Kundera, and Dickens," *Essays on Heidegger and Others. Philosophical Papers,* vol. 2 (Cambridge: Cambridge University Press, 1991), pp. 76–77.

44. MacIntyre, *After Virtue,* pp. 181–225.
45. MacIntyre, *After Virtue,* p. 191.
46. Aristotle, *Nicomachean Ethics,* bk. 2, ch. 1, 1103a32–5, trans. W. D. Ross.
47. Max Weber, "Science as a Vocation," in H. H. Gerth and C. Wright Mills, eds., *From Max Weber: Essays in Sociology* (New York: Oxford University Press, 1946), p. 147.
48. For a persuasive recent statement of this essentially Hegelian vision of the proper relationship between social theory and practice, already invoked in the prologue, see Charles Taylor, "Social Theory as Practice," in *Philosophy and the Human Sciences. Philosophical Papers 2* (Cambridge: Cambridge University Press, 1985), pp. 91–115.
49. Hegel, *Aesthetics,* p. 11.
50. Hegel, *Aesthetics,* pp. 9f.
51. Hegel, *Aesthetics,* p. 10.
52. Hegel, *Aesthetics,* p. 182.
53. Hegel, *Aesthetics,* p. 193.
54. Hegel, *Aesthetics,* p. 194.
55. Gadamer, *Truth and Method,* p. 23.
56. Gadamer, *Truth and Method,* pp. 29–30.
57. Gadamer, *Truth and Method,* pp. 36–37.
58. Martha C. Nussbaum, *Poetic Justice: The Literary Imagination and Public Life* (Boston: Beacon Press, 1995), p. 12.
59. Roger Scruton, *The Aesthetics of Architecture* (Princeton: Princeton University Press, 1979), p. 243.
60. For a summary and development of many of these arguments, see David Carr, *Time, Narrative, and History* (Bloomington: Indiana University Press, 1986). See also Ricoeur, *Oneself as Another.*
61. Taylor, *Sources of the Self,* p. 47.
62. Richard Rorty, "Postmodernist bourgeois liberalism," in *Objectivity, Relativism, and Truth. Philosophical Papers,* vol. 1 (Cambridge: Cambridge University Press, 1991), p. 200.
63. Friedrich Nietzsche, *The Birth of Tragedy,* in *The Basic Writings of Nietzsche,* trans. and ed. W. Kaufmann (New York: Modern Library, 1968), p. 135.
64. Richard Rorty, "Inquiry as Recontextualization: An Anti-dualist Account of Interpretation," in *Objectivity, Relativism, and Truth,* p. 110.
65. Taylor, *Sources of the Self,* p. 22.
66. Hegel, *Aesthetics,* p. 576.
67. Hegel, *Aesthetics,* p. 602.
68. Hegel, *Aesthetics,* pp. 607–8.
69. Tocqueville, *Democracy in America,* p. 487.
70. Arthur C. Danto, *The Transfiguration of the Commonplace: A Philosophy of Art* (Cambridge: Harvard University Press, 1981), p. vii.
71. Danto, *Transfiguration of the Commonplace,* p. 56. See also Danto, "The End of Art," in *The Philosophical Disenfranchisement of Art* (New York: Columbia University Press, 1986), pp. 81–115.
72. Arthur C. Danto, *After the End of Art: Contemporary Art and the Pale of History* (Princeton: Princeton University Press, 1997), pp. xiii-xiv.
73. Friedrich Nietzsche, *Human, All Too Human,* I.150, pp. 81–82, in *Sämtliche Werke, Kritische Studienausgabe,* ed. Giorgio Colli and Mazzino Montinari, vol 2 (Munich and Berlin: Deutscher Taschenbuch Verlag and Walter de Gruyter, 1988), p. 144. Cf. a private note from the Autumn of 1881: "*Music*—a hidden gratification of the religious. *To turn one's eyes* from the word! This is her advantage! Indeed, also from

images! So that the intellect would not be *ashamed!* Thus it is *healthy* and a relief for those drives that *yet want to be gratified!*" Nietzsche, *Nachgelassene Fragmente 1880–1882,* in *Sämtliche Werke,* Kritische Studienausgabe, ed. Colli and Montinari, vol. 9, p. 581.

74. On nationalism, see especially Ernest Gellner, *Nations and Nationalism* (Ithaca: Cornell University Press, 1983); and Eric J. Hobsbawm, *Nations and Nationalism since 1780,* 2d ed. (Cambridge: Cambridge University Press, 1992). Gellner, in particular, argues for an understanding of nationalism as providing modern society, estranged from tradition by incessant technological and economic change, with a sense of common identity and destiny forged through a common educational system, language, and history.

75. Friedrich Nietzsche, *Ecce Homo,* in *Basic Writings,* trans. Walter Kaufmann (New York: Modern Library, 1968), p. 704.

76. Friedrich Nietzsche, *The Case of Wagner,* in *Basic Writings,* trans. Walter Kaufmann, p. 636.

77. I owe the reference to the *Triumphlied* to Laurence Dreyfus.

78. Max Weber, "Science as a Vocation," in H. H. Gerth and C. Wright Mills, eds., *From Max Weber: Essays in Sociology* (New York: Oxford University Press, 1946), p. 155.

79. Benjamin Constant, *Principes de politique applicables à tous les gouvernements (version de 1806–1810),* bk 16: "De l'autorité sociale chez les anciens" (Paris: Hachette, 1997), pp. 357–81.

80. Constant, *Principes de politique,* p. 359.

81. Constant, *Principes de politique,* p. 359.

82. Constant, *Principes de politique,* p. 370.

83. Constant, *Principes de politique,* pp. 373–74.

84. For an interesting recent discussion of this notion, and one by an author whose historical experience makes him much less suspicious of the state, and much more appreciative of its importance, than I tend to be, see Charles Taylor, "Invoking Civil Society," in *Philosophical Arguments* (Cambridge: Harvard University Press, 1995), pp. 204–24. Taylor's view of the desirable relationship between the civil society and the state is further articulated in "Liberal Politics and the Public Sphere," *ibid.,* pp. 257–87.

85. Unless noted otherwise, all translations from *Die Meistersinger* are mine.

86. Trans. Frederick Jameson.

87. Trans. Frederick Jameson.

88. Carl Dahlhaus, *Richard Wagner's Music Dramas,* trans. Mary Whittall (Cambridge: Cambridge University Press, 1979), pp. 65–66.

89. Dahlhaus, *Wagner's Music Dramas,* p. 68.

90. Dahlhaus, *Wagner's Music Dramas,* pp. 72–79. See also Friedrich Nietzsche, *Beyond Good and Evil,* 8.240, in *Basic Writings of Nietzsche,* trans. Walter Kaufmann, pp. 363–64, and Theodor W. Adorno, *In Search of Wagner,* trans. Rodney Livingstone (London: NLB, 1981), p. 120.

91. Bruce Ackerman, "Wohlfahrt für Mozart?," *Der Standard* [Vienna], June 9, 1998, p. 31. I would like to thank Professors Bruce Ackerman and Andrzej Rapaczynski for letting me read this text prior to publication.

92. Immanuel Kant, *The Critique of Judgement,* trans. James Creed Meredith (Oxford: Oxford University Press, 1952), 204, p. 42.

93. Kant, *The Critique of Judgement,* 205, p. 44.

94. Kant, *The Critique of Judgement,* 207, p. 45.

95. Kant, *The Critique of Judgement,* 207, p. 46.

96. Kant, *The Critique of Judgement,* 210, p. 49.
97. Kant, *The Critique of Judgement,* 211, p. 50.
98. Kant, *The Critique of Judgement,* 207, p. 46.
99. Kant, *The Critique of Judgement,* 267, p. 119.
100. Carl Dahlhaus, *Foundations of Music History,* trans. J. B. Robinson (Cambridge: Cambridge University Press, 1983), pp. 111, 146–47. Cf. also Dahlhaus, "Autonomie und Bildungsfunktion," in Sigrid Abel-Struth, ed., *Aktualität und Geschichtsbewusstsein in der Musikpädagogik,* Musikpädagogik. Forschung und Lehre, vol. 9 (Mainz: B. Schott's Söhne, 1973), pp. 20–29.
101. Paul Oskar Kristeller, "The Modern System of the Arts," in *Renaissance Thought and the Arts. Collected Essays* (Princeton: Princeton University Press, 1980), pp. 163–227.
102. Aristotle, *Nicomachean Ethics,* bk. 10, ch. 7, 1177b, trans. W. D. Ross.
103. Aristotle, *Nicomachean Ethics,* bk. 10, ch. 6, 1176b, trans. W. D. Ross.
104. Aristotle, *Politics,* bk. 8, ch. 5, 1339b, trans. Benjamin Jowett.
105. Compare the related distinction between amusing escapist fantasy and edifying imagination which aims to grasp reality, not to escape from it, discussed in Roger Scruton, "Fantasy, Imagination and the Screen," in *The Aesthetic Understanding,* pp. 127–36.
106. Dante, *Inferno,* canto V.38–9, trans. Charles S. Singleton.
107. Dante, *Inferno,* canto V.118–20, trans. Singleton.
108. Dante, *Inferno,* canto V.124–25, trans. Singleton.
109. Dante, *Inferno,* canto V.137, trans. Singleton.
110. Dante, *Inferno,* canto V.138, trans. Singleton. Cf. Singleton's commentary on line 129 in *The Divine Comedy,* trans., with commentary, Charles S. Singleton, *Inferno,* 2. Commentary (Princeton: Princeton University Press, 1970), p. 94: "It is the *reading* itself that reveals their love to them and in this sense is their 'go-between'."
111. Plato, *Republic,* bk. 2, 377b, trans. Paul Shorey.
112. Plato, *Republic,* bk, 2, 378d-e, trans. Paul Shorey.
113. Plato, *Republic,* bk. 3, 401b-c, trans. Paul Shorey.
114. McGinn, *Ethics, Evil, and Fiction,* p. 62.
115. McGinn, *Ethics, Evil, and Fiction,* p. 89.
116. Aristotle, *Politics,* bk. 7, ch. 17, 1336a, trans. Benjamin Jowett.
117. Aristotle, *Politics,* bk. 7, ch. 17, 1336b, trans. Benjamin Jowett.
118. Plato, *Republic,* bk. 10, 607b-e, trans. Paul Shorey.
119. Nietzsche, *Human, All Too Human,* 2.58, p. 227.
120. See Laura Kipnis, *Bound and Gagged: Pornography and the Politics of Fantasy in America* (New York: Grove Press, 1996).
121. Wendy Steiner, *The Scandal of Pleasure: Art in an Age of Fundamentalism* (Chicago: The University of Chicago Press, 1995), p. 9. Steiner quotes from Stephen Salisbury, "Arguing obscenity," *Philadelphia Inquirer,* October 1, 1990, p. 7-D.
122. Robert Hughes, "Art, Morals, and Politics," *New York Review of Books,* April 23, 1992, p. 24, quoted in Steiner, *The Scandal of Pleasure,* p. 10.
123. Steiner, *The Scandal of Pleasure,* p. 33.

Chapter 3

1. Arthur C. Danto, *After the End of Art: Contemporary Art and the Pale of History* (Princeton: Princeton University Press, 1997), p. 95. To be sure, a fuller elaboration of this position would require one to say something that Danto says in his foreword to Martha Woodmansee, *The Author, Art, and the Market: Rereading the History*

of Aesthetics (New York: Columbia University Press, 1994): "It may be that the idea of a concept that exists outside the history of its progressive characterization in the course of philosophical inquiry is as much and as little warranted as the idea of the soul is, invoked to give unity to a life it lies outside of. The subject of a lived life, like the subject of a history, may be metaphysically posited, engendered by a kind of grammar, and given some pride of metaphysical place when in truth both soul and concept may simply *be* the histories, and have no reality outside them" (p. xv).

2. Hans Belting, *The End of the History of Art?,* trans. Christopher S. Wood (Chicago: The University of Chicago Press, 1987), p. 52.

3. Alasdair MacIntyre, *After Virtue: A Study in Moral Theory,* 2d ed. (Notre Dame, Ind.: University of Notre Dame Press, 1984), p. 187.

4. MacIntyre, *After Virtue,* pp. 188–89.

5. For a typical contemporary example, see Pierre Bourdieu, *Distinction: A Social Critique of the Judgement of Taste,* trans. Richard Nice (Cambridge: Harvard University Press, 1984).

6. MacIntyre, *After Virtue,* pp. 190–91.

7. Thomas S. Kuhn, *The Structure of Scientific Revolutions,* 2d ed. (Chicago: The University of Chicago Press, 1970).

8. Cf. Carl Dahlhaus, "Trivialmusik und ästhetisches Urteil," in C. Dahlhaus, ed., *Studien zur Trivialmusik des 19. Jahrhunderts,* Studien zur Musikgeschichte des 19. Jahrhunderts 8 (Regensburg: Gustav Bosse Verlag, 1967), pp. 13–28. See also Dahlhaus, *Foundations of Music History,* trans. J. B. Robinson (Cambridge: Cambridge University Press, 1983), pp. 108–9.

9. Johannes Tinctoris, *Liber de arte contrapuncti, Opera theoretica,* 2, ed. A. Seay, Corpus Scriptorum de Musica 22 (n.p.: American Institute of Musicology, 1975), pp. 12–13, trans. Oliver Strunk, *Source Readings in Music History* (New York: Norton, 1950), p. 199.

10. Nicolaus Listenius, *Musica* (Wittenberg: Georg Rhau, 1537), ch. 1.

11. Cf. Carl Dahlhaus, "On the decline of the concept of the musical work," *Schoenberg and the New Music,* trans. D. Puffett and A. Clayton (Cambridge: Cambridge University Press, 1987), pp. 220–33, esp. pp. 220–21.

12. Theodor W. Adorno, *Ästhetische Theorie,* ed. G. Adorno and R. Tiedemann (Frankfurt am Main: Suhrkamp, 1970), p. 209, trans. Stephen Hinton.

13. See in particular, Heinrich Besseler, *Das musikalische Hören der Neuzeit,* Berichte über die Verhandlungen der Sächsischen Akademie der Wissenschaften zu Leipzig, Philologisch-historische Klasse, Band 104, Heft 6 (Berlin: Akademie-Verlag, 1959). For a full history of these terms and concepts, see Stephen Hinton, *The Idea of Gebrauchsmusik,* Outstanding Dissertations in Music from British Universities (New York: Garland, 1989) and "Gebrauchsmusik," in H. H. Eggebrecht, ed., *Handwörterbuch der musikalischen Terminologie* (Wiesbaden: F. Steiner, 1988).

14. Strunk, *Source Readings in Music History,* p. 79.

15. Strunk, *Source Readings in Music History,* p. 80.

16. Heinrich Glarean, *Dodecachordon* (Basel: Heinrich Petri, 1547).

17. Gioseffo Zarlino, *Le Istitutioni harmoniche,* (Venice: no publisher given, 1558), pt. 2, ch. 4, p. 62.

18. Strunk, *Source Readings in Music History,* p. 220.

19. Zarlino, *Le Istitutioni harmoniche,* pt. 2, ch. 4, p. 62.

20. Zarlino, *Le Istitutioni harmoniche,* pt. 1, ch. 5, p. 10.

21. Zarlino, *Le Istitutioni harmoniche,* pt. 1, ch. 5, p. 10.

22. Johannes Tinctoris, *Proportionale musices, Opera theoretica,* 2a, ed. A. Seay, Corpus

Scriptorum de Musica 22 (Neuhausen-Stuttgart: American Institute of Musicology, 1978), p. 10, trans. Strunk, *Source Readings in Music History,* p. 195.

23. The following pages, describing the paradigm shift around 1600, reproduce in part my "Concepts and Developments in Music Theory, 1520–1640," forthcoming in *The New Oxford History of Music,* vol. 4, ed. J. Haar (Oxford: Oxford University Press), where the interested reader will also find the relevant secondary literature.

24. Nicola Vicentino, *L'antica musica ridotta alla moderna prattica* (Rome: Antonio Barre, 1555), fol. 48r.

25. Vicentino, *L'antica musica ridotta alla moderna prattica,* fol. 86r.

26. Vicentino, *L'antica musica ridotta alla moderna prattica,* fol. 94r.

27. Vicentino, *L'antica musica ridotta alla moderna prattica,* fol. 6v.

28. Vincenzo Galilei, *Dialogo della musica antica, et della moderna* (Florence: Giorgio Marescotti, 1581), p. 81.

29. Galilei, *Dialogo della musica antica, et della moderna,* p. 1.

30. Galilei, *Dialogo della musica antica, et della moderna,* p. 80.

31. Galilei, *Dialogo della musica antica, et della moderna,* p. 1.

32. Giovanni de' Bardi, *Discorso mandato a Caccini sopra la musica antica e 'l cantar bene* [1578], Biblioteca Apostolica Vaticana, Ms. Barberinianus latinus 3990, fol. 10r, trans. Strunk, *Source Readings in Music History,* p. 295.

33. Girolamo Mei, letter of May 8, 1572 in Claude V. Palisca, *Girolamo Mei: Letters on Ancient and Modern Music to Vincenzo Galilei and Giovanni Bardi,* Musicological Studies and Documents 3 (n.p.: American Institute of Musicology, 1960), p. 117.

34. Vincenzo Galilei, *Discorso intorno all'uso dell'Enharmonio,* Florence, Biblioteca Nazionale Centrale, Ms. Gal. 3, fol. 17v.

35. Galilei, *Dialogo della musica antica, et della moderna,* p. 89.

36. Galilei, *Dialogo della musica antica, et della moderna,* p. 89.

37. Giovanni Maria Artusi, *L'Artusi, overo delle imperfettioni della moderna musica* (Venice: Giacomo Vincenti, 1600), fol. 16r.

38. Claudio Monteverdi, prefatory letter, *Il quinto libro de madrigali a cinque voci* (Venice: Ricciardo Amadino, 1605).

39. Monteverdi, prefatory letter, *Il quinto libro de madrigali a cinque voci.*

40. Giulio Cesare Monteverdi, "Dichiaratione della lettera stampata nel quinto libro de suoi madrigali," in Claudio Monteverdi, *Scherzi musicali* (Venice: Ricciardo Amadino, 1607).

41. Giulio Cesare Monteverdi, "Dichiaratione."

42. Strunk, *Source Readings in Music History,* p. 413.

43. Jean Philippe Rameau, *Treatise on Harmony,* trans. Philip Gossett (New York: Dover, 1971), p. 22.

44. Rameau, *Treatise on Harmony,* p. 3.

45. Jean-Jacques Rousseau, *Essay on the Origin of Languages,* trans. John H. Moran (Chicago: The University of Chicago Press, 1966), ch. 19, p. 68.

46. Rousseau, *Essay on the Origin of Languages,* ch. 19, p. 72.

47. Rousseau, *Essay on the Origin of Languages,* ch. 13, pp. 53 and 55.

48. D. P. Walker, *Spiritual and Demonic Magic from Ficino to Campanella* (London: The Warburg Institute, 1958), pp. 25–26.

49. Tinctoris, *Liber de arte contrapuncti,* trans. Strunk, *Source Readings in Music History,* p. 198.

50. See Carl Dahlhaus, "Si vis me flere," *Die Musikforschung,* 25 (1972), pp. 51–2.

51. Denis Diderot, *The Paradox of Acting* and William Archer, *Masks or Faces?* (New York: Hill and Wang, 1957), p. 14.

52. Eduard Hanslick, *On the Musically Beautiful: A Contribution towards the Revision of the Aesthetics of Music,* trans. Geoffrey Payzant (Indianapolis: Hackett, 1986), pp. 48–49.

53. Lorenzo Bianconi, *Music in the Seventeenth Century* (Cambridge: Cambridge University Press, 1987), pp. 76–80.

54. Letter to Friedrich Hoffmeister, January 15, 1801 in Ludwig van Beethoven, *Sämtliche Briefe und Aufzeichnungen,* ed. Fritz Prelinger, vol. 1 (Vienna and Leipzig, 1907), p. 65.

55. Christoph Wolff, "'The Extraordinary Perfections of the Hon. Court Composer': An Inquiry into the Individuality of Bach's Music," *Bach: Essays on His Life and Music* (Cambridge: Harvard University Press, 1991), p. 392.

56. Wolff, "'The Extraordinary Perfections of the Hon. Court Composer': Bach's Music," p. 394.

57. *The Bach Reader: A Life of Johann Sebastian Bach in Letters and Documents,* ed. Hans T. David and Arthur Mendel, rev. ed. (New York: Norton, 1966), p. 222.

58. Johann Wolfgang von Goethe, letter to Carl Friedrich Zelter, trans. by A. D. Coleridge, *The Bach Reader,* p. 369.

59. Immanuel Kant, *The Critique of Judgement,* trans. J. C. Meredith (Oxford: Oxford University Press, 1952), 328, p. 194.

60. Ernst Theodor Amadeus Hoffmann, "Beethoven's Instrumental Music," in *E. T. A. Hoffmann's Musical Writings: Kreisleriana, The Poet and the Composer, Music Criticism,* ed. David Charlton, trans. Martyn Clarke (Cambridge: Cambridge University Press, 1989), p. 96.

61. Hoffmann, "Beethoven's Instrumental Music," p. 96.

62. Hoffmann, "Beethoven's Instrumental Music," p. 96.

63. Hoffmann, "Beethoven's Instrumental Music," p. 96.

64. Hoffmann, "Beethoven's Instrumental Music," p. 96.

65. Hoffmann, "Beethoven's Instrumental Music," p. 96.

66. Hoffmann, "Beethoven's Instrumental Music," pp. 96–97.

67. Arthur Schopenhauer, *The World as Will and Representation,* trans. E. F. J. Payne, 2 vols. (New York: Dover, 1966), vol. 1, p. 256.

68. Schopenhauer, *The World as Will and Representation,* vol. 1, p. 257.

69. Schopenhauer, *The World as Will and Representation,* vol. 1, p. 263.

70. G. W. F. Hegel, *Aesthetics: Lectures on Fine Art,* trans. T. M. Knox, 2 vols. (Oxford: Oxford University Press, 1975), p. 934.

71. Ernst Theodor Amadeus Hoffmann, "Old and New Church Music," in *E. T. A. Hoffmann's Musical Writings,* ed. David Charlton, p. 355.

72. Hoffmann, "Old and New Church Music," pp. 357–58.

73. Hoffmann, "Old and New Church Music," p. 358.

74. Hoffmann, "Old and New Church Music," p. 366.

75. Hoffmann, "Old and New Church Music," p. 371.

76. Hoffmann, "Old and New Church Music," p. 372.

77. Ibid.

78. Ibid.

79. Ibid.

80. Martha Woodmansee, *The Author, Art, and the Market: Rereading the History of Aesthetics* (New York: Columbia University Press, 1994), p. 31.

81. Woodmansee, *The Author, Art, and the Market,* p. 20.

82. Thomas S. Grey demonstrated to what great extent the desire to claim for music representational powers continued to animate even the most avant-garde mid-nineteenth-

century New German circles where it uneasily grated against the ideology of musical autonomy. See Grey, *Wagner's Musical Prose: Texts and Contexts* (Cambridge: Cambridge University Press, 1995), pp. 1–50.

83. Gianmario Borio and Hermann Danuser, eds., *Im Zenit der Moderne. Die Internationalen Ferienkurse für Neue Musik Darmstadt 1946–1966. Geschichte und Dokumentation in vier Bänden* (Freiburg im Breisgau: Rombach Verlag, 1997).

84. Arnold Schoenberg, "The Relationship to the Text," in *Style and Idea* (New York: Philosophical Library, 1950), p. 2.

85. Schoenberg, "The Relationship to the Text," p. 1.

86. Igor Stravinsky, *Poetics of Music in the Form of Six Lessons,* trans. A. Knodel and I. Dahl (New York: Vintage Books, 1947), p. 110.

87. Schoenberg, "The Relationship to the Text," p. 4.

88. Hegel, *Aesthetics,* pp. 952–53.

89. Schoenberg, "The Relationship to the Text," p. 5.

90. Arthur Schopenhauer, *Manuscript Remains in Four Volumes,* ed. Arthur Hübscher, trans. E. F. J. Payne (Oxford: Berg, 1988), no. 338, p. 230.

91. The Schopenhauerian background of Kandinsky's, Malevich's, and Mondrian's turn toward abstraction has been recently discussed in Alain Besançon, *L'Image interdite. Une histoire intellectuelle de l'iconoclasme* (Paris: Fayard, 1994). Besançon places this turn within the context of the history of iconoclasm and stresses the religious dimension of early pictorial abstraction: "Thus 'abstract' art developes within the womb of a religious, and more precisely mystical, movement" (p. 15). And further: "A new iconoclasm, if one considers that the abandonment of the reference to 'objects' and to nature is not a result of a fear in front of the divine, but of the mystic ambition finally to give the divine an image it deserves" (p. 16); "by refusing the figure as incapable of capturing the absolute, Malevich and Kandinsky recovered, without knowing it, the classical argument of iconoclasm" (p. 17).

92. Theodor W. Adorno, *Philosophy of Modern Music* (New York: Seabury Press, 1973), p. 5.

93. Schopenhauer, *The World as Will and Representation,* vol. 1, p. 261.

94. Schopenhauer, *The World as Will and Representation,* vol. 2, p. 449.

95. Eduard Hanslick, *On the Musically Beautiful: A Contribution towards the Revision of the Aesthetics of Music,* trans. Geoffrey Payzant (Indianapolis: Hackett, 1986), pp. 61–63.

96. Hanslick, *On the Musically Beautiful,* p. xxiii.

97. Hanslick, *On the Musically Beautiful,* p. 28.

98. Hanslick, *On the Musically Beautiful,* p. 29.

99. Hanslick, *On the Musically Beautiful,* p. 60.

100. Hanslick, *On the Musically Beautiful,* p. 64.

101. Hanslick, *On the Musically Beautiful,* p. 82.

102. Carl Dahlhaus, *The Idea of Absolute Music,* trans. Roger Lustig (Chicago: The University of Chicago Press, 1989), pp. 27–28.

103. Quoted in Carl Dahlhaus, *Die Idee der absoluten Musik* (Kassel: Bärenreiter-Verlag, 1978), p. 33.

104. Cf. Carl Dahlhaus, "Formästhetik und Nachahmungsprinzip," *Klassische und Romantische Musikästhetik* (Laaber: Laaber-Verlag, 1988), pp. 44–49.

105. Heinrich Schenker, *The Masterwork in Music: A Yearbook. Volume 1 (1925),* ed. William Drabkin (Cambridge: Cambridge University Press, 1994), p. 2.

106. Stravinsky, *Poetics of Music,* p. 19.

107. Stravinsky, *Poetics of Music,* p. 79.

108. Stravinsky, *Poetics of Music,* p. 46.

109. Stravinsky, *Poetics of Music,* p. 24.

110. Schoenberg, "Gustav Mahler," in *Style and Idea,* p. 26.

111. Schoenberg, "Criteria for the Evaluation of Music," in *Style and Idea,* p. 194.

112. Ernst Bloch, *Essays on the Philosophy of Music* (Cambridge: Cambridge University Press, 1985), p. 139: "Music—this kernel and seed, this reflection of the brightly illumined death-night and of eternal life, this nucleus of the mystical interior sea of servants, this Jericho and first township of the holy land."

113. Adorno, *Philosophy of Modern Music,* p. 9.

114. See Richard Taruskin, "Stravinsky and the Subhuman. A Myth of the Twentieth Century: *The Rite of Spring,* the Tradition of the New, and 'the Music Itself'," in *Defining Russia Musically: Historical and Hermeneutical Essays* (Princeton: Princeton University Press, 1997), pp. 360–18.

115. Inge Kovács, "Die Ferienkurse als Schauplatz der Ost-West-Konfrontation," in Borio and Danuser, eds., *Im Zenit der Moderne,* vol. 1, pp. 116–39.

116. Kovács, "Die Ferienkurse als Schauplatz der Ost-West-Konfrontation," p. 117.

117. Kovács, "Die Ferienkurse als Schauplatz der Ost-West-Konfrontation," p. 129.

118. Jean Clair, *La responsabilité de l'artiste: les avant-gardes entre terreur et raison* (Paris: Gallimard, 1997), pp. 71–72.

119. Clair, *La responsabilité de l'artiste,* p. 72.

120. State sponsorship of the supposedly subversive avant-garde has been one of the issues in the debate over the crisis of contemporary art that has been raging in France since 1991. (The debate has been chronicled in Yves Michaud, *La crise de l'art contemporain: Utopie, démocratie et comédie* [Paris: Presses Universitaires de France, 1997].) Jean Clair, for instance, writes: "The darling of the ministerial programs of cultural development, institutionalized and bureaucratized, it [avant-garde] nevertheless pretends still to embody the spirit of insubmission to the established power. Whence the survival of this astonishing privilege? Since it is surely no longer the matter of the subversion of established values. No state has ever subventioned the subversion of its own values" (*La responsabilité de l'artiste,* p. 20). See also Marc Fumaroli, *L'État culturel: une religion moderne* (Paris: Éditions de Fallois, 1992).

121. Roger Scruton, *The Aesthetics of Music* (Oxford: Clarendon Press, 1997), pp. 496–97.

122. Hegel, *Aesthetics,* p. 899.

123. Hegel, *Aesthetics,* pp. 901–2.

124. Hegel, *Aesthetics,* p. 954.

125. Adorno, *Philosophy of Modern Music,* pp. 19–20.

126. Adorno, *Philosophy of Modern Music,* p. 21.

127. Adorno, *Philosophy of Modern Music,* p. 133.

128. See Anthony Newcomb, "Once More 'Between Absolute and Program Music': Schumann's Second Symphony," *19th-Century Music* 7 (1984), 233–50; "Schumann and Late Eighteenth-Century Narrative Strategies," *19th-Century Music* 11 (1987), 164–74.

129. E. H. Gombrich, *The Sense of Order: A Study in the Psychology of Decorative Art* (Ithaca: Cornell University Press, 1979), p. 302.

130. Theodor W. Adorno, *Beethoven: Philosophie der Musik, Nachgelassene Schriften,* vol. 1, ed. Rolf Tiedemann (Frankfurt am Main: Suhrkamp, 1993; 2d ed. 1994), p. 27, trans. Stephen Hinton.

131. Witold Rybczynski, "A Truly Important Place. The Abundant Public Architecture of Robert Mills," *The Times Literary Supplement,* November 11, 1994, p. 3.

132. Walter Pater, "The School of Giorgione" in his *The Renaissance: Studies in Art and Poetry,* ed. D. L. Hill (Berkeley: University of California Press, 1980), p. 106.

133. *Über das Geistige in der Kunst, insbesondere in der Malerei* (Munich: R. Piper, 1912).

134. Arnold Schoenberg, "The Relationship to the Text," in *Der blaue Reiter,* ed. V. Kandinsky and F. Marc [1912]; ed. K. Lankheit (Munich: R. Piper, 1965) and *The Blaue Reiter Almanac,* ed. K. Lankheit (London: Thames and Hudson, 1974).

135. E. H. Gombrich, *Art and Illusion: A Study in the Psychology of Pictorial Representation,* 2d ed. (Princeton: Princeton University Press, 1961), p. 358.

136. Gombrich, *Art and Illusion,* p. 368.

137. Michael Fried, *Three American Painters: Kenneth Noland, Jules Olitski, Frank Stella* (Cambridge: Fogg Art Museum, Harvard University, 1965), p. 43.

138. Arthur C. Danto, *The Transfiguration of the Commonplace: A Philosophy of Art* (Cambridge: Harvard University Press, 1981), p. 87.

139. The affiliation between "absolute music" and *poésie pure* is explored in Dahlhaus, *The Idea of Absolute Music,* ch. 10, pp. 141–55.

140. M. H. Abrams, *The Mirror and the Lamp: Romantic Theory and the Critical Tradition* (Oxford: Oxford University Press, 1953).

141. Charles Taylor, *Sources of the Self: The Making of the Modern Identity* (Cambridge: Harvard University Press, 1989), ch. 21, pp. 368–90. For the late eighteenth-century turn from the representation of traditional communal myths to the expression of individual subjectivity, and from allegory to symbol, see especially Hans-Georg Gadamer, *Truth and Method* (New York: Continuum, 1975), pp. 39–73.

142. Taylor, *Sources of the Self,* p. 198.

143. See Daniel J. Boorstin, *The Image: or, What Happened to the American Dream* (New York: Atheneum, 1962).

144. G. W. F. Hegel, *Elements of the Philosophy of Right,* ed. Allen W. Wood, trans. H. B. Nisbet (Cambridge: Cambridge University Press, 1991), § 124, p. 151.

145. Alexis de Tocqueville, *Democracy in America,* ed. J. P. Mayer, trans. George Lawrence (Garden City, N.Y.: Anchor Books, 1969), p. 439.

146. Hegel, *Elements of the Philosophy of Right,* § 262, p. 286.

147. Hegel, *Elements of the Philosophy of Right,* § 279, p. 321.

148. Hegel, *Elements of the Philosophy of Right,* § 273, p. 312.

149. Hegel, *Elements of the Philosophy of Right,* § 206, p. 237.

150. Hegel, *Elements of the Philosophy of Right,* § 206, pp. 237–38.

151. Martin Heidegger, *Being and Time* (New York: Harper & Row, 1962), § 6, p. 42.

152. Hegel, *Elements of the Philosophy of Right,* § 261, p. 285.

153. Montesquieu, *De l'Esprit des lois,* in *Oeuvres complètes,* ed. Daniel Oster (Paris: Éditions du Seuil, 1964), 8.3, p. 571.

154. Joseph Raz, *The Morality of Freedom* (Oxford: Oxford University Press, 1986), p. 155.

155. Raz, *The Morality of Freedom,* p. 309.

156. Raz, *The Morality of Freedom,* p. 310.

157. Raz, *The Morality of Freedom,* p. 311.

158. Tocqueville, *Democracy in America,* p. 508.

159. Hegel, *Elements of the Philosophy of Right,* § 5, p. 38.

160. Hegel, *Elements of the Philosophy of Right,* § 6, p. 40.

161. Hegel, *Elements of the Philosophy of Right,* § 13, p. 47.

162. Søren Kierkegaard, *Either/Or,* part 1, trans. Howard V. Hong and Edna H. Hong (Princeton: Princeton University Press, 1987), p. 38.

163. Montaigne, *The Complete Works,* trans. Donald M. Frame (Stanford: Stanford University Press, 1943), p. 21.
164. Hegel, *Aesthetics,* p. 519.
165. Hegel, *Aesthetics,* p. 520.
166. Hegel, *Aesthetics,* pp. 527–28.
167. MacIntyre, *After Virtue,* pp. 128–29.

Chapter 4
1. Plato, *Republic,* bk. 3, 392c-394c, trans. Paul Shorey.
2. Aristotle, *Poetics,* ch. 1, 1447a13–15, trans. Ingram Bywater.
3. Aristotle, *Poetics,* ch. 1, 1447a26–28, trans. Ingram Bywater.
4. Aristotle, *Poetics,* ch. 2, 1448a5–6, trans. Ingram Bywater.
5. Aristotle, *Poetics,* ch. 1, 1447a16–18, trans. Ingram Bywater.
6. Aristotle, *Poetics,* ch. 2, 1448a20–24, trans. Ingram Bywater.
7. In thinking about the problems raised in this and the following chapter, I have found the work of the following literary theorists particularly useful: Mikhail M. Bakhtin, "Discourse in the Novel," in *The Dialogic Imagination* (Austin: University of Texas Press, 1981), pp. 259–422; Roland Barthes, "Introduction to the Structural Analysis of Narratives," in *Image, Music, Text* (New York: Hill and Wang, 1977), pp. 79–124; Wayne C. Booth, *The Rhetoric of Fiction,* 2d ed. (Chicago: The University of Chicago Press, 1983); Seymour Chatman, *Story and Discourse: Narrative Structure in Fiction and Film* (Ithaca: Cornell University Press, 1978), and *Coming to Terms: The Rhetoric of Narrative in Fiction and Film* (Ithaca: Cornell University Press, 1990); Gérard Genette, *Narrative Discourse: An Essay in Method* (Ithaca: Cornell University Press, 1980), *The Architext: An Introduction*, trans. J. E. Lewin (Berkeley: University of California Press, 1992), and, *Narrative Discourse Revisited* (Ithaca: Cornell University Press, 1988); Käte Hamburger, *The Logic of Literature,* 2d rev. ed. (Bloomington: Indiana University Press, 1973); Frank Kermode, *The Sense of an Ending: Studies in the Theory of Fiction* (New York: Oxford University Press, 1967), and *The Genesis of Secrecy* (Cambridge: Harvard University Press, 1979); Günther Müller, *Morphologische Poetik,* ed. Elena Müller (Darmstadt: Wissenschaftliche Buchgesellschaft, 1968); Emil Staiger, *Basic Concepts of Poetics* (University Park: Pennsylvania State University Press, 1991); Tzvetan Todorov, "The Grammar of Narrative" and "Narrative Transformations," in *The Poetics of Prose* (Ithaca: Cornell University Press, 1977), pp. 108–19, 218–33. Over and above all of those, my thinking has been centrally guided by Paul Ricoeur, *Time and Narrative,* 3 vols. (Chicago: The University of Chicago Press, 1984–88), as well as by the closely related work by David Carr, *Time, Narrative, and History* (Bloomington: Indiana University Press, 1986).
8. In addition to the literature specifically mentioned later, my thinking about the problems raised by painting in this and the following chapter is indebted in particular to Richard Wollheim, *Painting as an Art* (Princeton: Princeton University Press, 1987), and to the discussions of Velázquez's *Las Meninas* that have been stimulated by Michel Foucault's 1966 reading of the painting in *The Order of Things* (London: Tavistock, 1970), pp. 3–16, namely, Madlyn Millner Kahr, *Velázquez: The Art of Painting* (New York: Harper & Row, 1976), pp. 128–41; Jonathan Brown, *Images and Ideas in Seventeenth-Century Spanish Painting* (Princeton: Princeton University Press, 1978); John R. Searle, "*Las Meninas* and Representation," *Critical Inquiry* 6 (1980), 477–88; Joel Snyder and Ted Cohen, "Reflections on *Las Meninas:* Paradox Lost," *Critical Inquiry* 7 (1980), 429–47; Leo Steinberg, "Velázquez' *Las Meninas,*"

October 15 (1981), 45–54; Svetlana Alpers, "Interpretation without Representation, or, the Viewing of *Las Meninas*," *Representations* 1 (1983), 31–42; Denis Donoghue, "A Form of Attention," in Raphael Stern, Philip Rodman, and Joseph Cobitz, eds., *Creation and Interpretation* (New York: Haven Publications, 1985), pp. 75–100; Charles Karelis, "The *Las Meninas* Literature and Its Lesson," *ibid.,* pp. 101–14.

9. In addition to the literature specifically mentioned later, my thinking about the problems raised by music in this and the following chapter is particularly indebted to a number of theorists and critics who in the last three decades have explored the points of contact between literature and music. In Germany, the main stimulus to thinking about music in these terms came from the "Roman" chapter in Theodor W. Adorno's 1960 monograph on Mahler: *Mahler. Eine musikalische Physiognomik,* in Gretel Adorno and Rolf Tiedemann, eds., *Gesammelte Schriften,* vol. 13 (Frankfurt am Main: Suhrkamp, 1971), pp. 209–29. See in particular Hermann Danuser, "Konstruktion des Romans bei Gustav Mahler," *Musikalische Prosa,* Studien zur Musikgeschichte des 19. Jahrhunderts 46 (Regensburg: Gustav Bosse Verlag, 1975), pp. 87–117 (reprinted in Danuser, *Gustav Mahler und seine Zeit* [Laaber: Laaber-Verlag, 1991], pp. 152–84). In the United States, most work in this area is indebted to Edward T. Cone, *The Composer's Voice* (Berkeley: University of California Press, 1974); see also his "The World of Opera and Its Inhabitants," in *Music: A View from Delft* (Chicago: The University of Chicago Press, 1989), pp. 125–38, and "Responses," *College Music Symposium* 29 (1989), 75–80. See in particular Fred Everett Maus, "Music as Drama," *Music Theory Spectrum* 10 (1988), 56–73; Maus, "Agency in Instrumental Music and Song," *College Music Symposium* 29 (1989), 31–43; and Carolyn Abbate, *Unsung Voices: Opera and Musical Narrative in the Nineteenth Century* (Princeton: Princeton University Press, 1991). An independent strand of music-narratological inquiry has been pursued by Anthony Newcomb in "Those Images That Yet Fresh Images Beget," *Journal of Musicology* 2 (1983), 227–45; "Once More 'Between Absolute and Program Music': Schumann's Second Symphony," *19th-Century Music* 7 (1984), 233–50; "Schumann and Late Eighteenth-Century Narrative Strategies," *19th-Century Music* 11 (1987), 164–74; and "Narrative Archetypes and Mahler's Ninth Symphony," in Steven Paul Scher, ed., *Music and Text: Critical Inquiries* (Cambridge: Cambridge University Press, 1992), pp. 118–36.

10. Cf. Mikhail M. Bakhtin, *Problems of Dostoevsky's Poetics,* trans. Caryl Emerson (Minneapolis: University of Minnesota Press, 1984).

11. For the distinction between the "time of narrating" and "narrated time," see the classic 1948 paper by Günther Müller, "Erzählzeit und erzählte Zeit," *Morphologische Poetik,* pp. 269–86.

12. Cf. Philippe Lejeune, *On Autobiography,* Theory and History of Literature, vol. 52 (Minneapolis: University of Minnesota Press, 1989).

13. Adorno, *Mahler. Eine musikalische Physiognomik,* p. 225.

14. Kendall L. Walton, *Mimesis as Make-Believe: On the Foundations of the Representational Arts* (Cambridge: Harvard University Press, 1990), p. 56. See also Walton, "What is Abstract About the Art of Music?," *The Journal of Aesthetics and Art Criticism* 46 (1988), 351–64.

15. Roger Scruton, "Understanding Music," in *The Aesthetic Understanding* (London: Methuen, 1983), p. 100.

16. Adorno, *Mahler. Eine musikalische Physiognomik,* p. 226. Similarly, Cone, *The Composer's Voice, passim,* speaks repeatedly of the "multiple persona" of the chorus.

17. This point is argued in Maus, "Music as Drama" and "Agency in Instrumental Music and Song." By contrast, Lawrence Kramer argues that instrumental music tends to

be monological. Lawrence Kramer, *Music as Cultural Practice, 1800–1900* (Berkeley: University of California Press, 1990), pp. 187–88.

18. Cf., e.g., the following passages from Heidegger: "According to this idea [i.e., "the notion of language that has prevailed for thousands of years"] language is the expression, produced by men, of their feelings and the world view that guides them. Can the spell this idea has cast over language be broken? Why should it be broken? In its essence, language is neither expression nor an activity of man. Language speaks" ("Language," in *Poetry, Language, Thought,* pp. 196–97); "Language speaks. Man speaks in that he responds to language. This responding is a hearing" ("Language," p. 210); "Man acts as though *he* were the shaper and master of language, while in fact *language* remains the master of man. Perhaps it is before all else man's subversion of *this* relation of dominance that drives his nature into alienation" ("Building Dwelling Thinking," in *Poetry, Language, Thought,* p. 146); "Man acts as though he were the shaper and master of language, while in fact language remains the master of man. . . . For, strictly, it is language that speaks. Man first speaks when, and only when, he responds to language by listening to its appeal" (". . . Poetically Man Dwells . . . ," in *Poetry, Language, Thought,* pp. 215f).

19. Cf. Bakhtin, "Discourse in the Novel."

20. Charles Rosen, *The Romantic Generation* (Cambridge: Harvard University Press, 1995), p. 166.

21. I have described and interpreted this Beethovenian discovery in "Beethoven and the Aesthetic State," *Beethoven Forum* 7 (1998), pp. 17–44.

22. It is the great merit of Abbate's book, *Unsung Voices,* to investigate the means by which nineteenth-century music produces rare moments of significant *diegesis.* But while I see the first sustained exploration of such techniques in Beethoven's instrumental music, Abbate locates their origin in opera, Wagner's in particular. Similarly to Abbate and myself, in *Music as Cultural Practice, 1800–1900*, Lawrence Kramer concludes that narrative (that is, diegetic) effects in music are the exception rather than the norm (p. 189).

23. See, e.g., the discussion of a large-scale interpolation interrupting the first movement of Robert Schumann's piano *Phantasie* in C Major, Op. 17 in John Daverio, "Schumann's 'Im Legendenton' and Friedrich Schlegel's *Arabeske,*" *19th-Century Music* 11 (1987), 150–63. A small-scale interpolation of this kind, occuring in the first movement of Ludwig van Beethoven's Piano Concerto No. 2 in B-flat Major, Op. 19, is discussed in my "Toward a History of Hearing: The Classic Concerto, A Sample Case," in W. J. Allanbrook, J. M. Levy, and W. P. Mahrt, eds., *Convention in Eighteenth- and Nineteenth-Century Music. Essays in Honor of Leonard G. Ratner* (Stuyvesant, N.Y.: Pendragon Press, 1992), pp. 405–29. It is striking that in Abbate's *Unsung Voices,* the most sustained discussion of musical *diegesis* we have, all of the key examples involve some sort of interruption of the main discourse, that, as she puts it, "moments of musical narrating involve rending the fabric of music" (p. 152). See also James Webster, *Haydn's 'Farewell' Symphony and the Idea of the Classical Style* (Cambridge: Cambridge University Press, 1991), pp. 267–87.

24. On self-reflexive texts, cf. Lucien Dällenbach, *The Mirror in the Text* (Chicago: University of Chicago Press, 1989).

25. On self-reflexivity in *The Tempest,* see my "Prospero's Art," *Shakespeare Studies* 10 (1977), 211–39.

26. Cf. Roger Scruton, *The Aesthetics of Architecture* (Princeton: Princeton University Press, 1979).

27. Alexis de Tocqueville, *Democracy in America,* ed. J. P. Mayer, trans. George Lawrence (Garden City, N.Y.: Anchor Books, 1969), p. 484.

28. Cf. Paul Zumthor, *Oral Poetry: An Introduction,* Theory and History of Literature, vol. 70 (Minneapolis: University of Minnesota Press, 1990).

29. The felicitous term, though not the concept, was introduced in 1961 in Wayne Booth's *The Rhetoric of Fiction.* For a recent defense of the concept, with further literature on the subject, see Chatman, *Coming to Terms,* pp. 74–108. In *The Composer's Voice,* Cone postulates the existence of something analogous to the implied author in music. It should be apparent that if my arguments below against the need for believing in the existence of this entity in literature are convincing, they are equally valid in the case of painting or music. See also Cone, "The World of Opera and Its Inhabitants," in *Music: A View from Delft* (Chicago: The University of Chicago Press, 1989), pp. 125–38, and "Responses," *College Music Symposium* 29 (1989), 75–80.

30. Cf. the discussion of "organic unity" in Richard Shusterman, *Pragmatist Aesthetics: Living Beauty, Rethinking Art* (Oxford and Cambridge: Blackwell, 1992), pp. 62–83. Shusterman demonstrates "the essential sameness of [the Derridean] *différance* and the radical concept of organic unity" (p. 71).

31. Richard Rorty, "The Pragmatist's Progress," in S. Collini, ed., *Interpretation and Overinterpretation* (Cambridge: Cambridge University Press, 1992), p. 97.

32. See Roland Barthes, "The Death of the Author," in *Image, Music, Text* (New York: Hill and Wang, 1977), pp. 142–48, as well as Michel Foucault, "What is an Author," in Paul Rabinow, ed., *The Foucault Reader* (New York: Pantheon, 1984), pp. 100–20.

Chapter 5

1. Gérard Genette, *The Architext: An Introduction,* trans. J. E. Lewin (Berkeley: University of California Press, 1992).

2. Thus, arguing against the current usage, Genette points out that "the sole specificity of narrative lies in its mode." Gérard Genette, *Narrative Discourse Revisited* (Ithaca: Cornell University Press, 1988), pp. 16–17.

3. Paul Ricoeur, *Time and Narrative,* 3 vols. (Chicago: The University of Chicago Press, 1984–8). In *Coming to Terms: The Rhetoric of Narrative in Fiction and Film* (Ithaca: Cornell University Press, 1990), Seymour Chatman also concludes, independently of Ricoeur, that narrative is a fundamental "text-type," while the difference between the diegetic and mimetic modes (between, for instance, epic and drama) is secondary (pp. 109–23).

4. Ricoeur, *Time and Narrative,* vol. 1, p. 32.

5. Ricoeur, *Time and Narrative,* vol. 1, pp. 32–37.

6. Ricoeur, *Time and Narrative,* vol. 1, pp. 35–36.

7. Ricoeur, *Time and Narrative,* vol. 1, p. 37.

8. Ricoeur, *Time and Narrative,* vol. 1, p. 36.

9. Ricoeur, *Time and Narrative,* vol. 1, pp. 38–45.

10. Aristotle, *Poetics,* ch. 7, 1450b26–34, trans. Ingram Bywater.

11. Ricoeur, *Time and Narrative,* vol. 1, p. 41.

12. Ricoeur, *Time and Narrative,* vol. 1, p. 43.

13. Aristotle, *Poetics,* ch. 7, 1450b34–1451a6, trans. Ingram Bywater.

14. John Dewey, *Art as Experience, The Later Works, 1925–1953,* vol. 10 [1934] (Carbondale and Edwardsville: Southern Illinois University Press, 1987).

15. On the essential temporality of action, see David Carr, *Time, Narrative, and History* (Bloomington: Indiana University Press, 1986).

16. Gérard Genette, *Narrative Discourse: An Essay in Method* (Ithaca: Cornell University Press, 1980), p. 30.

17. Seymour Chatman, in *Coming to Terms,* pp. 6–37, distinguishes three "text-types": narrative, description, and argument. For Chatman, the defining feature of narrative

is its "internal" temporality (the duration of the story, the sequence of events that constitute the plot), which the other two types lack, as well as the logic of causality or at least contingency governing the relationships between the events. Description, which "is the text-type most favored by lyric poems" (p. 23), is governed "by a sort of casual contiguity" (p. 10); its logic is metonymic; it entails the relation of the described objects to each other. Argument attempts "to persuade an audience of the validity of some proposition, usually proceeding along deductive or inductive lines" (p. 9). In actual texts, one type is usually the "overriding" one, while the other two may also be present but in "subservient" roles. It should be immediately apparent that Chatman's "narrative" and "description" correspond very closely to my "narrative" and "lyric," even though Chatman treats his categories as "text-types" rather than types of "form." Chatman's "argument," I would like to claim, cannot be the "overriding" but only a "subservient" text-type in an artwork (as opposed to a philosophical or scientific treatise, say), since, unlike narrative and description, argument cannot be used to make a world (of the work) present (to the reader).

18. Svetlana Alpers, *The Art of Describing: Dutch Art in the Seventeenth Century* (Chicago: The University of Chicago Press, 1983).

19. E. H. Gombrich, *Art and Illusion: A Study in the Psychology of Pictorial Representation,* 2d ed. (Princeton: Princeton University Press, 1961).

20. Carolyn Abbate, in *Unsung Voices* (Princeton: Princeton University Press, 1991), p. 28, argues that the term "narrative" should be reserved only for discourses which employ narrators (that is, which are diegetic) and objects to the plot-centered usage (adopted by Ricoeur, Newcomb, and myself, among others). The latter usage, Abbate argues, renders the term "narrative" as applied to music unilluminating, since all music, being temporal, is "narrative" in this sense: "A heuristic strategy that enables us to read all musical discourse as narrative is clearly tautological one: is there no nonnarrative music, as there are nonnarrative text genres?" (p. 46). It is precisely one of the objectives of the following portion of the chapter to establish that not all music must be narrative.

21. Heinrich Besseler, *Das musikalische Hören der Neuzeit,* Berichte über die Verhandlungen der Sächsischen Akademie der Wissenschaften zu Leipzig, Philologisch-historische Klasse, Band 104, Heft 6 (Berlin: Akademie-Verlag, 1959).

22. Georg August Griesinger, *Biographische Notizen über Joseph Haydn* (Leipzig, 1810; reprint, Leipzig: VEB Deutscher Verlag für Musik, 1979), p. 117; trans. in Vernon Gotwals, *Haydn: Two Contemporary Portraits* (Madison: University of Wisconsin Press, 1968), p. 62.

23. Christian Gottfried Körner, "Über Charakterdarstellung in der Musik," modern ed. in Wolfgang Seifert, *Christian Gottfried Körner. Ein Musikästhetiker der deutschen Klassik* (Regensburg: Gustav Bosse Verlag, 1960), pp. 147–58. See also Heinrich Besseler, "Mozart und die Deutsche Klassik," in E. Schenk, ed., *Bericht über den Internationalen Musikwissenschaftlichen Kongress Wien Mozartjahr 1956 3. bis 9. Juni* (Graz-Cologne: Verlag Hermann Böhlaus Nachf., 1958), pp. 47–54.

24. Martin Heidegger, *Being and Time* (New York: Harper & Row, 1962), sec. 29, pp. 172–79.

25. Otto Friedrich Bollnow, *Das Wesen der Stimmungen,* 3d ed. (Frankfurt am Main: Vittorio Klosterman, 1956).

26. Similarly, Laurence Dreyfus de-emphasizes temporality in his readings of Bach's music in *Bach and the Patterns of Invention* (Cambridge: Harvard University Press, 1996).

27. G. W. F. Hegel, *Aesthetics. Lectures on Fine Art,* trans. T. M. Knox, 2 vols. (Oxford: Oxford University Press, 1975), p. 507.

28. See Carr, *Time, Narrative, and History, passim.*
29. Ricoeur, *Time and Narrative,* vol. 1, p. 52.
30. Ricoeur, *Time and Narrative,* vol. 1, pp. 74–75.
31. Alasdair MacIntyre, *After Virtue: A Study in Moral Theory,* 2d ed. (Notre Dame, Ind.: University of Notre Dame Press, 1984), pp. 211–12.
32. MacIntyre, *After Virtue,* p. 216.
33. Heidegger, *Being and Time,* sec. 29, p. 178.
34. Heidegger, *Being and Time,* sec. 29, p. 173.
35. Heidegger, *Being and Time,* sec. 29, p. 175.
36. Heidegger, *Being and Time,* sec. 29, p. 173.
37. Heidegger, *Being and Time,* sec. 29, p. 175.
38. Heidegger, *Being and Time,* sec. 29, p. 176.
39. Heidegger, *Being and Time,* sec. 35, p. 213.
40. Heidegger, *Being and Time,* sec. 29, p. 176.
41. Heidegger, *Being and Time,* sec. 29, p. 177.
42. Heidegger, *Being and Time,* sec. 40, pp. 230–31.
43. Heidegger, *Being and Time,* sec. 68, p. 395.
44. Bollnow, *Das Wesen der Stimmungen,* pp. 33–39.
45. Bollnow, *Das Wesen der Stimmungen,* p. 39.
46. Bollnow, *Das Wesen der Stimmungen,* p. 54.
47. Bollnow, *Das Wesen der Stimmungen,* p. 57.
48. Bollnow, *Das Wesen der Stimmungen,* pp. 43–44.
49. Bollnow, *Das Wesen der Stimmungen,* p. 50.
50. Bollnow, *Das Wesen der Stimmungen,* pp. 60–61.
51. Eduard Hanslick, *On the Musically Beautiful: A Contribution towards the Revision of the Aesthetics of Music,* trans. Geoffrey Payzant (Indianapolis: Hackett, 1986), p. 9.
52. Hanslick, *On the Musically Beautiful,* p. 11.
53. Hanslick, *On the Musically Beautiful,* p. 11.
54. Hegel, *Aesthetics,* pp. 902–3.
55. Hegel, *Aesthetics,* pp. 940–41.
56. Letter to Gustav Krug, February 1887, quoted in Friedrich Nietzsche, *Der musikalische Nachlass,* ed. Curt Paul Janz (Basel: Bärenreiter, 1976), p. 341.
57. Nietzsche, *Der musikalische Nachlass,* p. 342.
58. Martin Heidegger, "The Origin of the Work of Art," in *Poetry, Language, Thought* (New York: Harper & Row, 1971), p. 72.
59. Heidegger, *Being and Time,* sec. 34, p. 205.
60. Quoted from Carl Dahlhaus, "Lieder ohne Worte," *Klassische und Romantische Musikästhetik* (Laaber: Laaber-Verlag, 1988), pp. 141–42.
61. Friedrich Nietzsche, *Nachgelassene Fragmente 1885–1887,* in *Sämtliche Werke,* Kritische Studienausgabe, ed. Giorgio Colli and Mazzino Montinari, vol. 12 (Munich and Berlin: Deutscher Taschenbuch Verlag and Walter de Gruyter, 1988), p. 493.
62. Mikel Dufrenne, *The Phenomenology of Aesthetic Experience* (Evanston: Northwestern University Press, 1973), p. 519.
63. Hans-Georg Gadamer, *Truth and Method* (New York: Continuum, 1975), p. 87.
64. Heidegger, "The Origin of the Work of Art," p. 68.

Chapter 6
1. Hans-Georg Gadamer, *Truth and Method* (New York: Continuum, 1975), pp. 142–43.
2. Gadamer, *Truth and Method,* p. 146.
3. Gadamer, *Truth and Method,* p. 147.

4. Gadamer, *Truth and Method,* pp. 112–13.

5. Gadamer, *Truth and Method,* p. 80.

6. Gadamer, *Truth and Method,* pp. 81–82.

7. Michael Baxandall, *Painting and Experience in Fifteenth-Century Italy* (Oxford: Oxford University Press, 1972); Marc Fumaroli, *L'École du silence. Le sentiment des images au XVIIᵉ siècle* (Paris: Flammarion, 1994); Charles Rosen, *The Romantic Generation* (Cambridge: Harvard University Press, 1995); John Freccero, *Dante: The Poetics of Conversion* (Cambridge: Harvard University Press, 1986); Jean Starobinski, *Jean-Jacques Rousseau, Transparency and Obstruction,* trans. Arthur Goldhammer (Chicago: The University of Chicago Press, 1988).

8. Marcel Proust, *Swann's Way, Remembrance of Things Past,* vol. 1 (New York: Random House, 1934), p. 171.

9. See Aristotle, *Rhetoric,* bk. 3, ch. 4.

10. Aristotle, *Poetics,* ch. 21, 1457b, trans. Ingram Bywater.

11. Aristotle, *Rhetoric,* bk. 3, ch. 10, 1410b, trans. W. Rhys Roberts.

12. Aristotle, *Rhetoric,* bk. 3, ch., 2, 1405a, trans. W. Rhys Roberts.

13. Aristotle, *Rhetoric,* bk. 3, ch. 11, 1412a, trans. W. Rhys Roberts.

14. Aristotle, *Poetics,* ch. 22, 1459a, trans. Ingram Bywater.

15. On the relationship between metaphor and art, see in particular Paul Ricoeur, *The Rule of Metaphor: Multi-disciplinary Studies of the Creation of Meaning in Language* (Toronto: University of Toronto Press, 1977).

16. Hans Belting, *Likeness and Presence: A History of the Image Before the Era of Art,* trans. E. Jephcott (Chicago: The University of Chicago Press, 1994).

17. Nelson Goodman, *Languages of Art: An Approach to a Theory of Symbols,* 2d ed. (Indianapolis: Hackett, 1976), p. 69.

18. Scott Burnham, *Beethoven Hero* (Princeton: Princeton University Press, 1995), p. 25.

19. See Friedrich Nietzsche, "On Music and Words," trans. W. Kaufmann, in Carl Dahlhaus, *Between Romanticism and Modernism: Four Studies in the Music of the Later Nineteenth Century* (Berkeley: University of California Press, 1980), pp. 106–19.

20. Martin Heidegger, "The Origin of the Work of Art," in *Poetry, Language, Thought* (New York: Harper & Row, 1971), pp. 48–49.

21. Heidegger, "The Origin of the Work of Art," pp. 53–54.

22. Immanuel Kant, *The Critique of Judgement,* trans. J. C. Meredith (Oxford: Oxford University Press, 1952), 314, pp. 175–76.

23. See Martin Heidegger, *Being and Time* (New York: Harper & Row, 1962), sec. 32, pp. 188–95.

24. Gadamer, *Truth and Method,* p. 167.

25. Aristotle, *Nicomachean Ethics,* bk. 1, ch. 3, 1094b, trans. W. D. Ross.

26. Gadamer, *Truth and Method,* p. 150.

27. The contrast has been fully articulated and developed by Richard Rorty in a number of books beginning with *Philosophy and the Mirror of Nature* (Princeton: Princeton University Press, 1979). Other relevant texts can be found in *Consequences of Pragmatism (Essays: 1972–1980)* (Minneapolis: University of Minnesota Press, 1982) and *Objectivity, Relativism, and Truth: Philosophical Papers,* vol. 1 (Cambridge: Cambridge University Press, 1991).

28. Kant writes further in "What is Enlightenment?": "Tutelage is man's inability to make use of his understanding without direction from another. Self-incurred is this tutelage when its cause lies not in lack of reason but in lack of resolution and courage to use it without direction from another." Kant, *On History,* trans. and ed. L. W. Beck (Indianapolis: Bobbs-Merrill, 1963), p. 3.

29. See E. D. Hirsch, Jr., *Validity in Interpretation* (New Haven: Yale University Press, 1967), and *The Aims of Interpretation* (Chicago: The University of Chicago Press, 1976).
30. Hirsch, *The Aims of Interpretation,* p. 23.
31. Hirsch, *Validity in Interpretation,* pp. 4–9, and *The Aims of Interpretation,* pp. 2–3 and 79–80.
32. Hirsch, *Validity in Interpretation,* p. 57, and *The Aims of Interpretation,* p. 19.
33. Hirsch, *Validity in Interpretation,* pp. 72–88 and x.
34. Hirsch, *Validity in Interpretation,* p. 207.
35. Hirsch, *Validity in Interpretation,* p. 136.
36. Hirsch, *Validity in Interpretation,* pp. 141 and 162, and *The Aims of Interpretation,* p. 19.
37. Hirsch, *The Aims of Interpretation,* p. 90.
38. Rorty, *Consequences of Pragmatism,* p. 202.
39. Richard Rorty, "The Pragmatist's Progress," in S. Collini, ed., *Interpretation and Overinterpretation* (Cambridge: Cambridge University Press, 1992), p. 106.
40. W. K. Wimsatt and Monroe Beardsley, "The Intentional Fallacy," *Sewanee Review* 54 (1946), 468–88. For a useful recent discussion with a history of the debate generated by the paper and with references to the relevant literature, see George Dickie and W. Kent Wilson, "The Intentional Fallacy: Defending Beardsley," *The Journal of Aesthetics and Art Criticism* 53 (1995), 233–50.
41. Richard Rorty, "Texts and Lumps," *New Literary History* 17 (1985), 1–16.
42. Rorty, *Consequences of Pragmatism,* pp. 199–200.

Epilogue
1. Immanuel Kant, *The Critique of Judgement,* trans. James Creed Meredith (Oxford: Oxford University Press, 1952), 217, p. 58.
2. Kant, *The Critique of Judgement,* 217, p. 58.
3. Kant, *The Critique of Judgement,* 217, p. 58.
4. Kant, *The Critique of Judgement,* 218, p. 59.
5. Kant, *The Critique of Judgement,* 219, p. 60.
6. Kant, *The Critique of Judgement,* 227, p. 69.
7. Kant, *The Critique of Judgement,* 231, p. 75.
8. Kant, *The Critique of Judgement,* 229, p. 72.
9. Ibid.
10. Ibid.
11. Kant, *The Critique of Judgement,* 230, p. 73.
12. See Hans-Georg Gadamer, *Truth and Method* (New York: Continuum, 1975), pt. 1, ch. 2, sec. 1: "Play as the clue to ontological explanation" (pp. 91–119).
13. Roger Scruton, *Art and Imagination: A Study in the Philosophy of Mind* (London: Methuen, 1974), pp. 248–49.
14. G. W. F. Hegel, *Elements of the Philosophy of Right,* ed. Allen W. Wood, trans. H. B. Nisbet (Cambridge: Cambridge University Press, 1991), § 20, p. 52.
15. Charles Baudelaire, "The Painter of Modern Life," in *Selected Writings on Art and Artists,* trans. P. E. Charvet (Harmondsworth: Penguin Books, 1972), pp. 402–3.
16. Baudelaire, "The Painter of Modern Life," pp. 402–3.
17. G. W. F. Hegel, *Aesthetics: Lectures on Fine Art,* trans. T. M. Knox, 2 vols. (Oxford: Oxford University Press, 1975), pp. 7–8.

SELECTED BIBLIOGRAPHY

Abbate, Carolyn. *Unsung Voices: Opera and Musical Narrative in the Nineteenth Century.* Princeton: Princeton University Press, 1991.

Abrams, M. H. *The Mirror and the Lamp: Romantic Theory and the Critical Tradition.* Oxford: Oxford University Press, 1953.

Adorno, Theodor W. *Aesthetic Theory.* London: Routledge & Kegan Paul, 1984.

———. *Beethoven: Philosophie der Musik,* in R. Tiedemann, ed., *Nachgelassene Schriften,* vol. 1. Frankfurt am Main: Suhrkamp, 1993; 2d ed., 1994.

———. *In Search of Wagner.* Trans. R. Livingstone. London: NLB, 1981.

———. *Mahler. Eine musikalische Physiognomik,* in G. Adorno and R. Tiedemann, eds., *Gesammelte Schriften,* vol. 13. Frankfurt am Main: Suhrkamp, 1971.

———. *Philosophy of Modern Music.* New York: The Seabury Press, 1973.

Alpers, Svetlana. *The Art of Describing: Dutch Art in the Seventeenth Century.* Chicago: The University of Chicago Press, 1983.

Aristotle, *Nicomachean Ethics.* Trans. W. D. Ross, in *The Basic Works of Aristotle.* Ed. R. McKeon. New York: Random House, 1941.

———. *On the Soul.* Trans. J. A. Smith, in *The Basic Works of Aristotle.* Ed. R. McKeon.

———. *Poetics.* Trans. Ingram Bywater, in *The Basic Works of Aristotle.* Ed. R. McKeon.

———. *Politics,* trans. Benjamin Jowett, in *The Basic Works of Aristotle.* Ed. R. McKeon.

———. *Rhetoric.* Trans. W. Rhys Roberts. New York: Random House, 1954.

St. Augustine, *Confessions.* Trans. W. Watts. Loeb Classical Library, 2 vols. Cambridge: Harvard University Press, 1912.

Bakhtin, Mikhail M. "Discourse in the Novel," in *The Dialogic Imagination.* Austin: University of Texas Press, 1981.

———. *Problems of Dostoevsky's Poetics.* Trans. C. Emerson. Minneapolis: University of Minnesota Press, 1984.

Barthes, Roland. "The Death of the Author" and "Introduction to the Structural Analysis of Narratives," in *Image-Music-Text.* Trans. S. Heath. New York: Hill and Wang, 1977.

Baudelaire, Charles. "The Painter of Modern Life," and "Richard Wagner and *Tannhäuser*

in Paris" [1861], in *Selected Writings on Art and Artists.* Trans. P. E. Charvet. Harmondsworth: Penguin Books, 1972.

Baxandall, Michael. *Painting and Experience in Fifteenth-Century Italy.* Oxford: Oxford University Press, 1972.

Benjamin, Walter. "The Work of Art in the Age of Mechanical Reproduction," in *Illuminations.* New York: Schocken Books, 1969.

Belting, Hans. *The End of the History of Art?* Trans. C. S. Wood. Chicago: The University of Chicago Press, 1987.

————. *Likeness and Presence: A History of the Image Before the Era of Art.* Trans. E. Jephcott. Chicago: The University of Chicago Press, 1994.

Berlin, Isaiah "The Concept of Scientific History," in *Concepts and Categories: Philosophical Essays.* New York: Penguin Books, 1981.

————. "Historical Inevitability" and "Two Concepts of Liberty" in *Four Essays on Liberty.* Oxford: Oxford University Press, 1969.

Besançon, Alain. *L'Image interdite. Une histoire intellectuelle de l'iconoclasme.* Paris: Fayard, 1994.

Besseler, Heinrich. *Das musikalische Hören der Neuzeit,* Berichte über die Verhandlungen der Sächsischen Akademie der Wissenschaften zu Leipzig, Philologisch-historische Klasse, Band 104, Heft 6. Berlin: Akademie-Verlag, 1959.

Bloch, Ernst. *Essays on the Philosophy of Music.* Cambridge: Cambridge University Press, 1985.

Bollnow, Otto Friedrich. *Das Wesen der Stimmungen,* 3d ed. Frankfurt am Main: Vittorio Klostermann, 1956.

Booth, Wayne C. *The Rhetoric of Fiction,* 2d ed. Chicago: The University of Chicago Press, 1983.

Bourdieu, Pierre. *Distinction: A Social Critique of the Judgement of Taste.* Trans. Richard Nice. Cambridge: Harvard University Press, 1984.

Carr, David. *Time, Narrative, and History.* Bloomington: Indiana University Press, 1986.

Cavell, Stanley. "Music Discomposed," in *Must We Mean What We Say?* Cambridge: Cambridge University Press, 1976.

Chatman, Seymour. *Coming to Terms: The Rhetoric of Narrative in Fiction and Film.* Ithaca: Cornell University Press, 1990.

————. *Story and Discourse: Narrative Structure in Fiction and Film.* Ithaca: Cornell University Press, 1978.

Clair, Jean. *La responsabilité de l'artiste: Les avant-gardes entre terreur et raison.* Paris: Gallimard, 1997.

Collingwood, R. G. *The Principles of Art.* Oxford: Oxford University Press, 1938.

Cone, Edward T. *The Composer's Voice.* Berkeley: University of California Press, 1974.

————. "The World of Opera and Its Inhabitants," in *Music: A View from Delft.* Chicago: The University of Chicago Press, 1989.

Constant, Benjamin. *Principes de politique applicables à tous les gouvernements (version de 1806–1810).* Paris: Hachette Littératures, 1997.

Croce, Benedetto. *Aesthetic as Science of Expression and General Linguistic.* Trans. Douglas Ainslie, rev. ed. London: Macmillan & Co., 1922.

Dahlhaus, Carl. "Autonomie und Bildungsfunktion," in S. Abel-Struth, ed., *Aktualität und Geschichtsbewusstsein in der Musikpädagogik,* Musikpädagogik. Forschung und Lehre, vol. 9. Mainz: B. Schott's Söhne, 1973.

————. *Esthetics of Music.* Trans. W. Austin. Cambridge: Cambridge University Press, 1982.

————. *Foundations of Music History.* Trans. J. B. Robinson. Cambridge: Cambridge University Press, 1983.

————. "Fragmente zur musikalischen Hermeneutik," in C. Dahlhaus, ed., *Beiträge zur musikalischen Hermeneutik,* Studien zur Musikgeschichte des 19. Jahrhunderts 43. Regensburg: Gustav Bosse, 1975.

————. *The Idea of Absolute Music.* Trans. R. Lustig. Chicago: The University of Chicago Press, 1989.

————. *Klassische und Romantische Musikästhetik.* Laaber: Laaber-Verlag, 1988.

————. "Das musikalische Kunstwerk als Gegenstand der Soziologie," *International Review of the Aesthetics and Sociology of Music* 6 (1975), 11–24.

————. "Musik als Text," in G. Schnitzler, ed., *Dichtung und Musik. Kaleidoskop ihrer Beziehungen.* Stuttgart: Klett-Cotta, 1979.

————. *Richard Wagner's Music Dramas.* Trans. M. Whittall. Cambridge: Cambridge University Press, 1979.

————. *Schoenberg and the New Music.* Trans. D. Puffett and A. Clayton. Cambridge: Cambridge University Press, 1987.

Dahlhaus, Carl, and Hans Heinrich Eggebrecht, *Was ist Musik?,* 2d ed. Wilhelmshaven: Florian Noetzel Verlag, 1987.

Danto, Arthur C. *After the End of Art: Contemporary Art and the Pale of History.* Princeton: Princeton University Press, 1997.

————. *Beyond the Brillo Box: The Visual Arts in Post-Historical Perspective.* New York: Farrar, Straus and Giroux, 1992.

————. "The End of Art," in *The Philosophical Disenfranchisement of Art.* New York: Columbia University Press, 1986.

————. *The Transfiguration of the Commonplace: A Philosophy of Art.* Cambridge: Harvard University Press, 1981.

Danuser, Hermann. "Konstruktion des Romans bei Gustav Mahler," *Musikalische Prosa,* Studien zur Musikgeschichte des 19. Jahrhunderts 46. Regensburg: Gustav Bosse Verlag, 1975.

Derrida, Jacques. *Of Grammatology.* Baltimore: Johns Hopkins University Press, 1976.

Dewey, John. *Art as Experience, The Later Works, 1925–1953,* vol. 10 [1934]. Carbondale and Edwardsville: Southern Illinois University Press, 1987.

Diderot, Denis. *The Paradox of Acting.* New York: Hill and Wang, 1957.

Dufrenne, Mikel. *The Phenomenology of Aesthetic Experience.* Evanston: Northwestern University Press, 1973.

Elias, Norbert. *Mozart: Portrait of a Genius.* Trans. Edmund Jephcott. Cambridge, Mass.: Polity Press, 1993.

Ferry, Luc. *Homo Aestheticus.* Chicago: The University of Chicago Press, 1993.

Fish, Stanley. *Doing What Comes Naturally: Change, Rhetoric, and the Practice of Theory in Literary and Legal Studies.* Durham: Duke University Press, 1989.

Foucault, Michel. *The Order of Things: An Archeology of the Human Sciences.* New York: Random House, 1970.

————. "What Is an Author?," in *The Foucault Reader.* Ed. P. Rabinow. New York: Pantheon, 1984.

Freccero, John. *Dante: The Poetics of Conversion.* Cambridge: Harvard University Press, 1986.

Fumaroli, Marc. *L'École du silence. Le sentiment des images au XVII^e siècle.* Paris: Flammarion, 1994.

————. *L'État culturel: une religion moderne.* Paris: Éditions de Fallois, 1992.

Gadamer, Hans-Georg. *The Relevance of the Beautiful and Other Essays.* Cambridge: Cambridge University Press, 1986.

———. *Truth and Method.* New York: Continuum, 1975.

Gellner, Ernest. *Nations and Nationalism.* Ithaca: Cornell University Press, 1983.

Genette, Gérard. *The Architext: An Introduction.* trans. J. E. Lewin. Berkeley: University of California Press, 1992.

———. *Narrative Discourse: An Essay in Method.* Ithaca: Cornell University Press, 1980.

———. *Narrative Discourse Revisited.* Ithaca: Cornell University Press, 1988.

Goehr, Lydia. *The Imaginary Museum of Musical Works: An Essay in the Philosophy of Music.* Oxford: Clarendon Press, 1992.

Gombrich, E. H. *Art and Illusion: A Study in the Psychology of Pictorial Representation,* 2d ed. Princeton: Princeton University Press, 1961.

———. *The Sense of Order: A Study in the Psychology of Decorative Art.* Ithaca: Cornell, University Press, 1979.

Goodman, Nelson. *Languages of Art: An Approach to a Theory of Symbols.* 2d ed. Indianapolis: Hackett, 1976.

Grey, Thomas S. *Wagner's Musical Prose: Texts and Contexts.* Cambridge: Cambridge University Press, 1995.

Hamburger, Käte. *The Logic of Literature,* 2d rev. ed. Bloomington: Indiana University Press, 1973.

Hanslick, Eduard. *On the Musically Beautiful: A Contribution towards the Revision of the Aesthetics of Music.* Trans. G. Payzant. Indianapolis: Hackett, 1986.

Hegel, Georg Wilhelm Friedrich. *Aesthetics: Lectures on Fine Art.* Trans. T. M. Knox, 2 vols. Oxford: Oxford University Press, 1975.

———. *Elements of the Philosophy of Right.* Ed. A. W. Wood, trans. H. B. Nisbet. Cambridge: Cambridge University Press, 1991.

——— *Lectures on the Philosophy of World History. Introduction: Reason in History.* Trans. H. B. Nisbet. Cambridge: Cambridge University Press, 1975.

——— *Philosophy of Mind. Being Part Three of the Encyclopaedia of the Philosophical Sciences (1830).* Trans. W. Wallace. Oxford: Oxford University Press, 1971.

Heidegger, Martin. *Being and Time.* New York: Harper & Row, 1962.

———. *Poetry, Language, Thought.* Trans. Albert Hofstadter. New York: Harper & Row, 1971.

———. "Letter on Humanism" and "The Question Concerning Technology," in *Basic Writings.* New York: Harper and Row, 1977.

Herder, Johann Gottfried. *Essay on the Origin of Language.* Trans. A. Gode. Chicago: The University of Chicago Press, 1966.

Hirsch, Jr., E. D. *Validity in Interpretation.* New Haven: Yale University Press, 1967.

———. *The Aims of Interpretation.* Chicago: The University of Chicago Press, 1976.

Hobsbawm, Eric J. *Nations and Nationalism since 1780,* 2d ed. Cambridge: Cambridge University Press, 1992.

Hoffmann, Ernst Theodor Amadeus. "Beethoven's Instrumental Music" and "Old and New Church Music," in *E. T. A. Hoffmann's Musical Writings: Kreisleriana, The Poet and the Composer, Music Criticism.* Ed. D. Charlton, trans. M. Clarke. Cambridge: Cambridge University Press, 1989.

Hume, David. "Of the Standard of Taste," in *Selected Essays.* Ed. S. Copley and A. Edgar. Oxford: Oxford University Press, 1993.

Ingarden, Roman. *The Literary Work of Art: An Investigation on the Borderlines of Ontology, Logic, and Theory of Literature.* Evanston: Northwestern University Press, 1973.

———— *The Work of Music and the Problem of Its Identity.* Berkeley: University of California Press, 1986.

Kant, Immanuel. *The Critique of Judgement.* Trans. James Creed Meredith. Oxford: Oxford University Press, 1952.

———— "What is Enlightenment?," in *On History.* Ed. and trans. L. W. Beck. Indianapolis: Bobbs-Merrill, 1963.

Kenny, Anthony. *Action, Emotion and Will.* New York: Humanities Press, 1963.

Kermode, Frank. *The Sense of an Ending: Studies in the Theory of Fiction.* New York: Oxford University Press, 1967.

Kierkegaard, Søren. *Either/Or.* Ed. and trans. H. V. Hong and E. H. Hong. 2 vols. Princeton: Princeton University Press, 1987.

Kipnis, Laura. *Bound and Gagged: Pornography and the Politics of Fantasy in America.* New York: Grove Press, 1996.

Kivy, Peter. *The Corded Shell: Reflections on Musical Expression.* Princeton: Princeton University Press, 1980.

————. *Music Alone: Philosophical Reflections on the Purely Musical Experience.* Ithaca: Cornell University Press, 1990.

Kleist, Heinrich von. "Ueber das Marionettentheater," in W. Müller-Seidel, ed., *Kleists Aufsatz über das Marionettentheater. Studien und Interpretationen.* Berlin: Erich Schmidt Verlag, 1967.

Körner, Christian Gottfried. "Über Charakterdarstellung in der Musik," modern ed. in W. Seifert, *Christian Gottfried Körner. Ein Musikästhetiker der deutschen Klassik.* Regensburg: Gustav Bosse Verlag, 1960.

Kristeller, Paul Oskar. "The Modern System of the Arts," in *Renaissance Thought and the Arts: Collected Essays.* Princeton: Princeton University Press, 1980.

Kuhn, Thomas S. *The Structure of Scientific Revolutions,* 2d ed. Chicago: The University of Chicago Press, 1970.

Langer, Susanne K. *Feeling and Form: A Theory of Art.* New York: Charles Scribner's Sons, 1953.

Levinas, Emmanuel. "Reality and its Shadow," in S. Hand, ed., *The Levinas Reader.* Oxford: Basil Blackwell, 1989.

Lyotard, Jean-François. *The Postmodern Condition: A Report on Knowledge,* Theory and History of Literature 10. Minneapolis: University of Minnesota Press, 1984.

McGinn, Colin. *Ethics, Evil, and Fiction.* Oxford: Clarendon Press, 1997.

MacIntyre, Alasdair. *After Virtue: A Study in Moral Theory,* 2d ed. Notre Dame, Ind.: University of Notre Dame Press, 1984.

Man, Paul de. "The Rhetoric of Temporality" in Charles Singleton, ed., *Interpretation: Theory and Practice.* Baltimore: Johns Hopkins University Press, 1969.

Michaud, Yves. *La crise de l'art contemporain: Utopie, démocratie et comédie.* Paris: Presses Universitaires de France, 1997.

Müller, Günther. *Morphologische Poetik.* Ed. Elena Müller. Darmstadt: Wissenschaftliche Buchgesellschaft, 1968.

Nehamas, Alexander. *Nietzsche: Life as Literature.* Cambridge: Harvard University Press, 1985.

Newcomb, Anthony. "Narrative Archetypes and Mahler's Ninth Symphony," in Steven Paul Scher, ed., *Music and Text: Critical Inquiries.* Cambridge: Cambridge University Press, 1992.

————. "Once More 'Between Absolute and Program Music': Schumann's Second Symphony," *19th-Century Music* 7 (1984), 233–50.

————. "Schumann and Late Eighteenth-Century Narrative Strategies," *19th-Century Music* 11 (1987), 164–74.

————. "Sound and Feeling," *Critical Inquiry* 10 (1984), 614–43.

————. "Those Images That Yet Fresh Images Beget," *Journal of Musicology* 2 (1983), 227–45.

Nietzsche, Friedrich. *The Antichrist,* in *The Portable Nietzsche.* Ed. and trans. W. Kaufmann. New York: Viking, 1954.

————. *Beyond Good and Evil. Prelude to a Philosophy of the Future,* in *The Basic Writings of Nietzsche.* Ed. and trans. W. Kaufmann. New York: Modern Library, 1968.

————. *The Birth of Tragedy,* in *The Basic Writings of Nietzsche.* Trans. W. Kaufmann.

————. *The Case of Wagner,* in *The Basic Writings of Nietzsche.* Trans. W. Kaufmann.

————. *Ecce Homo. How One Becomes What One Is,* in *The Basic Writings of Nietzsche.* Trans. W. Kaufmann.

————. *Nietzsche contra Wagner,* in *The Portable Nietzsche.* Trans. W. Kaufmann.

————. *On the Advantage and Disadvantage of History for Life.* Trans. P. Preuss. Indianapolis: Hackett, 1980.

————. "On Music and Words." Trans. W. Kaufmann, in Carl Dahlhaus, *Between Romanticism and Modernism. Four Studies in the Music of the Later Nineteenth Century.* Berkeley: University of California Press, 1980.

————. *On the Genealogy of Morals,* in *The Basic Writings of Nietzsche.* Trans. W. Kaufmann.

————. *Twilight of the Idols,* in *The Portable Nietzsche.* Trans. W. Kaufmann.

————. *The Will to Power.* Trans. W. Kaufmann and R. J. Hollingdale. New York: Vintage Books, 1968.

Nussbaum, Martha C. *Love's Knowledge: Essays on Philosophy and Literature.* New York: Oxford University Press, 1990.

————. *Poetic Justice: The Literary Imagination and Public Life.* Boston: Beacon Press, 1995.

Oakeshott, Michael. *The Voice of Poetry in the Conversation of Mankind. An Essay.* London: Bowes & Bowes, 1959.

Parfit, Derek. *Reasons and Persons.* Oxford: Oxford University Press, 1984.

Pater, Walter. *The Renaissance: Studies in Art and Poetry.* Ed. D. L. Hill. Berkeley: University of California Press, 1980.

Perelman, Ch., and L. Olbrechts-Tyteca. *The New Rhetoric: A Treatise on Argumentation.* Notre Dame: University of Notre Dame Press, 1969.

Pinker, Steven. *The Language Instinct.* New York: HarperPerennial, 1995.

Plato. *Republic.* Trans. Paul Shorey, in E. Hamilton and H. Cairns, eds., *The Collected Dialogues.* Princeton: Princeton University Press, 1961.

Raz, Joseph. *The Morality of Freedom.* Oxford: Oxford University Press, 1986.

Ricoeur, Paul. *Oneself as Another.* Trans. Kathleen Blamey. Chicago: The University of Chicago Press, 1992.

————. *The Rule of Metaphor: Multi-disciplinary Studies of the Creation of Meaning in Language.* Toronto: University of Toronto Press, 1977.

————. *Time and Narrative,* 3 vols. Chicago: The University of Chicago Press, 1984–8.

Rorty, Richard. *Consequences of Pragmatism (Essays: 1972–1980).* Minneapolis: University of Minnesota Press, 1982.

————. *Contingency, Irony, and Solidarity.* Cambridge: Cambridge University Press, 1989.

————. *Essays on Heidegger and Others. Philosophical Papers,* vol. 2. Cambridge: Cambridge University Press, 1991.

————. *Objectivity, Relativism, and Truth. Philosophical Papers,* vol. 1. Cambridge: Cambridge University Press, 1991.

———. *Philosophy and the Mirror of Nature.* Princeton: Princeton University Press, 1979.

———. "The Pragmatist's Progress," in ed. S. Collini, *Interpretation and Overinterpretation.* Cambridge: Cambridge University Press, 1992.

———. "Texts and Lumps," *New Literary History* 17 (1985), 1–16.

Rosen, Charles. *The Romantic Generation.* Cambridge: Harvard University Press, 1995.

Rousseau, Jean-Jacques. *Essay on the Origin of Languages.* Trans. J. H. Moran. Chicago and London: The University of Chicago Press, 1966.

Sartre, Jean-Paul. *The Psychology of Imagination.* Secaucus, N. J.: The Citadel Press, n.d.

Schiller, Friedrich. *On the Aesthetic Education of Man. In a Series of Letters.* Trans. E. M. Wilkinson and L. A. Willoughby. Oxford: Oxford University Press, 1967.

Schopenhauer, Arthur. *Manuscript Remains in Four Volumes.* Ed. Arthur Hübscher, trans. E. F. J. Payne. Oxford: Berg, 1988.

———. *The World as Will and Representation.* Trans. E. F. J. Payne, 2 vols. New York: Dover, 1966.

Scruton, Roger. *The Aesthetics of Architecture.* Princeton: Princeton University Press, 1979.

———. *The Aesthetics of Music.* Oxford: Clarendon Press, 1997.

———. *The Aesthetic Understanding.* London: Methuen, 1983.

———. "Analytic Philosophy and the Meaning of Music," in R. Shusterman, ed., *Analytic Aesthetics.* Oxford: Basil Blackwell, 1989.

———. *Art and Imagination: A Study in the Philosophy of Mind.* London: Methuen, 1974.

Shusterman, Richard. *Pragmatist Aesthetics: Living Beauty, Rethinking Art.* Oxford and Cambridge: Blackwell, 1992.

Staiger, Emil. *Basic Concepts of Poetics.* University Park, Pa.: The Pennsylvania State University Press, 1991.

Starobinski, Jean. *Jean-Jacques Rousseau, Transparency and Obstruction.* Trans. Arthur Goldhammer. Chicago: The University of Chicago Press, 1988.

Steiner, Wendy. *The Scandal of Pleasure: Art in an Age of Fundamentalism.* Chicago: The University of Chicago Press, 1995.

Stendhal, *On Love.* New York: The Universal Library, 1967.

Taylor, Charles. *Human Agency and Language. Philosophical Papers 1.* Cambridge: Cambridge University Press, 1985.

———. *Philosophy and the Human Sciences. Philosophical Papers 2.* Cambridge: Cambridge University Press, 1985.

———. *Sources of the Self: The Making of the Modern Identity.* Cambridge: Harvard University Press, 1989.

———. *Philosophical Arguments.* Cambridge: Harvard University Press, 1995.

Tocqueville, Alexis de. *Democracy in America.* Ed. J. P. Mayer, trans. G. Lawrence. Garden City, N.Y.: Anchor Books, 1969.

Todorov, Tzvetan. "The Grammar of Narrative," and "Narrative Transformations," in *The Poetics of Prose.* Ithaca: Cornell University Press, 1977.

Walton, Kendall L. *Mimesis as Make-Believe: On the Foundations of the Representational Arts.* Cambridge: Harvard University Press, 1990.

———. "What is Abstract About the Art of Music?," *The Journal of Aesthetics and Art Criticism* 46 (1988), 351–64.

Weber, Max. "Politics as a Vocation" and "Science as a Vocation," in H. H. Gerth and C. Wright Mills, eds., *From Max Weber: Essays in Sociology.* New York: Oxford University Press, 1946.

Welsch, Wolfgang. *Unsere postmoderne Moderne.* Weinheim: Acta humaniora, 1987.

Wimsatt, W. K., and Monroe Beardsley. "The Intentional Fallacy," *Sewanee Review* 54 (1946), 468–88.

Wittgenstein, Ludwig. *Culture and Value.* Trans. P. Winch. Chicago: The University of
 Chicago Press, 1980.
————. *Philosophical Investigations.* London: Macmillan, 1953.
Wollheim, Richard. *Painting as an Art.* Princeton: Princeton University Press, 1987.
Wood, Allen W. *Hegel's Ethical Thought.* Cambridge: Cambridge University Press, 1990.
Woodmansee, Martha. *The Author, Art, and the Market: Rereading the History of Aes-
 thetics.* New York: Columbia University Press, 1994.

INDEX